LOVING PICASSO

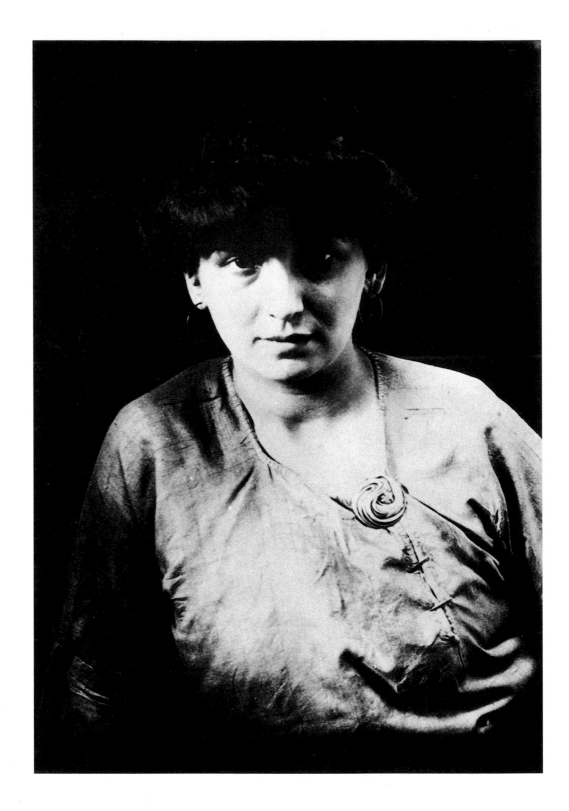

LOVING PICASSO

The Private Journal of Fernande Olivier

Translated from the French
by Christine Baker and Michael Raeburn

Foreword and notes by Marilyn McCully

Epilogue by John Richardson

Harry N. Abrams, Inc., Publishers

Editor: Elaine M. Stainton
Designed and produced by Michael Raeburn/Cacklegoose Press, London
Jacket design: Michael Walsh
Illustrations reproduced by Mani/Summerfield Press, Florence

Library of Congress Cataloging-in-Publication Data
Olivier, Fernande.
 Loving Picasso : the private journal of Fernande Olivier / translated
 from the French by Christine Baker and Michael Raeburn ; foreword
 and notes by Marilyn McCully ; epilogue by John Richardson.
 p. cm.
 Includes material originally published in French in Picasso et ses amis
 (1933) and Souvenirs intimes (1988), as well as a selection of letters.
 Includes bibliographical references and index.
 ISBN 0-8109-4251-8
 1. Olivier, Fernande. 2. Artists' models—France—Biography. 3.
 Mistresses—France—Biography. 4. Picasso, Pablo, 1881–1973—
 Relations with Women. I. Title.

 N7574 .O44 2000
 759.4—dc21
 [B] 00-057628

Printed and bound in Hong Kong

Harry N. Abrams, Inc.
100 Fifth Avenue
New York, N.Y. 10011
www.abramsbooks.com

Note: Fernande Olivier's spellings of names have been retained; [sic] has
been used only in cases where confusion might otherwise occur. Fernande's
underlinings for emphasis in her letters have been represented by italic type.

Frontispiece: Fernande Olivier photographed by Picasso, c. 1908.
Musée Picasso, Paris—Archives Picasso.

CONTENTS

PHOTO CREDITS

Copies of photographs and documents from Fernande's papers and photographs of his own paintings were kindly loaned by Gilbert Krill; these are reproduced on pp. 11, 15, 16, 17, 20, 63, 123, 146, 150 (*right*), 166, 175, 201, 208, 257, 270, 280, 284.

Photographs of works in the Musée Picasso and documents in the Archives Picasso were supplied by the Réunion des Musées Nationaux, and we are, as always, grateful to Caroline de Lambertye for her help. They are reproduced on pp. 2, 8, 130, 138, 145 (*left*), 150 (*left*), 160, 162, 164 (*left*), 183 (*right*), 212, 224, 226, 231, 241, 245, 252, 269.

Other photographs were provided by Roger-Viollet (pp. 33, 78, 81); Archives Larousse-Giraudon (p. 121); Arxiu Mas (p. 183 *left*); Sala Parès, Barcelona (p. 147); and the Musée Française de la Photographie (photo: André Fage, p. 83). The illustration on p. 36 was photographed by Gérard Leyris; and that on p. 96 by Victor Pustai.

The documents on pp. 32 and 40 are in the collection of Edouard Mancel, Méru. The photographs on pp. 48 and 49 are taken from Paul Strauss's *Paris Ignoré* (1893); and those on p. 120 from *L'Illustration* (1906).

The photographs of paintings on pp. 131 (*top*) and 133 are © 2001 The Museum of Modern Art, New York. The full documentation for these works is as follows: Pablo Picasso: *Standing Nude*, 1906. Oil on canvas, 60½ × 37⅛″ (153.7 × 94.3 cm). The Museum of Modern Art, New York. The William S. Paley Collection; and Pablo Picasso: *Meditation (Contemplation)*, late 1904. Watercolor and pen and ink on paper, 14½ × 10½″ (36.9 × 26.7 cm). The Museum of Modern Art, New York. Louise Reinhardt Smith Bequest.

Thanks are due for the loan of photographs to all those museums, libraries and collectors whose names are given in the picture captions and to the collectors who have preferred to remain anonymous.

ACKNOWLEDGMENTS

The editor and translators owe a great debt of gratitude to Gilbert and Carmen Krill, who have supported this edition of Fernande Olivier's writings since it was originally put forward in 1993. Their careful documentation has made possible our own research into the life and background of Fernande Olivier, and their hospitality, friendship and patience in the long process of bringing the book to publication is much appreciated.

John Richardson, who first proposed the book, has been unfailingly supportive, and we are most grateful to him for this, and for providing the Epilogue.

Among the many people who shared their research with us, we are particularly indebted to the late Judith Cousins, a legendary seeker for truth. Other friends and colleagues who have given generous help include Miriam Alzuri, Vivian Cameron, Anselmo Carini, Phillip Dennis Cate, Anita L. Dotson, Susan Galassi, Catherine Giraudon, Pascale Heurtel, Dorothy Kosinski, Yannick Lintz, Edouard Mancel, David Nash, Jacques Nicourt, Peter Read, Hélène Secckel, Jaume Sunyer, and Jeffrey Weiss.

Fernande Olivier's letters to Gertrude Stein and Alice B. Toklas are in the Collection of American Literature, the Beinecke Rare Book and Manuscript Library, Yale University. We are most grateful for their permission to include them here and to the staff of the library for their assistance. We also wish to thank the staff of the Bibliothèque Historique de la Ville de Paris, the National Art Library, the London Library and, especially, the Archives Picasso at the Musée Picasso, Paris, where, Anne Baldassari, Sylvie Fresnault and Pierrot Eugène gave great assistance.

We want to thank Bertram Fields and Barbara Guggenheim for their generous hospitality on many research trips to Paris.

We have been very fortunate in our colleagues at Harry N. Abrams Inc., Paul Gottlieb, Michael Walsh and, especially, our editor, Elaine M. Stainton, who has given devoted encouragement at every stage.

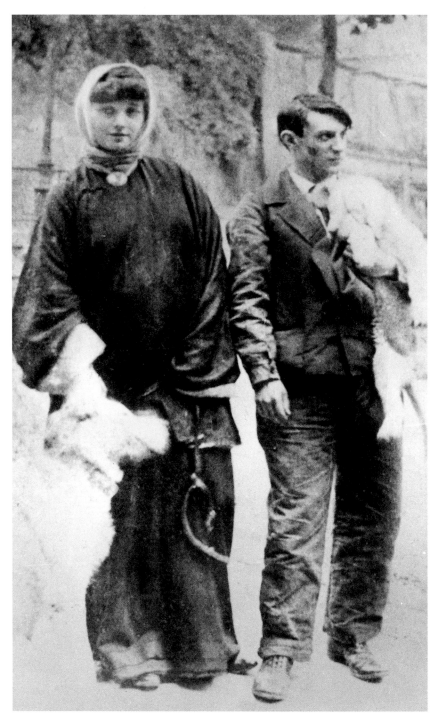

Fernande and Picasso in Montmartre with their dogs Frika and Gat, 1906.
Musée Picasso, Paris—Archives Picasso.

FOREWORD

The Mirror of the Cubist Acropolis

Marilyn McCully

Pablo Picasso decided at a very young age that he wanted to become an artist, and for the rest of his life he pursued this solitary aim to the exclusion of practically everything else. His family in Spain did all they could to support and encourage him, although they had hoped he would eventually establish a career as a distinguished academician either in Barcelona or Madrid. He realized early on, however, that his future lay in Paris, and, in 1904 at the age of twenty-two, he settled in Montmartre in the ramshackle building known as the Bateau Lavoir. Apart from the mutual support that existed among a close circle of friends, including a number of fellow Spaniards and the French poet Max Jacob, Picasso worked alone. Fernande Olivier, the beautiful artist's model whom he first met outside the Bateau Lavoir several months after he had moved in, was the first woman (apart from his mother and sisters) to play a significant role in his life. For an artist whose professional activity was so closely tied to his private and inner world, Picasso's relationship with *la belle Fernande*, as she was known among their friends, is reflected over and over again in the many works of art that her presence inspired.

Thanks to Fernande Olivier's memoirs we are able to know, in wonderfully entertaining and informative detail, about Picasso's life at the period when his work showed its most dramatic development. Fernande kept a journal for much of the time that she spent with Picasso and first published some of her reminiscences in the 1930s. Her lively observations of the comings and goings of artists and writers, patrons and dealers, bohemians, tricksters and clowns, who all played their part in the years before the First World War, are invaluable. The interrelationships among them and the events that affected them all, including suicides and love affairs, drug-taking and banquets, exhibitions and poetry readings, are described in a direct and engaging way. Max Jacob later claimed that Fernande's first book, *Picasso et ses amis* (1933), was "the best mirror of the cubist Acropolis";* and in spite of occasional errors of chronology and some notable omissions in her memoirs—very little is

* Max Jacob, *Chronique des temps héroïques* (Paris, 1956), p. 33

said, for instance, about the role of Georges Braque, or about major compositions such as *Les Demoiselles d'Avignon* (1907)—no study of the development of Picasso's art, especially the advent of cubism, can ignore what Fernande Olivier had to say.

While she and Picasso were together, Fernande spent practically all of her time with the artist, first in the cramped quarters of the Bateau Lavoir studio and later in a larger, more bourgeois, apartment on the Boulevard de Clichy. During the summers (beginning in 1906), they usually left the city together, either for Spain or the French countryside. No matter where they were, it was up to Fernande to keep Picasso company and be his lover, to make him a home and entertain their friends and, importantly, to protect his privacy when he worked long into the night. Her memoirs describe the ardor of the young artist's attentions from the moment they met, how he built a shrine to her in his studio, and his joy when she decided to move in with him in 1905. Fernande's presence, which the artist fiercely guarded, even to the extent of locking her up when he went out, was clearly essential to him during these years of artistic and personal struggle. At the same time, and from her point of view, the memoirs also reveal the difficulty she experienced living with a creative genius, whose dark moods and jealousy were often directed against her and eventually contributed to the break-up of the relationship in 1912.

Picasso et ses amis first appeared in book form in French in 1933, following the earlier publication of excerpts from Fernande's memoirs in the Paris journals *Le Soir* (1930) and *Mercure de France* (1931).* In his Epilogue John Richardson recounts in more detail the difficulties that Fernande experienced trying to find a publisher for the book, her shabby treatment by Gertrude Stein, who had promised to help her in America, and also how Picasso tried, unsuccessfully, to stop publication of the memoir in France. In 1934 another short selection was also published in English translation in *The Studio*,† but it was not until 1964 that the book *Picasso et ses amis* was translated into English, when it came out as *Picasso and His Friends*.‡

* Extracts from Fernande's memoirs appeared in 1930 in *Le Soir*, under the title "Quand Picasso était pompier," beginning with "De Barcelona à Montmartre. I," (9 September); "L'atelier du peintre et sa chapelle ardente. II," (10 September); "Deux amis du peintre. III," (11 September); "Le peintre et les marchands de tableaux. IV," (12 September); "Les soirées de la Closerie des Lilas et la fumerie d'opium. V," (13 September); and "Une soirée en l'honneur du douanier Rousseau. VI," (14 September). In 1931 the following excerpts appeared in *Mercure de France*, under the title "Neuf ans chez Picasso": "Picasso et ses amis," (1 May); "La naissance du cubisme," (15 June); and "L'atelier du boulevard de Clichy," (15 July). André Salmon claimed (*Souvenirs sans fin*, vol. II, Paris, 1956, p. 234) that the title of the book, *Picasso et ses amis*, was imposed by her French publisher Stock, and that Fernande had originally wanted to call it "Neuf ans chez Picasso." Fernande lived with Picasso for seven, not nine years; the error arose when she mistakenly reported that she had first met Picasso in 1903.

† Translated by Hugh Barnes as "Among the Artists of the Modern Movement," *The Studio* (London: April, 1934), pp. 199–203. This was described as "extracts from 'Nine Years with Picasso' by Fernande Olivier, Picasso's wife."

‡ Translated by Jane Miller and published in London (and in New York in 1965).

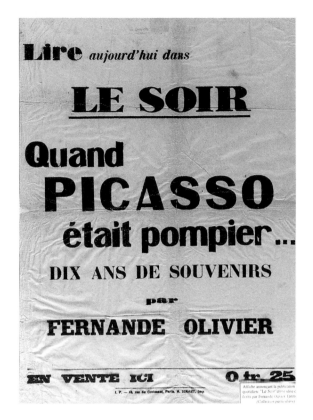

Advertisement for the first publication of excerpts from Fernande Olivier's memoirs in *Le Soir*, September 1930.

A second volume of memoirs by Fernande, *Souvenirs intimes*—probably written in the 1950s, although it may have been begun twenty years earlier—was published in French posthumously in 1988, and this includes the story of her life before she met Picasso as well as that of the years they spent together. *Souvenirs intimes* was based upon the journal Fernande had begun as a child, and continued through her first years with Picasso, while the later sections cover much of the period described in Fernande's earlier book. Sometimes the accounts concur, sometimes the later version reveals incidents or names that were disguised in *Picasso et ses amis*, and sometimes details given in the earlier book are omitted. The style of the two books differs markedly. The directness of *Picasso et ses amis* is conveyed by short sentences and abbreviated paragraphs, while *Souvenirs intimes* includes lengthier accounts, reflecting the private nature of the author's journal. Fernande told Paul Léautaud, who wrote the preface to the first edition of *Picasso et ses amis*, that the final version of the text, in fact, bore very little resemblance to her original words. She herself had edited the text, made corrections and reworked all the chapters.* In order to present her

* Léautaud, *Journal littéraire*, vol. 9 (Paris, 1960), p. 161. Léautaud says (vol. 10, 1961, p. 19) that Fernande had begun her autobiography in 1932 under the title *Françoise Laurent.*

complete story in a single volume, the translators here have incorporated material from the earlier book (in a new translation), though the more intimate narrative style of the *Souvenirs intimes* has been preferred wherever a choice was possible. In addition, the immediacy of Fernande's authentic voice is demonstrated in the selection of her letters, which are also included in this volume. All but one of these were written to Gertrude Stein or Alice Toklas. They include descriptions of life in the Spanish village of Horta de Ebro (1909) that, according to Fernande, were originally written with eventual publication in America in mind.

After Fernande's second memoir appeared, its authenticity was called into question by some critics and writers who had not seen the actual pages of script in Fernande's handwriting (some of which are reproduced here; see p. 20) and were baffled that such a document had remained secret during her lifetime.[*] John Richardson explains in his Epilogue why this happened. While it is true that the youthful journal upon which Fernande based so many early memories has been lost (perhaps when her apartment was rifled after her death), the later text of the *Souvenirs intimes* includes a great deal of material that subsequent research has confirmed. In Méru, where Fernande spent time as a girl, for instance, the name of her uncle Labrosse appears in the records of local domino producers (see p. 30). It has also been possible to track down many of the paintings and sculptures for which Fernande modeled before she met Picasso and which she describes in some detail; several are reproduced here. Photographs in the Archives Picasso, which have come to light only in recent years, turn out to be the very ones Fernande mentioned in Horta de Ebro in 1909, including a picture of the local *guardias* one of whom she described as a double of Apollinaire (reproduced here for the first time; see p. 241).

One mystery surrounding Fernande herself is her real name. Amélie Lang is the name that appears on her birth certificate, on an act of recognition by her mother, Clara Lang, and on her wedding license. The name of Fernande's father is unknown, although it may have been Bellevallé, a surname that Fernande adopted briefly in 1907 (she also spelled the name Belvallé or Belvalet). Several writers have suggested that Bellevallé was the name of Fernande's uncle, with whom she lived as a child.[†] However, the directory entries for manufacturers of feather and flower ornaments on Rue Réaumur at the time Fernande lived there with her aunt and uncle show no Bellevallés; her uncle was probably the *fleuriste* Petot at no. 55 Rue Réaumur.[‡] It has

[*] For example, Norman Mailer, *Portrait of Picasso as a Young Man* (New York, 1995), p. 147; Rosalind Krauss, *The Picasso Papers* (New York, 1998), pp. 220 ff.

[†] Fernande says that this uncle's wife, her pious aunt Alice, was a half sister of her father.

[‡] Pradines et Petot, fleurs et plumes, is listed in the Bottin directories from the 1890s up to 1904; in 1906 Mme Petot only is listed (and Fernande wrote in 1907 that her uncle had died two years earlier; see p. 192). No. 55 is also close to the corner of the Rue Saint-Denis, where the brothel known as the "Convent" (see p. 37) is likely to have been located, and the building itself seems to be consistent with Fernande's description.

also been suggested that the name Bellevallé was a gallicization of a name like Schoental or Schoenfeld, indicating that Fernande was Jewish. In her *Souvenirs*, Fernande describes her temperament as "Middle Eastern," a lineage that she says she inherited from her maternal grandmother. Perhaps this grandmother was called Bellevallé. In all probability, Fernande was a half or quarter-Jewish. Growing up in the assimilated society of Paris, she appears to have had little consciousness of this heredity. Later, as Richardson notes in the Epilogue, her part-Jewish ancestry must have been a worry to Fernande during the Second World War.

When Amélie Lang changed her name to Fernande Olivier is uncertain, although it seems most likely that she did so at the time she left her husband, Paul-Emile Percheron, in 1900, several years before she met Picasso. Judging by the frequency with which Parisian writers and actors, in particular, used pseudonyms during this period, Fernande was clearly following an accepted practice. In the Bateau Lavoir circle she made no secret of her real name. André Salmon in his memoirs refers to her both as Fernande Olivier (or *la belle Fernande*) and as "la jeune Amélie."*

Fernande changed some of the names of real people, notably that of "Laurent Debienne," who was actually called Gaston de Labaume. Since his wife was still alive at the time Fernande was writing her *Souvenirs intimes*, she was probably using discretion in this case. Brief biographies of individuals who can be identified from the text, many of whom used pseudonyms or whose names were disguised by Fernande, are given at the end of the text. In only a few cases, has it been impossible to trace people that Fernande mentioned.

Fernande's record of her life before she met Picasso provides a startlingly frank and close look at the experiences of a young woman growing up in Paris in the late nineteenth century. She was mistreated and abused as a child, raised without love by an aunt who had reluctantly taken her in—in all probability primarily for the money that the child's mother or father paid her. Because of the amateurish nature of Fernande's girlhood journal, some of the early material concerning her experiences at school, descriptions of the food and furniture in her aunt's home, and her childish flirtations, for example, have been abbreviated here. (Excerpts are indicated by [...] in the text.) Fernande has been accused of adopting the romanticizing tone of cheap fiction in *Souvenirs intimes*,† in order to justify her troubled past, especially her sexual history. However, there is nothing in the text to suggest that anything other than what Fernande describes actually happened. Indeed, her early story is probably not that much different from many young, deprived women struggling to make it alone in Paris in the *Belle Epoque* and later.

What is remarkable in Fernande's case is not only that she overcame the appalling difficulties she had experienced as a girl but that she recorded the events in her

* Salmon, *Souvenirs sans fin*, vol. 2 (Paris, 1956), p. 234.

† Krauss, *The Picasso Papers*, pp. 220 ff.

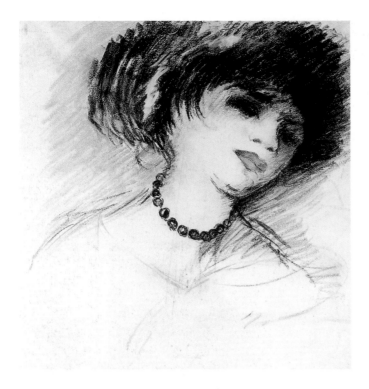

Kees Van Dongen. *Portrait of Fernande Olivier*, c. 1907. Petit Palais Musée, Geneva.

life in such a vivid way. When she was eighteen Fernande was forced by her aunt into marriage to a man who raped and beat her, and in order to escape him she fled to Paris, where she became an artist's model. Her descriptions of the different studios in which she worked and the demands of the different painters and sculptors whom she encountered is fascinating. We get a rare glimpse of what actually happened during the Prix de Rome competitions, how models and artists alike were cooped up in small, hot studios for hours on end, told from the point of view of the model. Fernande also gives us a good idea of the procedures and attitudes of academic artists, including the painter Fernand Cormon, who set up his models in theatrical settings for large-scale compositions, and the sculptor François Sicard. When in 1905 Fernande moved in with Picasso, he demanded that she give up modeling. Sicard, who had nearly completed work on a monument for Algeria for which she had been posing, tried without success to persuade Picasso to allow her to finish the job. Nonetheless, we recognize Fernande at an instant in the huge plaster (see p. 116) preserved in the Musée des Beaux-Arts at Tours, Sicard's hometown.

Fernande also served as a model for some of the aspiring artists in the Bateau Lavoir. She recounts sitting for Laurent Debienne (Gaston de Labaume), the sculptor with whom she had lived since she left her husband, mentioning in particular a bust that he did of her (presumably now lost). In 1904 she left Debienne and moved into a neighboring studio at the Bateau Lavoir, occupied by her friend

FOREWORD

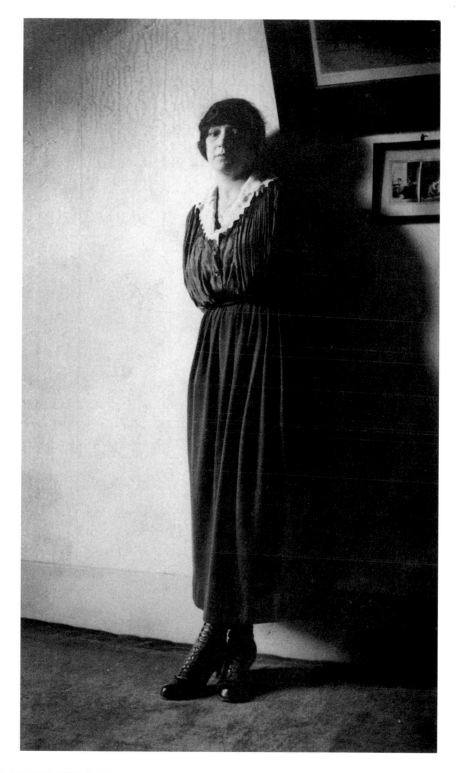

Fernande in
the 1920s.

THE MIRROR OF THE CUBIST ACROPOLIS

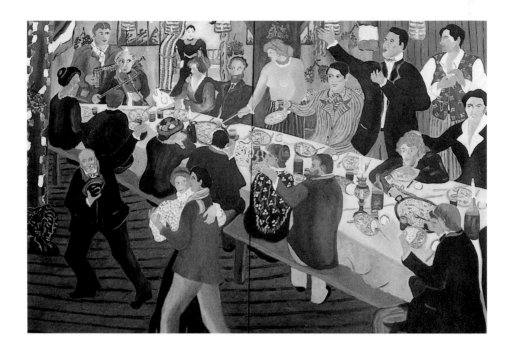

Benedetta Coletti, who was also an artist's model and the wife of the Catalan artist Ricard Canals. They posed together for Canals as Spanish señoritas at a bullfight (p. 147), a subject that had been commissioned by a Catalan patron, Ivo Bosch, who also lived in Paris. At Canals' studio, Fernande met another Catalan artist, Joaquim Sunyer, who became her lover and for whom she and Benedetta again modeled together (p. 131).

Fernande gave up modeling as a profession when she moved in with Picasso, although on a couple of occasions she posed for their artist friends, including Kees Van Dongen (see pp. 14, 134), who moved into the Bateau Lavoir with his wife and daughter in December 1905, and the sculptor Manolo (see p. 272). But she did, at least in the early years, frequently sit for Picasso. The engraving that he did of her in 1905 is, undoubtedly, the portrait to which she refers in *Souvenirs intimes* (p. 160). In general, however, the relationship between the paintings and drawings that Fernande inspired and the traditional notion of portraiture is not so straightforward. More often than not, Picasso's depictions of women during the years he and Fernande lived together (especially from 1906 to 1909), reflect her physical presence in the studio. In some cases he did paint or draw her embroidering, reading books or relaxing. But in the vast majority of his figure compositions, Picasso had absorbed her body and features so completely into his visual vocabulary that most of the women became, as it were, generic Fernandes. A case in point is the great *Demoiselles d'Avignon* of 1907. Although Flora Groult reported that Fernande claimed to have posed for this composition, neither can the quotation Groult cites

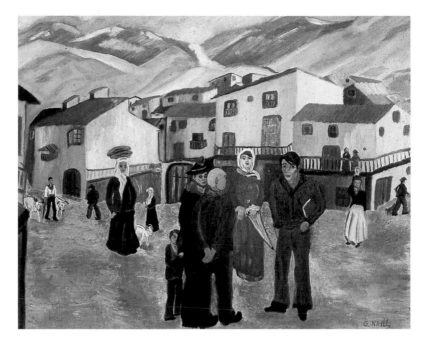

he traced, nor is there any evidence at all that Fernande did.* In fact, some of Picasso's *Demoiselles* sketchbooks include drawings done from life of a very different body type, suggesting that he may have used other models while he was working on the painting, precisely at a time when his relationship with Fernande was becoming strained. Nonetheless, the standing figures in the *Demoiselles* still relate in physiognomy to paintings and drawings of Fernande done in the previous year. But it is important to remember that Picasso was also responding to other sources, including Iberian and tribal art, photographs of African women, and to compositions by other painters, such as El Greco and Cézanne. The artistic process has thus transformed Fernande's image and body into a type that derives not from observation (of her), but from the artist's imagination. This process of transformation in his work would continue throughout Picasso's life, not only with the images inspired by Fernande's successors but by the people who were close to the artist at different moments during his long career.

Fernande's godson, Gilbert Krill, has given this new edition of Fernande's memoirs his fullest support and has generously provided much information about Fernande's life before and after Picasso. Gilbert and his wife Carmen were originally

* Flora Groult, *Marie Laurencin* (Paris, 1987), p. 66. Groult claims that "C'est le moment où il est en train de terminer les fameuses *Demoiselles d'Avignon*, pour lesquelles posera Fernande ("Ce tableau, je ne savais pas que je le faisais, mais je ne pouvais pas faire autrement."[1]) et qui provoqueront un tel scandale..." Fernande's words do not appear in any of her published memoirs, although in the note, *Picasso et ses amis* is given as the source.

responsible for assembling *Souvenirs intimes*, which they based upon the manuscript that they retrieved from what was left in Fernande's apartment at the time of her death, after her belongings had been ransacked. Since then they have tirelessly set out to preserve her memory and to acquire other documents relating to her life. As a painter himself, Gilbert Krill has over the last twenty years dedicated his energies to depicting many of the events that are described in the memoirs in compositions that reflect the atmosphere of the Bohemian world that his godmother evoked in her books. His works have been shown in Montmartre and elsewhere and have contributed to a continuing curiosity about the life that Picasso shared with his first great love, Fernande Olivier.

John Richardson's Epilogue traces the difficult course that Fernande's life followed after Picasso, including her love affairs with the Italian painter Ubaldo Oppi and the actor and writer Roger Karl. Although Karl later claimed that she was the best proofreader he had ever encountered, in order to live she had to work at a number of jobs over the years. As it turned out, it was her writing that eventually sustained her. Fernande re-established contact with Picasso after the Second World War and was able to persuade him to contribute to her support in the last decade of her life. While in her memoirs she remembered the years she shared with Picasso with bittersweet pain and regretted that she had ever left him, his tribute to her resides in the paintings and drawings of *la belle Fernande* that remain as a testament of their love and life together.

DEDICATION

To Pablo Picasso

It was hot, very hot that day. It must have been in the month of July or August, I don't remember any longer, maybe even the fourteenth of July, as the statue of the Chevalier de la Barre was being unveiled on the hill behind the Sacré-Coeur.*

It was a Sunday. I've never liked Sundays, they have an oppressive, unpleasant character. They are wearisome days, with a smell to them.

I had not left the studio where I lived on the Place Ravignan, a studio made of planks and glass which magnified every sound; the sultry heat was not conducive to doing anything. I was thinking things over sleepily, lying on a couch, holding a book that I wasn't reading in my hands.

Around five o'clock, all of a sudden, I made up my mind to leave all my brief and joyless past behind me and go to join you, to live close to you, with you.

For the months since I first met you I had resisted you, although you begged me and pleaded with your eyes. I saw that they were full of pain, of desire, of suppressed anguish, and all of this had wearied me but never softened my heart.

How cruel I was when I was young! A whim threw me into your arms one stormy day (storms have always made me lose control of myself). I only yielded to a stroke of madness; you took this gift from me in all seriousness.

And then, almost at once, I went off again, and you suffered, suffered for months without being able to forget. But I was so young and could do nothing, because my life went on in the same monotonous, not boring but superficial, way. Everything conspired to make me oblivious, and my heart, which had never spoken to me, still did not murmur anything.

I often refused to see you, I avoided you, but you always found a way to be where I was. And your eyes were begging me the whole time! Those eyes never showed rebellion, but often distress. And I was not the only cause of this, because your art, too, made you suffer.

* The statue of the Chevalier de la Barre was unveiled on September 3, 1905.

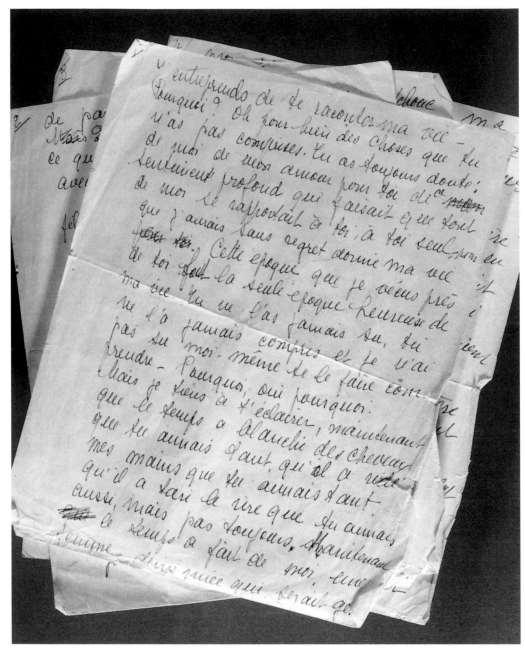

Manuscript pages of Fernande's preface to her journal, addressed to Picasso.

In the meantime, little by little, I began to think about this love I had inspired but which had not yet drawn me into its net. Little by little a warm feeling began to grow in my heart when I thought of you. Little by little I was becoming accustomed

to this love, and the idea that life together might be sweet began to take hold of me, perhaps without my being aware of it.

And alone, one day, as I was thinking how weary I was of the life I had led for almost a year and how unfulfilling it was, suddenly, that day—a summer Sunday when the sun was too hot—I made the decision to entrust myself to you.

You were not far away, living in the same building as I was. I only had to leave one door, mine, and go across to another, yours. I called you. You were working, but you left your canvases and brushes and came running, happy just to hear the sound of my voice.

I borrowed the small maid's trunk of blackened wood you had brought with you from Barcelona, I just flung everything in—all my veils and lace collars and the few clothes I owned. You stood there in front of me without seeming to understand. I gave you a nudge: "Come on then. What are you doing? Are you waiting for someone to come and stop me going?"

Then with one leap you were outside, dragging the trunk, which I could just as well have dragged on my own, my belongings were so meager. With another leap you were in your own home, you closed the door, I was there with you and the trunk, and your arms closed around me. Do you remember, dear Pablo, those days long since past?

Later, yes, later—the happiness in your eyes showed me just how much I could love you. I think there were tears in your eyes as you fixed them on mine and saw something that gave you more than hope. And the tears, which stayed in your eyes, seemed to be released in me, so gently that I felt happy, happy and distressed too, and ashamed to have made you suffer without even your suffering making me suffer. But did you understand that?

Oh, my dear, how could my pride have made me stop loving you that other day, darker, sunless, long afterwards, ten years afterwards. What a fool I was to trample on my heart, perhaps on both our hearts, but that is another story you never knew, which I was the only one ever to know.

So I arrived with no luggage, and when I left I took no luggage with me.

But what I still cannot forget is that it was with you—who have now become so distant and from whom I have become so distant, such a stranger—I cannot forget that it was only with you that I experienced happiness, the true penetrating warmth of a heart that is in love and in that way challenges love to be returned.

So I owe you more than life could ever have allowed me to hope for. The only thought that comforts me during my lonely nights, when in my despair I accept that it was my own fault that I ruined my life—my only comfort is to remember you, and the remembrance of you finally brings me calm and peace, and I fall asleep at dawn because I can forget my present life as I am cradled by the memory of you.

Fernande Olivier

PREFACE

to Fernande's Journal

I want to tell you the story of my life. Perhaps then you will understand me better. You always doubted me, doubted my love, the deep emotion that made me give my whole self to you, only to you.

Now that time has whitened the hair you loved, wrinkled the hands you loved, tarnished the laugh you also loved, though not always, I want to tell you about my life before you, and after you.

I was an unwanted child, born to a young girl and a married man, and I was brought up by a family who never accepted me. I always used to tell people that my mother had died when I was born, but that was not true; I was handed over to some of my father's relations; when I was two years old, he disappeared .

He used to come to see me two or three times a year, bringing me toys. I can vaguely recall a tall man in a top hat, holding me by the hand and taking me into a store to buy a rubber doll. I hardly ever saw my mother. I remember that I missed school when she came to visit me, but she just gave me a few cold and distant kisses. I have learned since that my father gave my mother enough money to pay for my upbringing for a few years.

I felt nothing for my mother, except a mild dread at the thought of her coming, and the relations I lived with did nothing to encourage me to see her. They used to tell me she did not love me. They themselves had a daughter, two years younger than I, whom they pampered and spoiled without a thought for my emotional isolation. There were no embraces for me, and I became more and more withdrawn.

I liked to be alone so that I could dream in peace. I lived a fantasy life, which was nourished by the books I read—fairy tales, *Robinson Crusoe, Uncle Tom's Cabin*— alone in my corner. I imagined I was the heroine of all sorts of adventures, happy or unhappy, but I was quickly brought back to reality by the scoldings I was given because, they said, I was hiding away out of idleness. They were of course partly right. I was lazy, but I was also high-spirited and reacted instinctively. When I answered back I would be punished, but this never bothered me much.

On my fifteenth birthday I started to write a diary.

AN UNWANTED CHILD

Fernande's Journal, June, 1896–August/September, 1898

Wednesday, June 6, 1896

I woke early this morning. Today, at eleven o'clock, I shall be fifteen! Is happiness in store for me? Someone's coming, I must get up. No more peace. "Seven o'clock! Get up lazybones!" There, what did I tell you? The grumbling begins.

I'm writing this in a little pocket notebook that I slip under my bolster when I go to bed. My aunt searches my things, my school bag, my exercise books, my pen case, my text books. At night, when she thinks I'm asleep, she comes in as stealthily as a cat. My eyes are shut, but I know she's there. I don't move. She'd get annoyed if she thought I could see her. My aunt has no tact, but she knows it and is embarrassed by the indiscretions she can't help committing.

I sleep with my dear little notebook where I jot down lines of classical poetry… and of my own. I'm sentimental, too sentimental, and I have to write down everything my heart dictates because I can't talk about my feelings.

I'm being called again. I've got to get up.

Wednesday evening

At last! The day is over. Here I am on my own again, which is what I like. My cousin, who sleeps in the same room as I do is asleep already. I know this because she has difficulty breathing through her nose so that she grunts while she sleeps. I don't like my cousin. She's two years younger than I am and is a replica of her mother. I don't like my aunt, and she certainly doesn't like me either. But I like my great big uncle, though he irritates me because he doesn't dare show his affection too openly. My aunt accuses him of liking me better than his "own daughter."

I don't care for the family as a whole. I prefer the maids, but as soon as I start to get attached to one of them, she leaves and is replaced by another who seems to be so similar to the last one that my attachment just continues. Stupid, isn't it, but I can't do anything about it. My aunt is the problem. She can never keep a maid. She finds fault with them the whole time; they're greedy, dirty, thieving, "emancipated" —that's a word she loves and that she fires at me the minute I take any kind of

liberty. Examples of such liberties: saying "I'm thirsty," "I'm bored," "I'm hungry," "I'll finish that tomorrow," "Where are you going?" My aunt, the "aristocrat" of the family, wasn't allowed to say things like that at the Augustinian convent where she was educated.

But I've got to go to sleep, I can hear my aunt. Tomorrow I'll write about what I did today.

Thursday, June 7

Yesterday evening my aunt came to check on me, but she must have sensed that I wasn't asleep, as she left as soon as she'd tiptoed in. I'd been writing in bed by the dim light of the night-light. My cousin is afraid of the dark, and I am too, in fact, but if it was just me there wouldn't be any night-light. When my cousin goes to stay with her godmother at Easter, as she does each year, I have to sleep in the dark. How will I be able to continue my journal? In the only place I can go where no one can spy on me!

Yesterday was my birthday, but there was no celebration except for a little sermon. Only my uncle slipped a brand new coin into my hand. My dear uncle. Every year he has a new coin for this occasion. I'd love him so much if he weren't so afraid of his wife. I've only twice seen him stand up to her for my sake. As I said, yesterday was nothing very special. I was fifteen, and I am now a young lady. I know this because my uncle gave me two francs instead of one for my weekly allowance. What can I do with these two francs, which I'll hide from my aunt and not put in my money-box? Everything that's given to me "openly" has to go straight into my money-box to make up the sum set aside for buying my clothes.

What a sentence; I never thought I'd get away with it! I'm writing too much for a diary, but I'll try to shorten it, to make my sentences more "concise," as my French teacher, Mme Dreyfus, puts it. She doesn't like sentences that are too terse, either. She criticizes me for this when she corrects the style exercises I do as homework, but, even so, I often get top grades. I'm doing all right in French, but I think math, chemistry, and the names of rivers in geography are awful. All my teachers say the same thing about me. "It comes far too easily. If she worked harder, she would do much better."

I only like work that amuses or interests me. The history of France is a wonderful story, and it captures my imagination even in the summaries I have to memorize. I've never been able to learn things by heart. I think it's stupid that you get a bad grade if you say one word instead of another when they both mean the same. They want me to be a teacher. I know for sure that if I do become one I won't have my pupils reciting by heart. But definitely, I'll never be a supervisor; that would be awful.

I've actually got off the subject of my dear aunt. I'm not surprised, since I so enjoy forgetting all about her. Unfortunately she won't allow herself to be forgotten for

long. I don't know why my aunt doesn't love me; after all if I'm not part of the family it's not my fault. I feel that I'm an embarrassment to everyone. My father and mother both died before I really knew them.* My aunt, my father's half sister, took me in at the time of her marriage. Before that I was fostered in Paris by an aunt of my uncle's, who had brought him up. We called her Maman Aubert. She had me baptized when I was ten months old. I don't understand anything about this whole business. There is some sort of mystery. If I mention my parents, if I ask questions about my mother, no one will say a word, they avoid me with their eyes, their faces become stern and I'm told not to ask ridiculous questions. Why? I'm not like other people, not pampered and spoiled like my cousin, who is stupid as well as being rather naughty. Of course I used to envy her when my aunt took her on her knee every night for a hug before putting her to bed. All I got was a dry kiss with the edge of her lips on my forehead, then I was told to say my prayers, to ask God to keep me from harm and from the sins I might commit. My cousin prayed to the Good Lord and to the Virgin Mary to guard her parents who loved her so much and to keep them from harm.

Now that I'm older I don't suffer like the little creature I was then. I try to understand like a grownup. I realize that a woman may not love a child who is not her own. A man like my uncle can, but for a woman it's not possible. And yet I would have really loved my aunt if only she could have responded by caressing me once in awhile. I spent my early childhood with a full heart, always looking for a kind gesture, for some tenderness, searching for it sometimes quite unconsciously. I'd have liked my uncle to take me away, leaving his wife and daughter so that he had no one but me to love, as if I were his true and only daughter. But life isn't that easy. Still, I can't say I was unhappy. I think of sad things which make me miserable for a time, but then I forget them. I have beautiful dreams, traveling through wonderful lands where everyone loves me and I love everyone. "There she goes, off again…" says my aunt reproachfully.

I also console myself by reading. I love to read, it's my passion. I hide books that I sneak from my uncle's library all over the place. Actually, he lets me read books which he says ought to prepare me for life. That's how I've come to read Eugène Sue's *Les Mystères de Paris*, *Les Misérables* by Victor Hugo and *Les Deux Gosses* by an author whose name I can't remember.† If life's really like that, it doesn't look as if it will be very pleasant when I'm thrown out into the world. However, I've read a book in secret that has given me what must be a more realistic idea of life: *Sous les Tilleuls* by Alphonse Karr. I've also read *Serge Pannine* by Ohnnet and *Sappho* and *Le Petit Chose* by Daudet. All these authors seem to have very different ideas about life.

* Although Fernande explains her family situation in this way here (see p. 22), her mother was certainly still alive at this time. We have no more information about her father.

† Pierre Decourcelle.

But I've got to get to sleep, or I'll find it hard to get up in the morning and tomorrow I have to take an exam so that I can continue my education. They want me to go on to the Sophie-Germain School. It seems very difficult—I'll never pass! —anyway, I've got no faith in myself, though, idiotically, I have faith in everybody else. My eyes are beginning to ache, as the flickering of the night-light is blurring my vision.

Sunday

I got one of the highest grades on the exam! It's a shame, I would far rather have failed. They tell me that with my intelligence, if only I weren't so lazy and would work harder, I'd always be one of the top three in the class. But I'm fed up with all that, I'd like to be a great tragic actress, which is something I'm talented at. Since my uncle took us to the Odéon some months ago to see *Pour la Couronne* I've thought of nothing else. But I'm timid, paralyzed by my family, who won't accept it. I said nervously that I wanted to study for the Conservatoire. My aunt shrieked loudly, "Go on the stage! Well! That's all we need to disgrace us completely! An actress! Mind you, it doesn't surprise me, blood will tell." My uncle asked her quite coolly to be quiet, and as she was going to go on and on, he took me into his office at the other end of the apartment.

We had to walk through the men's workroom and I saw my admirer. I know perfectly well that I've made an impression on this tall, dark, shy boy, who is one of our workers. My uncle has a small business manufacturing silk flowers and feathers for the fashion trade. We occupy two apartments on the same floor, which have been joined together by knocking down a partition. One contains the workrooms, the stockroom-shop, and my uncle's office. In the other there are three bedrooms, the dining room and kitchen, and a small living room where the furniture is draped in green dust-covers that are only removed when visitors come and at Christmas. They're put back on again after New Year's day.

…

Although my aunt is thrifty, we eat well at her house. I manage all right, although I'm always given the poorest cuts. When we have rabbit she makes a special point of giving me the head. So, those days I get no meat, since I've always found it disgusting to eat the head of anything. I pretend to take it apart, but leave it all on the side of my plate. I think my aunt's greatest fault is stinginess. My cousin, who only cares for milk, meat, potatoes, butter and cheese, is never forced to eat what she doesn't like. I eat just about anything apart from onions, milk and cheese. My aunt always says scornfully, "she likes everything," so I never have any excuse for refusing something, and she makes me eat onions, which give me heartburn. Until I was eight, every Sunday she forced me to swallow a few spoonfuls of vermicelli and milk soup. For several years I would vomit up the soup and I often had to be put to bed.

It went on like this until the day my uncle gathered up his courage and angrily warned my aunt that he would take me to eat in a restaurant if she insisted on making me eat things that made me ill. From then on, on Sundays, I went without the soup, but the smell of it made me nauseous, and my aunt used to enjoy that. I was never very hungry. She sulked at my uncle for a long time after his act of defiance.

I'm not jealous or envious, but I still feel miserable, although I'm fifteen, being treated like a stranger, and I really don't understand why.

…

My godmother came to see me yesterday—I see her almost every month. She's a governess to a rich family in Saint-Cloud, where she teaches French, English and German to a small girl. I think my godmother, whose family came from Germany, must have known my mother, but she never tells me about her. She lives with the family of a famous couturier on the Rue de la Paix. Her pupil is the same age and size as my cousin, and my godmother gives her pretty clothes, hardly worn—dresses, shoes, coats. So she's always well-dressed, unlike me. Beside her I look like the poor relation who is being brought up out of charity, which gratifies my aunt because it puts me down. She really seems to relish humiliating me. I've never understood why.

My godmother came in the afternoon. She took me out to tea in a cake shop near the Gare Saint-Lazare; I drank chocolate and ate raspberry and cinnamon tarts. I really like these, as I'm very greedy and don't often get such treats. She had kept two very large pears out of those she had brought for my aunt. She made me eat them in the waiting room at Saint-Lazare while we waited for her train. Of course, she knows I'm not spoiled, but she never asks me questions, and I sense that she wouldn't put up with any complaints from me.

I'd love to be consoled sometimes when I'm feeling low, but I've no one to tell my troubles to. School friends? … I'm too proud to tell them what it's like. Even with Antoinette, who's my best friend, I boast a bit when I talk about my family. I go to lunch with her and her family every Thursday, and of course they notice that I'm ashamed of the way I live. Each of the girls in turn invites her friends to tea on Thursday afternoons. One day, about three months ago, they asked me why I never invited anyone. I didn't dare tell the truth and felt so ashamed that I invited them for the following Thursday. This happened on a day when we were at Clotilde's. Right up until the fatal Thursday, I didn't dare mention it to my aunt. I prayed for help to Jesus, the Virgin Mary and the Saints, that there should be a flood, that I should fall ill, that my aunt herself be ill—anything so I could have an excuse to put them off. But the days passed and nothing happened. Thursday arrived: oh, how miserable I was. My only hope was that I'd be sent off on an errand with the maid or to pay a visit, so as not to be at home when they arrived. I had a glimmer of hope when at around half past two I was sent out with the maid. I told her how terrible

I felt. She managed to reassure me a bit, but, unfortunately, I got back too early, as my friends weren't there yet. I'd have to face up to the shock of their arrival. When I heard the doorbell ring, I felt quite ill. My aunt knew Antoinette, but she couldn't understand why three girls had come to see me. When she asked them why they were here and realized I had invited them I heard her from the kitchen, where I was hiding, saying in that uniquely acid voice: "Well, fancy that!" and then, even more bitterly, in a sharp tone, she called me. When I arrived, embarrassed, bright red and on the verge of tears, she said: "Since when have you taken the liberty of handing out invitations to my house? You know perfectly well that this isn't your own home. You are raised here out of charity. You have a nerve! I dread to think how you'll end up, and where. Judge for yourselves, young ladies, since I'm quite sure that in her place you would not have behaved like this. Anyway, since you're here, she can take you to her room so you can spend a moment together." So the image I had given of my life was shattered, which doesn't usually happen to a child. Needless to say, my aunt didn't even offer a single cookie to my friends, although she had quite recently been to dinner with Antoinette's parents.

…

I haven't been back to Clotilde's or Jeanne's and I'll never go there again. But Antoinette's mother, who's a really good friend to her daughter, came to collect us from school a few days ago. After we'd had tea and done some shopping she brought me back to her home. She asked me why I hadn't come to visit lately. I burst into tears and told her I couldn't visit Antoinette when I was forbidden to invite her back, and this seemed so unfair. She comforted me, telling me that I wasn't the one with bad manners and that I must come. Anyway, she said she would come to our house and discuss it with my aunt, which she did, and yesterday I went to lunch with Antoinette. After lunch we played Pope Joan with some of her friends. I spent the day there and my uncle and aunt came to dinner with Marguerite. Marguerite is the name of my aunt's spoiled daughter.

I like it at the Sellers' house. Antoinette's father is a councilor for the Réaumur neighborhood, and he's also an artist. He has a fashion design business employing two or three draughtsmen in his studio. Antoinette is in love with one of them (silently, of course), and I think he's in love with her. His name is Jacques Bréauté. He's seventeen, dark, and not very tall. I don't like short men myself, but he seems so nice. What will become of their love? When will they speak to each other? In fact, I too have admirers who have never spoken to me, but who come out into the street or stand by the window when they see me.

*[June 1897]**

The other day, I was in Antoinette's room, which is so nice compared to mine, so bright and fresh, with pink *toile de Jouy* wallpaper decorated with amorous shepherds and shepherdesses, and she showed me her breasts. They are very pretty—I never imagined anything could be so attractive. I don't like my own breasts that much. They're like two half apples stuck onto a chest that I think protrudes too much. Although I realize now that I'm pretty—at least, people say so—I still don't like myself physically any more than I did when I believed I was ugly, when I used to cry in front of the mirror because I thought my eyes were too small and my hair too curly. I just don't like my type of beauty. I probably wasn't very pretty when I was thirteen, but my aunt was always boasting about her daughter's eyes, which were as "big as doorways", and her plump hands. I've always had slender hands with double-jointed fingers that I could turn at right angles towards the back of my hand—the hands of a monkey or a midwife, my aunt would say. I always believed what they said about me. I believed, as I was repeatedly told, that I'd end up on the scaffold, that I'd turn out badly, that I'd be sent to a reformatory, that I'd never get married because I was ugly and bad-mannered, that I'd never succeed at anything because I was lazy, that I was heartless and would end up in the straw where I had been born, a bastard.

Although I've heard these sentences repeated mercilessly over and over again, I still believe I am sensitive and affectionate. I want to love and to be loved, to love people, animals, flowers, nature. I love true stories, beautiful poems which make me cry, music which enchants me in a strange way that I can't explain. I'm greedy, I like ripe fruit, as much for the pleasure of looking at it, of touching it, as of eating it. I want to love everything, and when the sun shines I feel in love with the sun. I love the rain which makes me melancholy and makes me dream of all kinds of tender things. I think I just love life and what it promises me. But I can't love either my aunt or my cousin. I often reproach myself for this, but I'm not sincere about it. I can't love them. I don't hate them, I don't wish for them to be ill or to die or that something dreadful should happen to them. I just wish I was away from them, not feeling that they are living the same life that, apart from them, I love so much. Perhaps I could love them if they were objects—tables, chairs, wardrobes—which is what they're like. But I don't want to live the way they live, to think the way they think, to see the way they see, to love the way they love. I don't know what I really want, but I don't want to be like them. Even when my aunt gives a penny to a poor person on Sunday morning coming out of church, I feel disgusted. But I'm sixteen and I'll leave when I've finished school.

* Fernande must have stopped writing her diary for almost a year. She turned sixteen on June 6, 1897, and this entry was evidently written several weeks before the summer vacation.

[June]

Yesterday some of my uncle's relatives came to invite us to spend our vacation with them at Méru in the Oise. Usually my godmother takes me in the summer to spend a fortnight at Rubécourt in the Ardennes with a relation of my mother's, I think, whom I call "Mon Oncle". It's very beautiful there. This uncle is a gamekeeper who lives with his family in a large lodge in the middle of the forest. ... The few days I spend with this half rustic, half urban family are always pleasant. I like the food they give us—mushrooms, fresh vegetables, little meat and, thank goodness, though I don't know why, no dairy produce. They also make a thick cabbage soup which I really enjoy, though I wouldn't like to eat it in Paris because of the bread, which is too "soggy". However, here too I feel I'm treated like a stranger. When people come up to me, they look at me as if there's some mystery that they want to solve.

On our way back from Rubécourt we've sometimes spent a few days in Méru, and I went there for the wedding of one of my uncle's nieces, but usually I don't get invited. However, this time Uncle Labrosse has insisted I come. He's very old, at least seventy, and he's rich. He used to be a pork butcher, but now he has retired. He was born in Méru, and his whole family lives there, including his older brother Charles, who makes dominoes. I feel more at ease with this family than anywhere else, and they make no distinctions between me and the other children. Uncle Charles looks more like a peasant, but he's quicker and more intelligent than his brother. I used to enjoy working beside him. Once the dominoes were ready he would allow me to put the drop of black varnish in each hole. I used a very fine brush and it only needed a tiny drop—it spreads very evenly and dries almost at once. It's a strange district, where all the locals make things from bone, ivory and mother-of-pearl. People keep large marrow bones, and traders, who come by from time to time, buy them to resell to factory workers, who prepare them, hardening and laminating them so that they can be worked. The little rectangles for the dominoes are delivered ready prepared, and they make dice here too, and jackstraws, which my cousin and I both collected.

There's a little brook in Méru that crosses the town, and the banks of this brook remind me of a fairy tale. All the waste from the mother-of-pearl is thrown there, so that everything is iridescent—it's like walking on a carpet of moonlight. When the sun strikes it, it looks as if you're on a rainbow. As a little girl, I'd run away down to the brook, where I'd sit on the ground, my pinafore full of fragments of pearl. I specially loved the pink ones and I'd sort them and try to grade them by color, but a ray of light would make them change hue. Even so, I'd spend days trying to make a selection. I have lovely hair the color of horse chestnuts, which is curly and catches anything that brushes against it. The specks of pearl used to become encrusted in it and, in any case, I liked to powder my head with them so that it glistened with a thousand lights. But what a business when it came to brushing it! In fact now, if I went to my brook and its banks, I'd put a scarf around my head, but I'd still go there

AN UNWANTED CHILD

to dream, to be on my own, to tell myself marvelous stories that I read in the luminous fragments of discarded shell. I have a box full of pieces of mother-of-pearl and I also have a set of small mother-of-pearl dominoes that Uncle Charles made for me as a reward for helping him with his work.

For a few years, we spent our holidays at Berck, because my cousin has weak lungs, which she must have got from her mother. My aunt had rented a little chalet in Rue des Oyats but, though I liked the sea, I didn't care much for Berck, and I found the sunny beach sad and boring. We weren't allowed to run there or to stay on our own, and there were dangerous waterholes, shifting sands and the risk of the tide coming in. My aunt was always afraid of everything: she saw danger everywhere and passed on her anxieties to me. Not for myself, I'm not frightened of anything, but for the people who are close to me. It's not that I'm brave—in fact, I'm timid—but because I'm never aware of danger. I'm only afraid at night. In the darkness my heart begins to pound at the slightest rustle; the creaking of a piece of furniture stops my breath. I seem to be surrounded by an invisible world. I believe in ghosts, in the devil, in spirits which float through the air. I'm even scared of my guardian angel because I know he's there—or so I've always been told—but I can't see him. I fear God, whom I think of as thunder. I've been told that thunder is God in a fury coming to punish the wicked—of whom I'm one. They used to tell me when I was little that lightning came from a battle between God and the Devil: the flashes are the little demons running away, and the thunderbolt is the Devil, whom God has captured and thrown out of Heaven. Now I'm older I know what to make of these old wives' tales, but I'm not really sure that they are "lies," and I'm still very frightened of all the noises at night.

I don't have many memories of Berck except of large carriages with children, who I thought were being punished, stretched out motionless, being pulled by dear little donkeys. I love all donkeys, but I was stopped when I wanted to go up to them. "You can easily get kicked," my aunt would say, "and if you disobey, you will be put in a cart and pulled around the beach for whole days by donkeys." I must say I would have liked to go in a donkey-carriage, but I felt a physical revulsion at the mysteriously pale and sad little faces of the children, and I preferred to keep away from them. My aunt, who is full of old-fashioned prejudices, told me the other day that all illnesses are contagious and that you should always keep away from people who are sick or in poor health. Now I know that the little martyrs in Berck were really ill, and I suppose my aunt made all that fuss to stop us going near them because she was worried we'd be infected. It sounds ridiculous but I'm sure that's what she thought.

Anyway, I didn't like Berck. I spent my time there looking for shells (though I preferred the mother-of-pearl from my stream), digging up cockles which I discovered by their little breathing-holes in the sand, their chimneys, as I used to call them. Sometimes I would let out piercing screams, and people near me would rush

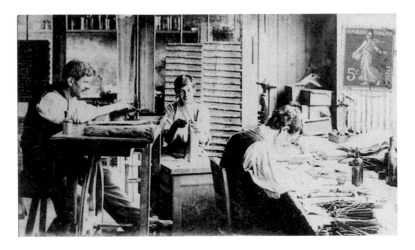

Domino-makers at Méru in the early years of the twentieth century.

up in panic, but it was only because, instead of a cockle, I had touched one of the big lug worms that the local women collect for fishermen.

The days have gone by and it will soon be prizegiving day. I passed my exams, but will I get any prizes? I won't get any firsts, so I am expecting the usual sour comments from my aunt. My cousin has never been able to win one at all, but in her case it's because of her "poor constitution," according to my aunt. In any event, this has never stopped her from enjoying the fattiest pieces of meat and eating three times as much as me, though what I really like are cakes and fruit. I'm bored today. Antoinette has had to go off to Switzerland to see her grandmother, who's very ill and asked for her to come.

Thursday, [July 1897]
No more homework, as Saturday will be the last schoolday of the year. But every Thursday my aunt gives me a task, this week two sides of a handkerchief to scallop. I loathe doing this, and my aunt always tells me how much my cousin loves needlework. God, how I'm bored. Now and again I escape to go into the lavatory. There, once the door is locked, I devour a chapter of a stolen book I've hidden on the water cistern—at the moment it's one called *Le Troisième dessous* (I don't know the author's name as the first ten pages of the book are missing).* I'm passionate about reading, just as I am about everything I like doing. Everything else, anything that doesn't interest me, I do idly, sulkily, unwillingly—like the sewing I've got in my hands at the moment. But if I don't work I get scolded, and I'm sensitive and everything immediately affects me deeply. I despair very quickly, but I also forget quickly, and sometimes I'm filled with hope—I don't really know what for—and the emotion is

* Jules Claretie.

AN UNWANTED CHILD

so intense that I think I'm going to die of happiness, although a moment earlier I thought I'd die of sorrow.

Friday

Prizegiving is on Sunday. To my horror, my aunt has decided to send me to the hairdressers for this glorious day. I shall look ridiculous, as the hairdresser gives me a hairstyle like a monument: I feel hideous when he has finished with me. Whenever we have to go to some event like this or to a wedding I have to suffer "the hairdresser." I only feel good when my hair is loose, as I'm allowed to have it on Sundays, or braided on either side of my head, as I wear it during the week. Since my hair's curly, it escapes from the pins on all sides, and since I really like that I've got into the habit of pulling out strands without my aunt noticing, because she hates untidy hair. The hairdresser gives me stiff, ugly ringlets, although you only have to twist my hair round a finger for it to fall into ringlets which are soft and graceful.

I shall be badly dressed as usual. To save money, my aunt cuts out my dresses herself and then has them sewn up by a seamstress who comes from time to time to mend the linen—which my aunt either hasn't the time for or doesn't know how to do. As she has no taste, my dresses are hideous. They also have to last a long time and as I keep growing, my clothes are usually too short. I'll wear a grey dress for the prizegiving. My cousin will be in white, in a dress that my godmother brought her last month. My grey dress, whose color I don't care for, has a collar of cream lace, and my grey hat, balanced on the mass of my tight curls, will, as usual, be trimmed with a spray of white ostrich feathers. I think parrot feathers are prettier, but they are reserved for my cousin, although it wouldn't have cost my aunt anything to

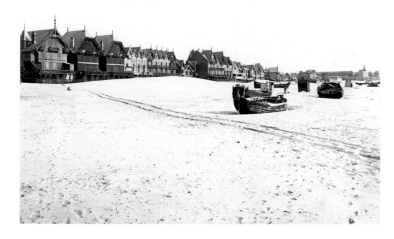

The beach at Berck at the turn of the century.

make me happy, as the drawers of the stockroom are filled with parrot feathers and plumes of every color.

What prize will I get? Maybe the fifth or sixth overall. Apart from the first prize for recitation and for English, I don't know what else I might get—perhaps French composition and history. And music. But whatever I win I'll still be criticized, so I'd rather not think about it.

Saturday

…

I was going to write Saturnal instead of Saturday; perhaps one can because it is Saturn's day. I read a good article about astrology in my uncle's newspaper. He takes *Le Radical* and is quite interested in politics. He'd like to stand as a candidate for town councilor in the hope that one day he'll be elected as a deputy, but my aunt won't allow it, saying that he would spend even more time out at the café. According to my aunt, my uncle has two vices, absinthe and playing cards for money. Every evening at six when the workers have left he goes down to the café—the one on the corner of our street and the Boulevard Sébastopol, in front of the Arts-et-Métiers square—and meets his friends. He plays his favorite game and drinks his sweet absinthe, which he doses expertly by pouring water drop by drop onto the sugar, which is placed in the special flat pierced spoon across the top of the glass. He has to be in by seven at the latest and my aunt scolds him if he's late. My aunt expects to be obeyed, and if my uncle's late he has to do what he's told. Sometimes she has fights with him which my cousin and I can hear from our room. She says: "If I'd known I was marrying a bar-prop I would have married someone else! I wasn't short of suitors!" and my uncle replies: "You never warned me you'd be the one wearing the trousers!" Then my aunt sulks and I'm the one to suffer. I have to watch myself at supper that evening, as I'll miss my dessert for the slightest infringement of the rules—Don't put your hands on the table, sit up straight, don't get that greedy look on your face when the food's put on the table, don't wolf your food or your drink, don't swing your feet, don't drop crumbs, eat with your left hand, etc. etc.

Monday

Thank goodness it's over. The prizegiving's a daunting ceremony if ever there was one. I was surprised to be third. Antoinette won the prize for excellence, and the prize of honor was won by the headmistress's neice, a shy, clever girl, full of high principles, who's a good friend, but too serious and concerned with her dignity for someone of her age.

I must have looked idiotic on the platform with my crown of alternate green and gold leaves perched on my pyramid of hair all crimped by the hairdresser. I wish the skilful construction crowning the stiff ringlets had come loose from the hairpins so that my hair could have fallen freely onto my shoulders. Despite the powder, which

AN UNWANTED CHILD

in her benevolence my aunt had allowed me to use in moderation, I felt exceptionally ugly. I received first prizes for French composition, history, recitation, reading and English. What surprised me most was getting a second prize for drawing: the teacher is always nagging me because I make my shadows too dark and—because I eat the charcoal. It's supposed to make your teeth white. One of the prizes was a book that I'm really pleased with. It's brown with gilt all around the edges, and it's about mythology, with engravings of gods and goddesses. I look like Minerva, at least I think so. I'd rather look like Diana, but there's nothing I can do about it, I'm Minerva.

After the ceremony my aunt, proud of me, trailed us around everywhere. My books were a great burden, particularly the prize for reading and recitation, which was an atlas about half a meter long; although it wasn't very thick, it was still difficult to hold under my arm. How I wished I could go home! My uncle was with his friends at the café, and my aunt took us there because my uncle's cronies had to be informed of my success. I was allowed a redcurrant and wine drink, and a friend of the family, who is always very nice to me, gave me a bouquet of white roses he bought from a flower-girl who was selling them on the street. This had the merit of annoying my aunt, who then wanted to go home.

Have I said that for some time my aunt has been wanting me to call her by her first name, Alice? She says it makes her old when I call her "aunt" I suppose if she wants me to—I'll try, but I don't like it. You call a friend by her first name, and my aunt is not a friend.

I was wrong to think I'd go to Méru straight away for the holidays. I have to stay in Paris for a while longer. My uncle has to go on a business trip and I can make myself useful in the shop. Up until now the shop and the workrooms have been out of bounds. It's fun to be able to stay there. A strange smell presides in this showroom—a mixture of hot wax, alcohol, ammonia, glue and naphthaline. The daylight comes dimly through the window, which opens onto a narrow yard hemmed in by the high walls of our house and the adjoining one. The building is very old. The staircase is so dark you have to feel your way using the banister or the wall to climb it; it's very wide with low and irregularly spaced deep steps; there are little unexpected landings, and people who don't know it trip and almost fall every four or five steps. We live on the fourth floor, but although it's high up, it's almost as dark as on the ground level. A weak light comes through a sort of skylight in the roof, which is supposed to illuminate this gloomy stairwell. The concierge's lodge is at the bottom of a long corridor off the carriage entrance. The lodge at the bottom of the stairs is also dark. I don't think I'd recognize the concierge if I met her in the street, so seldom does her face emerge from the gloom. There's a shop on the right of the entrance which is enormous fun: we're forbidden to look into it, but I wonder what

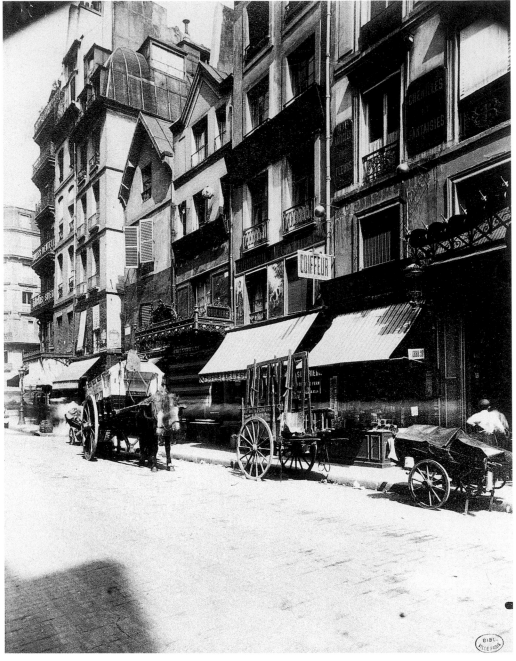

Rue Saint-Denis looking towards Rue Réaumur, at the heart of Paris's garment district. Fernande's uncle's workshop and apartment were most likely in the tall block at the end of the street, just around the corner.
Photograph by Atget, 1907. Bibliothèque Historique de la Ville de Paris.

AN UNWANTED CHILD

harm there can be. The shopfront is painted green with strange yellow and red figures. The entrance is set back, and the glass in the door and the front windows is opaque, so that you can't see inside. A barrier of trellis painted green—like you see in front of country houses—screens the door from the pavement, and high up, scarcely giving out any light, a lantern is always lit. The proprietress is a fat woman with disheveled red hair. She comes out occasionally through the door that opens onto the entry corridor, and as the inside of the shop is very brightly lit, the opening lets out a brilliant light, shining like a halo around this woman who seems, in all that darkness, like a luminous or supernatural apparition.

All of the mezzanine belongs to her, but it must communicate with the ground floor by means of an interior staircase. I've often heard her call one of her employees from the glowing threshold, as she stands there, her head raised, her hands cupped around her mouth. Music can be heard, songs, a piano, when this door is open, but apart from the *patronne*, we never see anyone else except on feast days: Mardi Gras, mid-Lent or July Fourteenth. Then women in fancy dress come out and dance in the street in front of the door, but they never stay outside for long. Why does my uncle call this house "the convent" and why are we forbidden to look? I'm so terrified of being locked in there one day, when I've done something badly wrong, that I pity with all my heart the poor women who are allowed out only two or three times a year on special holidays.

I've been helping the accountant. He makes me copy out invoices, which is boring. The accountant is a meticulous old boy—he's at least twenty-eight! Watching him work, I can understand why the office workers are nicknamed "pen-pushers": he annoys me with his carefully formed handwriting. I write twenty words in the time it takes him to write one. I have uneven handwriting, sometimes straight and upright, at other times bent and cramped, and he doesn't like this. The upstrokes and the downstrokes, so he says, are the distinctive features of good handwriting. He would have made a perfect schoolmaster—really finicky. His name is M. Maurice Dufour, and he comes in twice a week, from three until five o'clock. Apparently for the past eight years he has been looking after his invalid mother, whom he nurses with selfless devotion. It's kind, it's noble, it's everything you could ask for, he should be congratulated, he deserves a medal, but this really has nothing to do with being able to feel sympathetic towards someone. And my aunt infuriates me the way she never stops praising M. Maurice, who sets such a good example, who never raises his voice, whose oily manners are full of dignity and distinction, and who, in spite of being short, is an extremely handsome man. Ugh! Why does my aunt sing his praises at every opportunity?

I'd like to stay in the shop for a while, sorting the flowers and feathers in the high drawers, wrapping them carefully in tissue paper before arranging them delicately in the boxes for delivery to customers in Paris or sending parcels of them, well

wedged into their paper nests, by mail to customers in the provinces. We also sell samples overseas. But there it is, just when I thought I'd be doing all this in the shop, I've been stuck in an alcove that's used as an accounts office, in front of a table practically at the feet of the accountant, who's perched on a high stool in front of a high desk, and under his orders I have to copy letters, which I'll never succeed in doing properly. I make the paper too wet and the ink spreads, or it's not wet enough and the letters don't look even.

Anyway, in ten days' time I'll be in the country and will forget all this.

…

[July/August 1897]

My uncle brought us to Méru, where I've been for two days now. The house is pretty, standing right by the drinking trough, with a flower border in front and a long kitchen garden and orchard behind, which climbs steeply right up the hillside to the main road. I'd have preferred to go to Uncle Charles, the domino maker. He doesn't live in Méru itself, but at Lardière, a small village one or two kilometers from Méru, a village smothered in Virginia creeper, honeysuckle and wistaria. You see nothing but flowers and greenery framing the green-shuttered windows of the few peasant shacks that form the hamlet. There are no more than maybe ten or fifteen houses apart from the large farm, whose proprietor owns three-quarters of the land in the county. All the other villagers work as laborers, either at Méru making dominoes, or as brickmakers on the road between Lardière and Méru.

In Méru the main street is lined with huge walnut trees, which must be at least a hundred years old. I've never seen such big trees. What upsets me is that I always have to leave before the walnuts are ripe. I love all the fruits I can gather or pick in the country. I love green sour apples and the acid plums and wild cherries and blackberries. I like the little maggoty windfall pears and redcurrants and blackcurrants. I like the strawberries that are moist and often spattered with mud when it rains. I like the radishes that I dig up, the sorrel leaves which set your teeth on edge. Like a typical Parisian I love almost everything that country children despise. I love it when I get caught in a summer rainstorm that turns me into a streaming creature with hair dripping down my neck, and to feel the water seeping between my underclothes and my skin, so that I can't move because my dress sticks to my body and hampers my legs, and to feel my face varnished by the rain, water in my eyes, my ears, my neck and then, when the rain stops and a rainbow shines across the newly washed blue sky, to let myself slide on the glistening grass and to feel myself drying under the strong rays of the sun, back in his heaven. Oh how I love the country in all its moods! On the other hand, I don't like the locals, the country women with their inquisitive looks, which seem almost malevolent despite their honeyed words. I feel awkward, I feel like running away when they come near. Besides, I'm shy and I always appear stupid beside sly, deceitful folk.

Well, we've been in my Uncle Labrosse's house for two days now. My room is in the attic; I sleep with my cousin and I'm not very relaxed up there. When I was very young I didn't dare to fall asleep as I was frightened of "being frightened," and I've never got over this. I still often have that same feeling. I don't close my eyes for fear of being afraid. Aren't I foolish! I have to be able to see. I'm braver with my eyes open. Why have I been put in that room where the door doesn't close? There are strange noises up there, and sounds from the garden, right under my window, all night long. I am fed up that I'm not free to go for walks when I want to. In Lardière the countryside was mine whenever I wanted and as I wanted. I only had to appear at mealtimes. No one bothered about what I did. Here, everything is organized with something arranged for each hour of the day. In the morning, up at six to go into the country and pick flowers, get some fresh air, run. Back at eight o'clock for breakfast: chocolate and thick bread buttered twice. After breakfast, a wash. Then we have to help pick the vegetables and peel them, as the maid has far too much work to do keeping the house scrupulously clean. Everything shines here. It hurts your eyes.

We're going for a walk in the town. It's a public holiday, which is fun. I bought some dark glasses at a market stall and when I went to the confectioner's she thought I had bad eyes and felt sorry for me; I didn't disillusion her. At six we have to help water the plants in the front garden. Each one of us has a watering can—I'm bored with this chore. In fact the days pass slowly. We have dinner at seven. After a game of lotto or Pope Joan, around nine o'clock, everyone goes to bed. I've had enough of getting up at six. Tomorrow I'm going to say I'm tired and sleep until eight. I'm a bit fed up with group walks in the morning. I love sleeping.

All went well, just as I wanted. I didn't get up and Uncle Labrosse said I didn't have to if it was a nuisance. I'm going to make the best of it. Time is passing: I've already been here for eight days. I'm not enjoying myself much. There are no books in the house. I can't even read. I am longing to get away from here.

I was really frightened yesterday morning and even more so today. My cousin got up to go out with the others and I went on sleeping. Suddenly something woke me. I don't know if it was a noise or a pain. I opened my eyes and I saw, bent over mine, the face of old Uncle Labrosse. He was looking at me in a way which frightened me, but he smiled and told me he thought I'd called. Then he left. It's odd that he should come up like that. The door doesn't shut, and today he came back. I heard him on the stairs. I wished I could have shut the door. He came in and sat on my bed. He asked me if I was happy to be in his house, if I wasn't bored, what I did in Paris, and if I had any sweethearts yet. I felt ashamed and I must have turned very red. He put his rough, gnarled hands on my forehead and in my hair, and he wanted to caress me. I didn't dare say anything, but he made me even more frightened than yesterday. I told him I wanted to get up and for him to leave me alone—"Why? Do

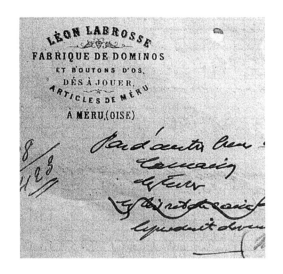

Heading of an invoice from the Labrosse domino workshop.

I embarrass you?" "At my age," he added, "everything is allowed, and at yours, you shouldn't be frightened of an old man." He told me he loves me as much as his granddaughter. He wanted to kiss me and pulled off the sheet and I screamed; then he left. Tomorrow I'll go for a walk with the others.

For three days I've been getting up at the same time as my cousin, but this morning I was too sleepy and went back to sleep. But first I put the table against the door in case uncle came again. Nothing happened, but I'll do the same thing tomorrow. That old fellow makes me sick with his affection. I'm not his daughter, not even a relation, I ask nothing of him, and also I'm unloved, which is surely why I feel awkward. Today he gave us candy, more for me than for the other two, and at four o'clock he is taking us to the cake shop. The cakes are awfully good around here.

Another adventure this morning which nearly turned out very badly. Once again I'd pushed the table against the door and gone back to sleep. Suddenly I was awakened by the disagreeable sensation of a hand on my breast and a weight on my bed, and I saw Uncle Labrosse almost lying on top of me. I wanted to get up, but he stopped me and put his hand over my mouth so that I couldn't scream. I went crazy. He was red and had such evil eyes that I thought he wanted to kill me. I was so terrified that my screams could be heard even from under his hand. He still held me and slid his hand under my nightgown while the other pressed harder on my mouth. I was almost suffocating as he said "Shut up, shut up, no one can hear you, they've all gone out. I won't hurt you—on the contrary, you'll see." I was in a dreadful state of terror. He was kissing my breast and wanted to get under the sheet beside me when suddenly he heard my cousins coming in and he ran off telling me not to say anything. What on earth had got into him? I was sick and trembling when my

AN UNWANTED CHILD

cousin came up, and she was puzzled that the table was out of place. I must have had a look which alarmed her because she went to warn my aunt, who came up. I said I had a headache and she believed me. I was nursed with lime blossom tea, but I'll never stay alone in the mornings now, I'm too afraid. That uncle must be mad. What's the matter with him?

Still another week here. I get up every morning now and in the afternoons we go to Uncle Charles's at Lardière. I asked him if I could stay at his house, telling him I'd rather be there than at Méru. He came back with us and said that he would have us to spend the last ten days of our holiday at Lardière. It will be better to spend the week there, although it's pretty poor compared to Uncle Labrosse's.

An extraordinary thing has happened which frightens me and at the same time makes me feel proud. The local coachbuilder has asked for my hand in marriage. He is the richest fellow for ten leagues around, I've been told, but I'm not old enough to marry. It seems he's willing to wait two years. They wanted to introduce him to me, and he was supposed to come over for this, since he had only glimpsed me whenever I passed his house, but after lunch I escaped to Lardière and stayed there not wanting to return to Méru. Tomorrow my cousin will come to join me and bring my belongings.
…

Tomorrow I return to Paris. Tonight we are allowed to go to the dance because its the local fête and our last evening. Charlotte, the eldest daughter of the family, often goes to the dances, which are held in a large hall in the one and only inn, which is also the grocer's. The dancing takes place among tins of food, bags of sugar, slabs of butter, packs of charcoal, cans of petrol, whole Brie cheeses, sacks of beans or lentils. But the room is very long and it's not too cramped. I was immediately asked to dance by the grocer's son. He asked me, "Is it true you're engaged to the coachbuilder?" I blushed and felt like crying. I didn't want him to believe it, but I didn't dare say anything. He would have liked to have partnered me for every dance, but other boys came and dragged me away by force, and, like Charlotte and my cousin, I had to dance with each one of them, though I saved the waltz for my first partner. He didn't want to dance with anyone else but me, and although I don't really know how to dance he was teaching me and it's fun. He asked me if I'd come back in three years; he was going away to do his military service and told me that if I didn't accept the coachbuilder's son, he would like to marry me. As usual, I didn't dare say anything, but I felt confused and delighted at the same time.

It didn't matter, as none of this was very "refined" as my aunt Alice would have said. At eleven o'clock we went home accompanied by my devoted escort, who held my hand in his all the way back.

Straight back to Paris. I'll be happy see my class again, Antoinette and the others, my books and my secret notebooks, and to gaze through the window at my sweetheart, the son of the shirtmaker opposite, who doesn't take his eyes off me as long as I'm willing to stay there. Uncle Charles drove us home and is going to stay for a few days. In Paris I live a life with no freedom. I'm not bored—in fact I'm seldom bored—and when I feel like it I live deep down inside myself and find wonderful companions there, promising, tender and gentle: my dreams. I can do anything when I dream. And afterwards, when I come out of myself, reality is less harsh because my eyes and my mind are still full of my dreams, so that I'm less aware of life. Today, at lunch, my looks were discussed. Uncle Charles finds my eyes and hands intelligent and pretty, but my aunt thinks my eyes are too small and my hands are like spiders. She's nice to say that in front of me, isn't she? As for my hair, I have too much of it, she says, and that looks common…but I don't care about these criticisms because I'm quite old enough now to notice things, and my uncle is certainly proud to go out with me. And then there's the shirtmaker opposite. I'm sure he's attracted to me. I'm not ugly—if you're ugly, no one's attracted to you.

[fall 1897]
Classes have begun again and I'm back with my friends: I rather like school life. Soon it will be Christmas, and then we have to go to a friend of my uncle's. When I say *we* have to, I'm being very pushy, because I mustn't impose myself.…I don't care. I'd rather stay behind than hear my aunt boasting about her goodness and her charity when she introduces me as the child she has raised to save me from public welfare. I've explained how charming she is. She said this several times until the day, not long ago, when I corrected her by reminding her that my father had given her money for my keep and my education. She went quite red, called me ungrateful, and I quite thought she was going to slap me in front of everyone. However, maybe now she won't dare go on like that, at least not in front of me.

[Christmas 1897]
I didn't go with my family to my uncle's friends, but Antoinette's parents took me to their house in Neuilly-en-Plaisance, where we celebrated with a feast after going to midnight Mass. Unfortunately there was no snow. There was a couple there I didn't know, M. Labat and his wife. They said I was beautiful—is it true? I slept with Antoinette, who took my hand and placed it on her breast. It was soft, but I felt ashamed. She lay very close against me, but she was hot and this prevented me sleeping.…

[1898]
Soon it will be spring. It has been decided that I won't be taken to school every day. As my cousin and I go to different schools because I'm in a higher grade, the maid

or shopgirl who takes us will leave me as soon as my cousin reaches her school (which is halfway to mine), but she'll have to keep an eye on me as long as I am in the Rue Réaumur. Antoinette, who comes from the opposite direction, will meet me at the corner of Rue Dussoubs, and we'll finish the journey together. Sometimes Clotilde, who comes from the Rue du Sentier, is with her. This morning, some boys from the Collège Turgot barred our way. They didn't want to let us pass until each one of us had chosen one of them, and one of them said that as I was the prettiest, I should choose first and the others would go along with my decision. I felt ashamed and wanted to run away, but at the same time I felt compelled by brute force to listen and stay there. I was also very excited. There were four of them, one of whom seemed much older than the rest. I shyly pointed my finger at him, and he flung his hat in the air and took my hand and kissed it. I was overwhelmed with joy and fear. I took to my heels as fast as I could, but my hat flew off, my hair-ribbon came undone and my hair, which is really beautiful and wasn't braided today, swung down to my shoulders. My sweetheart began to run after my hat, and then after me, to give it back to me.

I must have gone scarlet. At last I arrived at school and Antoinette, Jeanne and Clotilde eventually got there too, though they were almost late. What had happened after my flight? I must have seemed stupid to them, and now I'm in agony in case my foolishness has put my admirer off, as I feel that I love him passionately. I didn't see him too well because I didn't dare look at him, but I have promised myself a better look tomorrow. I have to have his features engraved in my mind, as I shall treasure his memory now. I have a reason to be happy. I'm in love and I'm loved. At last, at last, I shall be able to be tender and to yield. What joy, but what a sin too! And if this were to be discovered at home, it would be the convent this time, or the reformatory, I wouldn't get away with it. I'm frightened, but I can't give him up, it's not possible. It's such a joy to me. I'm in love and I'm loved. We'll get married, and it will be farewell to the accountant and the sick mother I'd have had to nurse after our marriage. Have I said that my aunt was arranging everything behind my back? "Do we have to consult you to arrange your happiness?" she asked me hypocritically. This marriage was just meant to get rid of me. Even without my new adventure, though, I'd never have said yes to that ancient accountant. But I needn't worry any more, I've just got to carry on with my lovely secret hidden inside me, this thing that belongs just to me, that no one can touch or take away from me. As long as my aunt doesn't take us to school tomorrow. What will he say to me tomorrow morning? I have often noticed this group of boys before, passing close by us in the morning and at lunchtime as well.

I'm writing my diary in class now. I rush through my homework and always have a little time before the next lesson to write a few lines, but I have to hide what I'm doing, especially during the French class, because Mme Dreyfus, our teacher, is

Jewish and seems to have eyes everywhere. She's always wandering around our class during lessons, often stopping near one of us and leaning with all her weight on whomever she has chosen. Often it's me. This infuriates me, and she has a habit of running her hands through my hair and stroking my neck. This tickles me dreadfully. What's more, she's very strict, especially with me. She hands out punishment for nothing at all and places me in detention, where she stays with me, making me do the next day's exercises or forcing me to write fifty or a hundred lines of some literary text she's chosen of the most boring possible kind. Still, it's even worse when she gives me a piece to copy from a book on moral doctrine or on civic instruction.

I think I've mentioned Mme Dreyfus already. Her sister is a well known actress, and she suggested to my aunt that this sister should give me some lessons. But my *bonne bourgeoise* aunt let out cries of horror. Anyway, I don't like Mme Dreyfus and she infuriates me. She seems to sense this and does her best to annoy me the whole time. She's a big bony woman, long and flat like an ironing board, with a long thin face, a slightly horsey head, faded blonde coloring, a crumpled skin lit up by large eyes of dirty grey just breaking the surface of her face, a long nose with pinched nostrils, a wide dry mouth with narrow, mean lips with drooping corners, jutting cheekbones, jutting shoulders, jutting elbows, long hands with thin jutting fingers, jutting hips—and they're sharp too. Everything about this woman is sharp. It's odd: while I was describing her I realized that she's a blonde version of my aunt, who is so dark. But Mme D.'s hair is a funny color like damp straw. My aunt says she dyes it. Is it possible that hair can become so ugly, and if so, why on earth dye it?

Here I am, a long way from my love. I'm in my bedroom, pretending to be busy with my French homework, but I'm writing for myself—my heart is bursting. I must talk to myself. Luckily I was on my own coming home at one o'clock, and I saw my beau. He passed close by me and gave me a note and blushed madly, although he's at least eighteen.

I took the note and, without daring to say anything, put it into a book of poems by Victor Hugo that I was taking for the afternoon's recitation class. I didn't have a chance to read it before three o'clock. We had an art lesson and then music on the blackboard. But at three o'clock it was reading: I opened my book and read my letter. He says he's called Albert de Marsault, that he has loved me since the beginning of term, that he thanks me for having made him happy by choosing him, and he asks when and where he can wait to talk to me after school. But I can't make a date with him, he's crazy! What if we met someone! It sends shivers down my spine. Yet I must hear him say nice things to me, I'm not used to it. All of a sudden I need this as much as I need air to breathe. What to do? Confide in the maid? Impossible, she's too stupid; she would give herself away—my aunt terrorizes her. It would be easier with the shopgirl. She's young and likes to laugh. She's become a friend since she takes me to school. The other day, when she left me at the corner of Rue

Réaumur, I could easily see that she'd joined a man I'd noticed following us, which frightened me. I wonder who it is.

…

This morning, in class, I didn't know my lessons. I did everything the wrong way round and failed to do a simple equation, but my head was turned by my adventure. I managed to leave a bit early; I've confided my love to Hélène, the shopgirl. She didn't think it was wrong and laughed at all my fears. So she left me as soon as I spotted Albert. He's not shy, which gives me courage. I took a thorough look at him and I don't find him particularly attractive. I like him even less as he doesn't seem very intelligent, so I quickly left. I met Antoinette with her sweetheart, who's the brother of one of our classmates. He reproached me for not choosing him, and it's true, I like him better than Albert and regret my choice. But what can I do? Antoinette loves him. His name is Pierre. I saw Albert again at four o'clock, but I didn't speak to him because I had someone with me. I feel like breaking it off now. I feel miserable. I know that it's Pierre I love despite his school uniform. I'm sad this evening. Love is much more complicated than I thought. When I was in bed, I cried tears of remorse that I had spurned Pierre, but in any event I don't want Albert any more. I don't think he'll suffer. I'll tell him my choice was a mistake. This morning Albert was waiting for me with a bunch of flowers. It was sweet, but I couldn't speak to him and he couldn't give me the flowers. I'd told Hélène to stay with me, that I wanted to break it off. She roared with laughter and I was annoyed. I won't tell her about my exploits any more.

…

Friday
Tomorrow evening my uncle is taking us to the Odéon to see a performance of *Caligula*, "a history lesson, a godsend for the children," he said to my aunt, who was balking at the price of the tickets.

…

My uncle's ill—he has laryngitis. He smokes too much and my aunt, who is nursing him devotedly, never stops scolding him about this and about his "apéritifs," as usual. She can't do anything easily or nicely, but has to mess up her good intentions with nagging and constant complaining. What patience my uncle has! Actually, I think he's quite indifferent to all that she says. He wants peace—let the storm blow over, let her have what she wants except for three things: his clay pipe (whose smell she detests), his daily cards and his absinthe in the café after work. She should have resigned herself to this ages ago, but no, she starts over every day. I think things will get hot the day my uncle loses his temper. So far he has remained as unruffled as still water: he just picks up his *Radical* and concentrates on reading it while my aunt

piles recriminations on him. But once or twice I've noticed the corners of his mouth trembling, and the other day, to calm himself, he kept the stem of his pipe in his mouth, while the bowl, which he'd been carefully breaking in, lay smashed on the floor. My uncle loves his little pipes. There are racks of them in every corner, which makes my aunt livid. It's true they smell bad, but fishing and breaking in pipes give my uncle some pleasure in life, and he asks for nothing more.

Does my uncle still love his wife? I think so, but I'm quite sure my aunt loves her husband. She admires his tall physique, his good looks and his masculine bearing, his deep melodious voice when he sings and his big hands, which are white and soft although he works just like his laborers. I'm not looking for that kind of happiness: it's a life that's too dull and monotonous.

We get our entertainment after dinner every evening, when my uncle reads out the serial from his newspaper in a loud voice. At the moment its *La Porteuse de Pain*.* He reads each episode from start to finish, beginning with the chapter number and never forgetting to conclude with "continuing tomorrow," when at last we're able to think about something other than the unfortunate characters in the novel. At nine thirty, the children (my cousin and I) have to go to bed; we say our good-nights and go to the twin beds in the room we share. Then we have to wash, turn down the beds, say our prayers, lie down and call out "We're in bed," so that they come to turn out the lamp and replace it with a night-light.

…

I am slightly unwell, I had a sort of blackout this morning when I got up. Yesterday evening I went to bed later than usual because of the dinner party. My aunt has asked the doctor to come by. He's coming this evening. I have to stay in bed, which is a bore.

I feel tired. The doctor came, and it seems I have slight heart trouble—asystolic —whatever that is. No overworking, he said, but in a few days I've got to do the diploma exam.

…

Monday, [June/July 1898]

…

Tomorrow: diploma.

I've passed, thank goodness, with high grades in the written exams (among the top ten), but I was almost failed. They didn't give me a zero, which would have meant rejection because I had 19 out of 20 for the French essay and 19.5 for handwriting; so even with the pitiful 3 I was awarded for math, I came out well above average.

* Novel by Count Xavier Aymon de Montépin, first published in 1884–85.

The oral could have been a disaster, as my aunt insisted on attending and she paralyzes me and takes away all my self-confidence. Luckily the examiners were charming. I did brilliantly: they all asked me to choose my subject. At last it's all over, and I can go to the Sophie-Germain school in the Rue de Jouy.

I've upset my teachers and the head of my school because I didn't go and report my exam results straight away.

…

I managed to get the fifth prize. These prizegivings are so ridiculous. I was taken to the hairdresser again. I looked awful and so as not to appear in public with this huge construction of hair on my head, I destroyed the whole thing as soon as I got home and redid my hair in its usual way. When my aunt realized she'd wasted her money on the hairdresser for such an important occasion, she was so furious I thought she was going to beat me. But the harm was done, and it was too late to have my hair redone.

What a scene! The local mayor gave out prizes and crowns and kissed the children. He placed a crown of silver laurel leaves on my head and a paternal kiss on my forehead while exhorting me to do even better; he gave me my two diplomas rolled separately and tied with a little tricolored ribbon striped like a flag. It was as nice as could be! But I was longing to sit down as I was holding two huge gilt-edged volumes, one brown and one green. The brown one is a book about stoic women, from ancient Sparta to the French Revolution, the green one is Michelet's *Natural History*. That's a lot to be getting on with. I love reading more than anything, but my aunt, in order to uphold her moral principles, only rarely allows it. I always have to do it secretly.

A large dinner to celebrate my acceptance at the Sophie-Germain school. Antoinette and her family were there as well as the Lortats—a banker and his wife who had us to dinner a little while ago. This time I was the guest of honor, not that this prevented them from serving me at the table in the usual way—that is, after everyone else—but I'm used to it. I am going away to spend a few days with Antoinette at Neuilly-en-Plaisance in her relatives' house. It's very nice there; I'm off tomorrow.

Antoinette is funny, she lies right up close to me when we're in bed and I put my arms around her because I'm much taller than she is and we fall asleep entwined. It's very sweet and I feel like crying at the thought of going home.

[August/September 1898]
The holidays are over and I'm back in Paris. My aunt, whose nerves were upset by the sea, was unbearable at Berck and never stopped tormenting me. I wanted to

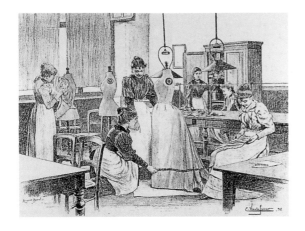

Dressmaking class at the Sophie-Germain school in the 1890s.

learn to swim, but she wouldn't let me, and the sad memories I have of this beach were only reinforced.

I had an admirer, whom I soon noticed. He was a young man who lived with his parents in the chalet next to ours. He was always by the window and watched for me while looking after his invalid sister, who stays in her little wheelchair the whole time. She's a young girl of about eighteen with coxalgia of the hip and she has been in the chair for three years. It's so sad to see these invalids, most of whom have no hope of ever walking again. Boredom seems to drain their energy and take away all their courage, all desire to get well.

In a neighboring street to ours there's a lovely big house with lots of servants, and on the terrace, blooming with geraniums and begonias, a woman, who's still very young, is always lying there, never moving. She's so pale you'd think she was dead if it weren't for her big dark eyes, which seem to follow the activity of the passers-by with envy—even jealousy. She has three children, the oldest of whom is maybe ten and the youngest four. She has been bedridden since the birth of her last child, who is a splendid boy, fair-haired and full of life. The three children play around the sort of sarcophagus in which their mother lies immobile, playing cheerfully, laughing and shouting, unconscious of the tragedy of their mother's life. Every Saturday the father arrives. He's older, with greying temples. He's tall, stooped and very elegant, but he seems nervous and bad-tempered. I've noticed that when he's there, the children go out more often, usually to the beach with their governess, who must be English or maybe German. How fascinating it would be to read the mind of that poor invalid for an hour, a woman who seems to be alive only in her dark and rather spiteful eyes.

But I must go back to the young man who was watching me for so long. Perhaps he would have liked to speak to me, but I was never alone and read many things in his meaningful gaze. I'd have liked to meet him, and I'd like to see him again. I like thinking about him.

AN UNWANTED CHILD

Drawing class at the Sophie-Germain school in the 1890s.

In three days I shall start the school year at Sophie-Germain. Why this determination to make me a teacher? Since I hate the idea, this provides my aunt with a great opportunity to thwart me. I'd so much like to go on the stage. I recite verses to myself, I learn long speeches from the classics, and my aunt insists that I perform them at every dinner party she gives or that we go to. And at weddings too! I hate this, and *L'Épave* by François Coppée has ended up making me feel sick because they force me to rehearse it so much.

The days go by. I work hard and have no more time for living, and, besides, I have to help my cousin. She's already fourteen, but hasn't managed to get her primary certificate yet. I saw my old boyfriend Gaston again. He's always in my street in the mornings when I leave for school, but I've absolutely forbidden him to speak to me, as everyone knows me there. I'm allowed to go to school on my own at the moment.
…

Hélène, the easygoing shopgirl who often took me to school last year, has come to talk to me in secret. Apparently her brother-in-law has seen me and now thinks of nothing else but me. I've never met him, but since he's an older man of twenty-eight I'm not particularly anxious to get to know him. If my aunt were ever to suspect that Hélène was talking to me like this, she'd throw her out at once. Besides, I've heard it said behind closed doors that Hélène is a wicked girl who lives with a man without being married to him. How can that be, and what's so bad about it?

Friday
Yesterday my aunt took me to see M. Lortat, the friend of Antoinette's parents, who might find a job for me as a teacher in England, because I ought to learn English.

I don't understand what's going on. Don't they want me to finish my studies? We went to see him at his office on Rue Vivienne. On the way my aunt bought two

little bunches of violets. How nice she's being, I thought, as we pinned them on to our jackets. M. Lortat made us very welcome and stared at me a lot. My aunt was all over him, made herself very pleasant and even simpered a bit. I've never seen her like this. M. Lortat is a very handsome man, but he's at least thirty-five and his wife, who's very pretty, wasn't with him. Eventually we left, but when we got down to the street my aunt realized she had lost her posy. She left me down there and went back up to fetch it, saying that it wouldn't do to leave one's flowers after visiting a gentleman, etc. When she came back she had found her flowers but lost her good humor. Naturally she looked for something wrong about me and scolded me because some locks of hair had escaped and were hanging down under my hat! Since my hair curls naturally, how can I make it stay stuck to my head? Oh, how I'd love to be married so as never to have to see her again—nor my cousin, who is such a hypocrite, pretending to be good and shy.

[May 1899]
The time has flown! Yesterday Hélène slipped me a letter from her brother-in-law begging me to do the impossible so that he can speak to me for a moment. He sends me little presents. I must say I'm flattered, as it's touching to receive attention from someone serious, but I've never seen him and have no idea what he looks like.... Tomorrow, as I have to go on my own to collect my birth certificate from the *Mairie* in Saint-Sulpice, I've told Hélène and her brother-in-law to watch out for me and walk there with me. At least I shall meet him.

My aunt made a scene and slapped me in front of the accountant because I told her in front of him that I'd never get married to a pen-pushing old fogey. She had made me furious, boasting about her plans and painting a glowing picture of the life I'd lead once I was married to him. I'd promised myself to kill the idea once and for all. I've done it, but although she's furious she won't give up the notion. We'll see which of us has the last word.

MARRIAGE

Fernande's Journal, June, 1899–April, 1900

Monday, [June 1899]

Now I'm really in trouble! I've let myself be abducted by Hélène's brother-in-law, and for three days I've been shut up in a tiny apartment that I don't dare leave, I'm so terrified of being found by my family. Yet I'd love to be miles away from here. Here's what happened. It's not amusing, and I still don't know how it came about, because I find the man who has abducted me really repellant.

Well, the other day I met this man, who came with me to Saint-Sulpice. His name is Paul Percheron. Physically he was a real disappointment: rather short with regular features, but a strange look—not improved by large black eyes, which look misplaced and seem to diverge—a dull complexion, good teeth in a thick mouth above a short chin, and black curly hair, which I hate in a man. He's thickset, rather heavy, with overlong arms, short blunt hands: very ordinary looking. When I met him he was waiting for me, and I was too timid to tell him I didn't want him to come. Instead of taking the tram, he called a cab, and there we were close together in the hackney. He was looking at me in a way that frightened me; he took my hands and covered them with kisses and he wanted to kiss me, but I cried out and he drew back. Then he started to tell me that he loved me, that he'd been driven crazy ever since he first set eyes on me, and that I was the only thing he could think about. In the end I found this quite nice.

When we got to the *Mairie* he waited for me, and when I came out he suggested we should go and drink some chocolate in the Bois de Boulogne. It was tempting, but I told him I had to be home before six o'clock. After leaving the *Mairie* I was supposed to call in at Sophie-Germain to give my birth certificate to the Head, but I thought I could drop it off the next day without my aunt knowing. So off we went to the Bois. I felt good in the carriage, driving under the trees. For the first time in my life I had a sense of my own importance. When we reached the Bois we went to a chalet, which was already quite full, and I felt rather embarrassed because I was poorly dressed and people were looking at us. But Paul seemed very proud and happy. We had tea and I ate cakes and sweets, and because I'm so greedy I forgot

about the time. When we looked at the clock I was horrified—a quarter to seven! I could never dare go home. This time I'd be sure to be sent to the convent or the reformatory they'd threatened me with so often. I began to cry. What could I do? Paul did nothing, but I sensed he was happy. At last he said: "Don't go home then, I'll take you back with me and tomorrow I'll go and ask your uncle for your hand in marriage." But this didn't cheer me up at all and I went on crying. We were walking down a path in the Bois and he dragged me roughly under the trees, took me by the waist and glued his mouth to mine, giving me the most disgusting kisses, which almost suffocated me.

Then he said: "There's a lot I'm going to have to teach you now that you're my wife, especially how to kiss."

"Never like that," I answered him, "it's filthy and pointless."

He began to laugh, and I laughed too through my tears because his face was pathetic and triumphant at the same time. There was nothing to do but go with him. I couldn't go back to my aunt's after my misbehavior; Paul made that perfectly plain to me. We took another cab, and the prospect of going to a restaurant suddenly made me feel better. In the restaurant I could order for myself and choose whatever I liked: consommé with pearl barley, chicken casserole, foie gras, salad and finally ice cream. I drank some wine and some cherry brandy, so I was quite merry when I came out of the restaurant, and after we had been to a café-concert he took me to his place, a tiny apartment on the sixth floor of a modern house opposite the Parc Montsouris.

What followed after that overwhelmed me with horror, terror and disgust! Only a few hours earlier I had been a child—how could I bear the hateful revelations of that night? I don't know. But I do know that I'm paying dearly for this sudden impulse, which is going to scar my life for ever. I have to stay here, because I'm still a good girl, whatever they may say or believe at home. What are they doing? They must be organizing a search for me. Hélène, who came with her boyfriend to spend the day with us yesterday, doesn't know anything, except that my aunt has a funereal look and there is whispering in every corner. Paul seems to be overwhelmed with joy. He has brought me more cakes, candy and fruit than I think I've seen in my whole life, and this morning he rushed round the neighborhood to find me some underclothes.

At midday, Hélène busied herself getting the lunch. I was made to smoke—which is not pleasant. As we couldn't go out, we played cards, but I felt ill, miserably unhappy, sick to death. The others were delighted, but what about? I heard Paul confiding in his brother, explaining that it was all a question of my beauty and my innocence, then Hélène, with a knowing smile, asked me: "Is it true what Paul says? Seven times last night? Congratulations." She had started to call me "tu" and this embarrassed me. Then at this reminder of the night I fell sobbing onto the couch and became almost hysterical. Henri, Paul's brother, came over to me, raised

me up, took my hands and with a compassionate look said quite simply: "Your poor little child. I didn't know anything about these schemes, and Hélène has a lot to answer for. Paul loves you, but still he's quite irresponsible. If only I'd known what was going on!"

Then he got hold of Paul and started to talk seriously to him, gently at first, then more harshly. Paul was stubborn and seemed to be about to fly into a rage, but Henri stopped and I heard him say to Paul: "If not, I'll tell the family," at which Paul's face changed from anger to a look of entreaty and huge tears ran down his cheeks. Suddenly I was scared, scared as I'd never been scared in the dark, scared of this man's love rather than of the man himself, a man who wasn't ashamed to be seen with his face distorted with misery and wet with tears.

Henri spoke just as harshly to Hélène, and acting on his instructions she put me to bed. It was what I needed: I was ill and exhausted and my bones and my flesh were hurting. She surrounded me with hot water bottles and it was agreed that both of them would spend the night here, Paul and Henri on the couch, Hélène and I in the bed. Since then they've continued to sleep here.

I'm in a living hell having spent nearly a week with this man. I don't understand life any more. Is this really what love is? This cruel, brutal possession, this madness where a man satisfies his passion for a woman in a bestial frenzy?

Henri and Hélène stayed here for four days, but Paul was horrible and kept losing his temper over the least little thing. He was kind and tender with me, but in the end he made some kind of threat against his brother to make him leave. Poor Henri, who has been my only protector, couldn't hold out, and he left yesterday with Hélène. Once again Paul spent the night "loving" me, as he calls it. It's awful.

I'm alone all day and don't go out. I don't eat, but I've found a pile of *Gil Blas*, which I devour. I love all the poems and stories, songs and drawings—Steinlen is so brilliant! When evening comes I'm huddled on the couch with the magazines scattered all around me. I've forgotten about time and life itself. When Paul comes in around six, he finds me dazed, disheveled and with my clothes in a mess, and it's obvious he's not pleased, but he keeps his anger under control.

The concierge in the building is a former policeman, who scares me. Yesterday he knocked on the door and when I didn't answer he said he wanted none of this filthy business with girls in the house. He was going to get me thrown out and would inform the police. When I told Paul about it he said he'd give him some money to leave me in peace. Today I haven't heard him yet. As soon as I stop reading I feel miserable and sad enough to die, but it's strange, I don't miss home at all. What are they going to do? I haven't heard a thing.

Another terrible night: how can I get away from here? I'd like to find work, but I don't know where to look and I'm scared to go out, scared of home, of going down

Pages from *Gil Blas Illustré* (12 May, 24 March), with the romantic stories and songs illustrated by Steinlen that Fernande read while imprisoned by her husband.

the stairs, of the concierge, of the street, of spies. I've started reading again. I eat bread and chocolate, I don't know how to cook, I hate that; I don't even know how to fix my hair. I'll have to cut through the tangled mess my hair has got into. At least that will relieve me of the chore of fixing it, as at the moment I set the alarm for five and start getting ready when it rings.

I could lead quite a pleasant life if I didn't have the nights with Paul hanging over me. What's the pleasure in making love? I find it filthy and hateful. Why not sleep peacefully one beside the other? What's the point of indulging in all that physical exertion? I can't understand it. Paul goes wild and he makes me so frightened that I tremble and let him do what he wants. He tells me I'm like a beautiful marble statue that nothing could ever bring to life. Thank God for that. I hope I'll never let myself go the way he does.

[July 1899]
This is it! My aunt's coming. Hélène arrived in a panic a little while ago. Apparently my family found out after they'd asked the police to look for me. When Hélène was

MARRIAGE

interrogated she admitted everything and gave them my address. I feel embarrassed at the thought of seeing my family again. What will happen to me? Will it be the convent or the reformatory? Maybe my aunt won't come herself. Dear God, make her decide not to see me! When I told Paul my aunt had my address he turned green. What's he frightened of?—that they might take me home? There's no risk of that. I know my aunt, she'll treat me like a leper. She'll be frightened my presence might contaminate the lily-white purity of my cousin Marguerite—who when she was eleven years old explained to me how to make love. I hadn't wanted to believe it and cried that day with shame and disgust, repeating, "You're horrible, how can you imagine that your parents, who love you and whom you love, could do a thing like that?" I was quite upset to have been told such horrible things. With her pious, hypocritical air, my cousin never aroused suspicion, and I was always supposed to be leading her astray. I didn't know anything about such filthy things. I was so innocent when Paul had his way with me that I still can't believe, despite everything I'm told, that every creature indulges in this behavior.

I was so happy, life seemed so glorious, so sweet, so pure, so full of hope. Must I give up the happy future that I was looking forward to only two weeks ago? Is everything so ugly, so low, so hateful? Is it woman's lot to submit to this disgusting behavior from men? Paul says it's love. When I think of my dear Gaston with his gentle eyes, so tender and honest, while Paul's are so shifty…this passion, this bestiality…When a woman sleeps with a man, he gets like this, Paul says. But would Gaston be like this too? I can't believe he would. It was so sweet when Gaston put his lovely white hands on my wrist, so sweet when his eyes met mine, but having Paul's heavy, hairy hands on my breast and his bloodshot eyes devouring my whole body is horrible.

I don't know what will become of me. I don't want to marry Paul. I'd like to go a long, long way away, so that he could never find me. I'd rather die than live with him for the rest of my life. He asked me if I expected to receive a dowry. I looked at him in astonishment. A dowry? Me? But I have no money, I'm an orphan my aunt had to take in because my father begged her to and left her a little money for my keep and my education. He looked thwarted when I told him this. "It doesn't matter," he said, "I love you enough to have you one way or another!" With a nasty laugh he leaped on me and I had to submit to his mauling. Sometimes he hurts me and I'm covered with red marks that turn blue. He calls me his "little virgin" and takes pleasure in hurting me. Today I can't stop thinking how disgusting I find it. And I'm so anxious about my aunt coming.

I think Paul's frightened I'll run away. He has hidden my shoes and my hat. What has he done with them? I can't find them. Now he does the shopping in the morning so that I can prepare dinner when he gets home. He has bought me a cookbook, but I don't understand it. Hélène, who of course is no longer employed by my aunt, is supposed to come and show me how to do the cooking.

I got up and dressed early in preparation for imminent disaster because of my aunt's visit, but she didn't come. Maybe she won't come after all. Hélène's here, we've had lunch together and she has shown me how to prepare stew; it's easy but I don't like peeling vegetables. She'd forgotten to put in any butter, so I put some in myself, and as there was a lot of water, I put in four cups of butter. When Hélène, who'd gone out for some bread, came back, I told her what I'd done; she almost lost her temper and told me I was as stupid at cooking as I was in love: I wasn't fit for either—not that I want to be.

I'm shocked because now Hélène treats me as an equal and I can see how common she is. I used to be the boss's niece and her manner with me was more guarded. She smokes from morning to night and would like me to do the same, but I don't like smoking, and I don't like drinking cognac or absinthe either. How can my uncle like absinthe? Now that I've tasted it, I can't understand. When I think that my aunt thought Hélène better brought up, more refined than the other girls working there, I wonder what the others can have been like!

I'd really like not to see her any more. The concierge, she told me, stopped her to ask who I was and she told him my story. He became a bit more friendly and wanted to kiss her and she says she let him. She's crazy! I suppose she might have done it so that he'll leave me alone. He terrifies me with his banging and thumping against the door. I'm always afraid when I'm alone that he'll find a way of getting in. Why does he persecute me like this?

Now it's evening. My God, let it pass quickly! Henri is supposed to come and join us for dinner. I feel safer near him. He asked me why I went off with his brother. I didn't know what to say except that I was late and didn't dare return home. He looked amazed and said, "Was it really just that, you poor child? It's unforgivable. You weren't even motivated by curiosity or perversity, and now you've come to this. What a sad story."

My aunt arrived with my godmother and a policeman. She threw herself on me like a fury and slapped me, and I cried just as I would have done before. She gazed at me with a look of disgust and amazement. My godmother had tears in her eyes and, looking at me, she said to my aunt, "She's still a little girl, Alice, be gentle with her."

My aunt's anger and hatred died down a bit and she began to inspect the room: "How shabby and squalid it is here! You can't even do your own hair. Why ever did you do this?"

When she saw I was too scared to reply, she turned hypocritical: "Why didn't you tell me you didn't want to marry M. Dufour," she said in a sweeter tone, "I wouldn't have forced you into it!" But I had told her this so often that now I looked at her without really understanding what she was saying. She didn't want my godmother

to find out about the way she'd persecuted me with the prospect of that marriage. I was paralyzed with terror at what might happen to me and couldn't answer at all.

The policeman walked over to me and I thought he was going to arrest me and I suddenly felt faint. I don't know what came over me. I lost consciousness for a very brief moment and found myself lying on the couch with water all over my face. I must have looked dazed. The policeman was saying to my aunt, "If you lodge a complaint for the abduction of a minor, I'll stay and wait for the felon and arrest him. As for this child, you can decide what to do with her, she seems to be innocent, but the man is a real bastard."

As I was looking more and more frightened, my aunt sat me up, sat down beside me and said: "You have to marry this person as soon as possible; tell me a bit about him."

But I knew nothing about him, not his age, nor what he earned, nor if he loved me. I said to my aunt, "I don't want to be married to Paul, he frightens me and mistreats me."

"What, he mistreats you?"

"Yes, Aunt Alice, all night long he stops me sleeping and I'm covered in bruises."

The policeman burst out laughing, and when this was echoed near the door, I turned my head and saw the horrible concierge, who'd been there all the time and looked as if he was enjoying himself. He was made to leave.

"It's your own fault," my aunt replied. "Depravity is always punished. You ought to get married, and you will get married. Otherwise I never want to hear of you again and you'll be sent to a reformatory."

"No, not a reformatory, send me to a convent!"

"Convents don't want fallen women like you."

Then I began to sob, to plead with my aunt and my godmother not to make me get married: "Send me to England as a teacher, or let me be a governess, anywhere, a long way away, but don't leave me with this man, I beg you. He terrifies me. I beg you!"

My aunt wouldn't yield an inch: "Either you marry him or you will be sent to the reformatory."

My godmother didn't say a word, and I sensed there was nothing she could do. Anyway, there was never any warmth in her affection for me. She had undertaken to perform a small duty towards her goddaughter, which she had carried out, and once I was married the duty would be fulfilled.

I didn't say anything else. I was a mess, huddled up and in tears, my eyes burning, my mouth dry, and all trembling. When Paul arrived, my aunt had no reproaches for him at all. She eyed him with contempt and asked, "What do you intend to do to put things right?"

"Get married as soon as possible."

"You hear that?" my aunt says to me, "Well then, that's understood, I hope you've chosen marriage."

I nodded and my heart swelled like a balloon about to burst. I stood up, feeling like a Racine heroine condemned to torture, and I promised myself I would leave as soon as I was married. Nevertheless, without holding out any real hope I asked: "Won't you take me home until the wedding day?"

"Out of the question. What about your cousin? Have you no consideration for her and for what our friends would say? No, you will not step inside my house until you are married. And you will have to find your own witnesses for the wedding, because no one from home will come to the ceremony. You can get married in three weeks time, and you'll receive a thousand francs to set up house, that's all you'll have. You can tell that to Monsieur," she added, tossing her head in the direction of Paul, who seemed as terrified as I was, and she managed not to address another word to him.

At last they left, and I was alone with Paul, who became almost hysterical, so angry had my aunt's spiteful attitude made him, though he didn't stand up to her. The policeman left as soon as I'd agreed to the marriage.

Hélène and Henri came in the evening and, as we hadn't eaten, Hélène made some chocolate and we ate bread and butter. I asked Hélène to sleep here. She agreed quite happily and remarked that I had no reason to be sad any longer and that all's well that ends well. Alas, it had "ended well," but this was the beginning of despair.*

I've become ill as a result of the scene with my aunt. I'm shivering and I have a fever. I realized it in the night as I lay beside Hélène. She felt me trembling, got up and covered me with warm towels and then made me drink some warm sweetened wine, but I vomited and started shaking again. Paul is horrified. The fever apparently made me a little delirious, and I cried out, "Cut off his arms, they're tentacles." At last, just before dawn, I grew calmer and fell asleep.

The doctor has been to see me. I have to stay in bed; I'm suffering from the after-effects of shock. But I found my journal and I've written all this down. My heart is weary. The doctor asked what provoked the shock that got me into this state. I told him my Odyssey, and he shook his head. He's still a young man, with quite pronounced Jewish looks. He has lovely pensive eyes and a very shiny black beard. He's practically bald, and this makes a striking contrast with his young, regular features. He left without telling me what he advised, but he warned Hélène, who's looking after me, that he wanted to see my boyfriend and that he'd be back this evening.

Hélène is very attentive, but she smokes, which makes me feel sick. She has made me drink some coffee and I feel a little better, but I can't get warm, in spite of having three hot water bottles beside me. Yesterday evening the doctor came back and I

* Shortly after her aunt's visit, on July 17, Fernande's real mother Clara Lang, signed an act of recognition of her daughter "Amélie" at the *Mairie* of the 6th *arrondissement*. Fernande does not refer to this in the journal.

think he lectured Paul, who seems all penitent and has promised to let me sleep alone or with Hélène for a day or two, just until I'm a little better. Paul will go and sleep at his brother's, and Hélène will stay with me. This illness is a real godsend, protecting me from Paul for a while, although it's very unpleasant to shiver the whole time and to have these dizzy spells and this nausea.

Paul has brought me a few books: Anatole France, D'Annunzio, Abel Hermant, Paul Adam. They're authors I don't know, but I've read so little. It's kind of him to bring them, and he also gave me some long pink and yellow gladioli, which look so gorgeous in the sunlight that I spend all my time gazing at them. If only he left me in peace at night, I might perhaps be able to feel some affection for him. I've started to hope that I might be almost happy.

There's plenty of sunlight in this little apartment, which is otherwise so shabby. Two rooms, an entrance hall, a kitchen near the front door, no bathroom: you have to wash in the kitchen, which is so small that the tub covers all the tiles. Opposite the kitchen there's a small room (about four by four meters) with a couch covered in the same yellowish material as the lined curtains, two wicker armchairs with mainly brown *toile de Jouy* cushions, a table checkered like a game board—this is very rickety, and you can't move it because of the wedges which keep it balanced—three chairs of colored straw (very ugly), a few shelves, a black wooden bookcase with glass doors, and on the mantelpiece some hideous bronzes, sort of Cupids drawing their bows. And above it all a hanging lampshade of green glass! It's even more pathetic and vulgar than it is cheap. The bedroom is furnished in pale rosewood, and the large, rather low bed takes up all the room. A wardrobe with a mirror, a bedside table with a reddish marble top, a small mahogany pedestal table and two pillows in the same blue velvet as the bedcover. Straw mats everywhere. Even so, when the sun streams through the windows overlooking the trees in the Parc Montsouris, it all takes on a festive air, gilded by the light pouring into the house. There's sunshine everywhere, on the bed, on the walls, on the matting on the floor, in the mirror opposite the bed, on me, on my hands resting on the sheet, but what ought to make me happy—I love the sun so much—just makes me sad, and I start sobbing so violently that Hélène, who's in the kitchen, rushes in in alarm and holds me gently in her arms. I calm down and start reading again, but I'm listless, tired of everything. I fall asleep, and that's the best thing that could happen.

Several days have passed. Paul has come home and is worried. He torments me endlessly with questions about my health.

My color's improved; I must be getting better. I ought to try and get up. It's true, I am better, but I don't want to let on. I'm so content like this, as far away from him as possible. When he comes close to kiss me, my heart seems to twist. He never

kisses me gently: he's violent and hot-headed, hurting me with his hands always groping at me, and in a week I've got to marry him!

Paul has arranged everything, and the banns have been published. The wedding is set for next Thursday.* Will I be able to stay in bed and remain an invalid for long? Of course I don't eat: staying in bed like this and getting no exercise, I have no appetite. I haven't been used to this kind of life. I'm very pale, I've got thinner, and my hands are getting skeletal. I read, but I can't get engrossed in what I'm reading as I used to. I dread the day when Paul will sleep with me again, and this terror fills my head and my body like an obsession. Everything's whirling round in my head! I'm so astonished and horrified by all this, and sometimes I don't believe it, I think I must be dreaming. Is it possible? Is it really me that's here? And to think I used to complain about life at my aunt's. If only I'd known; after all, they couldn't have forced me to marry M. Dufour. Even at the *Mairie*, even all dressed up in white—which I always used to dream would happen one day—I could always have said "no" to the mayor. Now it's this man who will make me honor and obey, and he's certainly far worse than the other one would have been, for at least that old boy was shy and kind.

What will become of me? I'm under age, I can't escape, I'd be caught and they'd send me to the reformatory. My aunt would never forgive me. For the present I'm going to have to accept the inevitable. Later we'll see. At times I get my courage back; then again, I think of ways of getting rid of Paul—pushing him out of the window, making him drink poison—but I'd never dare. I'm too frightened of the guilt.

Sunday, [August 4, 1899]
Today I got out of bed. Henri's coming and will watch out for me. I always look at him anxiously whenever Paul comes near me. Earlier I was almost suffocated by Paul's disgusting kisses. His behavior's so foul, his kisses are so slobbery. Why can't he leave me alone? What does he want from me? He must know that I find him repulsive and that he terrifies me. My fear of him is like my fear of snakes. When I see him coming towards me with his fixed stare, his gleaming eyes, I go cold all over and feel faint, as I used to when I looked at the reptiles in the zoo. Hélène and Henri will sleep here again tonight, but tomorrow I shall be alone again with Paul.

Monday
I'm on my own this morning, on my own for the day. Hélène's got a new job and can't stay. It's ten o'clock; I can survive until seven, but afterwards—another three

* According to the marriage certificate, the wedding took place on Tuesday, August 8, 1899. In the light of the diary entries that follow, it would appear to have been planned for August 3 and postponed on account of Fernande's illness.

days, and then I'll be married. Luckily there is such a thing as divorce. I'll investigate and find out what I need to get divorced. I'm staying in bed with some fruit, candy and books. I'll be happy until half past six so long as I don't think too much about the night ahead.

It all started again last night, I got almost no sleep. He was staring at me as I was just about to fall asleep, worn out and exhausted, then he flung himself on me again, crying, "You're so fresh, you're so pretty, I want you so much, the more I have you the more I want you. I'm crazy about you," and he started kissing me all over again. I let him get on with it. Luckily I was half asleep, and this spared me from feeling too disgusted.

It's the same every night. He gets unpleasant and loses his patience, asking me what I'm upset about, why I don't respond, and assuring me he'll make me feel pleasure and happiness. What pleasure? What happiness? And when I beg him to let me sleep, he rolls on top of me as if he were demented. I find it better to say nothing when his eyes get bloodshot and he clenches his teeth and says, "It'll be all right, I'll make you change, I'll bring you to life," but I get frightened and it seems to me that the fear he can read in my face excites him even more. Yesterday I couldn't stand it and yelled out, "My God, my God, although I've done wrong, although I'm unworthy, protect me or let me die!" Then he looked at me and started to cry. He didn't touch me again that night. This morning he knelt by the bed and asked my forgiveness. He wept and kissed my hands very gently and I started to feel some hope again, when all of a sudden, his face changed, it tightened, and he was on top of me again.

Is this what love is? I asked Henri this question and he shook his head. He seemed to want to say something, but then he turned away.

Monday
Tomorrow, alas, I'm getting married. I'd always dreamed of my wedding day: my heart would be overflowing with love for my fiancé, I'd be dressed all in white, coming to make him a gift of my life, and now—I've really messed up my life.

Wednesday, August 9, 1899
I've done it. Yesterday I was wedded to Paul. He was very emotional and so proud, with tears in his eyes. I had tears in mine too, but mine were of despair whereas his, he said, were of joy. Henri and some friends of Paul's were our witnesses, and not a single member of either of our families attended this unfortunate wedding ceremony. Paul's parents—his father and stepmother—live in the country and couldn't come. We've got to go and see them soon.

No word from my aunt. She had a trunk sent to me with my things in it—everything I had at her house. She also put in a grey dress, a hat and some grey shoes so

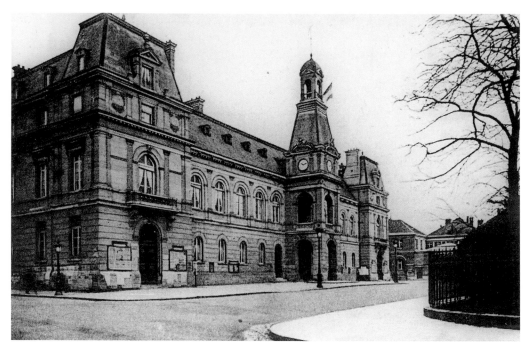

Mairie of the 14th *arrondissement*, where Amélie and Paul were married.

that I should be suitably dressed on my wedding day. My godmother sent me 500 francs. With the 500 francs from my aunt, that makes 1,000 francs, which Paul has taken. He doesn't leave me any money. He wants us to move and live in the suburbs. After the service we went to have lunch in the suburb of Robinson, at one of those restaurants with tables in the branches of the big chestnut trees, with Henri, Hélène, and the friends who'd been witnesses. That was fun, and we had a very good meal. But we had to drink champagne—which I don't like—and on the way back to get the train, I was overcome with nausea and felt very ill. Hélène looked at me in a strange way and said, "I think that in a few months you're going to have a little baby." I felt so happy. But is this possible? I still don't believe it.

Paul seemed to be furious after I told him, and he had another quite violent argument about me with his brother this evening.

[September]
The days go by and nothing changes. We're going to live at Fontenay-sous-Bois. Paul is treating me roughly: he wants me to do the housework and make dinner so that everything's ready when he comes home in the evening. I can't stand all that and I don't do anything. When he came back yesterday, he found me curled up on some cushions Hélène had made for me when she wasn't working, and I was so absorbed in my book I didn't even hear him come in. He went absolutely crazy and

Marriage certificate of Amélie Lang (Fernande Olivier) and Paul Percheron.

deliberately hurled a vase of marigolds onto the floor to smash it. "You're no good for anything, no better at housework than in bed," he yelled, and he slapped me violently. I was so terrified I wanted to run away. I reached the door, but with one leap he was on me and began to beat me. I still hadn't realized anyone could do this. I was beaten, beaten. All my life I'd heard my aunt saying how much she pitied one of her friends whose husband beat her, and I was taught to believe that this was the most degrading, humiliating and horrible thing that could happen. "This is the end, I've reached the very bottom now," I said. Because I clenched my teeth so as not to cry, I didn't react to the blows and I must have had a really hateful look on my face because he redoubled his efforts, saying, "Don't look at me like that, or I may kill you." But I couldn't stop myself looking at him like that. Suddenly he threw himself at me, flung me onto the couch and raped me brutally as usual. Afterwards, he remained inert, lying heavily on top of me, hardly breathing, while I didn't dare move. However, as I felt I was suffocating, I slipped to the floor and he slid lifelessly to the side. I was quite terrified—I went towards the door, wanting to open it and scream. Then he moved—and I was sorry he wasn't dead, for in spite of my fear that's what I'd secretly hoped for. I'm not ashamed to admit it. Can't some accident rid me of this man, who's relentlessly destroying my life and blighting my hopes?

When at last he came to his senses, he got up, drawn and dazed, then he remembered what had happened, went down on his knees, and once again said "Forgive

me," but how can I forgive him, above all for the disgust and the terror he inflicts on me?

He went out to get something for dinner and came back with his arms full of flowers, cakes and chocolates, but I had no interest in anything except sleep. I told him this and he offered to spend the night on the couch in the living room. I begged him to do this and went to bed alone.

At the end of the week we're going to move to Fontenay-sous-Bois, where he has rented a ground floor flat with a bit of a garden.

We're living in Fontenay. I'm pregnant. The doctor that Paul got to see me before we moved, because I was nauseous the whole time, has confirmed it. He told me to be careful of my heart and warned Paul that I mustn't have too much excitement. Paul isn't happy about this. He says he doesn't want to have a child, that in a month he'll take me to see a woman he knows who'll do something so that the child won't be born. I burst into tears and asked him why. "I love you alone; a child would get in our way and would cost too much. I don't earn enough." How can you prevent a child from being born?

I've started to do the housework and I'm trying to cook, but I find it tiresome and I'm no good at it, despite the book. Things are either undercooked or everything is reduced to a pulp. Paul, who's greedy, gets angry, but he hasn't beaten me again.

[late October 1899]
We've been at Fontenay for a month, and I feel better physically. Paul, who's calmer and also more tired, often leaves me to sleep. Can this last? Winter's coming, and winter in the country is miserable when you're not feeling happy. I've nothing interesting to read any more: I got through all the books I had in such a short time. I spend my days in front of the window, with my hands on my knees, trying to work out why I'm living through this tragedy. I think of Gaston, I think of my cousin, Philippe, who lives in Philadelphia and who said to me, "When I come back in five years, you'll be a young woman, we'll get married and I'll take you back to America." I realize now that he meant what he said, but I didn't take him seriously at the time. I even think of the accountant, my aunt's favorite candidate. Even that would have been better than what I've chosen.

Chosen? Did I choose? Do I really know what happened on that dreadful day when I met Paul and didn't go home? I don't understand. Something inside me seems to prevent me from seeing and discovering the real motive that drove me to this folly. Fear of my aunt, I suppose.

I'm married, I'm Madame. I have the family record book given me by the mayor, and I'm only just eighteen. I still feel like a little girl, but I feel as if I've lived through fifty years since I left my family. Days of unhappiness appear to go on forever, so that the past four or five months seem like fifty years. Everything's over for

me, I'll never be able to recapture my carefree days, the inner joy that, in spite of everything, comforted me with the anticipation of happiness. I was full of hope and confidence. How often did I imagine holding my promised happiness tightly in my arms, crushing it to my breast. I used to go to sleep with my arms crossed like that over my breast and wake up the same way. Now I'm shrivelled up, completely withdrawn. I'm scared, scared of the "beast" I've agreed to live with, and it's no use making myself as small as I can, cowering in the farthest corner of the bed when I go to sleep, I'll still wake up with this body on top of me.

I'm in bed, sick. Yesterday I fell down the steps. There was ice and I slipped and fell on my stomach down the five steps into the garden. So, last night I had a miscarriage, and evidently I won't have my baby. I cried, but Paul was pleased. The concierge looked after me: she covered me with hot towels, made me drink something horrible and fetched the doctor, who diagnosed the miscarriage. I hurt my forehead and I have a very bad headache. I'll have to stay in bed for five days. Just as well since it's cold and I don't know how to light a fire. Now someone else will light it and I'll be warm in my bed. I'll look at the red hot bars of the grate and the glow from the coal that spreads over the floor as night falls. I love that.

The concierge has agreed to come in every day to light the fire and do a bit of housework. I'm weak, but it doesn't hurt, except that occasionally when I breathe deeply I feel a sharp pain in my heart. I sleep almost all day, and that's good because I don't think about anything.

Wednesday
That episode's over with and I'm back to my monotonous life. My aunt came to see me when I was ill and brought me some linen and some oranges, and we're supposed to go and spend the day at her house the first Sunday I'm allowed out. That's sure to be next Sunday, as I'm supposed to get up tomorrow. I'll go into the garden because Paul doesn't like me walking around outside without him. Anyway, I never have any money. He always brings the next day's food from Paris and has the wine and groceries that we need delivered by Potin. Twice a month he settles the bill himself when he places the order and just leaves me enough to give a very small tip to the delivery boy. At home it was my aunt who looked after the money. No doubt he thinks I'm too young and imagines I'd squander it all.

Perhaps he's right. But I'd really like to have something of my own. I told my aunt this, but she takes my husband's side. "You must be kept in check," she says, "You've proved you're capable of the worst sort of turpitude"—this is one of her favorite words. We also have to pay a visit to Paul's family. We'll go at Christmas.

If the dinner's burned Paul gets angry—or if it's undercooked. This means he's always in a bad mood, but he doesn't beat me any more.

Monday

Yesterday we went to Paris to spend the day at my aunt's house. I went into the bedroom I used to share with my cousin, lay down on my bed and imagined that none of this had happened, that I was still a child. I was so unhappy and I cried. My cousin came up to me and seemed to be inquisitive about my life. "Love is a filthy mess" is the only thing I said to her. She looked shocked and told me I was the one who'd made it filthy by behaving badly. I shrugged my shoulders and asked her to leave me to dream in peace.

My uncle was very cold, but didn't stop staring at me. Finally he asked me, "Are you happy?" I shuddered, and he must have realized the truth as he added, "Why did you agree to this marriage?"

"What about the reformatory my aunt threatened me with?"

"Do you really believe I'd have allowed that?" he said, looking deep into my eyes. I was embarrassed and turned away. "You've certainly ruined your life," he went on, "it's lucky you haven't got a child."

As he kissed me goodbye he took my hand and slipped twenty francs into it. I'm going to go and buy some handkerchiefs and a bottle of perfume. I've always wanted them. It's true I could have asked Paul to buy me some, but I don't want to. I can't ask him for anything and I never will—this is something I feel really strongly.

Yesterday, when he came in, Paul smelled the perfume on me; I'd bought some carnation scent and spent thirteen francs on it. He was furious because I hadn't told him I'd been given money and because I'd gone out without his permission. "How did you manage to do it without a key?"

For the first time I felt my anger rising: "Sometimes I want to go out, as I eventually get bored, you know, so I always leave the door open. If we get robbed, so much the better! I hate everything here, the furniture, the house, everything!"

Then he started to beat me again like the first time, and like the first time I was incapable of reacting, not screaming or crying although he was hurting me quite badly. Afterwards he took me in his arms and carried me to the bed saying the worst and most horrible things, so obscene that I felt ashamed, and he took me in his usual way, and in my usual way I submitted, disgusted, lifeless, cold. This is my life.

I go out almost every day. There's a large garden, a sort of square where I go and sit. Hélène came to see me. She said she'd take me to Paris and that Paul wouldn't know anything about it. It's a quiet time for her and she's going to stay here for a few days. She has been asking me how I'm coping with my life, if I'm beginning to like Paul. When she saw the anger and disgust in my eyes, she realized there was no chance of this.

She smiled and said, "I think I know someone who could cheer you up, the friend of a lover of mine. Henri knows nothing about this and he mustn't find out. My

boss's son is in love with me and I've become his mistress, but I'm not in love with him. I agreed because he gives me money. But Henri really mustn't find out, as I'm anxious for our life to go on; we're getting married this summer."

"But your lover?" I asked.

"Oh, he knows I'm getting married, but he thinks I'm not in love with Henri and don't sleep with him, that we're just engaged, and since he can't marry me himself, he accepts that."

I'm horrified by this—two men at the same time!—and she used to love Henri! Can she get away with it, making the other man believe what she wants him to believe? Is it that easy to fool first one and then the other? How can she manage to do it?

Although I was frightened Paul might hear about it, I went out with her the next day. She and her boyfriend took me to lunch with a friend of his, who's the manager of a big café on the Boulevard Saint-Denis. I was very intimidated by this lunch in an elegant bachelor flat—the sort of place where I'd like to live. After the meal we drank liqueurs; then we stretched out on couches and suddenly I felt myself tightly encircled by strong arms. Then I was kissed gently, tenderly, kindly, and I felt quite limp and snuggled against that big male chest. However, when he made a move in preparation for that act that I dread with Paul every night, I screamed, tore myself from his arms and tried to leave. Hélène calmed me down, took me into another room and promised me no one would come in.

I heard her through the open door telling L. how upset I'd been by my experience of the act of lovemaking, then she came back, made me go in with her, and took me over to L., who assured me he wanted nothing from me that I wasn't willing to give him. I relented at the gentle tone of his soft voice, of his two strong arms which held me so tenderly, of his hot lips on my neck and on my eyes. His caresses, at once delicate and persistent, made me slide into a torpor which quite astonished me and felt very pleasurable. I don't know how long I stayed snuggled up like this against this man, but I didn't come out of my daydream until I heard Hélène's voice telling me it was time we went home. I could easily have stayed there without ever going back to Fontenay, but though I wasn't prevented from leaving, I was made to promise to come back again soon.

"Well now," Hélène said to me as we came out, "I don't believe you're as horrified by caresses as you were, and Paul will be all the better for that," she added coarsely. I looked at her with amazement. Why should my husband benefit from something another man had shown me? This fellow hadn't behaved like Paul, he wasn't driven. He'd done what should have been enough for my husband: embracing me gently without any brutality and without that final act I find so disgusting. "I think you're completely heartless," Hélène said.

"Heartless? Why—I don't understand what you mean. Aren't I just like other

women, like you yourself? I can't understand you. Isn't Henri sweet and gentle with you? He can't behave the way Paul does with me!"

"No!" Hélène burst out, "No really, do you think Paul is any different from this man? He's just more passionate, that's all, and you're frigid." I find it harder and harder to understand what she means. Getting pleasure from—from that? It's not possible, it's disgusting. I'll never feel differently about that. She went on in the same vein and I began to get angry when I realized she saw nothing unnatural about the way my husband made me spend the night. If Henri had been there Hélène would have had to watch her tongue, and she ought to have watched it with me, as she'd never spoken to me like that before.

There was something else I couldn't get out of my head. Why had she taken this lover? For money? But that doesn't interest her, and anyhow, she seemed to like him just as much as Henri and was very affectionate towards him—more even, it seemed to me, than towards Henri. I asked her and she replied, "I stick with Henri because he's going to marry me, but I prefer this one in bed." I find this a really horrible thing for her to do. She should tell Henri everything. How can she live with such lies? But she seems to find it all amusing and says, in a way which I find ridiculous, "I need several men; I'm hot-blooded and I'm fickle."

Does being hot-blooded mean wanting to play these filthy tricks? Ugh!

We got back by six, so that Paul wouldn't discover anything. I'm scared of him, I think he might kill me. There was another terrible scene last night because I wanted to sleep with Hélène. He wouldn't let me and reacted more wildly than ever.

I don't think I'll be able to stand this much longer now. But I'm so ignorant about the world and I'm frightened of leaving—I wouldn't know where to go. I've thought seriously of writing to my uncle and asking him to look after me, but I'm afraid my aunt would open the letter, and I'd never dare tell my uncle what Paul does to me. What could I tell him so that he'd help me get away, find me a job that would take me away from Paul and rescue me from him? There are moments when I want to die and yet I like feeling alive. If only I didn't have to endure these nights and his hateful presence. If he'd just leave me alone I'd find life pleasant enough.

Hélène's left, but she has given me some money to go to Paris next week to have lunch again with her and her boyfriend and Monsieur L. G. I don't know if I'll go. I'm so frightened that Paul will find out something, but I'd really like to see my friend again. He told me "I'll be your friend," and I believe him.

Wednesday
Several days have passed and tomorrow I'm going to meet Hélène. Monsieur G. will pick me up at the station. Paul will be home soon and I've got to make dinner.

He's not nice to me at all any longer. He must feel aggrieved that I can't warm to him. He can't help knowing how much he disgusts me.

What's going to happen to me? If Monsieur G. wanted to keep me—but Hélène has warned me not to hold out any hope for that. He'll never have a woman live with him. That means it would really be more sensible not to go. But I don't feel I can resist the desire to be back in his arms.

Monsieur L. G. was at the station, but Hélène had tricked me. The four of us didn't have lunch together. L. took me to his place like last time. Hélène was having lunch somewhere else, which upset me. I don't like all these lies. We had lunch "tête-à-tête" at a small table and I ate oysters and drank white wine. I had some caviar, which is delicious. After the meal I lay on the couch and L. knelt down close beside me. He started to kiss me softly and I felt him trying to unfasten my skirt. I hadn't the strength to stop him, as he went on kissing me—kissing me so much that I felt limp and strange. A strange sensation was coming over me that made me want to merge into him. Then I found myself naked and his lips ran all over me, stopping sometimes for a long while and withdrawing, and then I was the one who would bring him back when he drew away. It was like a game. Then suddenly his love-making overwhelmed me and I quivered with a sensation I would never have believed possible. Unfortunately I was brought brutally back to reality when he took me in the same way my husband does. Although he did it without violence, I was just as disgusted and came right down to earth as I realized with a shock that I would never get used to the idea of this act. Now I'm back home and I feel miserable. Why did he spoil the hours of tenderness that he had given me by defiling them like this?

Am I really the one, as Hélène says, that's abnormal? L. has asked me to go back on Saturday, but I'll never go there again. He wanted to give me a ring, but how could I have accepted it? I'd have had to hide it from Paul. I refused it and anyway, I'm angry with him. I like some of his caresses, his hands, his lips, but not the rest. There's something cruel in his good looks, and the ironical look in his eyes hardly ever gives way to softness, which is why, even if I don't detest him as I do Paul, I don't love him. No, I won't go on Saturday.

I did go back, not for lunch, but to be kissed: I told him this when I arrived at two o'clock and said I wanted none of that—culmination that disgusts me. Laughing, he took me into his arms and kissed me as before and undressed me. The same procedure, the same intoxication, the same final disgust—not that. I won't go back, but I'll miss some of his caresses. I miss them already. Even so, I can't overcome my repugnance. When Paul indulges in the same tricks with me, whatever they are, I find everything altogether disgusting, while with L. I felt a great deal of pleasure.

Hélène came and I told her I'd decided not to go to Paris again. "Oh," she replied, "does that mean you're very sensitive to some things and unfeeling to others and this fact upsets you?" I was annoyed but I didn't let her see it.

What a strange business! Yesterday, after lunch, Hélène lay down beside me on the couch and she started to kiss me and I felt strange, just like I do with L. Then she slid down to my feet and caressed me in just the same way and made me tremble just as I had with him—but it's so nice! "Don't say a thing to Henri," she told me. She knows I confide in him. Of course I won't say anything, it's a wonderful secret and I'm thrilled with it. Being able to experience such a heavenly sensation with so little effort!

I'm struggling not to to go back to Paris. I've met my parents-in-law. She's a fine and very sweet woman who looks at me as if she admires me. He's a large bony, rather common, fellow, who tries to kiss me in dark corners. Even his gestures are suggestive—revolting. They're finally leaving tomorrow. I think Henri's spoken to his father, as he's now sulky with me, but he leaves me alone.

They've gone. I'm sorry, since for four days I've been sharing my bed with my mother-in-law and haven't had to put up with Paul.

It's strange. No one ever wants to know if I'm happy, and yet I desperately need guidance, support and comfort. Paul is jealous of his brother, and when Henri's here, Paul doesn't leave me for a second. I can't complain any longer and tell Henri my troubles—yet another small light that has gone out. Hélène sometimes comes to lunch and I find her caresses comforting, but I don't like her.

There's been a disaster. Henri has found out all about Hélène's love affair and has made her confess to everything, even our meetings in Paris with L. My brother-in-law has left Hélène and never wants to see her again. But Hélène, who came to get some of the things she left when she stayed here, says I can be sure he'll take her back as he's got her under his skin. I wonder what she means by that? Henri scolded me quite severely but afterwards he kissed me and said that it all happened because of Hélène's perversity and that it was time she went. He made me promise not to go back to Paris, because if Paul found out about it he'd be capable of killing me. I just hope Hélène says nothing to Paul.

My husband and I fight every day now. He gets furious over an egg that's over-cooked or undercooked and wants to hit me, but now I hit back. I throw everything I can lay my hands on at his head. This calms him down. I've told him I'll run away one day. He shrugs his shoulders, and tells me, "I'll catch up with you and really give you a hard time."

"Even so, I'm going to leave, and soon."

April 1900

Spring has arrived. March was a beautiful month. The Exposition Universelle is about to open and everyone seems to be happy. I can't get to Paris. I have no money except two francs and fifty centimes, which I'm saving for the great day.

We have lunch with my aunt every Sunday. I ought to tell her about Paul's brutality, but I can just hear her saying in that dry voice, "It's what you wanted. Don't complain, you've got what you deserve."

Monday

Yesterday my uncle was in the workroom before lunch. I went to find him and said, "Uncle, I'm so unhappy I can't cope with this life much longer. What can I do?"

"Get used to it, poor child. You're married, that's the end of it."

"But I could leave Paul and find a job."

"You're thinking like a child. Hasn't marriage taught you anything? Nobody's happy, my dear. Do you think I'm happy?"

I looked at him sadly. He'll never understand me, I thought. He thinks I am exaggerating. I must say nothing and act on my own. I'm nearly nineteen!

My cousin Marguerite, watching closely all the time to see just how I'll react, flirts with my husband and holds forth like a good girl who'd never stray from the straight and narrow. One of her sayings, which my aunt also uses, is "Happiness is only found in purity." She's a fool; how does purity help? Her husband will make it his business to interfere with her purity, and I bet she won't suffer from it as I suffer. I asked her why she didn't become engaged to the accountant. "Why should I? I have a dowry," she said, "I'll be easier to fix up than you were, a 'desperate case' without money or morals. Look what became of you. Without Maman, who forced you to get married, you'd be living with the fallen women." Poor thing, I thought, with her petty morality, the petty pride of an unattractive virgin, and her meanness of spirit. How sad.

In spite of loathing my husband, I do have some sunshine in me. Life ought to be so beautiful. I feel everything in me striving towards what is great and just and beautiful. Is that what's in store for me? I'm still so young, and from now on I'm not going to do anything foolish. I've suffered so much that my mistake must be forgiven. And something in me illuminates me, floods me with hope—for everything I long for, everything I look forward to, everything that is sure to happen.

My uncle must have said something to Paul after all, because I was scolded for complaining to him. "What about me," he went on, "Shouldn't I be complaining about your coldness and your slovenliness in the house? You never do anything to please me, and I have to find excitement in your disgust, your resistence, and in your frigidity, when I'd hoped to find it in your love."

I gave a cruel laugh: "My love? But what do you suppose love is? I still don't understand what you mean by love? Do you mean the filth you submit me to? The repetition

of that act I find obscene, hateful, maybe just because you disgust me. What have you ever tried to awake in me that's clean or beautiful? I'm disgusted by ugliness, and everything about you is ugly, the expression in your eyes, your gestures, your pleasures." I was able to say this because I'm beginning to understand that this is the way all women live who have loveless marriages to insensitive men.

As I was speaking, his face turned to that of a madman, and all I achieved was to drive him to throw himself onto me, to drag me onto the couch, brutally lift my skirt and force his bestial passion on me. "Why don't you defend yourself?" I might be asked, but I'm frightened of him and when this happens I revert to being the terrified, dazed little girl I was the first time he raped me. Oh, his horrible face! I'm a coward, I'm afraid, I close my eyes! If I don't defend myself it will be over more quickly. Now he wants to force me to open my eyes and look at him, as he enjoys the fear he reads in my face, and he aggravates this with his crazy threats. He's going to kill me, he says, and only the violent, savage release of his energies saves me.

I'm going to leave, I'm going to leave. I'll take anything, the first job I can find, even working as a servant, but I have to get away from this. I must get away.

As always, once I'm alone again, my carefree nature takes over and I forget, I go back to building castles in the sky. I live a life entirely within myself, all of which is made up by my imagination, and in this I manage to enjoy some moments of happiness. But as evening comes, the anxiety of what's in store for me puts an end to all this and I feel my heart quiver within my trembling body.

ESCAPE TO BOHEMIA

Fernande's Journal, April, 1900–Late Fall, 1901

April 1900

It's over. I'm safe, I've left, I'm out of that hell. It's quite a story: yesterday evening we had one of our most violent arguments, and I got the worst of the fight. He hit me with a carafe so hard that I've got a gash in my shoulder where a splinter of glass penetrated a centimeter into my flesh. I was bleeding and had to tear a piece of my dress, which had got caught with the glass, out of the wound, but this still didn't prevent Paul from ending the scene by throwing me onto the couch the way he always ends these fights, before I was even able tend to my shoulder. Afterwards, when he came to his senses, he was worried sick because the blood wouldn't stop. I didn't want his attention. I think I'd have been capable of killing him if he had come near me then, and I'd made up my mind: tomorrow I'll go—tomorrow I'll go—tomorrow I'll go. Repeating this to myself helped deaden the pain of the wound, which still hurt a lot.

I refused to sleep with him and slept on the couch. He must have been crying all night because in the morning his face was all bloated; he was hideous. But I always find him hideous. How could I have waited so long before leaving him? Anyway, it's over. The word END can be written at the bottom of that chapter.

This morning, as soon as I'd heard his train leave, I gathered my papers: family record book, birth certificate, marriage certificate, my school diplomas and the notebook where I keep this journal. Why did I take the journal? I didn't set out to run away today. I just wanted to find a job. I put all this in a small flat bag and took the 10 o'clock train, which arrived at Bastille around 10:30 A.M. I'd copied down the address of an employment agency for office workers, salesgirls and teachers from a newspaper, and I went there and explained I was looking for a job. I left my papers with the manager, who told me to come back around four o'clock. She said she was sure she'd find me something, and I left.

I didn't know what to do till four. It was just about the first time I'd been free in Paris, but if I just wandered around I was scared I might run into a member of my family or a friend of my uncle's. I went into a square and stayed there for almost an

hour reading a book I'd brought with me. Then, when I heard a clock strike twelve I started walking again. I'm not too sure how I got to the Rue de Rivoli, but I was beginning to feel hungry, tired, depressed and on the verge of tears. My whole fortune consisted of one franc and fifteen centimes and my return ticket. I didn't dare buy a roll and eat it in the street. I'd been brought up never to do a thing like that and I still couldn't break those idiotic rules. It was 1:30 P.M.; I was hungry and afraid I'd gone too far to get back to the employment agency on Boulevard Henri IV in time.

I stopped by the window of a pâtisserie—I'm so greedy—but I didn't dare go in, and anyway, eating a cake wouldn't really have satisfied my hunger—and I was dying of hunger. My long walk, the exercise and all the emotion had made it much worse. I stood rooted in front of this tempting window as if I was hypnotized when I felt an arm slip under mine, lead me away, take me through the door of the shop and before I knew it I found myself sitting at a little table, face to face with a bearded man, young and smiling, who was ordering something from the waitress. I still hadn't realized what had happened to me, when a steaming cup of chocolate and some brioches were placed in front of me. I couldn't hold back and started eating voraciously. It was only after getting through several warm, golden brioches and draining my cup that I came to my senses. Then, seeing two large dark eyes, shining with amusement, fixed on my own, I surprised myself by bursting into laughter that was so joyful and bright that "the man across from me," as I called him after that, began laughing too. I seem to be able to pass suddenly from despair to gaiety, from despondency to confidence, without any good reason. I often feel carried away by joy, or slumped in misery and sorrow, as a result of something changing inside me that I can't control. I don't know how to explain what happens to me, but I think that, in spite of everything, I have an intense love of life and want to believe that life can make all my wishes come true.

I had been hungry and sad; now I felt restored and full of optimism. I'm not yet nineteen years old; I have nothing of my own except a few unhappy memories, which may perhaps serve to restrain the impulses that make me do ridiculous and pointless things. Deep down I'm easygoing, and my trust and hope are irrepressible. So there I was, sitting opposite a stranger, and suddenly I felt bashful. I hadn't had time to think about this man yet and I didn't know what to do. It would seem silly just to say thank you, rude to get up and go, but wouldn't talking to him seem very forward?

I was looking at him now rather stupidly and said, "I was hungry. I didn't have any lunch. Please excuse me."

"Let's go," he said once he'd paid, "where are you going?"

I didn't answer straight away as I didn't want to tell him I had an appointment at an employment agency. As we were passing a large café with a welcoming terrace, we sat down.

"First," he said, "I must introduce myself, Laurent Debienne, sculptor, who'd be happy to make a portrait of you if you'll permit me. I've just got hold of a piece of fine marble; would you mind posing for me for a few sittings?"

All of a sudden, he interested me. When I was a young girl I'd dreamed of knowing artists. They seemed to me to inhabit an enchanted world, where life must be so wonderful that it was too much to hope that I might one day share it.

Laurent told me he lives in Neuilly with his family and is totally dependent on his father, but he has a studio in Montparnasse, where he goes to work every day. He arrives in the morning around nine, has a quick lunch at midday so as not to lose any time, and leaves around six to go back to Neuilly.

"I work very hard," he said, "but my father has only given me two years to make something of myself. He's quite willing to help me till then, but after that I'll have to be able to make a living from my work. I finished my military service a few months ago. I postponed it several times so that I could study at the Ecole des Beaux-Arts, but when I was twenty-five I had to go into the army for three years. Now I'm twenty-nine. There, now you know about me. Tell me about yourself."

"Is it so embarrassing?" he asked, seeing me blushing. When I remembered the life I was living and thought about catching the train back to Fontenay, and when I recalled the stuffy smell in the employment agency where I soon had to return to see what they'd found for me, tears came into my eyes, and it was an effort not to cry. Eventually I began to tell him my story. His eyes seemed to invite confidences —big black eyes, which are the only good feature in a face that is otherwise too somber, with lines already starting to mark the corners of his eyelids and his nose. This is too prominent and seems out of proportion with his lean cheeks, which are covered by a beard that's too stiff and black. He has lovely shiny hair, but this again is too black, and his head's too large for his rather skimpy body, while his neck's long and thin with a huge Adam's apple that seems to move around the whole time. His hands are heavy and hairy, thick and tough—but this stranger gave off an air of reassurance that suddenly gave me confidence.

He listened without interrupting me. At the end he said: "Do you really want to work in an office? Do you realize the difficulties you're going to be up against? If you've told me the truth, I gather you're not used to fending for yourself and don't realize a job won't solve your problems straight away. You say you can't ask for help from anyone in your family, except a friend of your uncle's who told you he'd always be willing to offer assistance. But he won't do that without asking for something in return, and you've been through enough now to realize that it would mean paying with your body. Then you'll have to rent a room in a hotel, and you look very young. There would be difficulties, you'd be asked for your papers and if your husband arranges a search for you, you'd be found at once. You'd have to survive for a whole month before getting your salary, and—" he added laughing, "I wouldn't always be there to give you brioches and chocolate." I was shattered. It's true, I hadn't thought

about any of this, although I had thought of asking M. Enault for fifty francs or so until I could find a job. (M. Enault is a friend of my uncle's, who runs a similar business to his, and he did tell me one evening when he came to dinner with us—about a month before I left—that if one day there was anything I needed I could count on him.) Then I thought I could rent a small room for twenty francs and perhaps with the thirty francs I'd have left I could feed myself till the end of the month. Bread and chocolate, a bag of french fries and a sausage didn't cost much and you can buy them on the street. I'd seen stalls in the Rue Saint-Denis on my way to school that sold everything like this you could possibly want.

Now my new friend's words chilled me. He watched as fear, reflection, and then despair were mirrored in my face, then he made a suggestion: "Come back with me. I'll put you up in my studio, which has a couch, and I don't sleep there. There's also a bed in a small closet room. You can choose the couch or the bed, whichever you like. To pay me back, you'll just pose for me, and I'll give you a little money to live on. It'll be very little, I warn you, because I don't have a sou except for the small change my father gives me as pocket money. I receive a very small allowance from my mother—my father remarried—but I use this allowance of about 80 francs a month to buy all the materials and tools I need for my sculpture and I don't take anything from it for other things. Apart from that, you'll be well hidden. I live in Montparnasse near the avenue du Maine. Well then, that's settled. Don't be frightened to come. You'll be sleeping alone, I give you my word of honor."

And that's where I am now, and I can breathe again. Laurent settled me in yesterday evening, leaving after getting in a few supplies: bread, apples, walnuts, ham. There was already some tea, sugar, chocolate and coffee in the tiny kitchen. "I'm never short of those provisions," he told me, "my stepmother lets me take them from my father's house."

How good it has been to spend my first night here. I was a bit scared, as I'm not used to being on my own. I woke up at the slightest sound, and the attic above the closet where I've decided to sleep, must be full of mice, as I could hear them scampering about. But at dawn I fell asleep at last and didn't wake up until eight o'clock. I slept rolled up in a vicu—a skin, I think, or some sort of animal hide. There are no sheets or blankets here, but Laurent's supposed to bring some this morning. I washed in the little lean-to that serves as a shower room and toilet, but water has to be brought up from the kitchen. The studio is a large space with no amenities, a wide ground-floor room with windows onto a courtyard, where grass grows between the paving stones and which is surrounded by similar studios. Leading off it there's quite a large bedroom, which opens onto a small patch of garden, and this bedroom is filled with tubs full of clay and all kinds of rubble, pieces of marble, scrap iron and plaster. The studio itself is a pleasant room with an enormous stove in the center. Below the staircase there's an alcove that looks as if it has been furnished specially, with a couch covered in grey velvet and pillows in shades of red

from vermilion to garnet. There's a bookcase on the wall, where there are just a few books standing beside some small figurines, mostly Tanagras, and there's a small octagonal pedestal table, which is bright red with black and gold designs on it, running round it as if they were chasing after each other. At the head of the couch there are some grey velvet cushions and there's a goatskin rug in front it. A large curtain hangs down from the edge of the staircase, and if you want you can shut yourself away in this alcove, which gets enough light from a round dormer window. The closet room, which isn't much bigger than the bed it contains, is above this and there are a few more books scattered around. Its walls are covered with coarse grayish-brown cloth; there's blue carpet on the floor, and the bed, which is upholstered in blue velvet, has the large cover of tawny fur I slept in thrown on top of it.

I made myself a cup of tea, but I'm never hungry in the morning, so I didn't eat. Then I picked up a copy of Goethe's *Werther* and waited for my host to arrive.

Here I am, back on my own. Laurent arrived at ten with sheets, linen, a blanket, a packet of biscuits and some slices of roast beef wrapped in white paper, a bottle of eau de Cologne, some rice powder and—a curling iron. But my hair curls naturally and I've never worn powder. He laughed and looked at me curiously. We made the bed together and did the housework. He usually has a cleaning woman, but apparently she's ill. He told me that, to save money, he had taken some slices of meat from home. He often brings a lunch, which he prepares himself; he likes cooking. After we'd had a cup of coffee, he played the piano. I hadn't noticed the piano, which is in a poorly lit alcove at the end of the studio. Then he kneaded a large lump of clay and sat me on a modeling platform to begin work on my bust. He unfastened my collar, but as this wasn't revealing enough he asked me to pull down my bodice, draping a shawl over my front but leaving my shoulders well exposed. After an hour, I felt a strong urge to fall asleep. He noticed this, asked if I was tired and made me rest for a quarter of an hour. We worked like this until 5:30 P.M. I never imagined posing could be so tiring.

I don't think about my husband; but I won't dare to go out for some time as I'm so frightened of running into him. Anyhow, Laurent employs me to stay still. As I told him I like drawing, he has given me paper, pencils and everything I need to draw with. He's going to give me advice. I'm thrilled. I feel as if I've been here forever; it's funny how easily I can adapt. I've already begun to forget my past life, those dreadful nights beside Paul, the brutality and the caresses, which were as bad as the brutality. Now that I've managed to get away from all that, I'd rather die than go back to it. But what must my uncle, my aunt and my godmother—who never knew or wanted to know just how unhappy I was—be thinking of me? Still, they're not interested. I'd found a husband, which was all that mattered to them.

Yesterday, when he was leaving, Laurent came up and kissed me nicely. I put my arms around his neck and returned his kiss, thanking him for what he is doing for

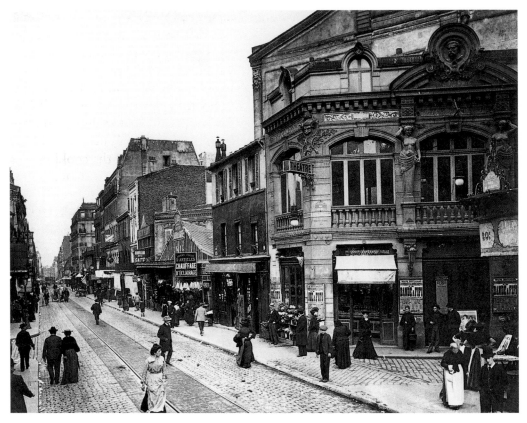

Rue de la Gaîté in Montparnasse, the center of Fernande's life when she was first living with Laurent Debienne in 1900.

me. "It's all right," he said, "you pay me back by posing. You're a good model and I'm the one who should be thanking you." When he'd gone, I started to organize my new life. I have to wash my underwear since it's all I have. If I could sell my wedding ring and the gold chain with the medallion that I wear around my neck, as well as a little ring that my godmother gave me as a birthday present, I could buy a few underclothes. I'll speak to Laurent about it tomorrow.

I went to bed early, right after dinner, I was tired. I have no night clothes, but I found I was fine wrapped in the fur. That's how I'll sleep. What a funny situation for a girl with a strict bourgeois upbringing. Sleeping naked in an animal skin—and my aunt taught us we had to change our slips by pulling the clean one over the dirty one for the sake of decency!

Time is passing and I've already been here five days. Laurent took charge of selling my little bits of jewelry, and I went out yesterday with some fifty francs which enabled me to buy two slips, two pairs of panties, two pairs of stockings, some

ESCAPE TO BOHEMIA

slippers, and a nightgown. If I wash things every day, I'll always have something clean in reserve to change into. Ah well! I'm not rich or well-dressed, but I'm so contented, so pleased with this new life. I enjoy going out in the neighborhood. The Rue de la Gaïté is a funny place, full of vendors selling french fries, snails and all kinds of food. The haberdashers all have the same plain linen in blue or bright pink in their windows, so I had to go farther afield to get what I wanted. I don't really like the area; everything is vulgar here and looks dirty, you only see hoodlums, and the only artists seem to be those living in our building. But I find it all fun.

I'm continuing to sit for Laurent, who does the housework and the cooking, but the cleaning woman came by to say she'll be back tomorrow. I pose the whole time, and it gets a bit wearing, especially as I can't see any progress in Laurent's work. He is so slow, and I think perhaps it's this slowness that makes me find him relaxing. Can you believe that he takes two hours to do what anyone else would do in ten minutes? Washing up a plate or peeling a potato takes him an age, and it must be the same with his sculpture. He's just the same when he tells a story: he has to settle down before starting to talk about the most trivial thing, he listens to himself while he's talking, constructs his sentences, comments on his own remarks, digresses, returns to the beginning and starts his story again with such self-satisfaction. He bores me quite a bit, but he's sweet, kind and helpful and lets me off the housework, which is something. He's becoming affectionate too. Just now he broke off in the middle of his work and stared at me for ages, so insistently that I began to feel embarrassed. When he's not there, I draw still lifes, which he sets up for me in a well-lit corner of the studio. I didn't know how to draw on an easel, but now I wouldn't know how to draw any other way, and there's also a box of watercolors and some oil paint. He's going to have to teach me how to use them. I'd really like that.

Yesterday evening I thought Laurent was at his father's house, but he came back around eight o'clock. He took me for a grand tour of the city, then to the Café de Versailles for an ice cream, and when we came home, he came and lay down beside me. I found this completely natural. I didn't have that feeling of dread I've always had before at the idea of making love. He kissed me with such gentleness that he possessed me without my resisting, and I felt neither pleasure nor disgust. But I still find it a bit upsetting, and I wish it could all happen without that final act which I don't understand and which seems pointless. I love the caresses and kisses, but I'm not in love with the man, as I'm beginning to realize. I slept very well, trustful and at peace. At last this is really the life of a mistress with her lover. "You're sweet." he said to me, "You don't know about sensuality yet, but that will come, and I'm patient." It's true he's patient, but with him this quality is really a fault. From now on he's going to sleep at the studio and will only go to Neuilly for dinner. He has brought me a parcel of linen and clothes that came from his stepmother. I'm really pleased with them, but how did he get them?…Never mind.

Life goes on, but it's slow and monotonous. My lover seems to be fond of me, and I feel gratitude towards him, but I'm not in love with him. Laurent has suggested I should do some modeling for other artists. It would mean I'd earn a bit of money so that we could live more comfortably. I'd like to do this.

[early summer 1900]
Yesterday I started to work; I'm a model. I sit for an old Italian sculptor who lives in Neuilly. I have to be there at 8:30 in the morning, and when I finish at half past twelve I've earned five francs. I also have to go to see a painter who saw me in the courtyard of our building and inquired whether I'd like to pose as Eve for him.

"Of course," Laurent said to me when I asked him about it. "For an artist a nude woman is more decent than a woman in her underwear." "And apart from that," he added, "I'm going to start a series of figurines of you—in dance poses."

"But when?" I objected, "since I work all day long."

"In the evening. I'll come back early and you can give me two good hours of work."

"Fine," I said, "if we can manage it."

This kind of life isn't much fun, I must say. For two weeks I've worked without a break: the sculptor in the morning, the painter in the afternoon, Laurent after dinner, Sundays for relaxation and Laurent at night. It's not a joke! I've lost weight, I'm tired, but Laurent doesn't notice. Besides, he thinks only of himself. I earn ten francs a day, which I put in a box. I must manage to dress a bit better. There should be more than one hundred francs in there.

Yesterday, I wanted to take some money to buy a hat and some shoes, but the box was empty. Laurent told me he had to cast some clay sculptures and that he'd bought some shirts. Why didn't he think of leaving some money for me? What an egoist!

Would you believe that now he has asked me to help the cleaning woman do the laundry once a fortnight in the garden? Definitely not. I work quite hard enough as it is. He's too selfish.

Today he lost his temper with me for the first time. I lost mine too. We had a fight, and he was the stronger—Afterwards he carried me to the couch, and it all ended just as it used to with my husband, except that Laurent is gentle and Paul was a brute. But what are men's expectations when they get excited by violence? I think one day I'll leave and live on my own, as soon as I'm sure of regular work. I already get more offers to model than I can take on, and we're going to move to Montmartre, to the Rue d'Orchamps on the Butte. I'm glad, as I don't like this neighborhood, which is run down and so dreary, and since I sit for a lot of artists who live on Boulevard de Clichy, I'll be closer to my work.

Laurent loses his temper with me at the drop of a hat now, because I don't do the housework. Since he likes doing it, he can do it himself. But we don't fight any more, and we don't embrace like that afterwards either. I told him that if that happened again, I'd leave.

I've been living with him for five months now. One of his old mistresses came to see him when I was in the studio on my own. She made a scene, hurling abuse at me, but I wasn't afraid of her. After an exchange of insults we calmed down and became friends. When Laurent arrived he found the two of us chatting like old acquaintances, which seemed to annoy him. Her name's Lita. She's very beautiful, with dark hair and enormous green eyes. Her mother's a concierge near the Place Saint-Michel. She herself is a dressmaker, and she's the mistress of a painter, whom she was two-timing with Laurent and quite a few others, so she told me. As it was a holiday and I wasn't working, she had lunch with us and afterwards all three of us lay down on the couch. Laurent suggested various diversions for three, which amazed me, but I wouldn't join in and, despite Lita's eagerness, Laurent got up and suggested going out. Lita was disappointed; I was quite relieved, though if Laurent hadn't been with us, I'd certainly have stayed lying down beside Lita and wouldn't have minded at all if she'd taken the initiative the way Hélène had in what seems now like the distant past. Lita's going to take me to model for her painter boyfriend.

The Bateau Lavoir studios on Rue Ravignan.

[fall 1900]

We've moved and live in Montmartre in a studio that is clean, bright, and cheerful—at ground-floor level in the front, which is on the Rue d'Orchamps. The bedroom is on the floor above, behind the studio, and opens onto a pleasant garden. The building is one of the three that make up the strange "Bateau Lavoir," which runs along the side of the little Place Ravignan, halfway between the Place Pigalle and the Sacré-Cœur, and is inhabited mostly by poor, young, aspiring artists. The first building, at 13 Rue Ravignan, is a strange wooden construction built on the level of the Place Ravignan with several studios on the ground floor and others below, which are reached by a dusty, echoing, wooden staircase. At the bottom there is a big square stairwell with, on the right, the only faucet for the twelve tenants in the building. Beyond it a smelly corridor leads to the only toilet, a black recess with a door that won't shut because the latch has come off, so that it bangs in the slightest draught—which means every time the big wooden street-door is opened. The narrow passage is lit only through the wired glass in the ceiling, a glass roof, black with dust that's been gathering there for ever, which connects with the glass roofs of the downstairs studios.

It's a weird, squalid building echoing from morning to night with every kind of noise: discussion, singing, shouting, calling, the sound of buckets used to empty the toilet clattering noisily on the floor, the sound of pitchers placed noisily on the grill below the faucet, doors slammed, suggestive moaning coming through the closed doors of the studios, which have no walls except the partitions dividing them, laughter, tears; you can hear everything. Everything echoes around the building and no one has any inhibitions.

In the brick building on the Rue d'Orchamps there are four studios on the ground floor, each with its own front door. The one we've rented is the third. The tenant in the first is a sculptor whose mistress, Laurence Deschamps, is a nightclub singer from Montmartre. Her specialty is performing the songs of Paul Delinet, whose mistress she was for a long time. She's about thirty-one, very beautiful, with a great figure but a face with cold, regular features and a hard, mean expression. Her mouth is cruel, and you can tell just by looking at her that she has absolutely no use for anyone she doesn't like. I find her quite intimidating; if I see her, I go back in —so I don't think she has ever noticed me. She can't be living there. He's rather colorless, and although he's quite tall and distinguished looking, he seems to have no energy.

The second studio is occupied by an elderly sculptor called Pozzi, a fine old fellow, still very spry, who sports a white beard that gives him a patriarchal look. Then we have the third studio. As for the fourth, I haven't seen anyone going in or out yet, which makes me think it must be empty. The concierge seems to be a nice woman, though a bit grouchy and offhand. Her husband's a tailor, and you can see him perched cross-legged on a table through the window of the lodge. This looks onto

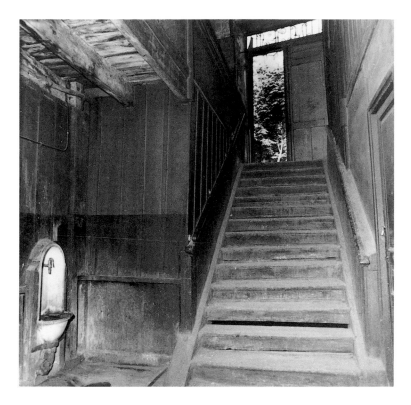

Communal water supply on the staircase of the Bateau Lavoir.

a little enclosed garden that leads to the third, stone, building and adjoins the wooden building I've already described.

I quite like this new studio, although it's much smaller than the one in the Avenue du Maine. But it's so bright and sunny—especially the little back bedroom—that I'm really glad to have moved. Laurent's busy with the decoration, hammering in nails, fixing things, sawing, shifting the furniture, changing it around, putting up shelves. He's putting a bookcase up on the wall, measuring the planks meticulously and drawing lines on the white wood with a big flat pencil with an enormous broad, thick lead. Then he starts sawing, but not before he has covered the pale wooden floor with a sheet, which he shakes out of doors from time to time to get rid of the sawdust. He undertakes every task as if it was a religious ceremony. Everything is planned, organized and thought out, and he never starts anything that he hasn't spent ages working out exactly in his head. If he makes a mistake, he doesn't lose his patience or get angry but just undoes whatever he has done and starts again.

How was he able to pick me up and take me away with him so quickly? Now that I know him so well, I imagine that while I was gobbling brioches and gulping down my chocolate he was thinking of the profit he could make with a live-in model, whom he would train to sit for other artists and who would relieve him of the material worries that were spoiling his easy life. He didn't like living with his father,

who has only grudgingly accepted his decision to be an artist and seems to have little affection for him. I've found out now that his father was widowed when he was quite young, remarried, and gave all his affection to his new family in preference to his rather spineless son. Luckily, Laurent's stepmother has a generous nature, or the poor boy would have suffered badly from the indifference of a father whom he loved and venerated.

I don't quite know what to think of Laurent. As a man, he's typically selfish and a bit of a nonentity, and he's a nonentity as a sculptor too, with no ideas—at least that's how he strikes me, even if I am an unsophisticated young girl. By watching artists, sitting for them, listening to them talking, discussing art, I'm beginning to have some idea of the way a real artist lives, which makes me feel dubious about Laurent with his eccentric little ways. He's so petty and methodical, careful and sure of himself. As a lover he doesn't live up to his promises: he talks a lot, extols the beauties of free love, the relationship between two human beings, disinterestedness, and so on, but he takes everything and gives nothing. He works but doesn't produce —what a funny fellow he is, older than his years—and his values are all over the place, since he treats me like a little girl although he allows me to work like a woman. He's quite flattering, a bit too sugary sometimes, but he becomes nasty and violent if I don't agree with him.

One of his friends is dearer to him than anyone in the world. He often spends the night at his place and loves him, it seems to me, just as he'd love a woman; he'd do anything for him. I'm not too keen on this Georges myself, although he's very kind, very different from Laurent—active, lively, extroverted, and generous, while Laurent approaches everything with grim concentration. Laurent makes me think of a rodent living underground in the dark, while Georges reminds me of a bird, some sort of rooster, enjoying himself in the sunshine, living from day to day, accepting everything that comes along so as not to miss out on anything in life, yet discarding it all just as quickly. Laurent nibbles, scratches, hides his life, his plans, and bides his time in the dark so that no one who comes close to him can see him in his true colors.

In the meantime, I'm continuing to work, and as I can never find any money at home when I need something, I've decided to keep part of what I earn, which Laurent doesn't seem to like, but I don't know where to hide my money so that he can't find it. And I don't know what he does with the money I bring him.

Yesterday, I found out something which may be amusing, but I found it disgusting. Every morning I get up at seven o'clock and leave the house at eight. Laurent gets up at the same time and makes the breakfast while I'm getting dressed. By the time I leave, he has always started working at something. Then yesterday I was supposed to pose in the Avenue Frochot for a painter, Axilette, who's quite well-known. When I arrived at the studio, his servant said to me, "Monsieur is ill; he has told me

to pay you for the sitting and asks if you'll come back in two days' time. If he's not better, he'll let you know."

So there I was at 8:30 A.M. in the Place Pigalle, wondering whether I should go straight home or, as it was such lovely weather, go for a walk. Then I remembered that a painter living in the Place Pigalle—MacEwen—had asked me to call in on him, so I went there. But he hadn't arrived. While I was ringing his bell, an old fellow came out onto the landing wearing a big black velvet beret with white hair flowing from beneath it. He looked exactly the way I picture painters: with a high-collared, black velvet jacket, a cravat, and an embroidered vest. He looked at me and said: "I thought it was my bell that was ringing." Then he shut his door, but opened it again almost at once. "Are you a model?" he asked.

"Yes."

"Come in, if you want. MacEwen isn't there. If he hasn't got a model coming he never turns up in the morning. My model's ill. Maybe you could take her place? Come in."

I went in.

"Take off your hat and your bodice—good, that's fine! Are you free tomorrow?" I was, and he told me to come and pose at nine o'clock. I left, not even realizing I'd been talking to Henner, the old Alsatian painter famous for his paintings of red-heads, and decided to return home. It was half past nine when I arrived at the studio, but there was no answer when I knocked. As I didn't have the keys, I assumed they were with the concierge and went to fetch them. The concierge asked me: "Have you knocked? But M. Debienne will be in bed. He never answers in the morning."

"What do you mean, in bed?—He was up when I went out."

"Of course, but then he goes back to bed again, my dear. He's never up when I bring round the post. He tells me to slip it under the door."

I was astonished. Why does he get up and start working before I leave, then? It's ridiculous, quite ridiculous! The concierge gave me a pitying look: "You poor little thing, all these artists are the same. The woman goes out to work to help them make ends meet, so that they can be free to work at their art, but in the meantime most of them just sleep or amuse themselves. I've seen enough of them over the past twenty-five years to be able to pass judgment on them. I love them, but I do condemn them. They're big babies, and in spite of everything, I'd do anything for them. But it's a pity to see a girl like you wearing yourself out for a man who sleeps all morning and spends his money in the afternoon on the sluts who pose for him. I can't think why they do it. Don't be so trusting; open your eyes if you care about your sculptor and your health. You're a nice young girl and I'm on your side. That's what I say."

She was so funny with her profession of faith and her advice that I started laughing as I thanked her. What she told me didn't really bother me, as I consider

Laurent more of a friend than a lover, and for some time he has left me in peace and only availed himself of my "favors" after quarrels. We used to have these a lot, but now that I've realized the pattern they follow I avoid them, and when I feel he's looking for one, I leave and go for a walk. When I come back he has calmed down. So I'm certainly not staying with him out of love. I didn't return to the studio till later, and then I felt embarrassed and didn't mention I'd knocked at the door and got no answer.

Georges's girlfriend comes from a "good family." Her name is Léno, short for Hélène, and she lives at her parents' house with two brothers and two sisters. They're German Jews and the strangest family I've ever known, but I'll save up and write more about them another time—it'll be worth it. I've become quite close to Léno, although I don't much like her. Still, she's generous and showers me with little gifts. I finally went to her house because she insisted so much that I couldn't get out of it. I don't know why she's attracted to me, as we're so different: she's very brazen, with no modesty, and at twenty-two, although she has never left her family, she claims to have had eleven lovers. I think she says all this just to brag—I don't understand why—though she has told me their names. She confessed to me that she'd wanted to seduce Georges to "swipe" him (her word) from her mother. And since he has already betrayed her with one of her sisters, she has apparently paid him back in kind by giving herself to one of his cousins! Then she went back to Geo, whom apparently she can't do without, sexually. All this alarms me a bit. I don't understand much about sex and I told her so, but she wouldn't believe me. "You're hiding your cards," she said, so I didn't argue. "Maybe you're right," I said. It's true that in one of the studios where I pose I've met a young painter who has lost his head over me and wants me to come and see him. He's nice. I'll go one of these days.

[spring 1901]
Laurent has decided to move studios. He has found a much larger one in the same building, on the ground floor on the Place Ravignan. I won't take any part in the move, but Laurent will be in his element. He'll be able to plane surfaces down, saw wood, drive in nails, paint and completely convert our new apartment at his leisure. I'm still modeling and some days I'm at my wits' end. The other day one of my painters wanted to kiss me. I threatened never to come back if he started his nonsense again; and since he's working on a large exhibition canvas he has promised to behave himself.

[summer 1901]
Something disgusting has happened. I came home early from a modeling session and found Laurent in bed with a girl of twelve or thirteen years old he has been using as a model. The little girl was naked and he hadn't had time to get up when I

arrived. I was furious, ashamed, sickened. What a hypocrite, with all his fine talk of the beauty, purity, and fragility of children! That was what he said about this model he'd been using for several days. It seems to me that her beauty has been inspiring him in a way that makes me rather dubious about the beauty—or at least the purity—of his impressions and feelings. I insisted that the girl get herself dressed and leave, never to set foot in the house again. Anyway, the poor child looked depraved, and she seemed to be mocking me when she said before leaving, "I won't go until I've been paid," and when I handed her 5 francs, the fee for a sitting, she said: "You think it's 5 francs, but no, he always gives me 10 francs." Now I understood. I won't stay with this nobody much longer. What a hypocrite, I thought.

To top it off, I had to pose for an entire day to pay for this child's three-hour "sitting." Laurent just assumed an air of injured dignity: "You're not capable of understanding an artist like me. I find your narrow-mindedness so upsetting, I don't even want to bother to explain. I could have created a masterpiece, but you stifle me completely." And so on. I don't know if I stifle him, but I know all too well that he does nothing but talk and listen to himself talk, and that he's a real bore. Does being an artist mean doing nothing, lying, babbling endlessly, watching yourself exist, talking, thinking, admiring yourself? I don't know. I'm not sufficiently at home in this world yet, but if that's it there's not much to it. The painters I pose for don't live like that. They're active, they work and don't spend their days daydreaming in front of a sketchy canvas, or grudgingly adding a touch of color, like Laurent, who makes me hold a pose for hours on end with nothing, or virtually nothing, to show for it. The figurines he has begun are still, as far as I can see, just rough studies, and he spends his time unwrapping them and then wrapping them up again in damp cloths, to prevent their drying out.

Some months ago, when we were still living in Montparnasse, he had a brilliant idea for a work for the Salon. He wanted to make a life-size statue representing "an alcoholic." He duly unearthed a tramp—I'm not too sure from where—a tall, thin, fellow with a bony face and large vacant eyes, who fitted in fairly well with what he was planning. As he had no cash, he agreed with this model that he'd feed him, house him and give him a bit of pocket money. This man moved into the studio, where he took care of everything. I had nothing to do with it, but Laurent managed to get him to do the laundry and the heavy work. He was a sort of philosopher in his own way and did everything he was asked: he'd pose for days on end for a work that made no progress, so long as he had his liter of wine with each meal and his ration of sleep.

The result of this experiment was disastrous. First, the clay statue collapsed several times—it had to be started all over again—and then it was rejected by the Salon. After this, the fellow didn't want to leave when Laurent decided to get rid of him—that was one of the reasons he decided to move—and he had terrible problems with him, not that he was a bad guy, but during the few months all this had

lasted he'd grown accustomed to sleeping in a bed every night under a roof, and to drinking and eating more or less what he wanted.

I don't know why I should mention this now instead of having written about it at the time it all happened, but I was so disgusted with Laurent's casual attitude that I'd decided to have nothing to do with the fellow. I don't think I addressed ten words to him in six months, despite which he was always extremely polite, even servile, telling me that in his opinion I "could have done better."

Meanwhile, I'm continuing to model, though I don't know how much longer life can go on like this. I find new assignments almost every day. At the moment I'm working for Bordes, who's a fashionable portrait painter, and recently during one of my sittings he had a visit from one of his friends, the Academician Cormon. Now Cormon has asked me to pose regularly for him too. He's very nice and I'll be happy to work for him.

[fall 1901]

In spite of all my problems, I don't spend my whole life modeling. I have some time to myself for reading and I'm starting to improve my mind. I borrow a lot of books and read mostly in the evenings and late at night. Since the episode of the little girl, I've told Laurent to keep away from me and I insist on sleeping alone. In any case, he leaves me in peace.

Laurent has a delightful friend, a Montmartre singer, who seems to like me a lot, in a fatherly sort of way actually, since he's at least thirty years older than I am. I trust him. Yesterday he came over when Laurent had gone to see his family. I was feeling sad, listless and depressed and he wanted to know what was wrong, as he said that no twenty-year-old should be allowed to feel like that. I told him everything about myself, about Laurent, whom I've never grown to love, about my character, my carefree nature, my longing to escape. "This life bores me," I told him. "Am I always going to feel bored and disgusted with life? Can't I ever be happy?" Then Jacques reassured me, talking to me in such a nice, reasonable way that I realized that it was all of my own doing. Happiness is within oneself, and it has to be cultivated. It's true what he said: I have a Middle Eastern character: apathetic, fatalistic, carefree, expectant, lazy. I must—I owe it to myself—escape these inborn traits. This lineage, which comes from my maternal grandmother, is my worst enemy. I respond badly or not at all whether to myself or to others—I just wait. He's right, in life you do yourself a real injustice by waiting for things to happen. You have to live in a different way.

Jacques has opened new horizons by talking to me like this. First, he said, I ought to love and be loved sanely, simply, "the way it should be." I'm living with—still staying with—a man I neither love nor respect, out of a kind of passive laziness. I'm frightened of having to "build" something else. I let myself drift. I told him that I did, after all, feel quite calm, but so discontented that this calm grates on my nerves.

I laugh and cry without any real reason and, worst of all, I don't feel love, and I should.

"Come back often," I said to Jacques, "Come back when Laurent isn't here; help me, by talking to me like this as often as possible."

"Coming back often, little baby"—that's what I'm called here—"would be very dangerous for a sentimental, wrinkled, old fellow like me. You're attractive, my dear child, and I no longer am."

At first he wouldn't let me, but then with a wild gesture I flung my arms around his neck and kissed him sweetly. When he was gone I wondered if I'd be happy with this man. He's too old for me, but I have an urge to give myself to him, to be cradled, caressed tenderly, loved, protected. He's divorced, he has a family—children older than I am. I know his eldest son, who's twenty-six and is quite attracted to me, but I prefer the father. I'm confused. I'd like to see him again, today even, meet him again tonight, open up his arms and close them around me. I need protection and warmth. Is that love?

It seems strange that my desire is directed towards a man who could be my father. Laurent will be back soon. I've forgotten to eat, but I'm not hungry. I'm going to bed so that when he gets back Laurent will think I'm asleep and not think of slipping in beside me. My couch is in a corner of the studio and I open out a screen to isolate it at night. That way I have the feeling I'm in a bedroom of my own.

Sunday

Laurent came back late that night. He had been to a fancy dinner party. He had drunk champagne and couldn't resist the urge to wake me up. He irritated me with his caresses. I think I'm in love with Jacques. I hope he comes today!

I don't have to work today, but the housework has to be done and I hate it. I've told Laurent, but he insists I help him clean the house. I don't want to. I want to rest, dream and read. He lost his temper, I told him to get lost, he slapped me, I threw a dictionary at his head. He avoided it, and then calmed down. "I'm the one who works all week," I told him, "who supports both of us for just about everything. You're going to have to do the housework yourself, otherwise I'll hire a cleaning lady. I want peace when I'm resting. Let me alone or I'll leave. I know where to go."

He didn't say anything else, but the angry swipes of the broom against the walls and the furniture spoke volumes. I said haughtily, "Don't make such a noise, you're giving me a headache." He shrugged his shoulders, left the housework unfinished and got dressed to go and spend the day at Neuilly with his parents. Wonderful! A day on my own, I thought, and inside me I felt a stirring of unease, an unfamiliar flutter of excitement. What if Jacques comes?

If only Jacques would come, but I know perfectly well that he has performances in the afternoon and evening, so he can't come; and I'm sure he doesn't think about me the way I think about him. I'm sad, I feel like crying, but I'm going to go on

reading *Madame Bovary*, which I started this morning. I like the book, but not Emma Bovary. I find her quite unsympathetic.

Monday

At six o'clock last evening there was a knock at the door and my heart began to beat so fast I thought I might faint. It was Jacques coming to ask if I wanted to go to the evening performance at the cabaret where he's singing. "Yes, of course," I replied, trying to hide my delight; but I took his hand and pressed it to my cheek. It was so nice, I wanted to kiss his hand, but I didn't dare. He realized something strange was happening to me and he made fun of me, I think. He lifted my chin with one finger and said to me, "And what, little girl, is going on in that pretty head of yours?" I felt ashamed, I blushed, I shrugged my shoulders and looked at him with a mixture of tenderness and anger. I turned my head away, as I didn't want him to see the tears that were forming in my eyes.

"Where are you having dinner?" he asked me, "Are you expecting Laurent? If not, would you come and eat with my son and me at our usual café?" His son irritates me, and I would have preferred to have dinner with him on his own, here, in the studio. I had an overpowering urge to confess everything to him; but as I'm proud and shy, I said nothing about my feelings and we left. We ate on the Boulevard de Clichy, near a band of singers who were making a terrible racket. One of them noticed me and asked Jacques to introduce us, which he did politely. I wanted him to be jealous, but he didn't seem to be; it was Marcel, his son, who seemed bothered. Can he really be in love with me? But I don't care for him, he has a morose and spiteful look. Jacques behaves towards me just as he did before I became aware of my feelings for him, and I'm so different. I love him, I'm sure of it. If he wanted to take me away with him tonight, I'd follow him.

I long so much for him to take me in his arms! What can I do? Tell him I love him? But if he made fun of me, I'd die of shame. Well, to get back to this dinner, when he was introduced to me, this man, whose name I've forgotten, started to flirt with me and asked me to go out with him. He sat down close beside me and tried to take my hand. After a while I didn't know what to do except say exasperatedly, "You're annoying me!"

"She means what she says," said Jacques. As for Marcel, I thought for a moment he was going to lose his temper, but it was nearly time for the performance, and we left the restaurant to go to the cabaret, which was nearby. Marcel looked after me, and I watched the performance until just after Jacques's turn, when he came and asked if I wanted to stay till the end. "Oh no," I replied, happy to leave with him. I knew that Marcel had to remain to the very end as he was appearing in a sketch. Outside, Jacques took me to Graf's to have a beer because he was thirsty.

I was sad. He talked about me, about life, about my life, and warned me against my fantasies. He seems to be deliberately trying to steer me away from him.

Eventually he took me home. Laurent had come in and scolded me for going out without leaving him a note; I told him to get lost and went to bed in a bad mood and unhappier than ever, though more in love.

[October 1901]

I've started modeling for Cormon. He's doing a sketch for a large tapestry with medieval characters. I'm one of the women in the foreground. He's very nice. It's an easy pose—I'm seated in full light—and today I fell asleep. He didn't wake me up as he could get on with his work perfectly well. He likes me, so there's a prospect of a long series of sittings ahead. He wants to do a lot of work with me.

In the morning I go to the Quartier Péreire, to my portrait painter, and in the afternoon to Batignolles, at the end of Rue de Rome, to Cormon's place. At four o'clock I leave there to go and pose for an art class of young girls in the Rue Victor-Massé. I get home at eight o'clock, tired and often depressed, and Laurent has the nerve to expect me to sit for him for an hour or two every night! Some hope! I've told him in no uncertain terms that I don't want to sit for him any more, and that it's pointless anyway. As for the money I earn, apart from what's needed in the house, I spend it. And now I have shoes, stockings and hats.

I haven't seen Jacques for five days now. If I don't hear news of him this week, I'll go and see him next week. The weather is miserable—a miserable, wet October.

I've been living with Laurent for more than a year. I'm fed up with him. I think about Jacques, whom I love but I don't know why. He isn't handsome; he's old, he's very tall, quite slim, though with rather a stocky look, strong features, deep eyes, thoughtful and good-natured. His mouth is thick, but well defined, and he has lovely white teeth, which are revealed when he smiles in his broad, frank, reassuring way. There are deep lines across his brow and running down his cheeks from the corners of his nose to the corners of his mouth. He has fine brown hair greying at the temples, and his complexion is a little ruddy, because he drinks too much strong beer. I don't know why I love him. I suppose it's because he spoke to me so affectionately and so openly. The fact is that I love him and want to be near him—that's all I know.

Saturday

Tomorrow Laurent's going to be around until six in the evening. If Jacques comes, he'll find him here. They're very fond of each other, and Laurent really seems to be very affectionate towards his friends, but Jacques always teases him a bit, accusing him of preaching and liking to talk just to hear the sound of his own voice without having anything to say. That's exactly what I think. Laurent doesn't get angry, but tries to convince him this isn't the case in yet another discussion, equally long and equally slow, though more insistent. As far as I'm concerned, Laurent epitomizes boredom. I haven't a grain of respect for someone who seems to me so

affected, pedantic and hypocritical. And there's nothing I loathe more than hypocrisy. Jacques stands up for Laurent and tells me I'm determined only to see what's bad in him and ignore what's good. He may be right, but I find his "good" uninteresting and his "bad" quite exasperating.

Sunday

Jacques came this morning. We asked him to stay to lunch and he agreed, so Laurent went out to do the shopping. Then, as soon as we were alone, I asked Jacques why he hadn't shown any sign of life that week. He seemed surprised. "But I've come just as usual," he said, and when I began to cry, he looked at me and told me not to be such a dreamer. He already knew the disappointment I'd feel if he listened to his own heart rather than mine. He wanted to spare me this disappointment—and himself, perhaps, great sorrow.

"I'll come and see you this week," I told him, "I want to see you alone at your place. I want to be closer to you than to anyone else. I love you, I know how much I love you; all I want is for you to love me. I think of nothing but you, I've never loved anyone before. I've never experienced this feeling of expectation, of desire, this need for trust, for protection. I must be loved, I must be loved or I'll be so unhappy." He held me against him and I felt his lips on mine, and I thought I'd faint with happiness. As we heard Laurent at the door, I came to my senses. I was sure of seeing him again, sure that he was going to love me. There was no point in arousing Laurent's suspicions.

I had a wonderful day, in spite of a storm, which made the shutters rattle outside and shook the wooden building that shelters us. What extraordinary happiness I felt inside me! What bliss! What a wonderful secret! How miraculously my life had changed—suddenly enriched and now so precious! I fell asleep with joy as my companion and slept a dreamless sleep.

Tuesday

Tomorrow I'm going to see him. He has a little place in the neighborhood of Batignolles. I'll skip my modeling at the girls' class so I can be at his place at 4:30 P.M. All I can feel is my impatience. I don't know what will be the outcome of this great love.

He was right, I am disenchanted and, though I'm ashamed to admit it, I don't love Jacques any longer. It's always the act of love which nullifies all other feelings for me. On Wednesday I arrived at Jacques's place. He'd prepared a lovely picnic, with cakes, flowers and cordials that he knows I like. But I had eyes only for him and for his arms that I wanted around me. I felt a pleasure that seemed quite amazing, right until that moment—you know all about, which I'm sure I'll never get used to or be able to take part in.

Suddenly I came to my senses and saw myself beside an unappealing old man, whose beard smelled of stale smoke and beer. I felt such disgust, for myself and for him, that I hastily put on my coat and hat to get away immediately. The poor man did nothing to stop me, but he held open the door, took my hand and said, "I was sure it would end this way. I have some experience of the sudden infatuations of young girls, but this is what you wanted. You're leaving me with my sorrow and a desire for you that I didn't feel yesterday."

What could I have answered? I was overwhelmed with shame and disgust, and I couldn't understand how I'd been in the grip of this mania for the last few days. I definitely think I'm different from other people. I've realized this now that I have gained some experience since that morning when I awoke, having been a complete innocent, after the terrible first night I spent with my husband. Poor Jacques. I wanted him almost in spite of himself and I've rejected him so cruelly. Pray God he doesn't start pursuing me.

I ran out of the house and was quite out of breath when I reached the studio. Luckily Laurent wasn't there. I took an icy shower and put myself to bed. I sleep so well when I want to forget myself and forget a life that's beginning to seem so devoid of pleasure. I slept without being woken. Laurent didn't come in, which often happens now. Apparently he sleeps at Geo's. I wonder why, as Georges lives with his elderly grandmother, who's frightened of being alone in her huge apartment once the servants have finished their work. I think Georges is the only person Laurent really loves. I catch him giving his friend the adoring looks he never gave me, but then he has never felt like that towards me. What a strange person he is!

[late fall 1901]
I haven't been well, and Geo's girlfriend, Léno, has offered to take me to Berck with her for a week. Although I dread the thought of the cold on that vast beach, which has no shelter from the wind from any direction, I've agreed to go with her.

On our arrival we were met by a sort of country gentleman, who'd first gone to Berck when he suffered from Pott's disease and had then moved there with his mother. He was neither good-looking nor pleasant, but I soon gathered he was a former lover of Léno's. This fellow, Maurice, didn't leave us all day long. He had lunch and dinner with us at the hotel and accompanied us on our walk. In the evening, with Léno's encouragement, he even had the nerve to suggest sharing the one room we had reserved. I lost my temper and told Léno that if that were the case I'd rather sleep in a room on my own. Unfortunately, that wasn't what Léno wanted, and since she was paying all the expenses of the trip and I have no money I had to give way. Luckily the room had two beds. I pulled one as far away from the other as possible and told them to keep quiet with their bedtime activities, which I didn't

want to know about. In the middle of the night I woke up with a body next to mine. It was Léno, who'd come to share my bed, complaining of her partner's impotence. She'd expected better of him—but I didn't hear the end of her troubles because I went straight back to sleep.

I'm still at Berck, basking in the pleasure of being on my own. I only see Léno at mealtimes and I don't mind it here. However, I have to be back in Paris on Monday, as I have a sitting at Cormon's at two.

I came home after an argument with Léno, who told me I was a grouch and accused me of being prudish and a little madam. "What good will that do you in life?" she asked, "Take everything good that life offers you. The day will come when you'll be sorry you didn't take advantage of pleasure at the right time."

She may well be right, but she irritates me. What does she mean by pleasure anyway? I don't like her intrigues, either. "Whatever happens, Geo mustn't know that I introduced you to Maurice and that I went out with him. He's jealous." And no doubt he has good reason to be, I thought.

All in all, although she has some good qualities, I don't like Léno. She has a way of looking through her eyelashes, which is annoying. Her blue eyes are short-sighted and have a slightly veiled gleam in them, moist but keen, that I don't like the look of. She's a pretty girl. Her hair is a wonderful blonde color, and although it's not very thick and cut quite short, it has a nice texture. Her skin is pale, with a little color over the cheekbones, but it has a few blemishes and is covered with fine down. Her neck is thick but long, her shoulders are broad, she's short-waisted and long-legged. Everything about her suggests something animal, which I realize, as I know her better, is becoming more and more difficult for me to tolerate. Her laugh is sensual, with a brutal sensuality which is her distinctive characteristic. She likes to tell me— going into great detail—about her love affairs at boarding school. She tells me of the pleasure she has always felt in making the people who love her most, but haven't succeeded in dominating her, suffer both physically and emotionally. When she's dominated, she's a different person, all gentleness and passivity, giving in submissively to her own feelings and to those of her partner. Geo has absolutely enslaved her. She's delighted by this, but takes it out on others. She says she only experiences real pleasure with Georges, but she cheats on him because she feels this desire to see people suffer. In short, she's a kind of sadist, who takes revenge on lovers who don't realize they have to dominate her to make her happy. A complicated girl, a slave to her vices and to the vices of others, all the others to whom she gives herself without love or enjoyment, just for the pleasure of debasing herself. She's too complicated for me to understand, and I don't want to give the impression I understand her hints about the enjoyment we could have together. I find all that rather horrifying and quite repulsive. I can't be her friend or think of her as mine.

I haven't seen Jacques again, and yesterday Laurent said he was surprised not to have heard from him. My memory of the little escapade is becoming blurred, but I feel slightly embarrassed at the thought of seeing him again. I wonder if I'll discover one day what love really is. I must change my life. I want to leave Laurent, but I live life from one day to the next, and in any case I'd find it very hard to live in a hotel.

Laurent's planning to go and find Jacques at the club one evening. I've said I won't come with him, as I feel too tired after work. It's not that I don't want to see the poor fellow again, but since all that happened it wouldn't be either pleasant or unpleasant to be with him. As far as I'm concerned he has gone back to being just what he was before I got all those crazy ideas into my head. I'd even be happy if he could be the quiet paternal friend he used to be. The first time I see him may be a bit awkward, but he's intelligent enough to get over this awkwardness, and to help me get over it too. I think Laurent's going to go and see him tomorrow night, which is fine. I feel a little guilty about it, but more astonished than anything. How could I have been so crazy? Ah well, it will all pass over and it gives me a bit of experience. I have so little.

Lovers in the Luxembourg Gardens, c. 1900, by Joaquim Sunyer. Jane Voorhees Zimmerli Art Museum, Rutgers, the State University of New Jersey, Joyce and Alvin Glasgold Purchase Fund.

STUDENTS, LOVERS, HUSBANDS

Fernande's Journal, 1902–1904

[1902]

I'm still living with Laurent and would be bored to death if I didn't have my secret life. I can spend a whole day stretched out, without reading, eyes closed, just with my dreams. I can summon them up and live a fantasy life to my heart's content, being what I want to be, what I'm longing to be, and feel satisfied. Laurent, who needs to busy himself, doesn't understand me and gets angry when he sees me "doing nothing," as he calls it. But I laugh at him. I've found that inertia is the best answer to his complaints, his lectures, his rages. I put up my shutters, close myself off, don't listen to anything and eventually he leaves me in peace. I'm lazy whenever I can be, but I get so few opportunities to indulge in my vice. I work hard, modeling all day, modeling the whole time.

Fortunately this work allows me to think about anything except what I'm doing. I'm sure this is why artists find me such a good model, amenable, graceful and not stiff. Holding a pose if you're bored gets too tiring and you get tense and don't look natural. If you're worried about keeping still you get stiff and rigid. To pose well you have to forget you're posing, think of something else, not be aware of the slowness of time, but forget life, forget who you are, lose yourself in another life completely within yourself, a life that's filled with a happiness you could never find except in your dreams. Luckily, I have this facility for dividing myself into two, which is ideal for this exhausting job.

I'm changing at the moment. I'm becoming more of an intellectual, with more ideas of my own, and men find me more interesting. Of the few friends who come to Laurent's, I know that two or three of them only come to see me, particularly a proud Spaniard, who's short, dark, devilishly bourgeois, very correct, very hidalgo, and is always dressed in the latest fashion, which looks quite out of place in our milieu. He prowls around me—not that it brings him any success as he has no idea how to keep me interested—bringing flowers, delicacies and books. He insists that he wants to make a date with me, and I'm equally obstinate in refusing. With his

large head, his overly black eyes, his thin hair and his hollow cheeks, he reminds me of a lecherous and ridiculous little gnome. I keep bumping into him wherever I go. If, when he's at the studio, I forget myself and mention what I'm doing the next day and where I'm modeling, he manages to find the address, and there he'll be, flowers in hand, eyes gleaming, and he looks so downcast when I snub him with a couple of words and slip away before he has realized I've gone. His Spanish accent is so strong you'd think you were hearing a drum-roll when he says, rolling his eyes, "Je vous adore," but nothing discourages him and he'll try again the next day.

I find it so idiotic for a man to chase a woman who wants nothing to do with him. I've come to the conclusion that rejection is spice to some men who don't have much success with women. I'm always on the defensive with a man. I can't let myself go and be confident, even with those I might like, or whom I do like. Instinctively I recoil physically, and this makes me recoil emotionally too. But I want to be happy. The life I live isn't pleasant, with no one to love. I long to love and be loved in return. I know I'm being idiotic, but I'm a coward. I'm frightened when I remember the sight of my husband's wild eyes, his terrifying look following me around, and I'm struck with such a vivid image of this whenever I sense that a man wants me. I don't know what to do to get rid of these memories. I've stored up so much tenderness in my heart, all the tenderness that has been building up since my childhood, which I haven't been able to give anyone. I've buried it so deep inside me, I'm sure nobody has any idea just how tender and loving I could be. My aunt rejected it with her cold looks, my uncle checked it with his reserve, my godmother frightened it away with her indifference (whether or not this was a pretense), so how could I open out my heart? This is such a weight to bear and so troubling, I'd like to unburden myself. I'm not really the woman I seem to be, but who can I reveal myself to? Laurent stole my heart at the very beginning, when he almost swept me off my feet with kindness, but he soon changed, and he's such a bore I prefer to be alone than to spend time with him. He's crazy, obsessional, and such a hypocrite. I've often thought his kindness to me was hypocritical, as he's not a good person and is capable of brutality. The only people he loves are Geo and his little sister—or rather half-sister—whom he talks about the whole time and for whom he feels an affection that seems to me a bit questionable. I've come to think he likes little girls, that that is his vice. I think the business with the young girl he had in to pose was one of his many dubious little schemes. I don't know why I'm writing about Laurent. I've been living on my own alongside him for so long now, and now he hardly ever comes home at night. I prefer that.

I'm modeling for a painter who teaches at the Ecole des Beaux-Arts, and this morning, during the sitting, three of his young pupils came to hand in their sketches for some competition. Two are young, cheerful, and pleasant. The third, who's older, I didn't much like. He looks like a heavy peasant, pig-headed and crude. As they

STUDENTS, LOVERS, HUSBANDS

seemed very interested in me, their teacher made fun of them and sent them out so that he could continue working without interruption. "Go and wait for her in the Luxembourg Gardens," he told them, laughing, "but leave us in peace now." (You can see the gardens from the window of the studio in the Rue d'Assas.) I didn't give them another thought, but when I left at the end of the sitting I found all three of them waiting for me there.* We walked through the Luxembourg together and they persuaded me not to go back to Montmartre for lunch as I had another job that afternoon in the same neighborhood. I had lunch with them in a little restaurant in the Rue Bonaparte, opposite the school on the corner of the Rue des Beaux-Arts, which is a meeting place for all the art students. It was fun and noisy—rather too noisy for my liking. My three new friends were overeager but well-mannered. I liked one of them a lot, and he was the one I listened to most. After lunch he took me right to the door of the building where I was going. I don't find him intimidating; he's almost as young as I am, very sweet and rather shy, though he tries to hide his inexperience behind an air of self-assurance, which doesn't fool me. He's fair-haired, tall, and has lovely soft blue eyes, which are artless and knowing at the same time. He could be a girl, and that's probably why I'm attracted to him. He talks in a pleasant, rather deliberate, way and doesn't dare make any move; he simply looks at me and then his eyes grow even softer. If he brushes my hand, he blushes, I don't know if from emotion or embarrassment. He has told me I'm not like the women he has known, he finds me intimidating and distant, but when he asked, "Would you like to see me again?" his eyes seemed to be imploring me and I melted. Is he going to be the one I fall in love with? I don't know anything about him yet.

I met him again at five outside the door and we went for a long walk in the Luxembourg Gardens. I had been thinking about him all afternoon. But I'd have preferred not to see him again today but just to go quietly back to Laurent's place, as I know he's away for two days. My sweetheart, whose name is Roland, was eager for me to have dinner with him, but I didn't accept. I left him at eight and got home late. I had my supper of bread and chocolate and went to bed so that I could think better. I don't know if I'm happy about this new friendship, but I'm happy to think someone is thinking of me at this moment—at least, I hope so. I'm tired of living like this. I'd like to have a regular life, to be married, have children and a husband I

* From references in *Picasso et ses amis* and from the addresses that are given later in the diary for the three students, it is clear that Fernande disguised the names of Raoul Dufy—Roland—and his friend Othon Friesz—Julien (Louis remains unidentified). They were pupils of Léon Bonnat, who taught at the Ecole des Beaux-Arts. Adolphe Basler later surprised Paul Léautaud with the information that Fernande "had been the mistress of Dufy before Picasso" (Léautaud. *Journal littéraire*, vol. 9, Paris, 1960, p. 65). In André Salmon's memoirs there is a reference to a "sister" of Fernande's, named Antoinette, who was Friesz's girlfriend, but it is impossible to tell if she is one of the characters mentioned in the journal.

could trust and respect, who'd protect me from other men, from myself, from life with all its snares. I'd like to be like other women, to love love for its own sake, and not for the illusions it offers. I know I'm thinking like this now, but in a moment I'll have forgotten these serious thoughts and all I'll want will be to live, to live life however it turns out.

Saturday

It's already a week since I met Roland and we see each other every day. Tomorrow I've promised to go and spend the day in the country with him. He doesn't have much money, so we'll take the boat as far as Saint-Cloud and bring sandwiches and fruit. It's going to be fun. But he's very shy, and as I am too, we must look like a pair of silly children a lot of the time.

The day before yesterday I saw Jacques again. He came to the studio at five and waited for me to come home. Laurent had seen him a few days ago, and I don't know how he explained his disappearance. He'd brought me a huge bunch of roses, which was sweet. He remembered that roses are my very favorite flowers. I was surprised how little I felt, and that I even felt slightly bored being with him again. It was such a stupid thing I did. I couldn't tell his true feelings from his face, but his hands shook a little as they took mine. Usually he kisses the hands of women when he greets them, but today he didn't. He wouldn't have dinner with Laurent and me but said he'd come for lunch on Sunday—when, as it happens, I won't be there. I've told Laurent I'm posing all day for a miniaturist, who'll give me lunch. As this has happened before, he wasn't surprised, only upset on Jacques's account. I wonder why he's so intent on bringing me together with Jacques.

I'm too tired to go out in the evenings and I'm always on my own. I don't like going out alone but prefer to lie on the couch with a good book, or my thoughts. I think a lot about Roland these days, and I feel bored when he's not with me. Tomorrow we'll spend the whole day together. I'm going to meet him at eight at his place on the Rue Victor-Massé. In order to deceive Laurent, it's essential I leave at the usual time, as he thinks I'm working.

Monday

I didn't come back to the studio last night, and this morning, when I got in around eleven o'clock, I found Laurent looking pale and tragic, convinced I'd had an accident. What a scene when he saw me coming in as if I'd only just gone out of the door. He threw a fit of jealousy that was so ridiculous, given the way he has behaved towards me for some time now, that I was quite taken aback by it. "But what about you?" I asked him, "You do what you like, you only sleep here two or three nights in the week; can't I be free to do the same?" His reply was typical of a man: "It's not the same thing!"

"Why not?" I asked, astonished.

"Because I trust you, and I know you're intelligent enough to understand that a man, an artist, needs complete freedom. Besides, you know I sleep at Georges's place."

"That makes no difference. You can sleep where you like. I don't care if you take no interest in me and I don't care if you don't come back at night, whatever your reasons may be, but I have the same rights as you do, and I'm free to spend the night out when I want to."

"No, no, no, a woman no longer has that freedom once she has shared a man's bed."

And so it went on for what seemed an age to me. But I felt that, to his surprise, he was discovering something in me he'd never suspected before and that it made me more interesting to him as a woman. I don't know what he wants, but I'm certain he doesn't want to lose the little bit of material comfort I bring him.

When he asked me where I'd been, I told him it was none of his business, but, if he really wanted to know, I now, as of last night, had a lover, and that if he upset me I'd leave without any qualms and go and live with this lover. Then Laurent started crying. I really don't understand it.

I didn't have any work today and was able to calm myself down with my pleasant memories of yesterday and last night. I didn't go to the country, but spent the whole time in Roland's arms. When I arrived at his place (I've already been there once before) he was waiting for me in a state of great excitement. He was happy and neither of us felt so shy. His kisses felt very sweet and I found myself undressed and in his bed without being quite aware of what was happening. I was very quietly happy, his gentle caresses brought no disappointment, and if I felt no pleasure in the act of love, it didn't upset me, as I just wanted him to be happy, and his happiness made me glad. I'm pleased it went like that; clearly the only pleasure I'm going to get from this act is the happiness of my lover. We stayed in bed the whole day, and at night I slept close to him, trusting and at peace. If Laurent doesn't make too many problems, I'd like to be able to spend the night at Roland's whenever I want to. He asked me to go and live with him, but I don't like the idea. The familiarity of living together tends to spoil things, and unless I were really deeply in love I know my feelings wouldn't last.

Now Laurent is being tiresome. He wants to claim me again, just as if he'd never had me. He sleeps at the studio now and I'm the one not coming home for a day, sometimes two. Then there are fights, which I find exhausting. He wants to caress me and seems to think that this will make me stay with him, but nothing on earth would persuade me to allow him to touch me. We can be friends, but I like my new lover too much to be able to put up with Laurent coming too close.

Roland's getting jealous too, but he's so gentle, so tender, that I quickly reassure and comfort him. I like his caresses. He works hard, at school in the mornings and

in the afternoons at home in his little studio. I've met his friends again, and we often have dinner together. There's Julien, whom I like very much, and sometimes, despite my attachment to Roland, I have the feeling I ought to have chosen Julien; and there's Louis, the rustic one, who's a good fellow. They both live in studios in the same building in Rue Campagne-Première. They all want to paint my portrait, but I don't have the time to sit for them.

[?1903]

Laurent's a coward. He was threatening to follow me to find out who has enticed me away from him, which is the way he sees it. I said, "Well, you'd better be strong"—actually, Laurent, who's stocky and thickset, has terrific strength in his arms and hands—"you'll come across someone stronger than you are, who's tall and muscular too." This isn't true. Roland, though he's quite tall, is in fact slim with a light build, and I doubt he'd put up much of a fight. He isn't very, very—shall we say, bold. But my lie was enough to restrain Laurent's "belligerent and vengeful" instincts. What's funny is that when I told Roland what Laurent had been contemplating, I saw fear in his eyes. I don't really like that, but I know perfectly well that he's no hero. He's a tender, sweet lover and very much an artist, but he doesn't care for passion or excess of any kind. He's cautious, sensible, practical, steady, caring and accommodating and takes care to conceal what he's really thinking. During the month I've been his mistress I've learned to understand him quite well and I know beforehand what to expect from a day or a night spent with him. He's tremendously ambitious and only wants to "be successful." I'm sure he'll make it. At the same time, he loves me very much and will be unhappy when I leave him, which won't be long now, since this is—and I say it with some regret and bitterness—just one experience among those I've decided to try out in an attempt to discover the secret of love.

Besides, a few days ago I took another lover, a young painter called Jean, who's a fellow-student of Roland's. He's a very different character, very fiery, imaginative and passionate. I still feel the same cold indifference in response to that final act, although there's no fear or disgust, which is already something. I now sleep at Jean's place in the Luxembourg neighborhood, and I see less and less of Roland, who's miserable but not rebellious and goes to cry on the shoulders of all his friends. I feel sorry for him, I'm very fond of him, but I can't help it. And if I go back to see him, out of pity really, Jean gets furious, as I don't hide anything from him.

Laurent's been making scenes the whole time, and I'd really like to go and live with Jean. After all, I earn a good living, have my freedom and am independent financially. Jean's a fine tall fellow, with brown hair and blue eyes, but his teeth, although they're white, are irregular and uneven, and this spoils the shape of his mouth. He has a mocking look, teasing and sarcastic, but he's very sensitive and loving, and very sensual too. He finds it surprising that I'm voluptuous and frigid at

the same time. He talks of the beauty of the act of lovemaking as if it were one of the sacred things in nature, and he wants to awaken this sensation in me. But I feel certain I'll never understand it. He says he's sure I'm wrong and that he'll prove it to me. Anyway I like it when he embraces me, and I like his voice and what he has told me of his ambitions.

Jean talks to me about painting in a way no one's ever done before. He takes me to the Louvre and the Musée du Luxembourg and little by little I feel I'm beginning to appreciate things. He has interested me in Impressionism, which I understand and love more than anything, and he has introduced me to medieval painting, which I admire a great deal. My mind now has something to occupy it and is gradually opening up to art that I've never been able to approach before. I'm becoming inquiring, analytical, eager for beauty, enthusiastic. I don't spend so much time daydreaming and I've begun to draw and soon I want to start painting. At school, I drew a lot, but I rebelled instinctively against the rigid methods imposed by hopeless teachers. I was bored by anything trite, and nothing they tried to show me or make me understand affected me, whereas now I'm astonished and delighted. I'm proud, too, to feel that I'm on a superior intellectual plane. Life really does offer more than I could have believed. Before, I was so naive and arrogant I thought I loved and understood life, but it was only nature—though that is wonderful—that I loved. I was like a young animal, hungry, healthy and impetuous, but now I've also learned to think, to know why I like something, and that's marvelous. The world of the body and the world of the spirit are interdependent. But when will I really experience the world of love and affection? All these little "affairs" have nothing to do with love.

Roland has found out about me and Jean, who is a friend of his. He begged me to leave Jean and stay with him, but I can't.

Laurent, whom I haven't seen for ten days, although I haven't actually moved out of his studio, came into a restaurant where I was having dinner with Jean. He assumed a somber, mysterious and dramatic look and asked me to go and talk to him at the table where he was sitting. He asked me to come back to him, to reflect on what I was doing, telling me I was getting involved in a life that would do me no good. He told me how deeply he loved me, that his love would never alter, that he would never leave me, and he even offered to marry me one day. I'm not divorced, so this doesn't really mean anything, particularly as I'll never ask for a divorce, for fear of seeing my husband again. He said he wouldn't allow me to work so hard any longer, he'd been wrong to allow me to get so exhausted, and he was starting to earn a little money himself. Things would improve, we could be happy, he was to blame, and so on. No, I told him, I don't want to live with you, I get bored when I'm with you, and anyway, I can't make you happy. He became irritated when I broke off suddenly, saying I'd see him tomorrow.

I'd noticed that Jean was getting impatient, and I dreaded an argument between the two of them. I left the restaurant on my own, telling Jean not to come with me so as to avoid pushing Laurent too far, but that I'd wait for him at the café where we usually meet. It all went off all right, but this is so unsettling, so complicated.

I've seen Laurent and promised him I'd come and sleep at the studio, on condition that he leaves me alone. I sleep better at Laurent's than at Jean's place, where everything's uncomfortable and the building is so noisy it's impossible to get any rest. It wasn't easy to convince Jean, but eventually he grudgingly accepted it. I'd like to find a studio I could rent myself, which would be my own home, but I spend everything I earn and I'm not in the least bit practical. I can never keep money. I spend it, or I give some to girlfriends who don't have any, so by the next morning I haven't a sou.

When I say "girlfriends" I'm exaggerating, as I hardly ever see Léno any more and I don't have that many acquaintances. I don't like women much; they're always jealous and scheming, and I only realize it after I've been betrayed. I must look like an idiot. I never think badly of them—until there's no other explanation for their behavior, and then I'm shocked. I wish women weren't so perverse. I know I have serious faults: I'm indifferent towards them, intolerant, distant, brutally frank, and I don't flatter them, but I'm not treacherous or spiteful, and I'm not in the least interested in harming them. Anyway, most women make mischief for its own sake, just to be hurtful, either because it's their nature or out of jealousy.

Meanwhile, I've resumed my old life at Laurent's, and he seems happy to have me around. I'm seeing less of Jean, but I feel happier when we do get together.

This morning the one thing I dreaded more than anything else in the world happened: I ran into my husband. It actually happened at noon, after I'd come out of a painter's house on Boulevard Saint-Germain. I was waiting for a tram there when I found myself face to face with him. I was seized with a sort of panic, I trembled inside and for a moment I felt my heart stop beating. I thought my legs would give way under me, but I managed to put on a brave face. He looked at me sorrowfully with those wild eyes. He's quite changed: he's thin, pale and hollow-cheeked, and his clothes hang from his skeletal body, but his eyes still burn with that strange fire that becomes veiled and then shines even more brightly.

"It's you," he said, "I've been waiting so long to find you, and here you are at last!"

I didn't reply and he went on, "You're going to come back, aren't you? You have nothing to fear. I'm living in Paris, near the Parc Montsouris." His voice was soft and not angry.

Then I answered, "I'd really like to, but not right now. I'm on my way to work, I'm due there now. Would you like me to meet you tonight?"

"That's fine. Tonight. Promise me, won't you? Right here, at seven o'clock."

I agreed eagerly, squeezed his hand, jumped on to my tram, which just arrived,

and he'd disappeared far into the distance before I got over my amazement at his letting me escape like this. I was sure he wished he'd stopped me, as he had a perfect right to do this in any way he could. I suppose the shock must have paralyzed him momentarily, but I was burning and felt ill all day. I told Laurent about it, and he could hardly believe I'd managed to extricate myself from it so well.

I'll write to my painter to say I'm ill. I can't be seen in the Boulevard Saint-Germain for a while, because if I know Paul, he'll spend his time prowling around there.

Laurent has asked me to sit for a bust for the Salon, and I can't refuse, as I do owe him a lot. He has been making caricatures of prominent people in colored plaster, which have been quite successful and are earning him some money. He's doing his best to be less selfish and gives me presents. But it's too late. I don't even feel friendship for him any longer. Although we've lived together all these months, we've become so distanced from one another. I don't see Roland any more. I know he has a new girlfriend. Deep in my heart I feel a great tenderness towards him, and I'll always have fond memories of him.

I do a lot of modeling at Cormon's, where I see famous and powerful politicians. One of them, a *général-en-chef*, who comes to sit in a splendid outfit (a cavalry uniform, I thought after looking closely), makes eyes at me, and my dear "maître" calls me a "little fool" because I'm not interested in money. Cormon, who should know what he's talking about with all his experience of life, advises me: "With money you'd have everything, but without it's a dog's life. It's a woman's duty, to herself and to others, to make the most of her beauty and her youth." But I don't know how women can sell themselves for money.

Yesterday the general came in civilian clothes. He left at the same time as I did and invited me to have an ice cream with him in the Bois. I turned down the invitation on the pretext of having another appointment. He left rather disgruntled, and today he had flowers and chocolates sent to Cormon's studio. I'm quite happy to accept these, but that's all. He's no older than Jacques and he's better looking, but I'd still never allow those old lips to touch me. I don't know what fit of madness drove me to Jacques. Perhaps it was boredom.

Something unpleasant has happened: Jean's cheating on me. I was warned about it by a woman, though she certainly didn't tell me out of kindness. She wanted to be hurtful. It does hurt, and since yesterday I've felt a pain in my heart that's worse than I'd ever imagined. At lunchtime I went over to the street he walks down to go to lunch with his parents, who run a large picture gallery. He wasn't on his guard, as I never go to meet him at this hour, and I saw him coming in the distance with this woman close beside him. I felt like running away, but I saw him draw slightly away from her and realized he'd seen me. So I straightened up and

passed right by him without appearing to notice he was stopping and continued on my way without turning round. He came up behind me and took my arm to hold me back, but I shook him off roughly and started to run towards his parents' home. He was scared they'd see what he was doing and let me go. I don't know how he explained this to the other woman, but I don't want to see him again. Why does he lie? What use are his declarations and his caresses, if he gives them to other women?

I'm miserable and I've been crying. I'm never going to see him again. Laurent found me in tears when he came in. I let him comfort me and I enjoyed his caresses. I told him the story, but when I detected a gleam of triumph in his eyes, I regretted having said anything, especially as I find it tiresome having him around now. I even feel a little disgusted with myself.

I've just received a *pneumatique** from Jean begging me to meet him. He can explain everything, but it's all my fault. He wasn't seeing enough of me any more and I ought to live with him. Going out with a woman doesn't mean anything, and there's nothing between them, and so on and on. But I don't believe him and I'm not going to reply. I never lied to him. I stopped seeing Roland, even as a friend, just so that he wouldn't be unhappy, and I told him all about Laurent, and he knows what sort of relationship we have. I don't know why he's doing this to me, when I was beginning to love him so much. I won't reply. Luckily, he doesn't know where I'm modeling at the moment, and he won't be able to find me tomorrow.

Laurent wanted to sleep with me, but I told him he was annoying me. He nearly lost his temper, but held himself in check. If only he realized how well I know him, how I can read his real feelings when he's comforting me. He's triumphant, he sees a way he may be able to keep me with him. He's going to give me a lecture and, without putting it in so many words, he'll reproach me for not understanding him or appreciating his qualities, which he thinks are so wonderful. To hell with him, with me, with everything. I'm miserable, so miserable—. That's all I can say.

This morning I felt so fed up with everything that I decided not to go to work and sent two *pneumatiques* excusing myself to the two artists who were expecting me. Presently, one of them came to see what was wrong. I was alone in the studio, where he has never been before, and he found me lying on the couch with my eyes all red. He looked at me humorously and spoke like a typical artist: "It's not that bad, my dear. It must be your heart that's bruised. Working is the best way to forget. Come on, you come with me and I'll tell you some stories about the studio, like the one

* Up until the mid-twentieth century, the Paris post offices operated a system of air-pressured underground tubes, through which metal cartridges containing express letters written on lightweight blue paper were sent from one office to another. The letters were then delivered locally by messenger boys.

when my pupils balanced a saucepan of water on top of a door to trick one of their pals and it landed instead right on my head."

I couldn't help laughing at the thought of his thin faunlike face soaking and dripping with water, that little goatee—He took me for tea and cakes at Wepler's and for an hour or two I almost forgot my misery, but when I came home again it became even more intense. Laurent came back to dress for a dinner party at his parents' house.

At about eight o'clock there was a knock at the door, and when I opened it there was Jean, all wet, as it was pouring with rain. I couldn't stop him coming in, especially as his face was drawn, tight, furious, ready for anything—as I used to tell him laughingly whenever he got angry. He started by trying to explain, to say something—which I didn't understand at all—about his relationship with this woman. I shrugged my shoulders, telling him that all I wanted was for him to leave me alone.

"But that's just what I can't make up my mind to do. So I've come to take you back."

"Oh no. You're going to leave on your own."

He lost his temper, demanding that I get dressed and go with him, as he wouldn't leave without me.

"All right, then you can sleep there," I said to him.

He flew into a rage and attacked the bust of me Laurent has started, and, grabbing a pair of the big wooden calipers sculptors use to measure their proportions, he struck so furiously at my poor face that he gashed great furrows in it. I was appalled. What would Laurent say? But I felt even more terrified when Jean rushed towards me brandishing the same weapon, which is quite dangerous as the arms are tipped with steel points. I thought he wanted to hit me with it and let out a scream. Then he made as if to hit himself and that changed everything. I've always had a sense of the ridiculous, and he looked so grotesque wielding this improvised weapon, which reminded me of the wobbly legs of a toddler who has been made to walk too early, that the rusty points no longer looked threatening and I was overcome with insane laughter. This had the effect on him of a cold shower and he threw down the calipers and sat down in an armchair with the shamefaced look of a child caught doing something silly. Then he looked at me.

I wasn't laughing any more, but my eyes were full of tears. I don't know if they came from my laughter or my distress. Now he begged me to forgive him and kissed me, holding me tenderly against him. I let him do this, lulled by his promises, the sincerity in his voice and his soft eyes. "What am I going to say to Laurent when he sees what you've done to his work?" I asked. But it wasn't as bad as it looked. The bust was barely sketched and Jean set to work and made it look as it had before, and I wrapped it in damp cloths, as I knew how to do. Then, if Laurent noticed anything unusual, I could say I'd pressed the cloth too tightly against the soft clay. But I wouldn't agree to go with Jean, and after we'd made up and exchanged all kinds of

promises, he left. I'm supposed to go and see him tomorrow and spend the night with him. Laurent won't be expecting that.

In spite of everything, I think something has changed now in my feelings about Jean. Luckily the scene he made had no serious consequences. I don't think Laurent noticed anything and he just went back to work.

I went back to Jean's, but it's no longer so enjoyable. He explained all about his affair, which I didn't ask him to do, and he told me it's my frigidity that's the problem. I've noticed from time to time that what he's looking for in a woman is a kind of sensuality, which he doesn't find in me. Good luck to him! I don't even want to know what he means by sensuality. But how sexually complicated men are!

I'm gradually weaning myself from Jean. I find Laurent more irritating every day. I don't know what I should do.

I've neither seen Jean nor heard anything of him for several days. He must be coming to terms with our separation. I'm not heartbroken, but I do feel wounded, and it's an unpleasant feeling. Although I understand it, I can't really accept it. Laurent's slowly getting on with the bust—slowly, very slowly, in the words of the song. Can he really be human? Anyhow, I always fall asleep after posing for ten minutes.

Jacques comes over frequently. He brings me books, especially poetry, and flowers, the white roses he knows I love. He's so nice, I really feel sorry for him. I can tell he hasn't forgotten my "mistake," but there's nothing I can do for him. He's understanding and well behaved, but I don't dare stay alone with him. I'm afraid he'd talk of his suffering, which I know is genuine. I can't do anything, but I really don't mean any harm.

Yesterday he had a talk with Laurent. He told him he was in love with a woman who is too young for him and doesn't love him. He seemed to need to unburden himself and Laurent reacted strangely, either from anxiety or embarassment. Does he suspect I'm at the center of it all? Well, I couldn't care less about any of it.

[?1904]

There's been no further sign of my husband, and I've started modeling on the Left Bank again, which I'd stopped after we ran into each other. But I feel even more frightened and can't control a sense of panic at the thought of him. He seemed so weird that time. I've really had to pluck up my courage to go back to the neighborhood where he saw me.

But coming home I always walk through the Luxembourg Gardens, where I often meet artist friends. We chatter away in the shade of the trees while the sun beats down on the terraces. Several of them are in love with me, but I don't care for most of them and I don't want to carry "my experiences" too far, because every time

I have I've been disappointed. I often eat dinner with some of them, in a group or just with a friend, and I go back to Montmartre on foot. I love walking in the evening through the dark, empty streets of Paris; someone always comes with me, and that makes it seem like a lovers' walk. Sometimes I feel something stirring in my heart, but as soon as I try and catch hold of this hint of love, it vanishes, "craftily" I always think.

I've started painting. I seem to have an eye for color, but I don't have the patience to draw well. I only enjoy putting in shading and bright colors. I'd work harder if I had more time. I wonder if I ought to continue my boring career as a model. It's so monotonous and idiotic most of the time, and it's tiring too. But what else could I do to earn as much? It's not that I want a lot of fashionable clothes—or at least I only want certain things. I like white collars, lace at my throat, hats, handkerchiefs and underwear. I adore perfume and I stick to rose or sandalwood. I'd really like to buy every perfume that appeals to me, but they're too expensive. As for my clothes, I like dark suits and brightly colored blouses. Oh, yes, and veils. I'm crazy about veils. I have quite a collection of them, and I wear them halfway down my face to my nose. They lend mystery to my eyes, which aren't big, beautiful and wide but are elongated slits shaped like almonds which slant towards my temples. This way I think I look more glamourous, or at least I make more of an impression, because I'm not really beautiful. I'm a bit too tall, and a bit too heavy (at least, I think so), but my face is young and fresh, though only my mouth, forehead and coloring are really striking, and I have luxuriant hair, the color of very ripe chestnuts, with big natural waves which make all the women around me jealous.

Why am I writing about myself? Oh, yes, because of the veils. But enough of that.

I haven't seen Léno for some time, but yesterday I had a note from her asking me to meet her urgently in the evening in the little café on the Place Péreire that's decorated all in white. On my way there I wondered why she needed to see me so badly, as we're so unlike each other. I'm rather shy and Léno always intimidates me slightly: she's very dictatorial and so self-assured she probably thinks she has more influence on me than she really has. But she's warm-hearted, generous and openhanded, while I'm accommodating and nice to her (which I find easier than being difficult and uncooperative), so we understand each other pretty well and I'm always willing to help her, and I'm sure she'd do the same for me. But otherwise we can go for months without seeing each other if there's no special need. I don't often see Geo, although Laurent is with him the whole time—but always at Geo's apartment. I only meet him on his rare visits to the studio. I guessed things were still pretty mixed up between Geo and Léno and she wanted to talk to me about it, and that's why I agreed to meet her. The café she'd suggested for the meeting was where the four of us all used to get together some time ago.

She seemed changed. She'd lost weight, her cheeks were hollow, there was a defeated expression in her eyes and she looked bewildered and exhausted, which wasn't like her at all. She greeted me the same way as ever, without much ceremony, and looked at me carefully for a moment with those faded blue eyes, squinting through her eyelashes so as to see better.

"What is it?" I asked, "you look exhausted. You were always so cheerful."

"I'm getting married, that's what," Léno said.

I assumed she meant to Geo. "Well, now you'll be happy. You've wanted this for ages."

"It's not Geo, but Joseph Jacob."

I looked at her in astonishment. Joseph Jacob, whom she'd told me about several times, was a friend of her father's, an agent for some sort of business.

"Why Joseph Jacob?"

"Oh, why, why!" she cried "because Geo hasn't a sou, because he needs money, because he doesn't want to marry me if my father keeps refusing to give me a dowry, because I don't want to lose him and so I have to find a solution which will let me get my hands on the dowry. And I can't bear the thought of living the way you do, with no money, no clothes, working the whole time to lead what seems to me such a miserable life."

I was shocked. She may think my life is miserable, but nothing on earth would make me want to exchange it for hers. She could see I didn't know what to say, so she went on: "I'm sorry. I'm being harsh, and the state I'm in makes me exaggerate. But I don't share your unconcern for material things, and it irritates me that you seem to be happy enough with what you've got. You seem to have no feelings or pride, and practically no desires."

I responded. "How can you believe that? I have intense inner feelings and desires, but I also think it would be pointless to tempt fate, so I resign myself to waiting. I'm young, and even if things at the moment are unsatisfactory I have the whole of my life in front of me, and at least I don't do anything I find degrading."

"You'll never understand someone like me, but don't let's argue. It's just that I can't help being envious of that air of serenity you seem to have. I'm sorry, you see I'm talking about you without knowing you. I've never met a woman more secretive than you when it comes to your innermost feelings."

"But I don't hide anything. I behave just the way I think I am."

"I know you believe that, but you're wrong, I once saw you angry, and your eyes surprised me."

I was amazed Léno was so observant. I had always imagined I didn't count for anything in her eyes, and what she said meant she must have been watching me far more closely than I'd thought.

"Anyway, that's got nothing to do with the business that made you write to me. Tell me more about this baffling marriage."

So she began to tell me (as I already knew) that her father had been persuaded by her mother to refuse to give her a dowry if she flouted his authority and married Georges. This was her mother's revenge on her for stealing her young lover. As this Jacob keeps asking her to marry him and has been pursuing her like the old faun he looks like, she has finally pretended to accept him. He knows all about her love—it would probably be more accurate to say her frenzy—for Georges, but he doesn't think it matters. He is sure that he'll know how to hold on to her once she's his wife.

Then she admitted she and Georges had dreamed up this wedding. Jacob needs a considerable sum of money to expand his business, and Léno's father has promised to give the dowry money to his daughter as soon as the ceremony's over. During the wedding lunch, as soon as she has got her hands on the money, she's going to slip away just when she's supposed to be leaving for her honeymoon, to meet Georges, who'll be waiting for her in a cab.

I find it rather odd that a father would hand over a large sum of money to a daughter who has reluctantly agreed to get married against the dictates of her heart. Well, it's possible…but it's quite obvious she's in such a state of anxiety waiting for the ceremony, which is due to take place next week, that it's making her sick.

Poor Léno, being the victim of a neurotic like Georges, whom I suspect of sexual perversion. She's extremely sensual, but she's also the victim of a form of hereditary hysteria that all three daughters in that crazy family get from their nutty old mother. She told me that Georges, conspiring with Laurent, had been the first to think she should marry the fellow—a white wedding, naturally. She'll ask for a divorce immediately afterwards, on any grounds that will entitle her to it: non-consummation, physical revulsion, whatever.

Maybe she and Georges are right to trust Laurent, but I, usually the most trusting person in the world, would be on my guard. Maybe I'm wrong to be mistrustful, but I can't help it. I think I'm quite familiar with the dark and murky depths of Laurent's nature—but I kept my thoughts to myself. I still think she'd have done better to find some other way out. I'm not surprised about Georges: this is like all the other shady schemes of his I've found out about, without wanting to at all. Georges seems to me to be a kind of smalltime adventurer, completely unscrupulous but too scared to undertake any plan on a really large scale. He's not in love with Léno, any more than he was with her mother—no, nor with Manon, her elder sister, nor will he be with Simone, the youngest, who's only fifteen, but whom he's closing in on right under Léno's eyes. She's furious but makes no protest because she'd allow him to do anything so long as she doesn't lose him. What a strange world!

When I left Léno, I promised her I'd join Laurent and Georges to wait for her after the lunch, which will be held in a famous pâtisserie on the Rue de Rivoli following the ceremony at the Jewish Temple.

I came back to the studio feeling irritated with myself, furious that I hadn't given Léno the answer she deserved. Even if I do have a miserable life and know it myself, it's not in the way she imagines. This evening I'm thinking about all this. Yes, I am to be pitied, but only because I lead such a passive existence. It doesn't matter that for all the work I do I earn barely enough to live on, but I wish I could understand why I'm overwhelmed by these great waves of feeling—of joy, of sadness, of love, of disgust. I don't seem to know how to make the most of what I've been given. I'm surrounded by people who are obsessed with ugly things, by conceited idiots who feed on each other's admiration, by egoists living like animals, by arrogant, envious, ambitious people. The intellectuals I see never suspect I might be a thoughtful, intelligent, analytical, rational being, but just see me as a beautiful, spirited, healthy animal. This annoys me and irritates me so much, but what am I to do?

I don't understand myself or anyone else. I respond spontaneously and don't understand my motivations. I don't understand, but there it is. I don't understand life, or other people, or myself. I breathe, I look, I feel, but that isn't enough for me. I read, I try to understand, I'm sensitive, but isn't this all the wrong way round? When will I grow up? I remember my uncle talking to my aunt about me and saying, to try and reassure her, "she'll grow up and that'll knock some sense into her head. There's no need to be alarmed about her future. She ought to be impulsive and spontaneous for as long as she can, and we must hope that her image of life won't become tarnished." Tonight I feel as if a great deal has been tarnished, starting with my image of myself. Too bad. I'm going to bed, to read a bit and sleep. Tomorrow I've got to be at a painter's house in the Rue de Courcelles at nine o'clock.

[spring 1904]
Laurent hasn't been back for the past three days. I don't know what he's up to. He sent me a *pneumatique* to say that his stepmother is ill, but actually I think he's with Georges. We had an argument before he left. He wanted to sleep with me and I refused. But I need to be caressed, so I'll go to Jean, though I'm not in love with him any more and I can't stand the idea of "sharing." Even so, I like to see him occasionally. If I could be sure Laurent wouldn't come back, I'd have him over to sleep here, but I'm terrified of Laurent returning at the wrong moment. It would be amusing to have Jean sleep in the bed I don't allow Laurent into any more. That's a mean, contemptible idea, but Laurent gets on my nerves so much that I feel I need to get my own back by making him appear ridiculous. He's so pleased with himself, so self-assured that unless I can find a way to leave him I'm going to be ashamed of everything I do or think that involves him.

Why am I a woman? It's so much easier to feel at peace with oneself as a man. Still, if I were like Léno it would all be quite easy. She doesn't think, she feels; and from the moment she feels, desire takes over. She once told me that nothing can stop her once she feels a strong desire for something. She'd do anything, anything at all, with no

shame, no regret, no fear of guilt: "If I want money, I look for it and take it where I can find it and do whatever I have to do to get it. If I want a man, I'll offer myself to him and throw myself at him, with all my clothes off if necessary. If I'm jealous of another woman, I'll do whatever it takes to find ways to harm her—it's all instinctive. If I'm hungry, I eat. If I'm tired, I sleep. If I want love, I give myself and take it. If someone upsets me, I want to get rid of them, and if there weren't laws and police I'd kill them in cold blood." And Léno's ice-cold eyes showed she meant what she said.

But I'm always questioning myself. I run away from emotion, I grope my way, I hesitate, I go forward and then fall back again—but that doesn't stop me making mistakes and doing idiotic things, far from it. After going through all this performance I plunge, head first, eyes shut, mind closed, into the most dreadful affairs. I suppose I'm exaggerating again.

I'm going to sleep. Tonight I like the feeling of being on my own, knowing Laurent won't be coming back, although I'm pining for a kindred spirit—How trivial it is, loving solitude but crying because I'm alone. Bed, sleep and night are precious things. I sleep on my right side, all curled up at first, then I stretch out little by little until I get drowsy and can embark on my fantasies. I start with a thought—if only this or that, I—and so on. As a new life begins for me, sleep overcomes me and all the sorrows, anxieties, hesitations, regrets and desires dissolve in a sense of physical well-being, which is perhaps my only happiness. But this isn't ideal. The ideal would be to be capable of doing wonderful things, not just carrying on a physical existence. Maybe love would make this possible, exclusive, devoted love—but no, that isn't the solution either. I should be guided only by my intellect, but even my intellect is treacherous, for I find myself saying, "What's the point? I'll never attain my ideal."

I'd like to be an artist myself, independent, a bit of a tomboy, like a few I've met. But I'm ruled too much by my heart, and my need to love and be loved soon overrides all my ambition to live by my mind alone. I'm so feeble, I don't deserve to be happy. I never persevere with anything, but always wriggle out of it. I'm disgusted with myself.

Several more days have passed and Laurent hasn't been back for a week. Jacques came to find me, but no one was in and he left a note. He's coming back this evening. I don't like being on my own with him. He has a hangdog look. I think he was deeply affected by the rotten trick I played on him. It was an awful thing to do, and I feel bad about it, although I don't like to admit it. Never mind—Tomorrow is Léno's wedding day. We have to meet at five: Georges, Laurent and I will be in the car waiting for her. What a strange business.

There's a Spanish painter who has just come to live in our building and seems very taken with me. Should I go back to his place? I'm not too sure about the idea.

Jacques never returned, in spite of his note.

Today began stormily. Laurent finally came back yesterday evening. Why hadn't I gone to bed yet? I was in trouble for having let the dirty dishes pile up and for not having done any housework. I told him to forget it. "I work till six in the evening and come home dead beat from having had to stand up to model all day, and that's enough. In any case I wouldn't dream of having anything to do with the housework. If the cleaning woman's sick, it's up to you to arrange something. As long as I have clean sheets I don't care about anything else."

Léno's wedding was a complete farce. She never saw the dowry, but that was only to be expected. We waited from 4:45 P.M. in the cab like conspirators, all three of us squeezed into the back, and she was supposed to be there around five after changing out of her white dress (she'd wanted to have a proper wedding outfit, except for the orange-blossoms, which were replaced with white roses). We could see from her downcast expression that everything had gone wrong. Her father, who's a shrewd Jew, had anticipated everything and handed over the money to his son-in-law, so it was a penniless Mme. Jacob who collapsed on Georges's breast. Georges put a brave face on things and did his best to comfort her. We drove around the Bois and then had dinner at the Brasserie Universelle. Georges persuaded Léno to go to join her husband that night—not alone, but taking me with her to demonstrate her independence. That's when the farce started.

At around 11:30 P.M. she and I reached her brand new apartment off the Place Péreire. It's on the ground floor. We got out of the cab and ran straight into the family, who were gathered at the front door. We had to walk right through the middle of them and nobody, not even the bridegroom, made a move to stop us or speak to us. We went into the sitting room, where there was a large sofa, and locked ourselves in. Everyone must have left quickly, as the faint murmuring we heard through the closed shutters soon gave way to the sound of receding footsteps, the door being locked, and silence.

There was a thud against the door to the sitting room. The bridegroom wanted to come in, but the locked door prevented him. In his German Jewish voice he said:

"Vill you open ze door, Hélène! I vant to speek viz you."

Not a word from us.

"Open up! You heff no rright to keep me out!"

Silence!

"Vill you giff me an answer?"

An ever more determined silence. A thump on the door.

"You vant I make a scantal?"

"Go ahead," Léno shouted, "and leave me in peace."

He went away and puttered around in the neighboring rooms. Fortunately the room has only the one door, and we pushed the heavy sofa against it. Léno said

coolly: "Don't worry. If he bothers me too much or kicks up a fuss we'll get out through the window."

Half an hour later he came back. His accent's so strong I could hardly understand him, but he demanded to talk things over with his wife and insisted that at least she send "that voman"—me—away. He wouldn't put up with this shameful licentiousness (as he called it), and knew exactly what was going on between us (the idiot). If she didn't answer him he'd summon the "serchants te file," the police.

At that, we burst out laughing and Léno replied, "Go ahead. You can open the champagne that's cooling in the ice bucket and drink to my health with them."

Then he got really furious. He began to bang on the door and tried to force it open. Léno signaled to me to be ready by the window to open the shutters if the door looked like giving way, but M. Jacob, who's only a tiny little man with glasses, a goatee, thinning hair and narrow shoulders, could do no more than shake the door, which, as I've said was blocked by the heavy (Directoire) day-bed. In the end, when he wouldn't stop his shouting, a mixture of entreaty and invective, Léno got irritated and shouted coldly that if he went on like that, she'd fire her revolver through the door.

Poor little M. Jacob, even though he's head over heels in love, is a coward, so he gave up his attempt and we heard him retreat into his beautiful new Louis XVI bedroom. We lay down without undressing, having made up our minds to leave through the window in the morning, as Léno decided she couldn't stay any longer. "You can be a witness to the non-consummation of my marriage," she said, "as I'm going to ask for an immediate divorce."

After one or two more little alarms in the night, we ran off at six in the morning, and I went with her to rent a room in a boardinghouse on the Avenue de Villiers.

I've written all this back in the studio. Léno and Georges came to lunch, Laurent cooked his usual broccoli soup and this was followed by shellfish, cutlets, spaghetti, fruit and cakes that Georges had brought along with some champagne. They all like dry champagne and I prefer it sweeter, so I didn't drink any. Léno has been to see a lawyer friend of hers who'll handle the divorce, but if she wants to get it she'll have to stop seeing Georges for a while, because of the grounds she's citing. She's happy to be free.

I find the whole business slightly sickening, and it has also quite exhausted me. What deceit, what a mess, how boring it all is.

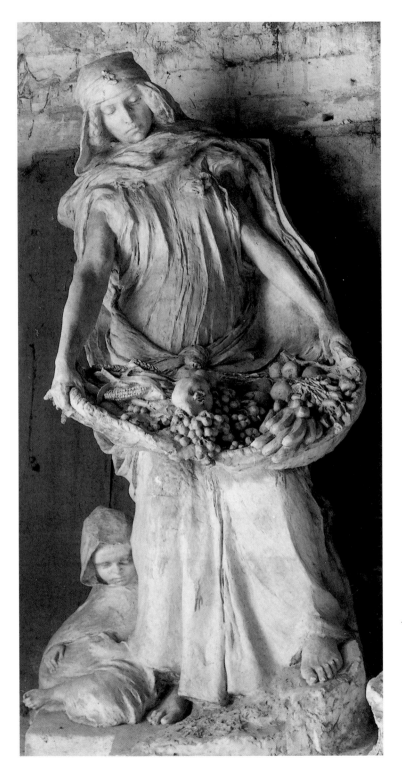

Algerian woman with a basket of fruits, the central figure, modeled by Fernande in 1905, for François Sicard's monument to Jérôme Bertagna for the port of Bône (Annaba) in Algeria. Tours, Musée des Beaux-Arts.

ARTIST'S MODEL

Fernande's Memoir, Part 1: 1900–1907

For five years I worked as a artist's model, starting in 1900, when I was just nineteen. Looking back to that time, I have many memories. Since academic painting was still the dominant style, modeling was extremely arduous. I will never forget struggling against an overpowering desire to fall asleep, which was largely the result of having to stay absolutely motionless, for fear of disturbing the line of a movement or a fold—the beautiful heavy fold of a dress, stiff or supple, the fold of a shawl or a handkerchief, the curl of a lock of hair—the fixed details all those *pompiers* loved so much, the very antithesis of natural compositions.

Their art had very little to do with the revelation of their subject. There was no "literary" invention, and not a single brushstroke was ever inspired by imagination. The eye was law. Accurate, exact copying was the thing, which was very exhausting for the live model. That was what they meant by following nature. They did not seem to understand that the essence of painting is to deceive the eye, that it is a convention formed by skill—a knack—so that personality is really the only thing that counts in art.

I could never understand the angry reaction of some of those painters to the works of artists who saw things differently. For them, there was only their own school, their way of copying nature, their way of rendering what they saw, or believed they saw. Each one had his own version of truth.

Even so, I admired many of these academic painters then, although I did not much care for their work. I have always been attracted by things that surprise me, and there was nothing much surprising in the work of the artists I worked for: Cormon, Axilette, Bordes, Carolus Duran, Edouard Sain, Henner, Boldini, Rochegrosse, Roll, MacEwen, Deyrolles, Dubuffe, the lithographers Chahine and Janniot, the sculptors Carlier and Sicard, and some engravers who were members of the Académie.

Henner was the oldest of these, and I got to know him only a few months before he died. He began a sketch of me and I was astonished to see him copy my features very

carefully, although I would not have recognized myself once the picture was further advanced. You sensed a power in Henner, an authority and distinction, but also something obstinate, a stubborn inflexibility, which was a sign of his implacable character. He had followed his own course, from which he never allowed himself to be deflected, and although he was not blind to commercial considerations, Henner's art was uncompromising and he practiced it with complete dedication. He seemed to be guided by his conscience alone. The painter Benner, a fellow-Alsatian, who had known Henner since childhood and remained his close friend, told me that Henner's ambition—or rather his quixotic wish—was to purchase the largest possible area of land in his native Alsace, where he refused to acknowledge the German rule that had been in force since the war of 1870.

Henner lived in a building on the Place Pigalle, between Rue Frochot and Rue Pigalle and his studio was on the same landing as that of Puvis de Chavannes, which was occupied at that time by the English, or rather typically Scottish, painter MacEwen, for whom I often modeled.

MacEwen was tall and fairhaired with a ruddy complexion, but he was also tough, cold and methodical. He preferred to paint small genre pictures, particularly interior scenes in the Dutch, or rather, Flemish, manner. But, God! how I suffered during those sittings, as he used to forget, when he had placed me in the most awkward poses, that I was flesh and blood and not a "robot." He would watch me attentively for hours at a time, as I sat dressed up in my costume, dreamily, in front of a window with curtains slightly drawn to simulate soft, filtered Nordic light. At other times, still dressed as a peasant or a Flemish housewife with a coif and apron, I would remain seated at a table, apparently lost in a reverie, quite forgetting I was peeling vegetables that were to be placed in the large copper basin at my feet, a corkscrew of peel dangling from the knife. All this was rendered on the canvas in minute detail. MacEwen must have loved his women to have a dreamy look on their faces, whoever they were, wherever they came from and whatever pose they adopted, although there was nothing of the dreamer in his own personality. Apart from the Flemish school, MacEwen admired Wissthler [sic], who I believe had been his friend.

I used to model for Bordes, because the society women whose portraits he painted did not have the time or could not be bothered to pose regularly. When they were there, the painter worked on their faces, their shoulders and their bare arms, and I supplied the rest, putting on sumptuous outfits, mostly evening dresses, which suited me very well, although they had not been made for me. The current fashion was for high-waisted dresses in velvet or shimmering silks. I often posed in them, dressed to the nines, as a stand-in for Mme So-and-So or Mme Such-and-Such. My shoulders also sometimes substituted for shoulders that could not cope with the

chore of posing, and I would wear beautiful dresses with trains you had to pick up and let fall in gentle folds at your feet, so long you could not see the end of them.

Bordes looked like a typical, French gentleman, and nothing in his appearance suggested an artist. He was conscientious and able, as he would have been in any other career—banker, or chocolate maker, or just like M. Duval the soup manufacturer, though by this time M. Duval had adopted a personal style which perhaps would not have suited Bordes. He was in rather bad physical condition, and some time later I saw in the newspaper that he had died.

I also used to pose in an academy for young society girls, where the director and instructor was the painter Edouard Sain, who appeared to me to be extremely old. But he was a spry little man, quite charmless, who always used to wear a round cap of black velvet on his snowy white hair, which gave him the look of a parish clerk. He was courteous and unruffled, but his gentle manner masked an air of authority which, although he hardly ever had to call on it, lent him respect as a teacher. He admired me as a model for my long, heavy, wavy, chestnut hair and for my clear skin. I usually modeled for his class, but once I sat for him himself.

How dreary Sain's paintings are. They have so much technical skill, but with that ingratiating, sugary technique that seemed to be popular in those days, when the "modernism" of Mucha was all the rage and Art Nouveau was beginning to take off. For the young ladies learning to paint at Edouard Sain's, one posed only head and shoulders, with bare arms and sprigs of flowers in one's hair over the ears, always in "Mucha" style. How short-lived this style was!

It was at Sain's that I met his friend Carolus Duran, who came to correct the young ladies' work. Despite his age, he was really impressive. He was tall, upright, and handsome and still seemed youthful and seductively charming. He would lean over one of the pupils supporting himself on one hand, legs braced, head high, and with moist lips and a wise expression suggest a correction to her, or he would sit down opposite her to hold her attention more fully. I think many of the young pupils in this fashionable studio were, or thought they were, in love with their respected master. They followed him around with enraptured eyes, listened to him with such eagerness and delight. His halo of glory served him well, as he had already passed a certain age. He also looked very romantic, with beautiful silver hair that he wore in long waves, and he was always dressed in pale grey. The hearts of his young pupils beat in unison the day Carolus Duran came to to do the correction. He was a new "Sun King" as he entered the bright and spacious studio on Rue Rochefoucauld. He was fortunate enough to die while he was still so handsome. I do not know if he would have had the courage to accept physical decline, despite his celebrity.

The artist I modeled for most regularly was Fernand Cormon, and I was one of his favorite models. He was just like an elderly art student, in spirit if not in his

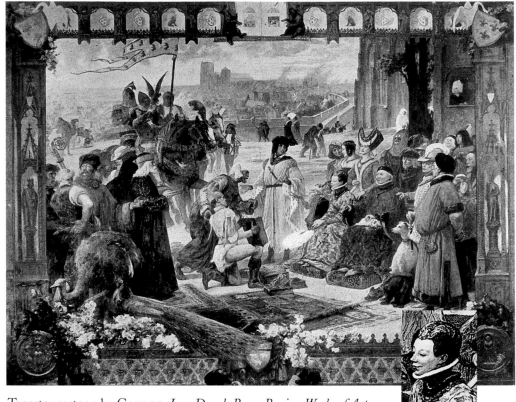

Tapestry cartoon by Cormon, *Jean Duc de Berry Buying Works of Art*, exhibited at the 1906 Salon, with (inset) the head of the Duchess for which Fernande modeled.

appearance. He was of medium height, dry as a vinestock, with a small head, and his narrow face was set off by a graying goatee—like a mask of a faun, but with good-humored, mischievous eyes. He was charming, easy, witty and kind, and quite open-minded. He was wonderful to work for, never difficult or too demanding. He was so good-natured and understanding that he would always break off if ever a pose became the least bit tiring.

He used to climb his ladder, positioned in front of an enormous canvas, as he was preparing huge cartoons for tapestries commissioned by the national workshops. He worked from mock-ups, using models only for the flesh tones and effects of light.

I never heard him speak ill of the young painters who were following in the wake of the Impressionists or who gathered around Picasso. He just said: "They'll come back. You can't distance yourself from nature; that's a law every true artist has to obey." However, he seemed curious about their ideas. He used to ask me, "What are your heroes of the future doing at the moment, then?" and I would answer him with my own impressions or with ideas I had picked up here and there. I would find

ARTIST'S MODEL

arguments to defend and justify them, and he would listen seriously to this twenty-year-old girl who idolized everything that seemed to be new, rejected the familiar and looked towards the future. Of course, he remained rooted in the past. After all, he was over sixty and a professor at the Ecole des Beaux-Arts, and he had to defend his teaching. But he used to end our conversations saying, "It's wonderful to be young."

At that time he was painting a portrait of President Loubet at the Elysée Palace, and General André used to come and sit for him at his studio in the Rue de Rome. He had beautiful hangings and lovely old furniture in his studio, which was always polished and tidy and seemed to me to represent the height of luxury. He did not like doing official portraits, which he called his "forced labor." He relaxed by painting little genre pictures for himself in his apartment on the Boulevard des Batignolles. He was so concerned about truth to life that when he used me as a model he set my looks against those of his wife, who was dark. I remember the contrast of dark bare shoulders and bare shoulders which were almost tawny when I posed next to Mme Cormon.

Despite their age this delightful couple still reminded me of a bohemian art student with his milliner girlfriend. What a long time ago this was.

Cormon gave me practical advice, which I never followed: "Marry a young man who's rich. Think of your future. Don't let yourself get sucked into this Bohemia." He had forgotten that when he was very young he had married a girl who worked for a milliner's who had nothing except what she earned with her own hands. He had known all the problems there are when you start out and how many disappointments have to be overcome. He tried to warn me.

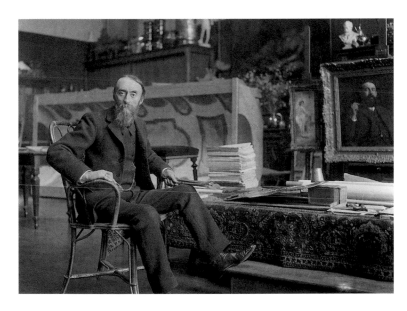

Fernand Cormon
in his Paris studio.

One day Cormon said to me, "My dear, I'd like you to do me a favor. However unpleasant this may appear to be, you're going to have to model for one of my pupils who is entering a competition for the Prix de Rome. I have great hopes of him. He needs an Eve for his competition subject, and you are the perfect model."

I had never been willing to pose in art schools except for Edouard Sain's, and I was not very pleased, but I could not refuse to do this for Cormon. So there I was, booked to pose in an examination room in a garret in the Ecole des Beaux-Arts.

Patissou, a young painter who looked like a short, stocky, peasant with a strong face, was witty and wily. He was more of a craftsman than an artist, but he loved his art and understood it without getting caught up in any particular fashion. He was intelligent and was already proficient enough to be rated highly among the young hopefuls of the Academy. He was also a vigorous, sparkling colorist, much more so than the other Beaux-Arts painters at that time.

It was not pleasant staying shut in for twenty days, from eight in the morning until five in the afternoon, sometimes longer, and only being allowed to leave the tiny, suffocating studio with the permission of the supervisor: "Nothing in your hands, nothing in your pockets, you may go!" But I resigned myself to it. Isn't it right to suffer for art?

The caretaker, who was employed as a jailer for the occasion, stood guard, armed with a huge bunch of keys which jangled in a sinister way whenever he had just opened or shut the doors. He only released you or locked you in after having re-corded "with his own eyes" that you were not taking out or bringing in anything unauthorized. A competitor who cheated by bringing in a sketch or other forbidden documents would be disqualified.

Each individual studio, made almost entirely of glass, was three or four meters high and the same in width and length—an airless box of some thirty cubic meters. It was so hot in there that the only way to survive was to take a shower at each break, in other words, every hour. That was what I had to do, like the others. But what a performance!

You would call the caretaker, bang on the door, shout your head off and curse because he was slow, while he, with twenty young, noisy and sweaty people in his charge, became confused, mistook the doors, muddled the keys, and finally opened up everything, so that everybody met, painters and models queuing up, often in the simplest attire, by the only sink, where an improvised shower had been set up—a long rubber hose fixed onto the faucet. You turned on the faucet, put the end of the pipe on your shoulders and your head, and you soaked not only yourself, but the others waiting, the stairs, the corridor and the caretaker as well! But the shrieks, curses, laughter and singing were evidence of the good humor. Beer was drunk from the bottle, croissants were eaten (at five centimes each), and after ten minutes every-one duly went back. Refreshed, we were locked in again, the brush and the pose were resumed with renewed courage, and with the return of deep silence work began.

All this was much more innocent than "ordinary" people would ever believe. It was crucial for the future of young artists who were dedicatedly pursuing their ideal. Most of them were ambitious and believed that all this hard work would earn them their just reward, and that winning the Prix de Rome would open for them the gates of glory, fame and fortune. But so many of them eventually had to recognize that they had labored in vain—like Patissou, who won only the second prize and had to resign himself to returning to his native province while he was still a young man—and that the most they could hope for was local celebrity and the possibility of earning a meager living from their art.

It is a pity that Patissou only came second, because his painting of me as Eve sparkled with light, and its colors were so warm and so bright she almost looked as though she were painted with sunlight. Cormon thought the reason he was not awarded the first Grand Prix was that his painting was too free. It was not fair.

Cormon was also responsible for my posing for the sculptor Sicard. He was a former winner of the Grand Prix de Rome and had executed the statue of Georges Sand that is in the Luxembourg. He used me as the model for several studies and

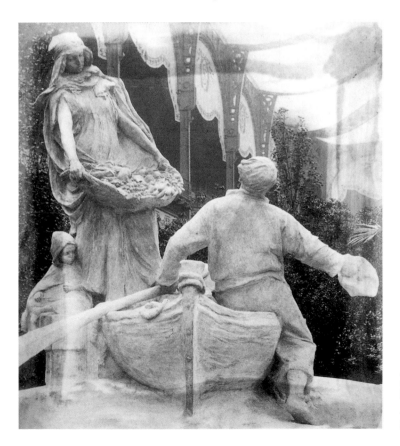

Figure group for Sicard's monument for Algeria in the 1906 Salon exhibition.

also made some maquettes, including a series for a statue designed for a port in Algeria, which depicted a woman in peasant dress with her arms outstretched holding one of those large soft raffia baskets that fish- and fruit-sellers from exotic places always use—but I had to stop posing before the statue was finished.

Physically, Sicard had the typical appearance of sculptors as I remember them at that time: not very tall, heavy, bearded, very dark and with a grave, serious expression. Sculptors (I am not sure why), as opposed to painters, seldom look like artists. They are more like workmen on a building site, stonemasons—which is what they are, after all. Their manner often reveals their humble origin and they have a strong, brutal look, so that their art, which may be assured and sensitive, is a secret to which their appearance gives no clue. It is as if they themselves are hidden in the ore of the rock and their sensitivity is something shameful. It is only when you look at their works that you can really understand them. Then you discover that they are deep, human and emotional, but there is often nothing attractive about their own personalities. I liked Sicard, but I was not remotely attracted by his work.

One of the artists I modeled for was a Turk, who had a studio in the Rue de Courcelles. He was very rich and very much a man of the world, but he suffered from an unpleasant disease and used to look at me in a repulsive way. I usually posed all day for him until five o'clock, and when we broke in the middle of the day we would have lunch together, served by a footman who stood stiffly behind my chair. I always wanted to laugh in his face as he bent his tall, straight body over, making a perfect right angle, whenever he stooped to offer me a dish or pour me a drink. As I only drank water, all this ceremony seemed so ridiculous, but I was amused by the element of charade in it all. I had to be careful not to let my eyes wander to my host's neck, or my appetite vanished completely. It was full of pits and scars, some very red, and of disgusting festering spots. But I modeled for him because he paid me very well.

I would be dressed as an Egyptian dancing girl and had to wear wide puffy pantaloons in silver or gold cloth, light as chiffon, that caught the light, a little blouse with long sleeves, cut very wide but tight at the wrists (just as the trousers were tight at the ankles), a light, short bolero of silk velvet, either red or green embroidered in gold or silver, and a veil on my head that covered the lower part of my face up to my eyes, which were the only things that were alive in my masked face—though I would take this "haik" off for lunch. Every evening, when the sitting was over, he put two fingers into his waistcoat pocket, took out a handful of change and gave it to me. There were often a few gold coins among the others, and considering five or ten francs is what I normally got paid for half or a whole day's sitting, the thirty or forty francs I brought home from my Turk seemed well worth the unpleasantness of working for a man who suffered from such a nasty disease. It was not that I cared that much about money, but you had to work for as much as you could get.

Working for miniaturists was something completely different. It was sometimes fun but often got very boring, as it was so monotonous. I modeled for a course in miniature painting run by Mme Debillemont-Chardon, and I have lively and cherished memories of this charming woman, with her simplicity and goodness. Apart from her, these miniaturists seemed to be people of a quite different sort, very "old maid." I do not know if it is the minutely detailed research their art demanded of them, but even when they were very young, miniaturists were always like old provincial spinsters, their hair smoothed down under their flowered lace bonnets. Everything about them seemed to be monochromatic, faded and slow. Since they half-close their eyes to improve their focus of the details of the model, this becomes a habit and then an obsession. They never stop squinting and therefore all appear short-sighted. They have affected mannerisms, small, fine, pale, hands, and when they hold their three-haired brushes these "refined" ladies delicately crook their little fingers, as they do when they eat or drink.

They are never disorganized in the way other artists so often are. They have well ordered paintboxes with very clean little compartments. The little colors, the little brushes, the little squares of ivory, the carefully sharpened little pencils, each has a fixed place in a box. They have a horror of smudges, of untidy models, of exaggerated make-up. When they speak of their art, they do so with an affectation that is not without charm, but alas, without much interest. They bore me; they are the "pen-pushers" of painting.

Mme Debillemont herself was a real woman. She had mahogany-colored hair, wore make up and dressed stylishly, but there were certain sides to her that fitted the mould. There was something about her, I am not sure what, that was characteristic of her profession.

Another artist I modeled for was Dethomas. He was tall and stout, with a pallid complexion, the type of slightly fleshy giant who spent his nights making sketches in night clubs. He had great difficulty staying awake after meals, which for him always had to be enormous.

I used to arrive after lunch around two o'clock and would take up a pose, and he would begin work. He had a litter of pretty little Siamese cats that would climb all over me or play with my bare feet in a way that was often quite fierce. Dethomas sketched, putting down a line on the paper or canvas with a steady hand, then he would get up, go and lie on the couch and—fall asleep for at least an hour. During this time I was free to play with the cats, to read and eat the candies lying around in various dishes, even to sleep myself, in fact to wait for him to wake up in whatever way I felt like. And this happened frequently.

As soon as he woke we would work without a break until five o'clock. People would knock on his door, ring the bell, call to him, he would not move, he never answered. I often met Suzanne Després, who had been his model for a long time,

Ignacio Zuloaga (left) and Maxime Dethomas, with Toulouse Lautrec seated between them. Drawing by the Catalan artist Ricard Opisso. Private collection.

there. It was at the outset of her acting career and she was already attracting attention. Dethomas had a great reputation in his time, but no one knows his name any longer. I think, though, that the small fame enjoyed by graphic artists tends to die with them, as they never seem to be remembered.

Dethomas's brother-in-law was Zuloaga, a great painter, who did several pictures of me. He had a theatrical way of working, although perhaps he did not realize it. It was strangely different from that of Dethomas. They had some physical likenesses: both were tall, bald, pale, mustachioed, with fine, deepset eyes that were like dark holes in their rather lifeless faces, giving them a distinguished, romantic look. But Dethomas always sat down slumped in front of his easel, while Zuloaga remained standing and seemed to glow. He painted from a distance, at arm's length, his eyes ceaselessly moving from the model to the canvas. He would make a stroke with his brush, stand back, stare fiercely at his model, and then, just as fiercely, would lunge towards his easel and add another stroke, drawing back again and repeating the same maneuver for several hours. He must have been exhausted at the end of each sitting. His paint was rich but heavy, his oversized figures had power, but one would have liked to have seen more subtlety. A lack of moderation, or perhaps of taste, made his works rather heavy-handed, but they were sometimes redeemed by their strength and a quality of universality.

He was much influenced by the Spanish old masters, especially El Greco, but he never absorbed their sensitivity. His heavy touch was due to his abrupt manner of working, for he hardly allowed himself time to feel, or breathe, or reflect. He never slept, Good Lord, no! But I often wonder where he found his inspiration. I think it was mainly within himself. He worked with great passion, forgetting the model, but

never forgetting himself. The poor model, sitting or standing in a pose that was difficult to hold—any short rest she requested was postponed for as long as possible and granted only with great reluctance.

Zuloaga had another passion: he had wanted to be a bullfighter. He loved bullfights, and I was told he had gone into the ring several times to fight. He owned a fortune in paintings by Spanish old masters gleaned from old churches and convents in Spain, which he had often obtained in exchange for his own religious works.

I modeled for Boldini just once. I never went back as I couldn't stand the idea of putting up with his attentions a second time. He looked like a little pot-bellied satyr, rather ridiculous and slightly grotesque, so that, physically, he was far from being the man of his work. His paintings were done with such harmony, grace and skill that he was considered one of the best portraitists of women of that period. He may have been charming and he was certainly an ardent lover of women, but unfortunately the attentions he lavished on his models were not confined to the professional! There was no silent languishing; he seemed overcome with a sudden passion. In a moment he leaped on me, and his arms, which were too short, tried to embrace me. This made me stumble, as I became entangled in the long dress I had put on, and I was prevented still further from defending myself by the large, high-backed medieval armchair I was seated on for the pose, in which he had me imprisoned.

It was an epic battle! I was taller and stronger than he was and managed to get the upper hand, though not without some difficulty. I fled, trampling over the field of the brief battle, which was strewn with crushed tubes of paint, for mess seemed to be characteristic of him, and everything was scattered on the ground around his easel. Apparently these scenes were not uncommon, if I am to believe several models, including some very distinguished ladies, who complained of them.

Besides these stars of academic and fashionable painting, I worked for some less celebrated painters, among them two young German painters one of whom later married Marie Laurencin.* These two artists, who never stopped chatting, spoke in German, and I listened with curiosity without understanding any of their language, which was punctuated frequently with French words—always the same ones— "Café de Paris," "Moulin Rouge" or other fashionable night spots of the time.

The engraver Janniot, who had a great following in his day, could not have offered a greater contrast to Boldini. He was stone deaf and seemed immured in silence. When I entered his studio, I had to go right up to him and touch his shoulder so that he would realize I was there. He worked in one of those shadowy ground-floor studios in the courtyard of the Institut which opens onto the Rue Mazarine, where

* Marie Laurencin married Otto von Wätjen in 1914. His companion has not been identified.

grass, sparse but tall and sickly, grew between the sharp, uneven paving stones that jarred your feet.

Janniot was a pleasant artist, kind and cheerful, and he liked a joke, but he seemed only to live for his art. Sincere and conscientious, his works seemed to me to be rather personal, with no great imagination, but pleasing and lively, technically very skilled, harmonious and simple.

He had a very pretty wife and an equally pretty daughter, who later married the actor Charles Dullin. But when I used to enter his studio, the heavy silence seemed like death. I felt isolated, lost, cut off from everything living, from all human passion. A dim light penetrated the studio through dusty windowpanes, giving the place the air of an alchemist's workshop in the Middle Ages, and I would sit there, uncomfortably and rather grumpily, from eight o'clock until midday for a seemingly endless series of sessions, so that he could capture my profile. This was far more clearly visible on the wax model—eventually used for a commemorative medal— than in the uncertain daylight.

The charm of this neighborhood was only to strike me much later. At the time, I felt hopelessly out of place among these veterans of the art world, but since then I have often thought of the old studio at the Institut and the old engraver who worked there, deaf to all voices except that of his artistic conscience. And whenever it comes to mind, or I go—by choice now—to that ancient courtyard, I am seized with a pain of regret and tenderness. Perhaps because, in all my shyness, I offered my youth here. Now I love the old yard, looking like the courtyard of a country house, with its grassy paving stones, which is still rather unwelcoming and where you still trip if you look away from your feet up to the sky.

In those days, once I was outside and back on the *quai*, in the vibrant light of the open air where the sun was reflected in the Seine, I would rummage around the bookstalls, whose owners were sitting having their lunch on benches or folding chairs, and avidly look through the shelves with books at five or ten centimes. Then I would feel happy to be alive again. I used to love browsing. I even managed to make some interesting finds which, even if they meant I had to do without a proper lunch, made me happy for the rest of the day.

It is strange, but I can only remember the summers of those years, but my eyes can still see the sparkle that shimmered over the city in the golden light of the sun.

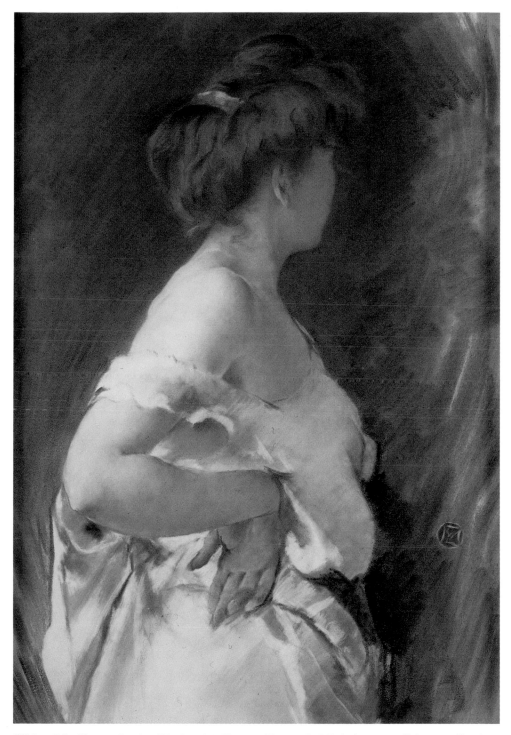

Walter MacEwen. *Study of Redheaded Woman (Fernande Olivier)*, c. 1903. Private collection.

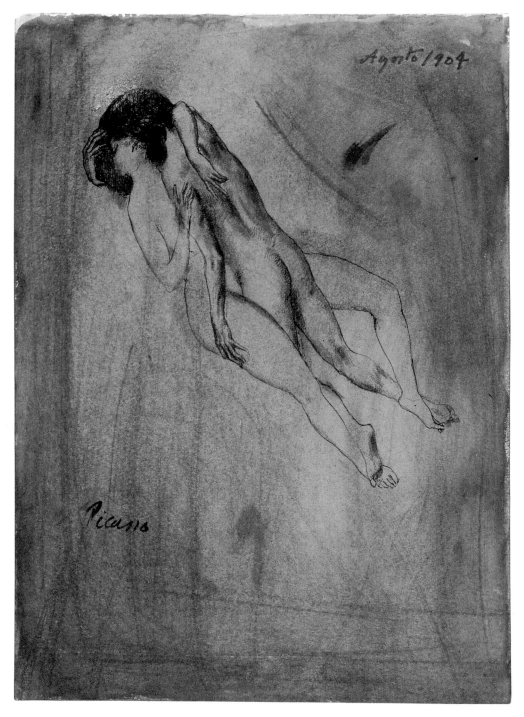

Picasso. *The Lovers (Fernande and Picasso)*, August 1904. Musée Picasso, Paris.

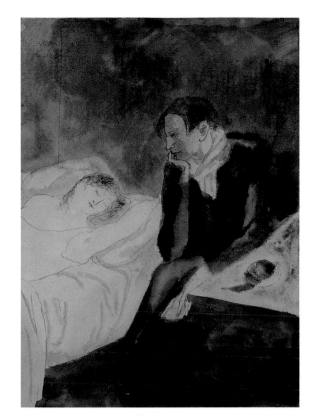

Picasso. *Meditation (The Artist Watching Fernande Asleep)*, 1904. The Museum of Modern Art, New York. Louise Reinhardt Smith Bequest.

Joaquim Sunyer. *At the Circus*, 1905. Private collection. Fernande modeled for the woman on the right, Benedetta Canals for the woman on the left.

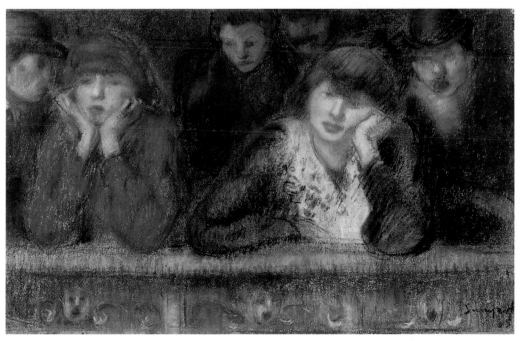

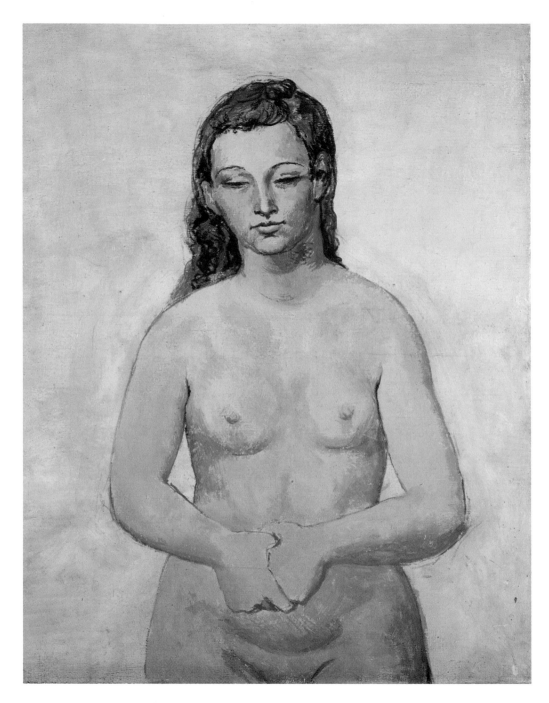

ABOVE:
Picasso. *Nude with Clasped Hands (Fernande)*,
Gósol, 1906. Art Gallery of Ontario,
Toronto. Gift of Sam and Ayala Zacks, 1970.

OPPOSITE:
Picasso. *Standing Nude (Fernande)*, Gósol,
1906. The Museum of Modern Art, New
York. The William S. Paley Collection.

COLOR PLATES

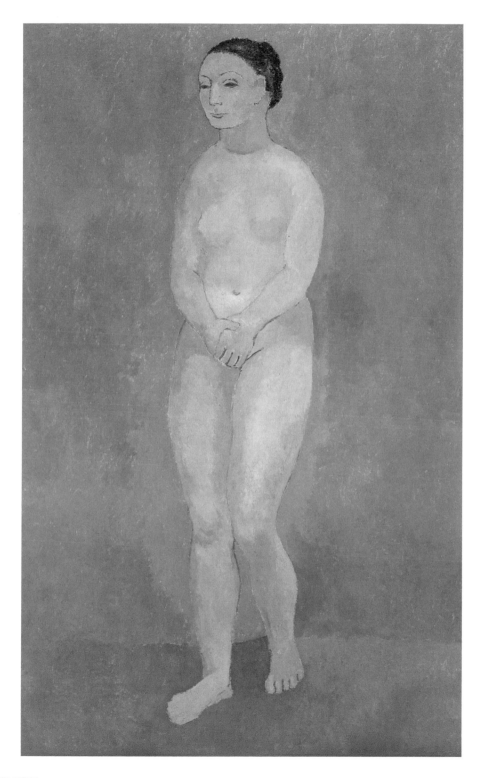

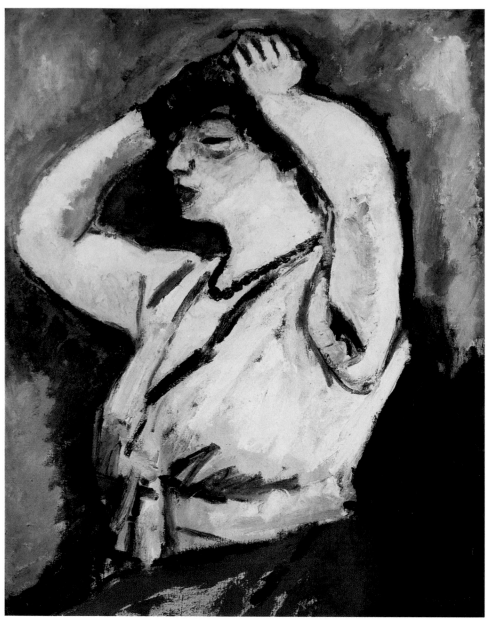

Kees Van Dongen. *Fernande Olivier*, 1907. Samir Traboulsi Collection.

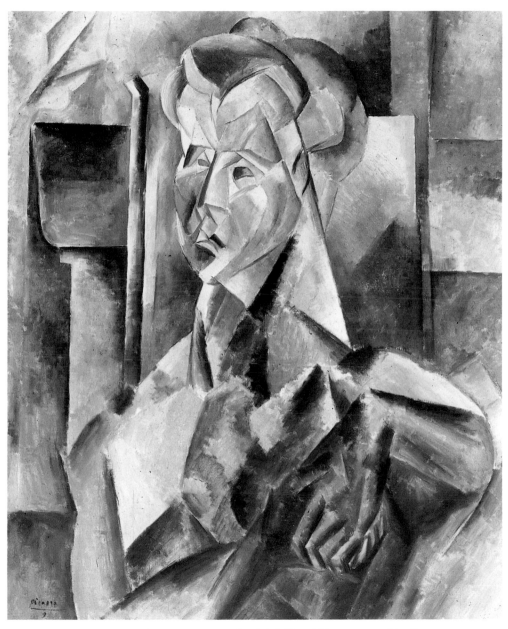

Picasso. *Woman in Green (Fernande)*, 1909. Stedelijk Van Abbemuseum, Eindhoven.

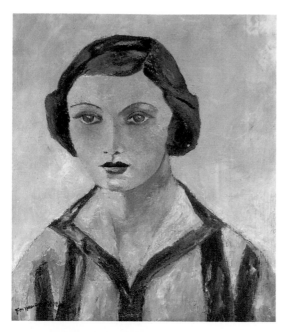

LEFT:
Fernande Olivier. *Self-Portrait*. Private collection.

BELOW:
Marie Laurencin. *Apollinaire and His Friends* (Picasso, Fernande, Apollinaire, Marie Laurencin). The Baltimore Museum of Art—The Cone Collection, formed by Dr. Claribel Cone and Miss Etta Cone of Baltimore, Maryland. BMA 1950.215.

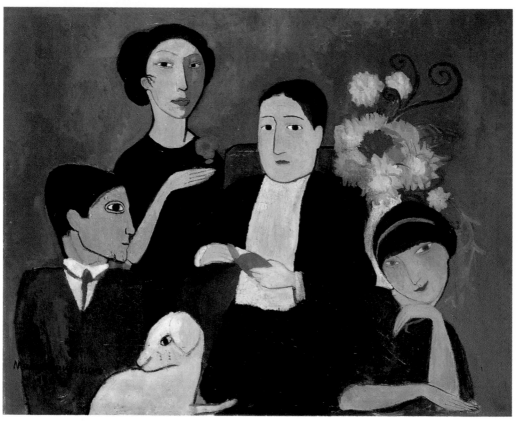

THE SPANISH PAINTER

Fernande's Journal, August 1904–September 1905

[*August 1904*]

I think that yesterday I may have embarked on another stupid adventure; all because of the storm that broke over the Place Ravignan. Our little square is shaded by four trees and surrounded by four buildings with four streets leading into it. It's like the heart of a primitive cross, a shrine reached by climbing about ten steps, all pretty much worn away by the weather, a little wayside shrine on the hill, halfway up to the Sacré-Cœur, a shrine—without a crucifix or a statue of Jesus—that's shaded by the huge, dusty, diseased trees. There are two nice old painted wooden benches, though the paint is peeling off them, and in summer it's pleasant to sit here and collect your thoughts when the sun is so strong it chases all the other residents inside to hide behind their closed shutters. In winter the trodden-down snow on the path that winds up the steep slope makes it as slippery as an ice rink and the square is deserted. Such simple things can sometimes be so poetic, but more poetry seems to attach to things the humbler they are. Not that this little square always strikes me as poetic; it seems to depend on my changing moods. When I'm happy and cheerful it seems to me "pure poetry," but when I'm fed up with everything and depressed it's just "thoroughly unpleasant."

I know I shouldn't be fed up with everything, fed up with being alive, at my age, but if you're as curious as I am about life in all its aspects and in what it promises… I know perfectly well that my responses to life are often extreme—for good or bad—but I evidently have no sense of moderation in the way I react to people and things and never have, even as a child. My responses are so varied and often so short-lived. I wonder if I'll ever experience true love—even more after yesterday. I'm sure I've done something stupid, but I don't understand, at least not properly, what makes me do these things.

I've mentioned the Spanish painter who lives in our building. Well, for some time now I've been bumping into him wherever I go, and he looks at me with his huge deep eyes, sharp but brooding, full of suppressed fire. I don't find him particularly attractive, but his strangely intense gaze forces me to look at him in

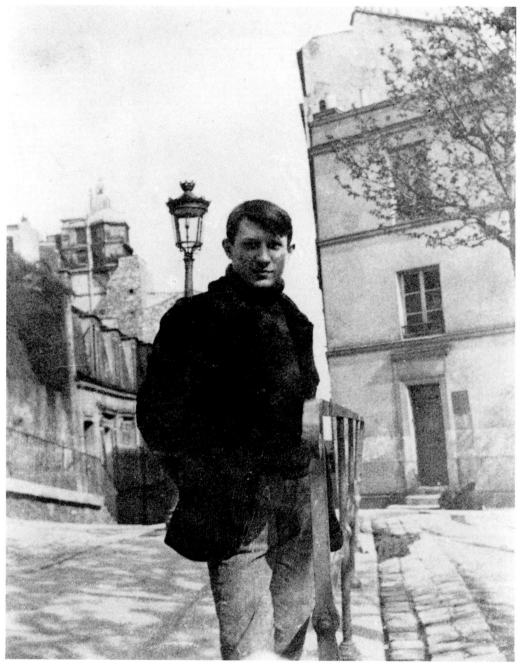

Picasso on the Place Ravignan, 1904. Musée Picasso, Paris—Archives Picasso.

return, although I've never answered him when he tries to make conversation. I don't know where to place him on the social scale and I can't tell how old he is. His mouth has a lovely shape, which makes him look young—while the deep lines from his nose to the corners of his mouth make him look old. The heavy nose with broad nostrils makes the face a little coarse, but everything about him suggests a powerful and deeply spiritual personality. Even when his lips are laughing, his eyes remain serious, and the pupils seem to be steeped in an inexpressible melancholy. His gestures are tentative, suggesting the kind of shyness that may conceal pride.

In the evening, when I get home, I've got into the habit of sitting in front of my door on the Place Ravignan and relaxing with a book until the sun sets. Laurent is never around at dinner time as he eats with his family, but when other friends come, we take chairs out of the studio and form a little circle. The Spanish painter, too, is often in front of his door to the building, surrounded by a gang of other Spanish artists who talk noisily. I find them slightly annoying, but they make the little square even more colorful.

Anyway, yesterday afternoon the atmosphere was really oppressive before the storm. The sky was black, and when the clouds suddenly broke we had to rush for shelter. The Spanish painter had a little kitten in his arms which he held out to me, laughing and preventing me from going past. I laughed with him. He seemed to give off a radiance, an inner fire, and I couldn't resist this magnetism. I went with him to his studio, which is full of large unfinished canvases—he must work so hard, but what a mess! Dear God! His paintings are astonishing. I find something morbid in them, which is quite disturbing, but I also feel drawn to them.

The furniture in the studio is very meager. There's a bedstead with four legs in a corner. A yellow earthenware bowl standing on a rusty little cast iron stove serves as a wash basin and there's a towel and a piece of soap on a whitewood table beside it. In another corner, a little trunk that's painted black makes an uncomfortable seat. There's a wicker chair, some easels, canvases of every size, tubes of paint scattered all over the floor, paintbrushes, containers with turpentine, a bath of etching acid, no curtains. He showed me his tame white mouse, which lives in the drawer of the table, and which he cares for lovingly.

He's working on an etching showing an emaciated man and woman seated at a table in a wine shop, who convey an intense feeling of misery and alcoholism with terrifying realism; and one of his canvases also particularly struck me: a cripple leaning on his crutch, carrying a basket full of flowers on his back. Everything, the man and the background, is blue, except for the flowers, which are painted in fresh, brilliant colors. The man is gaunt, emaciated and wretched, and bears a look of pathetic resignation. It's a strange, tender and infinitely sad composition depicting the ultimate renunciation, an agonized appeal to all human compassion. It seems to show a deep and despairing love of humanity.

Picasso. *The Frugal Repast*, 1904, the etching that impressed Fernande on her first visit to the artist's studio. Private collection.

I've been back to see my Spanish painter. He adores me with real sincerity, which I find touching, but I have to conceal my destination when I go to visit him, as I don't want Laurent to find out, though luckily Laurent has to go away soon to do thirteen days' military training. I think perhaps I may eventually come to love this young man.

Picasso is sweet, intelligent, very dedicated to his art, and he drops everything for me. His eyes plead with me, and he keeps anything I leave behind as if it were a holy relic. If I fall asleep, he's beside the bed when I wake up, his eyes anxiously fixed on me. He doesn't see his friends any more, doesn't work any more, stays out in the square so as to catch sight of me more quickly and more often. He's asking me to come and live with him, and I don't know what I should do. I'm very tempted; it's sweet to be loved like this, and I like him physically too. He's constantly doing portraits of me. He's kind and gentle, but he doesn't look after himself, and I find that upsetting. I don't mind untidiness, but I'm horrified by lack of personal cleanliness. I don't dare let him sense this; it's a delicate matter, but I'll get round to it.

I've decided not to sleep at Laurent's any more. Léno and Georges have offered to let me sleep in Georges's office, which is empty at night as Georges goes back to his

Picasso's drawing of Fernande asleep,
watched by her jealous lover, 1904.
Private collection.

grandmother's for dinner and sleeps there. I've pretended to accept, but go to Pablo
instead. Still, it's a tricky business, as Laurent, who for quite some time was never
around, is now getting jealous, and despite my snubbing him he's determined to con-
vince me to stay with him. I leave after dinner, he watches me as I walk away, and
then, once he's back in the studio, I come running back and go in to Pablo, who's wait-
ing behind the open door. There haven't been any fights yet during the ten days or so
I've been playing this little game. It's rather fun, but, I must admit, not very nice.
And it can't go on forever—I don't want any quarrels, and Laurent can get violent in
spite of his cowardice. An argument with Pablo could also get nasty. Pablo immedi-
ately talks of guns—bang! Would I be scared? Well, no, I'm not scared, but I have a
horror of fights or of drawing attention to myself. I'd rather go about things quietly.
Laurent's leaving tomorrow—what a relief!—and I've got to make up my mind.

Laurent left a week ago for his military training, but I can't go and live with Pablo.
He's jealous, he has no money at all, and he doesn't want me to work. It's ridiculous!
And besides, I don't want to live in that miserable studio—you see, I'm not in love
with him—it's another mistake. On the other hand—What an idiotic character I've

got. But I don't want to sleep with him any more, and this constant adoration that seemed so wonderful at first grows monotonous. I'm fed up, bored as soon as I'm with someone else. I never get bored with a book, but with a lover I'm bored and fed up. When will I fall in love?

[late August]
Laurent's back, and we've had another argument about the housework and my independence. When I was ten years old, I used to say when I got fed up, "Oh, when I'm a big girl!—" at fifteen, "Oh, when I'm grown up!—" and now I say, "When I'm older!—" I do nothing but wait, but what am I waiting for, exactly? For my hair to grow white? For my mind to start wandering? I don't deserve to be alive or to have a mind.

I'm modeling the whole time like an automaton: Cormon every afternoon, Bordes in the mornings, and at six o'clock a miniaturist. I'm really caught up in it, but at least I can buy some books and some perfume, which is what I like best. I don't get any advice on what to read, but from time to time I make a lucky choice, and I think I'm managing to improve my mind.

Poor Pablo is very unhappy, but I can't do anything about it. He writes me desperate letters in a French that is highly imaginative and quite barbaric.

A real *coup de théâtre*: Léno has gone back to her husband. At Georges's suggestion, she put on a little act, agreed to have dinner with him, allowed herself get tipsy and was taken to bed, so now she's Mme Jacob for good and all.

I've been invited to spend some time with them at Berck. I'll leave tomorrow.

[September]
M. Jacob took me to Berck yesterday. We arrived in the evening. Léno's being very sweet, she's happy. M. Jacob is always ingratiating, but he detests me. He thinks that Leno and I—Yes—and Léno tells me he wants to take advantage of it. I can't understand all that. She laughs about it, but it makes me feel sick.

We're having a great success at Berck. Léno and I have good bodies, and when we go swimming in our rather low-cut bathing suits, everyone watches us. She has downy blonde hair on her legs and arms, while I'm as smooth as marble.

Yesterday a boy, an invalid who's here to convalesce, sent me a letter with a proposal of marriage. It made me laugh, though I'm not sure why. Perhaps I laughed with emotion. He's going to be in plaster for another two months and asks me to wait until he's "liberated" to give him my answer. But I'll always think of him as he is now, and I find that quite frightening. I must stop thinking about his proposal, yet it would be good to make somebody happy who has been waiting for a cure since he was seven years old. No, no. I don't want to think about it.

Cartoon satirizing the behavior of young women at the seaside. From *Frou Frou*, 1901 (the year in which Picasso contributed to the magazine).

I think I mentioned that Léno has two brothers and two sisters. Her elder sister's married. She's very beautiful. The younger one isn't, but she radiates an aura of sensuality and at fifteen attracts men more than either of the others. The oldest in the family is a bachelor, a fair-haired Jew of the most hideous kind who walks with a limp. The younger one is seventeen and looks like a brown monkey. His arms are too long, his legs are too long, and he sports ties in loud colors and incredible felt hats. He's desperately naive and considers himself very smart, very up-to-the-minute, and with me he plays the faithful admirer. He's ridiculous and sweet in his idiotic way, and now he has fallen in love with me. Life is cruel.

Yesterday he got me in a corner and kissed me timidly, asking me to teach him to make love. I laughed so much I nearly made him angry. Then he said: "All right then, I'll go to a brothel and after that I'll force my way into your room at night."

"Well, I mustn't forget to lock my door."

"I'll get in through the window even if it means risking my neck." My room's on the second floor and he knows I sleep with the window open. He's a joke.

Laurent has arrived in Berck. He and Geo are staying with Geo's grandmother. We don't speak. Just as well. I'm going to stay here another week and then I'll go back to Paris. If only I could find somewhere else to live. But where? I don't have the money to buy furniture or I'd rent a studio, as I can't stand hotels.

Drama between Léno and Georges, who has left her for her younger sister. She walks around with a revolver inset with mother-of-pearl and silver. She wants to kill herself in front of him. M. Jacob follows this drama with a seemingly disinterested eye, but he hopes to benefit from it by securing his wife for himself once and for all. He has been cunning: he has let her do just as she wanted, he has been gentle and sweet and has showered her with presents and luxuries, and she seems to be getting fond of her elderly husband. She weeps on his shoulder. He comforts her, she lets herself be comforted, and I'm sure it will all work out. Jacob will go on being cuckolded and Léno will go on loving one man or another as the fancy takes her, but she won't forget that a husband like hers is always the most dependable kind from every point of view. He may be a weakling, but he earns a lot of money and that lends him weight. He's also gaining self-respect, holds his head high, is becoming rather pompous, orders the servants around and—looks after his wife. I wouldn't want any of it for anything in the world.

I've come back to Paris after a little argument with Laurent. I don't want to see him any more. As he's going to stay in Berck for another month, I'm still in the studio. When I got back, I looked for Pablo. He wasn't home, but I was told he was having lunch with his friends Ricardo and Benedetta Canals, and though I only know them by sight I went to find him there. When Pablo heard my voice, he abruptly dropped a guitar, which almost broke as it fell, and came running like a madman. I was glad he was so happy to see me.

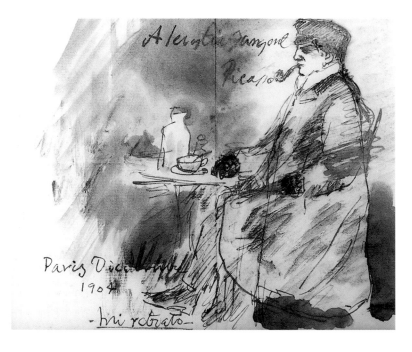

Picasso. *Self-Portrait at a Café Table,* December 1904. Private collection.

THE SPANISH PAINTER

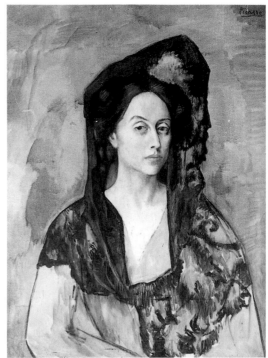

Ricard Canals in his Bateau Lavoir studio, photographed by Picasso, 1904. Musée Picasso, Paris—Archives Picasso.

Picasso. *Portrait of Benedetta Canals*, 1905. Museu Picasso, Barcelona.

I've often seen Canals in the group of Spaniards around Pablo outside the Bateau Lavoir. He came to Paris a few years ago, at the same time Pablo made his first visit here. They make a striking contrast when you see them together. Canals is tall, thin, pale and cold, with the candid blue eyes of a child, while Pablo is short, dark, and uneasy in a way that makes you feel uneasy yourself, and he has that deep, piercing gaze from his strange, dark, almost staring eyes. His gestures are awkward, his hands are effeminate, and he's badly dressed and unkempt. A thick lock of shiny black hair falls over his intelligent, obstinate forehead. His clothes are part Bohemian, part those of a workman, and his hair, which he wears too long, sweeps the collar of a shabby jacket. Canals is a conscientious and committed artist and his wife encourages him—and keeps a tight rein on him too: she only allows him one cigarette at each break, and when Canals and Pablo came in one evening hardly recognizable, having both shaved off their mustaches, she was so angry with them she became quite hysterical—though they're both still clean shaven. Benedetta is a beautiful redhead, and they have a little boy, but I don't think Canals is his father.*

* Octavi Canals was Picasso's godson.

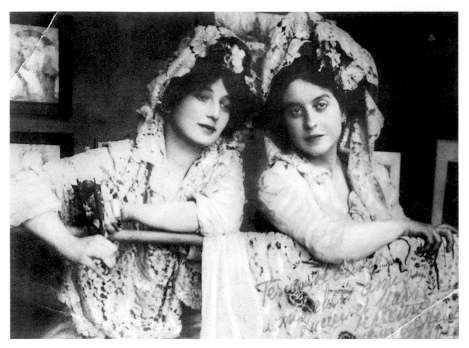

Fernande and Benedetta in Spanish costume in Canals's studio, 1904.

After lunch Pablo and I went back to his studio. He was devastated when I said that I only wanted his friendship, but he would rather have that than nothing.

I've started working again, modeling for Roll and Dubuffe. I find Roll intimidating, in spite of his friendliness, whereas Dubuffe isn't intimidating but irritates me as he "prowls" around me. You'd think he was guarding me. He likes women, but the fact that I'm not sensual seems to irritate him.

I'm painting a little and Cormon asked me to show him what I'm doing. He says I don't know how to draw like a "painter." He's right, but how can I learn? I don't have the time.

I visited Degas's studio with Benedetta Canals, who used to model for him. He's not painting at the moment, but is working on small statuettes from his model S.V. [Suzanne Valadon]. I wouldn't be his type as a model. He's a strange old man, with a tough, sarcastic quality that comes from his strength, and a kindness that comes from his humility. But I only saw him for a very short time. Benedetta also modeled for Bartholomé, posing for one of the figures in his *Monuments des Morts*.*

* Paul-Albert Bartholomé's *Monument des Morts* was erected in 1895 in the Père Lachaise cemetery.

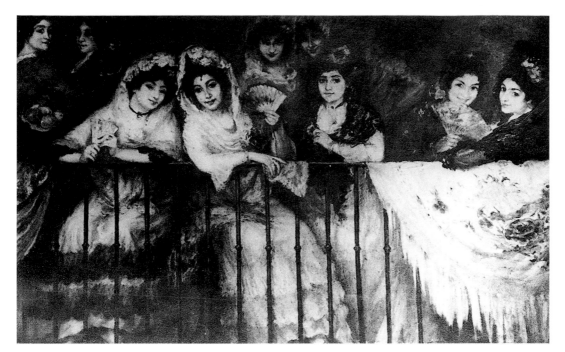

Ricard Canals. *At the Bullfight*, 1904. Private collection.

I told Benedetta how fed up I am with living at Laurent's and how I long to get away, and she suggested I should come and live with them. I've agreed and am moving in tomorrow. I'll sleep on a couch in the studio.

[September 1904]

Life at the Canals's is delightful. I work in the morning, come back at lunchtime and go out again afterwards, or else I pose for Canals, who seems to me to be very talented. At the moment he's doing a large painting for the Salon, a box at a bullfight: two Spanish women in mantillas, one black (Benedetta's), the other white (mine), lean on their elbows and smile as they converse. They're wearing picturesque costumes and there are fine embroidered shawls thrown over the edge of the box, so that their bare arms stand out sharply against them, making a play of light and shade. Their mantillas are fixed with very tall combs like the ones Spanish dancers wear and they have crimson carnations in their hair. It's bright, cheerful and amusing, and the colors are harsh and soft at the same time. I like this picture and the way the interplay of our slim hands—Benedetta's smaller and more gracefully shaped, mine more supple, more individual and with my fingers turned up—gives life to the composition.

This is the first picture I've posed for that I like. Well, I do remember being very pleased with myself in a study by MacEwen of a nun—a Dominican, I think, or

maybe one of the American orders—in a white habit set off by a long cross of appliquéd red cloth, which seemed to follow the movement of the body despite the voluminous folds of the costume. I had to wear long white veils and a starched white wimple, masking my face all round so that it stood out against all the mass of whiteness around my head, shoulders and neck. I loved myself like that and wished I could really have been that nun. I felt I was her soul. But what torture those sittings were! I had to kneel in front of the lighted candles, my face raised, my hands folded in prayer, and often I almost became ill with fatigue. Posing for Canals is quite the opposite; it feels like a rest, and when you aren't suffering from fatigue all your gestures become more natural.

Pablo is never out of his friend's studio and has his lunch and dinner with us. I often wonder when he does any work, but apparently he prefers to work at night so as not to be disturbed. There's often no money, although I give Benedetta what I earn, but she puts a large part of it on one side to buy all the things I need. They are so nice to me. I'm so much happier than I was at Laurent's.

The Spaniards who come to the Canals's flirt with me, which is funny! There's Paco Durio, the sculptor I met at Pablo's during the few weeks I was sleeping there. At that time he didn't really approve of me, as he thought I was preventing Pablo from devoting himself fully to his art. He's very different now. He wants me to marry him. If they knew I was already married, how amazed they'd all be! But there's no point mentioning it. I've managed to forget—or, at least, never think about—my horrible husband. I wonder what's become of him?

In the evenings there's a lot of merriment here: five or six friends come over, they play their guitars and sing Spanish songs after dinner. This often simply consists of an enormous dish of spaghetti. Madame Benedetta is Italian and this is one of her specialties; it feeds us all and we can afford it. The men are all artists and talk among themselves about their work. Benedetta and I stretch ourselves out on the couch and are happy to be the focus of admiration. Madame Benedetta is very beautiful.

Yesterday, on my way home from a sitting, I was followed by a young man, very Spanish-looking, who didn't dare speak to me. I continued on my way and climbed up the Rue Lepic, not thinking any more about my pursuer until I arrived in the Rue Girardon at the house where the Canalses live and realized he was still behind me. He is persistent, I thought, following a woman, who clearly doesn't want to be picked up (in cases like this I put on a very distant expression, which usually puts off even the most shameless men), all the way from the Place Clichy. I climbed the six floors leading to the welcoming studio, with its atmosphere I love so much, and decided to rest with a nice cup of tea, so I lay down on the couch that serves as my bed. Five minutes later the doorbell rang, Benedetta went to open it and came back escorting—my pursuer, a friend of the Canalses, who was of course introduced to

me. I was rather surprised, and he said: "Do excuse me Mademoiselle, but I've been following you for so long now that today I decided to keep going until you reached your destination. I've followed you, or rather escorted you, two or three times before without your having noticed. When I saw you going into this house just now, I was overjoyed, as you could only be coming to see my friend Canals, and now, thanks to my persistence, I have the pleasure of making your acquaintance."

He's a Catalan painter and not especially attractive—he looks too much like a Spanish guitarist. He's quite young and has a strong face, but there's something self-centered about him, something "sly." He's very well dressed, quite elegant even, but there's a faintly dubious quality about him that bothers me. He's nice though, very ardent, and he certainly didn't waste any time before paying me compliments. I stopped him and spoke abruptly, rather rudely, to him: "Don't put yourself to any trouble on my account. Compliments and flattery don't interest me. I'd be pestered with them the whole time if I took any notice. You say you'd like to do a portrait of me. Well, you can do it here if you want to, if Benedetta agrees, but I'm not going to your place. I don't want to raise any false expectations." He just smiled gently, but I noticed a little gleam in his eye, and he looked pleased with himself. I have to admit that he's amusing and artistic, and intelligent too.

Canals told me: "I hardly recognize Sunyer, he seems to be intimidated and he's usually so sure of himself. He's a playboy who usually only goes after rich women—and he owes much of his stylish appearance to them—but I think you've made a big impression on him." Sunyer had dinner with us and a group of friends came round. Of course Pablo never misses a single day and spends his time gazing at me with a sad look. It seems impossible to escape his penetrating eyes.

Yesterday I met a friend of Benedetta's who came to visit her. She's a tall, thin girl, brown haired with blue eyes and with a nice complexion—rather dark but unusual. She was unfriendly to start with but improves on acquaintance. She's vivacious, full of energy and drive, and we soon became friends. She's open and direct; I like that. She likes people who are more intellectual than she is herself, which is an attractive quality, and art is the one thing she really likes. She writes a little and has a lover who makes her unhappy, but she's in love with him. It sounds as if he's half crazy. Although he's intelligent and enterprising, all his undertakings are hampered by his hysteria and total lack of any practical sense. Luckily, Renée (that's her name) is very practical and can give him quite effective help.

He has started an interesting paper, *Le Journal des Curieux*, but Renée does all the legwork. He chases women, and this makes her desperate. She told me after we'd known each other no more than an hour, "Louis will make a pass at you, I'm sure, but please don't respond." She has nothing to fear. I never try to take a man away from his wife or his mistress and I'm sure I'll never break this principle. I think I have a strong feeling of loyalty, not a word much used nowadays!

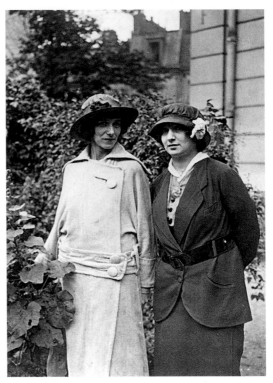

Renée Peyron. From a sheet of caricatures by Picasso, 1905. Musée Picasso, Paris.

Fernande with her friend Reneé Peyron in the 1920s.

This morning Renée introduced me to the lithographer Janniot, who was very impressed with me and booked me for ten sittings. I'm to start posing tomorrow.

I've been to dinner with Renée, who lives in tiny lodgings in the Rue Lepic. She has a feeling for intimacy, and it's nice in her home. Sunyer appeared after dinner, because he knew he'd find me there. He brought me flowers. He's kind and I find him attractive, although I don't really like him. I don't understand my feelings at all.

This morning I sat for Janniot, who did a nice drawing of me that he's going to turn into a color lithograph. He's skilful and assured, but pretty trite.
 Renée is devastated, as her lover has left her again. She has asked me to go and live with her so that he can't come back. That would certainly be for the best. I've accepted without really thinking about it, and Benedetta is upset. Too bad.

Laurent is after me again. I find him so tiresome. If only he'd sort himself out with his little girls. He threatens me, so I avoid him as much as possible, as he becomes violent so quickly.

THE SPANISH PAINTER

What a life, modeling the whole time—from eight o'clock in the morning I'm hard at it, I rush back at half past twelve, have lunch in twenty-five minutes, then leave again to be with one of my painters by one thirty. After all this, there's no time left for living. I'm heavy-eyed by nine o'clock in the evening and sleep until morning. Do I have to live like this? And all because I am waiting to fall in love and be loved in return.

Why don't I agree to live with a man without loving him? It's what most other women who are beautiful enough to attract "serious" men do. Wouldn't love grow out of the habit of being together? Can't one become attached to a man simply because he loves you? Oh, how complicated the heart is, and I'm still the same as ever; I don't understand anything about it. Picasso is truly in love with me, but could I bear to live in poverty with someone just because he loves me? Just because of that? It isn't possible. I'd rather work. If people knew the kind of life a serious model leads, they'd respect us rather more. Yesterday a doctor who has been pursuing me for some time said: "Oh! you're posing for so-and-so and so-and-so. But these are great painters! Do you 'sleep' with them?" That was exactly the term he used. I shrugged my shoulders and said nothing. This bourgeois way of thinking is disgusting: artists usually respect their models, apart from a few maniacs, and a woman modeling can usually be sure not to be bothered. The doctor's a real bourgeois, and a Jew too, though otherwise quite nice, but I find it repulsive that he pursues me with his desire. He's like a little satyr. It's nauseating when he talks about his love. I think that all the men who seem to be drawn to me just by desire are disgusting.

I think I'd like Pablo better if his feelings of real tenderness for me weren't tainted by desire. Am I different from other people in my horror of the act of love? I think I must be, as other women seem to be flattered and attracted by the desire they provoke.

I've agreed to have dinner with Sunyer. I'm going tomorrow evening. When I told Renée she smiled in a funny way. What does she think?

Life with Renée is easy. She takes care of all the practical things that I always find so tiresome. She looks after me as if she were my big sister. We read at night before going to bed. She writes and so do I. I've done some sketches of her that are quite good likenesses. On Sundays we walk along the *quai*, and when we get back I find Laurent spying, but as I'm not on my own, he doesn't dare say anything.

I've become Sunyer's mistress, physically the willing and, at last, loving mistress—but only physically, which has never happened to me before. What does he have that the others haven't had? It's strange. I don't like him apart from "this." I didn't want to spend the whole night with him and went home. I told Renée what had happened. She told me: "It's often like that." So, does love not play any part in sex? Here's this young man, well groomed, quite attractive physically, an artist, not a

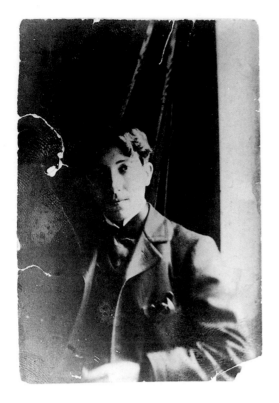

Joaquim Sunyer, c. 1900.

fool, who hasn't succeeded in touching my heart. Yet, when almost by accident I fall into his arms, he shows me a side of life I've never known. It's magnificent and exciting, but although my senses cried out, my heart remained silent, closed. When I left his embrace I only wanted to get back to my own bed and fall asleep alone, away from his arms. And yet, on waking, I thought that nothing could prevent me seeing him again that evening. Poor Pablo, whose only consolation for the disappointment of his love was his belief that I was on my own. If only I could love him.

Yesterday Laurent, who knew that Renée was away for two or three days, appeared like a lunatic and took me back to his place. I was in bed and had to open the door to him. He didn't push me around but just carried me off like booty. He's a stocky little man and his heavy, muscular hands have been exercised so much by his sculpture that he's very strong. But he didn't upset me. To my great surprise, I didn't resist his "ardor," and I didn't lie inert as I always have in the past, but I still found him disgusting. I was afraid he might get violent when I refused to submit a second time. Tonight I'll go to Sunyer.

I've worked all day and I'm exhausted from modeling for Axilette and then for Bordes—too exhausted to go and spend the night with Sunyer. I'm planning to

THE SPANISH PAINTER

stretch out in my bed and sleep. I'll go to bed, provided Laurent doesn't repeat yesterday's performance.

Sunyer, who comes to look for me whenever he hasn't seen me for two days, came round when Renée and I were having dinner. He brought me a huge bunch of roses. He's kind. But he seemed put out when I made him leave without me. I don't believe he loves me, and I can only stay with a man if I feel I'm loved.

Still the same calm, boring life. Sunyer has asked me to live with him, but I'm hesitating. His studio is depressing and he has no money. Renée is so good and kind. She understands how to make life cosy and comfortable and spares no pains to make that possible. I feel deeply attached to her, she's so devoted.

I've been with Sunyer for three days. Renée has gone to collect her Louis, who's ill. I'm fed up. I feel no love for him, but I still love his embraces, without feeling anything else. What does he do? How does he live? He doesn't give me any money to live on, and if I didn't work I wouldn't eat. He's out all day long. Yesterday he came back with a package that contained underclothes for himself, silk underclothes, shirts, underpants and socks. Could it be true, as I've heard, that he has an old woman as a mistress, who gives him everything he needs except money? So what, I don't care.

He has started a portrait of me, which seems successful, but it has no character, although it's forceful and sensitive.

Yesterday I was supposed to model for Bordes morning and afternoon, but when I got there at nine o'clock the maid told me he was ill and that he wanted me to come back in three days time. He lives a long way away in Rue Pergolèse. I'd come on the tram and only had just enough money to get there, so I had to go home on foot to Rue Notre-Dame-de-Lorette. As Sunyer had already left, I didn't eat all day. I went to bed at four so cold and hungry I cried, but Sunyer didn't get in until around one in the morning. He felt really sorry for me and as he had a little money, he went out to get something, but I didn't touch the ham or anything else he brought back. Today, when he goes out, I'm going to leave. I'm going back to Laurent, who has been begging me to for ages. What an idiotic, unsettled life. My lack of will power and my inability to face up to things that really have to be done leave me at the mercy of the people I like least.

As I was climbing up the hill with my little bundle of belongings—everything is at Renée's—I met Pablo, who wouldn't let go of me. He was so happy to see me that his eyes were full of tears. With his comical accent he said, "Biens, Biens" for "Viens" (come to my place), "I love you, I shall do everything for you—you don't know what I could do"—but I still said no. He looked at me avidly with huge eyes,

shining, worried, sad. He certainly loves me, but I don't love him. Perhaps he loves me too much? It's not because he's so poor that I won't agree to live with him, but something inside me refuses to say yes, although I feel warmed by his love. Maybe I'll come to care for him if he's patient and goes on caring for me.

I'm not sure why I'm going back to Laurent when I find him so infuriating. I suppose it's habit and my love of independence. With Laurent I can do as I like without caring whether it makes him suffer or not. Besides, with him, it would only be his self-esteem that would suffer.

Two serious proposals of marriage: from a doctor and a painter. The doctor has been pursuing me for some time, but I find him repulsive. He nauseates me when he talks about his love. Anyhow, I couldn't get married without finding my husband and asking for a divorce, and nothing in the world would persuade me to confront my husband again. Where is he? What's become of him? I hardly ever think of him, or of his people, who were supposed to be my family—uncle, aunt, father-in-law— and when I do I feel sick at the thought of seeing them all again.

Pablo, my painter, also says to me, "We can get married if you like." But I couldn't even if I wanted to, dear friends. You're going to have to give up that idea. I've turned them both down. Anyway, I've had so many other offers of marriage I haven't bothered to mention. I don't even think about them. What's the point? It's of no interest.

[1905]

I feel morose and rather depressed this spring. I read a lot, Laurent is never here. So why was he so keen to have me back here? I think I hurt his self-esteem.

This morning, while I was posing for a sculptor in Boulevard Malesherbes, I suddenly thought of a friend I hadn't seen for three years, maybe more. He was an intern then at the Beaujon hospital. I'd had scarlet fever when I was fifteen and one night when I was feverish and the doctor who was looking after me wasn't at home my uncle had knocked on the door of this student, who lived in our building. He attended to me and, later, used to come from time to time to chat with my uncle. The young man was interested in his workshop, in the machinery and in the simple, needy people working there. I hadn't seen him since I had left my family. I don't know why I should have thought of him this morning. Then at midday, as I was leaving the studio, I heard someone calling to me from the middle of the boulevard. It was the young man, driving past in a two-wheeler, who recognized me and pulled up his horse. He seemed so pleased to see me, while I was stunned. I told him I had been thinking hard about him less than an hour earlier, and I wanted him to explain this "phenomenon" to me. He couldn't, but I agreed to have dinner with him the following day. He has a practice on the Boulevard de Courcelles. I'll have to

smarten myself up to go there. My dress is worn out and so are my shoes, but Renée will fix things up a bit this evening.

I had dinner last night with André F. Renée loaned me her dark red shoes, the nice ones. They pinched my feet a bit, but so what, they looked elegant. My dress was repaired, and Benedetta, who isn't angry with me any more, gave me a beautiful lace collar. I really looked my best. The magnificent apartment was rather intimidating for a little bohemian like me, but André F. quickly put me at ease. He's nice and behaves very correctly. I think I coveted him a little as he's very goodlooking, but he still just saw me as the little girl he had looked after when she was fifteen.

When I told him about my marriage, he seemed upset, and when he learned I was a model, he looked embarrassed. He's a real bourgeois. I talked very freely to him about my life and he looked at me and seemed to be thinking, "What a pity!"

Yes, it is a pity! I've ruined everything with my timidity, laziness, weak will, and indulgence in fantasies. But I still have the future ahead of me. Although he invited me, I don't think I'll go back to see Dr. André F.

[early summer 1905]
What am I doing at Laurent's? Whenever we see each other, which isn't often, we argue. He'd like me to help more with the housework, although I go out to work (three sittings a day), and he wants to me to sit for him when I get home, exhausted. I tell him to forget it. He complains and gets angry but doesn't dare touch me. I'm only living at his place temporarily, but I don't know how to economize. I spend everything I earn and as he has no money he counts on my earnings to get by.

I love the summer and the sun.

Today I saw General A[ndré] at Cormon's. I also met an old painter friend of his, Deyrolles, who lives in Brittany and works in Cormon's studio when he's in Paris. He was up a ladder, squaring up a drawing on a large panel for a tapestry, when I arrived. He looked down on me with a charming smile and said to Cormon: "Old boy, if I were rich, I'd take this child and shower her with gold to make her speak all day long. Haven't you noticed her voice, such a pretty voice, it's enchanting," and so on. I was pleased he thought my voice was lovely, just as I'd been proud that Picasso admired my hands, which are not conventionally beautiful, but which have a lot of character in their thin, almost disjointed way.

[July 1905]
Yet another scene with Laurent. Luckily he's leaving on Monday for another turn of military duty that will last more that three weeks.

Picasso came in last night at about four o'clock with some friends and their uproarious shouting roused the entire neighborhood. They seemed to have it in for the decadent poet Jules Laforgue, and all that could be heard was "Down with Laforgue! Out with Laforgue!" I don't know if there was any reason behind all this indignation—they wouldn't have been able to explain—except that they were drunk.

I met Picasso as I was coming back at lunchtime from Cormon's, where I'm still posing for a large tapestry. I was walking up Rue Ravignan. He was with a poet friend, Guillaume Apollinaire, whom he introduced to me, a large, jovial, pleasant fellow. He was wearing a suit of rough, beige, English tweed and his coarse straw boater seemed too small for his skull. His head is slightly pear-shaped with pointed features that look sympathetic and distinguished: his small eyes are very close to his long, fine, hooked nose, and his eyebrows are like commas. He has a small mouth, which he seems deliberately to make even smaller when he speaks in order to make whatever he says more biting.

As it was some time since I'd last visited Picasso, I told him I'd go and see him at around five o'clock on my way home from Cormon's. For once, he wasn't enthusiastic, presumably because of the state in which his drunken friends had left his studio last night. "How am I going to be able clean it all up?" he asked. Guillaume gave a wonderful laugh and told him not to worry, he'd take care of it.

I went to Picasso's as I had promised. As I went in I was overcome by a mixture of smells. He and Apollinaire had spent the entire afternoon cleaning it up, but they hadn't been able to find anything better to wash the floor with than paraffin, and it was only when the job was finished that they realized the smell was unbearable. To remedy this they dipped the broom in bleach and swept it again, then sprinkled it all with eau de Cologne to give it a pleasant perfume. You can imagine the fumes that this combination gave off.

Picasso was overjoyed to see me in his home again! I think I've grown fond of him this past year. I felt almost happy, touched by seeing him so moved. He had the sensitivity to let me leave without asking anything of me.

Laurent's off tomorrow. What luck!

Laurent has gone, and I'm supposed to be seeing Picasso tonight. He told me he has been smoking opium at the house of some friends, but that he was going to buy his own pipe, lamp, and needle and a supply of the drug and let me smoke some too. I listened to him with amazement. Here's something new at last, and of course I'm fascinated.

Picasso has bought the necessary equipment: the tiny, mysterious oil lamp; the long bamboo with its ivory end decorated with enamels and chased silver plaques and its

octagonal clay bowl with that treacherous, sensitive, acid and penetrating reek of opium; the needles, which are always slightly coated with "dross"; and most importantly, the pot of oily paste in shades of a lovely golden brown like ancient amber. You lie on the dry mat covering the floor as if it were a featherbed, you make sure the stuff is within your reach and all you have to do is perform the simple action required to reach the bamboo. You prepare the pipe by kneading the teardrop of paste you have taken with the tip of the needle, apply this to the bowl as you hold it above the pale flame of the lamp, then take the ivory end of the pipe between your lips and slowly inhale into your open lungs the pungent smoke given off by the opium as it continues to burn above the flame, taking care all the time you're inhaling to use the needle to keep the chimney in the center of the bowl clear.

In spite of having an upset stomach and oppressive headache afterwards, which kept me in bed the next day, I couldn't wait to start again so as to achieve that spiritual intensity and sharpening of intellectual awareness that one experiences under the influence of the drug.

Everything seems beautiful, bright and good. It's probably thanks to opium that I've discovered the true meaning of the word "love," love in general. I've discovered that at last I understand Pablo, I "sense" him better. It seems as if I have been waiting all my twenty-three years for him. Love has risen up in me like a feeling that is suddenly coming into flower.

A curious closeness makes me feel as if he's a part of myself, as my fantasy has wanted him to be, and this feeling, which has stayed with me, must be the reason I made up my mind almost instantly to bind my life to his, for better or for worse.

I have spent three days with Pablo. I love to smoke opium, I love Pablo. He is tender, kind, amorous; he pleases me. How can I have been blind for so long? Not to have understood that this might be the place I would find? I no longer think of getting up in the middle of the night and going off to find Sunyer, as I was still doing only recently because of the pleasure his lovemaking gave me.

I'm happy in Pablo's arms, much more fully happy than I ever was with Sunyer. I love him; I'm going to love him so much. He doesn't want me to go on modeling, which is a problem, as Cormon and Sicard have embarked on *grandes machines* with me as a model. He wants me to go and live with him. What should I do? I'm going to try and gain a week's respite by seeming to hesitate, but my mind's made up.

Laurent won't be back for another two weeks. In spite of Picasso's insistence, I can't go and live with him and let down the artists who have always trusted me. What should I do? I don't want Pablo to be unhappy, and he will be if I don't move in with him. However, I'm frightened of his jealousy. He can be violent. Renée and Benedetta say I shouldn't delay.

This summer is marvelous. The sun rejuvenates everything in the Place Ravignan; even the squalid Hôtel du Poirier seems cheerful and lively. The little

square is baked by the sun, the benches with their blistered paint are burning to the touch, the pebbles shimmer, the leaves are drying on the branches, the old Bateau Lavoir stands guard and defends its bohemians from the approach of undesirables. "Wealthy bourgeois, keep out! Keep away from this retreat where artists lead a full, demanding life you know nothing about. Here life is preserved by hope, love and intellect. Here the law is made by youth. All you well-informed, sensible, rational people, leave those who live here in peace. They know nothing about ordinary life; they are crazy, illogical, cynical, scathing, they respect nothing but beauty."

Since I have come to understand Picasso and his friends, I think like this. I'd like to wave a banner with the inscription: "Make way for artists, the only people with the right to live outside society." What an awful word, "society"; it's black, it's grey, dusty, sticky. Ugh! I don't like society! I really have been won over by the madness of the people I'm going to be living with now.

I've met another of Picasso's good friends today on the Place Ravignan, Max Jacob, who has just returned from a trip to Quimper, where he was born. I've heard so much about him that he didn't seem like a stranger, but I'd formed a completely false impression of him. I imagined a young man, but he's middle-aged, or at least he looks it.

The first thing he said to me was ambivalent, both cutting and flattering. I was just coming from the studio of an old Italian sculptor on the Rue d'Orchamps who wants to make a cast of my shoulders and arms. With my clothes all spattered with plaster, I was going home to change, and since I gave this excuse to cut short the introductions, Max said to me: "But why? The stains don't show in the sunshine."

After Picasso had introduced him to me, I looked with some astonishment at this dapper little man with strange eyes that pierce through the lenses of his spectacles, looking ceremonious and pleased with himself as he bowed very low with his hat in his hand. He's already bald, and his eyes are a little shifty; he has a rather high complexion and his mouth, which is beautifully curved, is delicate, but witty and malicious too. All his features are beautiful. His head is perhaps a little too large and his body is ill proportioned, with narrow shoulders. His slightly provincial air was emphasized by the cut of his brand new clothes. His whole personality seems to convey an indefinable sense of anxiety, but one is immediately struck by the impression he gives of originality and intelligence.

Yesterday Pablo sold a few drawings for sixty francs to a bedding merchant on the Rue des Martyrs so that he could take me out to dinner at the Lapin à Gill.* Apollinaire was with us and Max Jacob and some others. I got a kiss from the old *patron*,

* The Lapin à Gill (or Lapin Agile), a Montmartre cabaret on the Rue des Saules, was a favorite haunt of the *bande à Picasso*; see p. 173.

Frédé, whom I've only seen before when he goes around the Butte de Montmartre on Fridays sitting in his donkey-cart shouting out his "bouillabaisse." His wife Berthe was there too. It's the first time I've ever been to this tavern, and I met some interesting people during a very convivial meal. Guillaume Apollinaire was extremely attentive to me, and Pablo became depressed and jealous with all the festivity going on around him, as he can't bear it if anyone else shows an interest in me.

Some Germans who are admirers of Picasso came in, and they carried him around in triumph. Pablo began firing revolver shots in the little square at about three in the morning so as to get rid of them. I went back to Laurent's and fell asleep immediately. I found all this glorification rather frightening.

Sunday, [September 3, 1905]
Today, in the scorching sunshine, I've taken my things over to Picasso's. It wasn't very heavy. I just had the little black wooden trunk he lent me, packed in haste and carried across to his studio even more hastily.

Laurent got back yesterday. He didn't leave till quite late to have dinner with his family. I didn't say anything to him as I'm frightened of his rages. I'm going to have to shut myself in at Pablo's until I know he has gone out in the evening.

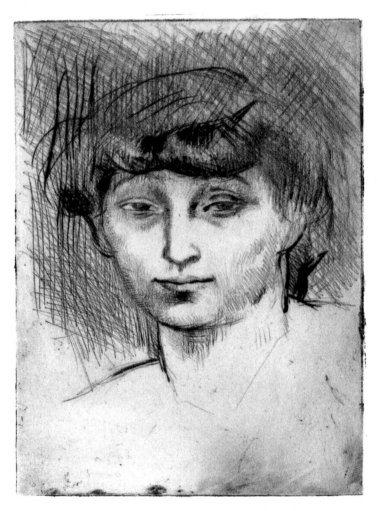

Picasso. Drypoint portrait of Fernande, 1906. Musée Picasso,
Paris.

IN LOVE WITH PICASSO

Fernande's Journal, Fall 1905–March 1907

[fall 1905]

At last I am happy, and Pablo tells me that he feels as if he has awakened after a long sleep. All he did from the moment I agreed to come and live with him was wait for me. Life is going smoothly and I've given up working. Cormon is such a sweet old bohemian that he quite understood when I told him I wouldn't be able to go on modeling, and he didn't protest. Sicard wrote to Picasso and even paid him a visit: "Come with her to the sittings, there's only a fortnight's work left to be done,"

"Well, I don't give a f…!" replied Picasso.

I feel at peace, hidden away in this studio. I can't venture out alone, except after Laurent has left, but as I have no money I'm not interested in any of that. Now we go out in a group with Guillaume Apollinaire and Max Jacob to Vernin's, a bistro where you can eat on credit.

I feel as though I'm beginning to live my real life. Pablo loves me. I sleep a lot; I've been used to going to bed early after my tiring days, so I still fall asleep around nine. Pablo watches me, draws, works at night and goes to bed at around six in the morning. As he's in the habit of working at night so as not to be disturbed, and he's at his best at night, he complains about my sleeping all the time. It's true, I'm going to have to adapt so that I can be a little closer to Pablo when he's "awake."

The studio is quite unique. Standing at the entrance, despite the fact that there's practically no furniture, you wonder just how you're going to be able to make your way into it. It's full of the strangest assortment of utensils and household objects, including a rusty old frying pan grandly called "receptacle serving the function of chamber pot" and a large tin bucket for washing, which is always full to overflowing with dirty water.

Across from the door is an enclosed space with rotten floorboards that's supposed to be a bedroom, but Pablo uses it for storing all kinds of junk and, before I moved in, he set up a kind of shrine there dedicated "to the memory of a young woman I used to know and hope will return to me." On the wall there's a quite beautiful portrait of his heroine done (once, while I was asleep, during those weeks I was here

Roofs of the Bateau Lavoir with the location of Picasso's studio marked by the artist.
Musée Picasso, Paris—Archives Picasso.

last year) in pen and ink and, in front of it, a table with lighted candles, which are immediately replaced as soon as they burn out, as well as two deep blue Louis-Philippe vases with artificial flowers in them, like those Cézanne must have had. The drawing on the wall is framed and covered with glass and bordered by a white blouse of fine lawn that I used to wear. What inspired him to create this shrine dedicated to unrequited love? As well as nostalgia, a mocking self-irony and humor, I think it showed a kind of mysticism that Pablo must have inherited from his Italian ancestors, although he himself is Spanish. He pretends to laugh at this "votive" chapel, but he won't allow me to disturb it.

The paintings he's doing are quite different from those I saw when I first came to the studio last summer, and he's painting over many of those canvases. The blue figures, reminiscent of El Greco, that I loved so much have been covered with delicate, sensitive paintings of acrobats, and he's done a large red harlequin with a pointed cap over the picture of the old cripple with his basket of flowers. There's another large canvas showing acrobats exercising in front of their caravan; a child is balancing a ball and a couple performing precarious leaps in a haunting, deserted landscape, painted like a fresco in pale, matt, pastel shades. But he never seems to be satisfied with his work and is constantly reworking the pictures. He has started

IN LOVE WITH PICASSO

a drypoint of Salome dancing in front of Herod and holding the head of John the Baptist.

I'm getting to know Pablo's Spanish friends, some of whom I met at the Canals's and at Pablo's studio last year. There's a mattress in a corner of the studio and, although it's a bit hard, it's always there if anyone stays late or doesn't have anywhere to go, like the guitarist Fabiano, who has taken up painting in rivalry with Picasso. Life is hard for most of the artists, as there aren't many collectors, while dealers are suspicious and keep their distance.

Paco Durio, the one who asked me to marry him last year, is very small, very round, and has a tireless, enquiring mind. He's a sincere, original artist and adores art. He lives in a little alley near the maquis in a large studio, where he has installed a kiln for his pottery. He was a great friend of Gauguin's when they both lived in the Rue de la Grande-Chaumière, before Gauguin went to Tahiti, and Picasso is his other great passion. His warm-heartedness to his friends is matched only by his tact. Pablo told me he once found a can of sardines, a loaf of bread and a liter of wine on his doorstep, which Durio had left for him.

We still often have simple meals with the Canalses, but we sometimes supplement this diet of spaghetti with dinners given by Zuloaga, where the expenses are shared with his compatriots Etchevarría, Pichot, and Anglada, who are a little better off. Anglada is from Barcelona, and so is Ramon Pichot, an old friend of Pablo's who looks like Don Quixote. He's very humorous and has a heart of gold, though his irony can be quite biting. Etchevarría is a Basque, a wealthy, fashionable painter with a respectable, rather distinguished appearance.

Another of the Spanish artists, Manolo, is quite the reverse—bohemian and easygoing, always after a bed, a meal, or "una peseta," or any profitable deal. He has an extraordinary accent and is typically Spanish, with very black eyes in a very dark face beneath very black hair, ironic, cheerful, sensitive, lazy, and extremely crafty. He'll appear to agree to something if he's put on the spot, but he'll wriggle out of any commitment. He's a sculptor, whenever the day-to-day problems of existence allow him to be, which isn't very often. He's always dreaming up highly complicated schemes that are so surprising, so ineffectual and so fantastic, that, however warmly he's welcomed, you always feel slightly mistrustful. And he's always playing outrageous tricks, though no one holds this against him. Paco Durio is a great help to him, giving him his old clothes—though Manolo claims he can only wear the trousers as cycling shorts.

Manolo has an amazing reputation in Barcelona, where he was both penniless and homeless before coming to Paris. It's much harder to survive there like that than it is here, but fortunately he became the sweetheart of a dairyman's daughter and was employed to sculpt animals and flowers in the lumps of butter that the dairyman displayed every day in his shop. Apparently he even created little pastoral scenes.

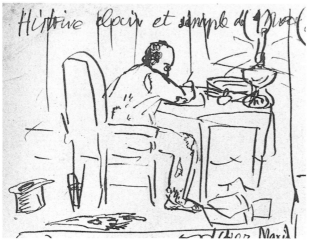

Picasso. *Max Jacob at His Desk*, 1905, the first scene of a comic-strip fantasy of the poet's rise to fame and fortune. Musée Picasso, Paris.

Picasso. *Guillaume Apollinaire*, caricature, c. 1905. Private collection.

The studio is like a furnace, and Pablo and his friends quite often strip off completely. They receive visitors practically, if not completely, naked, just wearing a scarf tied around their waists. Pablo likes this as he makes no secret of his beautiful body. He has small hands and Andalusian feet that I know he's very proud of, just as he is of his legs, which are well proportioned if a little short. He has broad shoulders and is rather stocky; he'd love to be a few inches taller, so that he'd have a perfect physique.

Max Jacob and Apollinaire come by every day, and Max, who's so witty and amusing, so spirited and dynamic, is our master of ceremonies. Picasso and Guillaume could laugh all night long at Max's improvisations and stories, his songs, and the faces he pulls. Then other friends turn up and the studio echoes to our laughter. Sometimes we become quite idiotic and, like children, encourage each other to see who'll take things farthest, but the prize always goes to Max. He can be so funny, particularly when Pablo is in one of his more morose and scathing moods. But then someone makes a chance remark that sobers us up and conversation degenerates—or rather, becomes more serious. Then we discuss art and literature with as much passion as we've put into our fooling.

I drop out of the conversation once I feel it's moving into areas beyond my range. But I listen, I take note, I understand, and my interest in these discussions has helped me develop talents I'd never have guessed I had.

IN LOVE WITH PICASSO

Guillaume is a strange mixture of the aristocratic and the vulgar, especially his crude, childish laugh. He has the hands of a priest with unctuous gestures (there's a rumor he's the son of a Vatican priest; his mother is Russian or Polish), but he also has a gentle, childlike quality, calm and serene, serious and tender, that makes you listen trustingly when he talks, and he does talk a lot. He's charming, cultured, and artistic, and such a wonderful poet. I wouldn't say he has particularly refined sensibilities, but his infantile, childish sentimentality has great charm. He's paradoxical—histrionic and bombastic at the same time as he is simple and naive.

Like Picasso, he smokes a pipe, and he always has his pipe in his mouth or in his hand when he tells the most trivial or hilarious stories in his solemn manner. He loves to recite his own poetry, but he does it atrociously! Even so, despite this inadequacy, he manages to touch our hearts. He always turns up in a great hurry with a lot of old books under his arm, or with a few engravings he has unearthed for a few francs in some odd place. Invariably he thinks he has found an amazing bargain, even though he sometimes forgets one of the books he's just bought on the seat of a bus or a train.

One of the others who comes here a lot is André Salmon, who's also a friend of Max and Guillaume, though he's very different and his poetry has more sentiment. He's refined, subtle and clever, perhaps a little superficial, but very elegant. It's the delicacy of his wit that makes an impression, and he can tell the raciest stories in a most exquisite fashion. He's very friendly, although he can be quite caustic, and has a tall, slim, distinguished appearance, which makes him look very young. He's a dreamer whose senses are always alert, and the eyes in his pale face shine with intelligence. He has a special way of smoking the wooden pipe he always holds in his long, slim hands, and his rather awkward, clumsy gestures are an indication of his insecurity.

Guillaume lends me books. He has an excellent library where you can find works by almost all the important authors from the eighteenth century to the present day. What would I do without reading? We don't have any money, so we hardly ever go out, except somewhere in Montmartre where we can have dinner on credit. After we've eaten we often go for a walk and observe Paris asleep from the top of the Butte near the Sacré-Cœur. Then Picasso seems to be less anxious, less ferociously silent, less wrapped up in the one thing he cares about, his painting. He becomes more cheerful and seems to be more interested in things around us, in the things that amuse me.

I know I have a talent for painting, but I've never had any instruction except when I was at school, and that was useless. I've asked Pablo, but he refuses to give me any advice. "Enjoy yourself," he says, "be satisfied with that, as the pictures you do are more interesting than anything you'd do if you were advised by someone else." He's very Spanish and believes that women, if not inferior, should not trespass on men's

Fernande Olivier.
Vase of Flowers.
Private collection.

preserves. But it annoys me just to dabble in things I'm really excited by, and I want to go into them much more deeply. So I spend most of my time reading, as that allows me to study more seriously. I am a little surprised that Pablo, who seems to be well informed about the literary world, never reads. When I first got here I could only find one book, Stendhal's *De l'Amour*. But he works too hard to be able to devote any time to books. He'll even go for whole days without speaking. Sometimes I worry and wonder if he's getting tired of me, but when I ask him he says, "I'm thinking about my work, but I love you more and more." That makes me happy and I go back to my reading.

We're managing to survive on fifty francs a month and sometimes we have enough left over to pay the bill at the paint shop. Pablo sweeps out the studio and gets in the provisions, and I must admit I'm very lazy. But I do the cooking, and although I have to make do with one or two francs a day, Picasso's friends like what I prepare. Luckily, we're able to get a lot on credit. The tradesmen round here are very trusting

and the accounts soon mount up to considerable sums—fifteen or twenty francs—which are difficult to pay off.

Lunch is never so good as when there's not a sou left. Then we resort to getting things from the cake shop. We order lunch from the pâtissier on the Place des Abbesses, asking him to deliver it at noon precisely. The errand boy arrives at the appointed hour and knocks at the door but there's no answer, so he has to leave his basket on the step. The minute he has gone, we open the door—and we pay a few days later, when we've got a little cash. We've also had meat on credit from the charcuterie, and for a while all our visitors were treated to slices of a large, succulent Bayonne ham.

When we eat out we always go to Vernin's, as we can get credit there too. Vernin, who comes from the Auvergne, has his place on Rue Cavallotti, just by the pawnbrokers, which is handy if we're lucky enough to find anything left to pawn. He has a terrible memory and is very decent to artists, never refusing them credit. This is why Pablo and all his friends regularly meet there at midday or at seven in the evening, and the numbers are generally swollen by friends that one or other of them has brought along, whose meals get put down to somebody's account.

A lot of theatrical people go there and it often looks like a scene Pablo might paint. There are young actresses like Christiane Mancini, who studies her part as she eats, propping the script against her half carafe of red wine. Her sister Louise, who sings at the Opéra, often goes there too. Several actors eat there regularly—Roger Karl, Charles Dullin, and Marcel Olin, a tall man, who can be violent and unpleasant, but also amusing as he's always on the scrounge. He does quite well at Vernin's: "Another place to hoist the flag!" he says.

The mathematician Maurice Princet is often there with his wife, but they are such a sad couple. He's very thin, and his face, which is hidden by a bushy red beard, never loses its mocking, spiteful expression. She's the precise opposite of her husband—very pretty, dark, with a smooth skin and a cruel, angry, passionate mouth.

Max has written a little verse about Vernin, which fits the tune of a popular song:

> "Ça m'ennuie d'aller chez Vernin,
> Mais il faut y aller quand même
> Parce qu'on y prend des verres nains
> Et des fromages à la crè-è-me!"*

The customers there are a mixed bunch, and in that hot, cramped room, the smell of the cooking mingles with that of the rough wine rather unpleasantly. But nobody minds, it's always very lively and we all eat heartily. We're more cheerful when we get back and ready to resume work with renewed energy, for everyone in the group

* It's a bore to go to Vernin's, but you have to go there just the same, because of the dwarf glasses (verres nains = Vernin) you get there and their cream cheeses.

is dedicated to work. Of course, there are wasted days from time to time, but they are always made up for later.

Dealers are beginning to come round to the studio. They criticize the work, assess it, think it over and then argue before deciding to "do business." Pablo hates them, as he can't bear to sell works he considers unfinished, and he says that to him a painting is never finished, something could always be added. He resigns himself to parting with his pictures because he's forced to, as he wouldn't otherwise have the materials to work with, but he always complains about it and feels resentful for days afterwards. He becomes particularly disagreeable if a dealer makes him waste several hours of time when he could have been working.

One of the reasons Pablo often works at night is to avoid being disturbed, and then he goes to bed at dawn and sleeps until the middle of the afternoon. If he gets awakened during the morning it puts him in a murderous mood, even if the intruder happens to be a dealer. However, one day, when there was no money to buy paints or canvases, he went to find the dealer Clovis Sagot and invited him to visit the studio. Sagot, who's the stingiest of the whole lot, worse than a Jew and nine Armenians combined, knew perfectly well what was behind this offer: dire financial straits. He came in with Pablo and decided on three quite large works: two gouaches Pablo had done in Holland and a life-size painting of a little naked flower-girl with a basket of flowers. Sagot made an offer of 700 francs for the three, and when Picasso turned this down he left.

Picasso spent some weeks in Holland last summer, before I moved in, with a bohemian Dutchman, Tom Schilperoort, who had come into some money. He didn't like the country much; it is too foggy for someone who loves the sun, but he was amazed how tall the Dutch girls were. He told me that these "little girls," who towered head and shoulders above him, would kiss him and sit on his knees. He couldn't get over it. "I felt embarrassed," he said "and those lines of young school-girls the size of guardsmen walking in a column down the street are absurd." But he did some good pictures of them, including one of three Dutch women with strange caps perched on their heads. This was one of the ones Sagot had admired.

Anyway, after a few days we still desperately needed money, so Pablo decided to go back to Sagot and accept his offer. But Sagot said he had thought it over and that 500 francs was really the most he could give for the three pictures. Pablo was furious and came back to the studio having refused the offer. A few days later they went through the same performance, except that Sagot's offer was now down to 300 francs and Pablo had to accept.

Sagot is completely unscrupulous. His set up his gallery in an old chemist's shop, and he offers the patent medicines he found when he moved in to his artists if they are sick. He has tried to get me to take a medicine for diabetics when I've had a bad chest cold. And he brings great armfuls of flowers from his garden in the country to Pablo: "so that you can do a picture of them and make me a present of it," he says.

Just recently, when Sagot came to the studio to buy a drawing, I caught him wrapping up one or two extra. I found some pretext to take back the roll, undid it and gave him back his one drawing, returning the others to their folder without saying a word. Sagot wasn't the least put out by this, not even embarrassed. He just smiled, and that said it all.

Vollard isn't much more generous than Sagot, but he's honest and he doesn't try to bargain. He's always in a hurry. He comes to the studio, chooses the things he likes, makes an offer and whether or not it's accepted, never goes back on his price.

One of the other buyers is completely different. He has a shop on the Rue des Martyrs, opposite the Cirque Médrano, where he sells bedding and all kinds of secondhand bric-a-brac. Everyone calls him Père Soulier. He comes to the studio quite often and buys drawings for a few francs. He always concludes his dealings with Pablo at the bar of the bistro next door and he'll offer a drink to anyone who happens to be in the studio. I can't make out what he wants with Picassos or who he sells them to, unless it's to someone who wants to buy really cheaply as a speculation. There's someone called Libaude who does that, a horse dealer who writes under the name of Lormel, and owns some of Pablo's paintings.

Once Père Soulier asked Pablo whether he had a picture of flowers he could have immediately. He didn't, but offered to paint him one.

"But I must have it tomorrow!" exclaimed Soulier.

"All right. You'll have it tomorrow evening, but the paint won't be dry!"

"Never mind, I'll be careful how I carry it."

Unfortunately Pablo was right out of white paint and had run out of credit at the paint-seller's, Schwartz-Morin in Rue Lepic—his account had reached 900 francs!

So he decided to make do without, and produced a very pretty, brightly colored, flower piece, quite big too, which he sold to Père Soulier for twenty francs.

It's dreadful having to work under these conditions, but Pablo never complains. He really lives for his art and when he works is able to forget all his troubles and worries, and he'd rather sell a painting for twenty francs than do something he doesn't believe in.

[1906]

We've had no celebrations during the holidays. We were aware it was Christmas, but on New Year's Day Max and Guillaume both went off to their families. Dullin was the only one who came to see us, around six o'clock, and we took him with us to Vernin's. He didn't have a sou and neither did we. I was a little tired of that walk—down the Rue des Abbesses, over the Pont Caulaincourt, up the little Rue Cavalotti with its pawnbrokers, where we have nothing to pledge—but when we got to Vernin's, Dullin played the fool and entertained us.

Roger Karl was there, having dinner there with Christiane Mancini. They were making a show of being madly in love but didn't appear to feel this very deeply. It

was more like a scene from a play. They even exchanged photographs on which they inscribed dedications to each other. Dullin told us all about them. Max is also a friend of Roger Karl and has told us some pretty nasty things about him.

[February/March 1906]
I have already been living here with Pablo for six months. When I arrived it was too hot in this studio; now it is terribly cold, so cold that if we leave a little tea in the bottom of our cups it's frozen by morning. This doesn't prevent Pablo from working the whole time, but I stay in bed so as not to get frozen stiff. We have no coal, no fire, no money—Pablo has just gone out in search of a few sous—but I'm happy in spite of this. We're not miserable; we love each other.

I don't know how I could have resisted Pablo for so long. I love him so much now!

Yesterday Pablo managed to sell a few drawings. He went straight to the coal merchant, and now the stove's red hot. How happy we are! So happy we didn't go out to Vernin's but had dinner here with Max by the fire. Paco Durio came and so did Manolo and Fabiano the guitarist.

Picasso seems to have settled into a new pattern. When he works during the day, he lets the daylight fall straight onto the canvas, which he props up against the easel on the floor. Then he sits on the floor, or on a low stool, or stands, depending on what part he's working on, with his palette, his sable brushes and his paints scattered beside him to his right. He paints with the same kind of oil we use to fill the lamps.

It's cold, and we're out of coal again. Pablo doesn't seem to notice when he's painting at night. I made him some tea. He came to bed frozen at about three in the morning. Luckily I was really warm. He took me into his arms and we slept until midday.

After dinner on Tuesdays we've been going to the Closerie des Lilas, which has kept some of its charm from the days when shopgirls used to go dancing there and meet their sweethearts—artists, students or shop assistants. The Closerie is in a quiet residential area at the corner of Boulevard Montparnasse and Rue d'Assas, and its terrace spilling over onto the sidewalk looks almost suburban, with its potted oleanders stunted by the shade of the tall trees around the statue of Marshal Ney. But the new crowd that goes there has created quite a different atmosphere— they're almost all intellectuals or artists, the picture of bohemianism, with their capes, broad-brimmed felt hats, untidy long hair and loosely tied cravats.

Often we go on foot, which is fun, even if it means walking right across Paris. These Tuesday evenings are organized for *Vers et Prose* by the journal's founder, Paul Fort, and are attended by poets, writers, painters, sculptors and musicians, young

and old, who crowd into the café and onto the terrace. Drink is unlimited and by midnight everyone has become quite exhilarated. Paul Fort, who's always full of energy and manages to create chaos everywhere, tries to make his strange, shrill little voice heard through the pandemonium, but the discussions often go on so long that the owner ends up throwing us all out.

The poet Jean Moréas never misses an evening. He's always in his favorite seat at the back of the room, facing the door, and you can hear his imperious, resonant voice booming from one end of the café to the other as he greets new arrivals with remarks that are often cutting or downright offensive. He does this on purpose, as he finds their embarrassment amusing, but people admire him so much they'll take anything from him. He always greets Pablo by asking him, with heavy sarcasm, "Tell me, Picasso, did Velázquez have any talent?" and then, making a sound as if he's gargling, he adds: "What do you think of Lope de Vega Carpio?" He loves this name for its wonderful sound and intones it as if it were a beautiful poem.

One evening, the wife of a poet was fawning on him, telling him she couldn't bear the idea of aging and didn't want to live beyond forty. Moréas turned to her: "Well, Madame, your last day is nigh." He can't stand Jews and is always making fun of them. Once, when a little-known, untalented Russian Jewish writer started a sentence, "when I'm dead…," Moréas interrupted, "But my dear friend, you've been dead for years!"

He himself is victimized by a tiny woman, who seems quite out of place in this company but holds her own with the sharpness of her Parisian humor. She's blonde, vivacious, quick as a street Arab and always directs her banter at Moréas. He takes it all cheerfully, though he flinches a bit when she teases him about his dyed mustache, which he curls with tongs. He's extremely vain, but is rather careless about personal hygiene and one day she said, "You know Moréas, at twenty centimes an hour, a charwoman probably wouldn't charge you more than forty centimes to scrub out your ears and clip all the hairs hidden in them." Moréas carefully licked his fingers, twirled his mustache, which made his fingers black with dye, and answered gravely, "I'll think about it!" It was very funny.

If he wants someone to come and sit next to him he'll make all his cronies move. One evening recently I arrived shivering with cold in my light coat, but wearing a little otterskin hat that had come from Pablo's sister. Moréas looked at me with my hair refusing to stay put under this little bundle of fur and boomed out: "Come here, little rabbit, come and sit beside me," and the wife of the famous poet Gustave Kahn had to give up her seat.

I sometimes play dominoes with him. He has a passion for the game, but takes it very seriously and likes to win. He gets furious if his opponent has a stroke of luck or anyone makes a mistake. Once when I was his partner, playing against Paul and Suzon Fort, I made a real blunder. He picked up a fistful of dominoes and threw them in my face. I got upset, but five minutes later he had forgotten all about it and

after the Closerie turned us out he insisted we go with him, as often happened—Paul Fort, Suzon, André Salmon (who was the secretary of *Vers et Prose*), Apollinaire, Max, Picasso and I—to his regular morning hideaway, a little bistro close by on Boulevard Montparnasse. That night dawn had already broken before we were able to get away.

I don't know if Moréas is really poor or just very tight with money. He's very fond of Manolo; he finds our friend's quick wit entertaining and likes his company. One evening, he took him on a walk through the Latin Quarter and they sat down in his favorite café. Moréas ordered dinner for himself and a sandwich for Manolo. And after dinner he lit a fat cigar and offered Manolo some cigarette ends.

Another of Manolo's "patrons" is also a regular at the Closerie. Maurice Raynal seems intent on squandering the small fortune his father has recently left him in a grand manner, seeing himself as a patron of the arts and helping many artists. A couple of years ago, when he was in the army, his unit was serving in the garrison at Toul, and he took Manolo there for quite a long period. He paid for everything and they managed to scandalize the whole district.

It was at one of these Tuesday gatherings, before I started coming with him, that Picasso had met the pair who, like several others there, take opium and persuaded him to try the drug.

Frédé, who runs the Lapin à Gill, sometimes comes with his donkey, Lolo, to visit us in the studio, which is on the ground floor, and has lunch with us. They arrive laden with food and coal and we all devour this impromptu feast with hearty appetites. The last time they were here, we noticed the sound of chewing and saw that Lolo, who was standing quietly behind us by the couch, was eating the two beautiful Spanish silk scarfs we use to cover it. We were sure she considered them to be a fancy dessert to help her digest her main course, a packet of strong tobacco (50 centimes) she had snapped up from the top of a table.

Frédé always looks so picturesque with his beautiful white beard. He wears a brown corduroy suit with a broad, red flannel belt and has a crimson scarf knotted around his head like an Italian bandit. Over this he wears a shapeless felt hat, which the weather has turned green. He knows nothing about music, but when he sings sentimental old street songs, strumming unharmoniously on his guitar or his cello, his fine voice is full of subtle variations. His smile is candid but shrewd, and I've detected a gleam of cruelty and greed in the depths of his small, inquisitive eyes.

He's always happy to see his artist friends at the Lapin à Gill and welcomes us warmly. The place used to be called "Le Cabaret des Assassins," but the cartoonist André Gill changed its name when he took over as tenant. The actual owner was Aristide Bruant, who was a great friend of Frédé's. We often end up at the Lapin after an evening walk through Montmartre. We eat at rough wooden tables, which are well scrubbed by Frédé's wife, Berthe la Bourguignonne, and stand on a stone

floor with sawdust scattered on it. The dark old room is dimly lit by two kerosene lamps suspended by wires fixed to the ceiling, which smoke under their pleated red paper shades. The walls are covered with posters and paintings, including one by Picasso, and with drawings by Suzanne Valadon, Poulbot and others. In one corner, near a window with murky panes—the dim light adds to the mystery of the place—Frédé has built a plaster fireplace, where white mice are always running about, and in another corner there's a huge statue of Christ on the cross, also in plaster, a sensitive, forceful work by the sculptor Wasley.

It often gets noisy in there, as the thick, chipped glasses are banged violently on the table when discussions get heated, but at other times all our friends join in with Frédé when he sings his old French melodies, and Berthe adds her clear, childlike voice to the male voices in the choruses. Sometimes Dullin recites poems by Villon or Jules Laforgue in the darkest part of the room; he is a true genius. All this is watched, with varying degrees of indifference or interest, by the "gangsters"—pimps and worse—who've been coming here since its days as "Le Cabaret des Assassins," and who get along perfectly well with the artists, their wives and the other neighborhood regulars.

The only thing you can order to drink—or just about—is the house special, a mixture of white wine, grenadine and perhaps a drop of straight alcohol or some other indistinguishable ingredient. They also have wonderful cherries in eau-de-vie at a few sous a dish (any that a customer hasn't eaten get put back into the jar), and if ever we order a meal at the Lapin we eat remarkably well for quite a modest sum. Berthe's cooking is legendary.

We've had a windfall. Picasso never answers the door in the mornings, and the concierge, who knows this (and about our ever-pressing need for money, among other things), came at ten o'clock this morning, knocking at the door herself and shrieking: "M'sieu Picasso, M'sieu Picasso, you'd better open up, this is a serious visit."

Picasso, who was fast asleep, leaped out of bed to open the door, while I took refuge in the little bedroom. It was Olivier Sainsère, and after getting Picasso, who was never embarrassed by his state of undress, to put on his trousers, Sainsère bought some drawings for 300 francs. He stayed for ages, while I was shivering with cold, as I had hardly anything to cover me, but afterwards we warmed ourselves by dancing for joy at the sight of those banknotes. After one last kiss I went back to bed while Pablo went to order coal—several sacks, so that we wouldn't be cold again for some time. He brought me cakes, candy and fruit and got back into bed with me. The coalman came and I hid under the bedclothes while he dumped one of his sacks by the stove in the studio. Then we made a fire and some coffee.

After that Pablo got down to work; he's doing a drypoint of me. Max and Guillaume came at around six in the evening, and a little later André Salmon and Manolo turned up. Then we all went out to eat at an Italian restaurant on the

Boulevard de Clichy and afterwards on to the Médrano circus. After that we climbed up to the Lapin, where Berthe gave us onion soup. We laughed, sang and talked, and Pablo didn't even get jealous, so I was able to be unreservedly happy. But when everyone eventually left to go to bed our 300 francs were sorely depleted. We've got just 70 left.

This Sainsère is a serious and conscientious collector, and his love of and faith in modern painting are more like an artist's than a collector's.

We've got to know a Dutch artist, Kees Van Dongen, who moved into the building with his wife and child around Christmas. They're very hospitable, as his wife likes to be surrounded by friends, although I know she often has to make do on less than a hundred francs a month. He spends his evenings sketching in the local dancehalls and cafés and is becoming steeped in the life of Montmartre. Their little girl, who must be about two, calls Picasso "Tablo" and spends her days with us. I've made her a little black rag doll, which is now her favorite toy, and she arrives after breakfast clutching this in one hand and an enamel bowl in the other. She knocks on the door with her bowl, shouting, "Tablo, Fedande!" and takes possession of the studio, and of us, too. Pablo is very fond of little "Gussie" and never tires of playing with her; she can get him to do whatever she wants. I'd never thought he'd enjoy himself so much with a child.

Spring has arrived at last. I've been so bad at keeping up my journal. I don't seem to be able to see anything through. It's the same when I make up my mind to keep a record of our daily expenses: I do it for a day or two and then I forget.

Our love for one another has not diminished in any way. On the contrary, the ties between us seem to be getting stronger and stronger. All our thoughts and feelings seem to coincide, physically, spiritually and emotionally. We have fights, as we are both very stubborn, but these don't count for anything. I've always tried to avoid interfering with Picasso's work in any way, although I know just how much he regrets not being able to give me everything I want. But all I really want—and I'm jealous about this!—is his affection. If ever he does manage to earn a little extra, he lets me do as I like with it, and I accept it happily. He never denies me anything and would deprive himself of food, even pretending he has already eaten, to buy something to please me. I ask for very little, but in our situation it's still a lot that he gives me.

At the moment we're absolutely destitute, and a few days ago Pablo was asked to do a series of drawings for the satirical magazine *L'Assiette au Beurre*. This could have earned him 800 francs, and he looked at me to see if I wanted him to accept. It was tempting, but I could see he was really unhappy about it and signaled "no" to him.

"Are you sure? I understand, you know, and I'll do it for you."

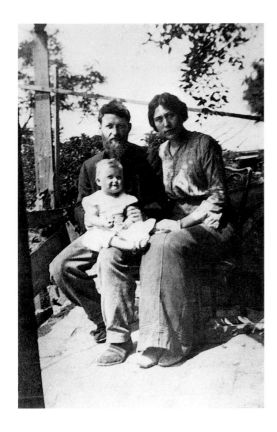

Kees, Guus and Dolly Van Dongen, 1906.

"No, really, you mustn't do anything you don't want to do." I knew he'd find this kind of work upsetting and it would make him unhappy. I thought to myself, "I'm so happy now, and I'm sure it would make me unhappy too. So it's best to refuse and then everything will be all right."

Even so, we'd probably have gone hungry that evening if we hadn't been able to eat on credit at our restaurant. We went quite late, as I haven't got any shoes at the moment and in the dark no one can see my old espadrilles, which once used to be white. But Pablo always makes sure I have my bottle of perfume, my rice powder, my books, my tea—and, best of all, I have his love.

The days are passing and our life is settling down a bit, although it's still quite disorganized. I think it does him good to have a woman around. We're eating most of our meals at home, but Pablo is so jealous he won't allow me to go out alone, and he takes the string bag and does all the shopping himself. This obsessive jealousy is the sole cause of our occasional fights.

He threw a stupid tantrum when we came in around midnight last night. We had been to the Lapin and he accused me of deliberately attracting the attention of one of the diners. I replied that I thought he behaved in a very familiar way with some

of our women friends. Didn't I see him with one of them sitting on his lap? Eventually I lost my temper so badly I didn't know what I was doing and ran out of the house, fled down the Rue Lepic, crying with rage, without any thought of where I could escape to. I was still running when Pablo, who had run after me, grabbed my arm roughly and tried to take me back to the studio. I refused to go with him, but he wouldn't let go and we almost came to blows. Then my rage evaporated and with a sense of despair I allowed myself to be taken home.

The danger is that a scene like this brings home to me just what miserable circumstances I'm living in. I'm young, and people say I'm beautiful, and yet I'm spending the best years of my life in abject poverty. I'm ready to accept this for love, but my lover's morbid jealousy is aroused by the slightest involuntary gesture I make, and he forgets that I am a woman who ought to be entitled to a more comfortable way of life. I told Pablo all this, I couldn't help myself, and he turned pale and said nothing. I thought he was angry with me, that I'd been tactless, but I didn't say anything else and went to bed. He started working and I had been asleep for a long time when at last he came to lie down beside me.

I didn't hear him get up, but when I awoke around midday he was gone. I was frightened, and felt my love for him come back stronger than ever. I was ashamed of my behavior and wondered if he would return, if I would ever see him again. I didn't have the courage to get up all on my own in the studio, and I tried to go back to sleep. I had almost succeeded when I heard the door open and Pablo entered. He came over to the bed and asked: "Are you asleep? Are you still angry with me?" I looked at him, he was holding out a few banknotes and a small parcel—perfume! Dear Pablo, if only you knew that at moments like this there is only one thing I need to make me happy: just for you to be here and to love me.

I haven't been out for at least a week. The other day, after that tempestuous night, we went to buy some books and then came home, where he began to work and I settled down to read.

The weather's beginning to get warmer.

A little while ago we got a cat and now we don't see any more mice, which is certainly an improvement. Minou often goes out onto the roof of the other part of the building, which is below the studio window. We use one side of this as a larder, and on the other side, where the little bedroom is, we tip out dirty water, which drains away into the gutter. The cat can get into other apartments from this roof, and he steals whatever he can find. The other day he came in dragging a long piece of sausage. I gave it a good wash, cooked it and then we ate it, though we felt we had to give Minou his share.

Olivier Sainsère has been back to see us, and as a result of his visit I have been able to buy some shoes, a hat, and some perfume, which ran out a few days ago. I admit

that I do adore perfume—mostly I wear rose or amber—and I use it quite extravagantly. If ever I've been to an opening at a gallery somewhere, any friends who come later say: "Aha! Mme Picasso has been here, and if we follow her scent it will guide us all the way to Pablo."

Pablo still won't let me go out without him. When he goes off he doesn't leave me a key, and although he's never gone for too long this is not pleasant. The other day I heard unfamiliar comings and goings echoing through the building. When I looked out, I saw our neighbors and the concierge gathered in front of the entrance and they shouted to me to come and join them, as a fire had started in one of the studios below ours. The wooden building is so dry and riddled with woodworm that eveything could have gone up in flames, and me with it. I collected a few things together and put on a coat, but everything had already calmed down and the fire was under control. Apparently a kerosene lamp had exploded. Afterwards I was terrified, when I thought that Pablo often double-locks the studio door. He was frightened too when I told him what had happened, and now he leaves the keys when he goes out.

Pablo has brought a young girl to the studio—goodness knows where he found her. He wants to paint her as Joan of Arc. Her face is extraordinary rather than beautiful, with striking red hair and large features, which are perfect, although slightly coarse. She began to pose two days ago. But last night I realized she must be infested with vermin as she has given us both fleas. The simplest thing was to wash our hair with camphorated alcohol, and an hour later we had got rid of these filthy parasites that made us so uncomfortable.

When the girl came back, I didn't let her in. I gave her the fee for modeling and a little extra to buy something to treat herself with, and told her to come back when she was clean. We never saw her again, and Pablo's Joan of Arc never got any further.

I'm not allowed to go to the Lapin without Pablo, but yesterday Frédé was attacked and fired his revolver from the window at the man who was threatening him, wounding him seriously. So today I went on my own to see Berthe and get some news, but Picasso had the same idea and ran into me there. He gave me a violent slap, which took me completely by surprise, and then shoved me roughly out of the forbidden place, while the crowd on the terrace looked on ironically in stunned silence.

Everything Picasso does is in the image of his physical being: a mixture of toughness and softness, balance and imbalance, will and weakness. It's the same when he looks at the works of his friends or companions. He hardly ever says anything, and it's impossible to know what he thinks, and he soons turns away. But everything registers, and he never forgets what he has seen. But he's never jealous of fellow-

artists, and if what he says is sometimes edged with biting wit, this is just a game he likes to play; there's no malice at all.

We've had some surprise visitors at the studio. They are two Americans, a brother and sister, called Leo and Gertrude Stein. He looks like a professor. He's bald, wears gold-rimmed spectacles, has a long reddish beard, and looks at you shrewdly. He strikes awkward poses with his tall, stiff body and makes abrupt, nervous gestures. He's the archetypal German-American Jew. She's fat, short, and massive, and has a beautiful, strong head with fine, pronounced, regular features and intelligent eyes. She's perceptive and witty and has a clear, lucid mind. Her voice, indeed her whole appearance, is masculine.

Picasso met them a little while back at Sagot's and was so attracted by Mlle. Stein's physical presence that he suggested he should paint her portrait, without even waiting to get to know her better. They came here dressed in brown corduroy and wearing sandals, in the style of Raymond Duncan, who's a friend of their's. They're rich and intelligent enough not to worry about looking ridiculous and are so self-assured they wouldn't care what other people think anyway. He wants to be a painter and she used to be a doctor, but now she writes—and has been praised by H. G. Wells, which she's inordinately proud about.

They are very knowledgable about modern art and discuss its artistic value and the influence it is going to have. They really admire avant-garde artists and seem to have an instinctive understanding, a kind of flair for it. They know exactly what they are doing and bought 800 francs worth of pictures on their first visit, far more than we ever dreamed possible.

They entertain on Saturdays and have invited us to dinner.

One of the things Pablo and I enjoy doing together is going on Sunday mornings to the open-air market on the Place Saint-Pierre right below the Sacré-Cœur. If we've managed to get out of bed early enough, we set out around eleven o'clock in the morning. Pablo wears his workman's overalls and cap with a colored silk scarf around his neck, while I wear a black lace mantilla.

The most incongruous miscellany of wares is laid out on tarpaulins, or just strewn on the ground itself, right up to the edge of the sidewalk. You can acquire a complete wardrobe there for practically nothing. Men's shirts cost 95 centimes or 1 franc 45, depending on the shade, though Pablo spent 1 franc 95 for a red and white spotted flannel shirt, which he loves for its beautiful color.

You can get socks, all kinds of handkerchiefs, from coarse tartan ones for snuff takers to silk ones trimmed with imitation Valenciennes lace; women's underclothes in garish pink or blue, unless they're made of calico, heavily glazed so that they'll wear longer; and silk stockings and strong cotton stockings from 45 centimes to 1 franc 95 a pair. The "best quality slips, for ladies of the highest class"—still in the

Picasso. *Leo Stein Walking*, caricature, 1905.
Private collection.

same price range—are lavishly trimmed with lace, but after one wash their garish color disappears and they look as if they are made of butter-muslin marbled like the endpaper of a book. I know, I've got one, well worn for lack of anything better. Then there are ladies' hats of every shape, trimmed with flowers, feathers and ribbons, a little dented and tired, but so well stiffened they could easily be brought back to life; there are stylish ostrich feathers and parrot feathers, not too badly bent; shoes, from heavy soldiers' boots to delicate satin ballroom slippers trimmed with buckles, but often you can only find a single one and have to search forever to find its partner; there are long underpants, white or with blue stripes; sheets and pillowcases; dusters; towels; suits for little boys and dresses for little girls; flounced petticoats; women's dresses and coats; working clothes for men; trimmings; innumerable packets of artificial flowers; remnants of cloth, from cottons to brocades and lamés; purses; umbrellas; shopping bags; beaded handbags for going dancing; carpenters' trousers in rough canvas or corduroy; blankets; baby clothes; even saucepans and toys.

The market traders, men and women, dressed in flashy clothes chosen from their stock, entertain the customers as they advertise their wares, frowning on people who are bargaining but always ready to knock off a few sous. They keep a sharp eye on the women and men who are half-undressing themselves to try on a shirt they're afraid may be too tight, or who are admiring the look of a dress on a little girl or a sailor suit on a little boy who's kicking and screaming.

People congregate in the Place Saint-Pierre from all the surrounding neighbor-hoods, coming to Château-Rouge from Barbès in the south or Porte Clignancourt

in the north, traveling for up to two hours to shop here rather than go to the Marché aux Puces, where everything is secondhand. The pimp can find his special cap here, and the girl he has in tow can find the slips and fancy stockings she needs for her profession, as well as dandy little pinafores—black or red with pockets—and those fashionable bows of red or russet ribbon to tie round your neck when you go out waltzing. At the edge of the market there are stalls where you can stop and rest and eat french fries for 5 centimes a portion and drink good cider for 20 centimes a bottle. Pablo loves all this working-class hubbub and it takes him out of himself, away from his preoccupation with his creative life.

We've become regular visitors to the Steins and often take our friends to the Saturday evenings they hold in their little house and studio at the back of a large building in Rue de Fleurus. They have a wonderful collection of paintings: Gauguins, one of them a painting of sunflowers; Cézannes, including the beautiful portrait of the painter's wife wearing a blue dress and seated in a crimson armchair, and several watercolors, landscapes with bathers, and so forth; a small Manet, not especially important but painted with great sensitivity; an El Greco; some Renoirs, including a bather seen from the back, which is filled with light; two fine Matisses; one Vallotton, a very precise and cold painting of a reclining nude; some Manguins; some Puys; and now Picasso has joined this throng.

There's another brother, who has come to live in Paris with his wife and is also a passionate lover of painting, though he doesn't seem to have the same understanding for it. He has started collecting Matisse.

The evenings there are often entertaining, but if you get bored there are always the works of art cluttering the studio to look at, and they also have a very good collection of Chinese and Japanese prints, so you can disappear into a corner, sit down in a comfortable armchair and lose yourself in contemplating these beautiful masterpieces.

[spring 1906]
Vollard has been to the studio and bought twenty paintings for 2000 francs. We're rich, so we've decided to go to Barcelona, where we'll be richer still as the exchange makes the money worth 15 per cent more. I'm glad of a change, as our life has been getting rather monotonous, and Pablo is happy too, as it means he can visit his family and, what's most important, see all his friends.

[May 22, 1906]
We've reached Barcelona. It's the first long journey I've ever made. We left the studio at around six in the evening, accompanied by Max and Guillaume, each of whom was holding one handle of the large wicker trunk we had bought for the occasion, which was weighed down with tubes of paint. We went down the Rue

Ravignan and easily found a cab, which took us at the pace of a weary horse to the Gare d'Orsay, where more friends were waiting. We kissed them and made our farewells, and then got on the train.

We were in a third-class compartment, and I felt so nervous and anxious I couldn't sleep at all, and this kept Pablo, who wanted to sleep, awake as well. I couldn't wait for the sun to come up, and my impatience exhausted me far more than the jolting of the carriage, which was very badly sprung. I didn't sleep after daybreak either, as I was so enthralled by the novelty of the countryside unfolding before my eyes. We stopped for breakfast in Narbonne and got back in the train, which arrived at Port Bou around one o'clock. I was exhausted and felt very depressed. In Spain we changed to a first-class compartment—it's just too uncomfortable otherwise—and I recovered some of my initial excitement, but around seven in the evening, as we left the train in Barcelona, we were surrounded by crowds of noisy Catalans. I felt overwhelmed with despair and tearfully begged Pablo to take me back to Paris. He loves me and can't bear to see me crying, and I think if there had been a train leaving for France just then, we'd have taken it.

Luckily there wasn't one. After taking a bath in our hotel, the Hôtel d'Angleterre in the Plaça de Catalunya, I went to bed, with Pablo watching me glumly, and fell asleep immediately without having dinner.

I was awakened this morning by the sun, and I feel refreshed and happy with no desire to return to Paris. Pablo was ready to go back immediately. What I said last

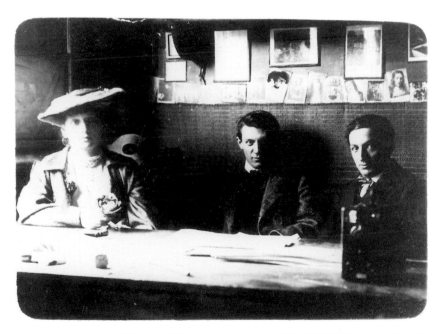

Fernande, Picasso and Ramon Reventós; photograph by Vidal Ventosa, Barcelona, July 1906.

night was just the result of exhaustion and my inexperience as a traveler, but Pablo took it quite seriously.

Dear thoughtful Pablo. He only thinks of making me happy, even at the cost of his own pleasure. Apart from his work, I think he cares for me more than anything else in the world.

We've spent several weeks in Barcelona, and life here is very pleasant. We live mostly at night; everything here seems cheerful, lively and colorful. We have lunch with Pablo's parents and then meet his friends at around three o'clock. Then we sometimes go on an excursion; Pablo loves to go up to Tibidabo, a hill overlooking Barcelona from which there's a complete panorama of the city.

We spend much of our time with our friends, who are charming and intelligent and call me "Picasso's fiancée." Benedetta and Ricardo Canals are here, as well as the doctor Jacinto Reventós and Miguel Utrillo, the adoptive father of Maurice.

We've also visited Gargallo, the sculptor, who's very poor and has his studio in a basement, though he always looks bright and cheerful. He's a great comedian and regales us with his racy stories from Aragon, which are very funny and full of surprises. There are two other sculptors we see, Casanovas and Mateu de Soto. Mateu was one of Pablo's companions when he first visited Paris, where he used to do the round of the Spanish colony every morning. He looked so emaciated they would always help him find lunch. I think Picasso liked him better than the others did, perhaps because of his frailty: he was so small and looked pale and pathetic.

Pablo is quite different in Spain. He's more cheerful, not so wild, more sparkling and animated, and he takes a calmer, more balanced view of things. He seems to be at ease. He glows with happiness, so unlike the kind of person he is in Paris, where he seems shy and inhibited, as if the atmosphere is alien to him. I've never met anyone less suited to life in Paris. He has decided we should go to Gósol, a little village in the Pyrenees above the valley of Andorra. Casanovas, who has spent a summer there, suggested it.*

[June 1906]

Gósol is magical, though the journey was quite an adventure. You have to ride on a mule for several hours, and the paths are bordered on one side by walls that scrape your knees and hands, while on the other side the drop is so sheer I had to shut my eyes to prevent vertigo. These precipices look as if they're bottomless, but it doesn't worry the mules, who are always careful and completely dependable. At one point I felt the straps holding my saddle come unfastened and I began to slide slowly back-

* In June and July Fernande and Picasso wrote several letters to Enric Casanovas, who was planning to join them in Gósol, requesting that he bring them various items: Fernande asked for "a bottle of *essence de Chypre*," stamps and picture postcards of Barcelona, while Picasso asked for carving tools and Ingres paper. Casanovas, however, was unable to make the journey before they left Gósol.

IN LOVE WITH PICASSO

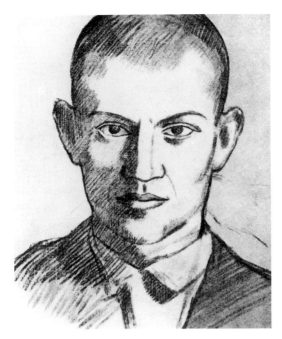

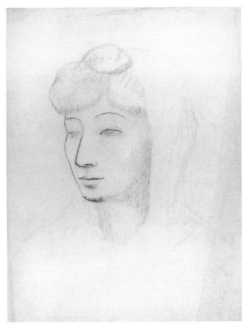

Picasso. *Self-Portrait*, Gósol, summer 1906.
Private collection.

Picasso. *Fernande Wearing a White Scarf*,
Gósol, summer 1906. Musée Picasso, Paris.

wards. Luckily I was able to alert the muleteer, who put us all back together—the mule, the saddle, and me.

The village is up in the mountains above the clouds, where the air is incredibly pure, and the villagers—almost all of whom are smugglers—are friendly, hospitable and unselfish. We have found true happiness here. There is no one here for Pablo to be jealous of, and all his anxieties seem to have vanished, so that nothing casts a shadow on our relationship.

I love the simplicity of living here, among people who are untouched by civilization. Our hosts in the clean, rustic inn, are friendly and considerate, although, when Pablo's working, I can only make myself understood by signs. Everything gleams in the sunlight, the yellow houses, the rocky earth and the white sand, and the sky is a soft pure blue I've never seen before. When I go out walking, wearing my espadrilles, I brush past wild roses, which catch and scratch my bare legs and feet, and I see marvelous green or stone-colored lizards, which disappear in a flash into invisible cracks as soon as I get close. But everyone seems enchanted with us too. They love us, come looking for us and bring us partridges or thrushes to liven up our daily meals of "cocido" (Spanish stew), and we join in their strange mountain games. Pablo is in high spirits and likes to go off hunting with the villagers or join them on excursions into the high mountains.

Picasso. *View of Gósol*, summer 1906. Private collection.

He is working on a portrait of the innkeeper, a fierce old fellow, a former smuggler, with a strange, wild beauty.* He's over ninety but has kept his hair, and although his teeth are worn right down to the gums, they are very white and not one of them is missing or has ever been damaged. He's difficult and cantankerous with everyone else but always good-humored with Pablo, whose portrait of him is very lifelike. He's also doing a portrait of the innkeeper's grandaughter, a girl of about twelve. The atmosphere of his own country seems to inspire him, and there is much stronger emotion and sensitivity in these drawings than anything he has done in Paris.

People still follow the old customs here. For instance, the women never take their meals with the men, but eat whatever's left over, standing in the kitchen or in a corner. I find this offensive, and one feast day I insisted our hostess eat with us. Eventually, after a lot of persuasion, she placed her plate at the end of the long narrow table, but she was almost too ashamed to eat. I've noticed that in Spain women have no kind of status compared with men and they all, even upper-class women, seem to accept this situation, which I find so intolerable. Another custom,

* Josep Fontdevila.

which comes from their peasant piety, is that all the most important saints' days are celebrated with a day off work, and there are often one or two a week. There always seems to be a holiday in Gósol.

The country here is too mountainous for any regular farming, and each family grows its own vegetables. Almost all the men make their living by smuggling—matches, tobacco and goodness knows what else. This too is a local custom. Pablo loves their endless stories and never tires of listening to them, like an attentive child.

[mid-August 1906]

We've had to leave Gósol and are on our way back to Paris. The innkeeper's daughter contracted typhoid. There's no doctor in the village and it's a journey of several hours by mule to the nearest town to get one, so she was treated with tobacco leaves soaked in vinegar. In winter, people die if they are taken seriously ill, as it's impossible to cross the mountain because of the danger from avalanches and glaciers. Pablo has an almost morbid fear of illness and couldn't wait to get away, although I wasn't worried, as I've never been concerned about threats of that kind. I was sorry to leave the village and its people, while the old innkeeper was determined to come with us to Paris. His children had the greatest difficulty in dissuading him.

Pablo wanted to go to France by the most direct route, as we only had just enough money for our return fares, and this meant crossing the Pyrenees on mule-back. We had to leave Gósol at five yesterday morning in order to reach a village where we could get a carriage by five in the afternoon. Pablo carried the little fox-terrier I've been given, holding him to his breast, which made his balance on the mule even more precarious. We stopped for lunch on the mountainside, eating hard boiled eggs, tomatoes and fruit, and drinking a white wine that was as light as water—or so I thought—without letting our lips touch the leather flask. But when it was time to get going, my legs wouldn't support me and I had to have an hour's sleep before we were on our way again. At around six in the evening we reached Puigcerdà, a picturesque little town planted like a terrace on the mountainside across from the border with France. Pablo felt tired and unwell and had to go to bed as soon as we arrived.

Today we'll take the diligence to Bourg-Madame, where we can get the train for Paris.

[late August 1906]

We eventually reached Paris, and although the studio was like an oven in the summer heat we're glad to be back. We noticed that the mice had returned in full force and had gnawed at everything in their path. As they couldn't find any food, they had reduced the taffeta cover of a particularly elegant long-handled umbrella, which I'd forgotten to take with us, to confetti. This was upsetting enough, but it was much worse when we got into bed and discovered that bedbugs had taken

advantage of our absence to infest the bed in the small room. We moved into the studio to sleep on the couch, but they were there too, so we lay down in a corner after putting sulphur to burn in receptacles all over the studio.

Life has resumed its course. I won't call it normal, as nothing in our life is very normal, except looking for ways to get money. My fox-terrier, who was such a sweet little dog, has died, although Pablo took him to the vet practically every day, still further depleting our meager resources. Pablo is again absorbed in his work, while I'm going to try and reorganize the household, so that that we can have regular meals at last. Although he loves Spain, I think Pablo is pleased to be back in his studio and with his friends. However, he doesn't like to be disturbed and won't open the door unless he knows that his visitors are close friends. Dullin knocks at the door almost every day at about five or six o'clock, accompanied by his friend Jeannot, and they announce themselves: "Jeannot, Dullin." Jeannot is a close friend and a great admirer of Briand, so we are kept informed about every detail of the great politician's private life. Dullin is remarkably self-effacing. He has a big nose, with inquisitive eyes, his hair is plastered onto his forehead beneath his large hat, and he always looks sad. He says very little, but watches critically and waits.

Harry Baur, who is also an actor, comes quite often, and he's the complete opposite of Dullin: loud, conceited, and self-assured. Pablo calls him "El Cabo," and

Picasso. *Fernande Sewing*, Paris, fall 1906. Private collection.

IN LOVE WITH PICASSO

that's how he always announces himself, knocking at the door and shouting, "El Cabo! El Cabo! Open up, it's me!" He is trying to be a writer, and he forces us to listen to his long, vapid, boring essays, while we exchange looks of desperation. Salmon, who is working at the *Paris Journal* and has recently published his first book of poems, and Princet also come almost every day.

Another frequent visitor is the composer Déodat de Séverac, and he often brings a friend of his, the violinist Bloch, who has taught us a lot about the great musicians by playing us their music. However, our dog, Frika (who was sold to us by Raynal), is tormented by this, and starts howling plaintively the minute Bloch starts, so we have to shut her up in the little bedroom, and even then she won't stop whining.

Often our friends stay to dinner, and I've learned to cook quite well and they appreciate my meals. I'm quite used to managing on very little money and I'm still very happy with Pablo.

One evening recently we were with our friends after dinner sitting by the light of the "Matador" oil lamp we have just bought. I was resting on some pillows at Pablo's feet, my head leaning on his knees, and I was suddenly filled with a great wave of joy and felt that I just couldn't be happier. What does it matter if day-to-day life is difficult, that our surroundings are drab, without furniture or comfort? This studio still seems to me the one place that holds my good fortune. What does it matter if Pablo is jealous or forbids me to go out? Where would I be better off than at his side?

[March 1907]

The other day Apollinaire arrived at the studio, his forehead creased with a familiar frown of displeasure. He was gloomy, solemn and anxious, quite unlike his usual self. He had come to ask Pablo and Max to give him support, as he had to fight a duel. Jean de Mitty was going to be one of his seconds and he wanted Max to be the other. His opponent, who, he claimed, had insulted him, was the journalist Max Daireaux. It had happened at a banquet, when Daireaux had complained about the "Apollinaris" mineral water, staring sarcastically at Guillaume the whole time, an insult Guillaume felt demanded retribution.

Apollinaire was just swaggering, but he was so puffed up with his own importance that he couldn't see this. To Max it seemed to offer great possibilities for his ever alert imagination, though he too was really rather frightened, and he agreed to take on the responsibilities of a second. Picasso took it as everyone else ought to have done—as a joke—but Jean de Mitty, who was known as an eager if clumsy swordsman, assumed responsibility for all the arrangements in the hope that things would not be settled.

The fact that the duel didn't take place was no thanks to him, but rather to the two opponents, neither one of whom wanted to fight the other. Everything was sorted out amicably, but Max submitted a bill for his expenses as a second.

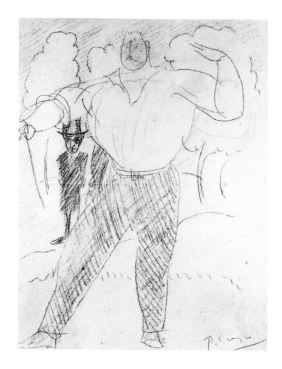

Picasso. *Apollinaire's Duel*, caricature, 1907.
Private collection.

Apollinaire was highly indignant, though he ended up thinking it was funny. The expenses look like this:

Day 1: at 9 am: a small cup of coffee for second no. 2 0,10
at 10 am: one box of matches for second no. 2 who had left his at home 0,10
at 11 am: a roll for the second whose lunch would be late 0,05
at 1200: a newspaper for the second who is waiting and who is bored .. 0.05
at 05 pm: second no. 2 buys an aperitif for second no. 1 1,20
Day 2: among other things, second no. 2 buys a drink for the "enemy" to soften him
up, and so on.

There were two such long bills, the total of which, though not huge, has made Guillaume reflect on the financial risks that another duel might expose him to. But during the process of reconciliation, Apollinaire was waiting anxiously at the studio for the results of the negotiations—which ended with mutual apologies.

[End of Fernande Olivier's Journal]

IN LOVE WITH PICASSO

LETTERS TO GERTRUDE STEIN

August 8–October 8, 1907

[Letter from Fernande to Gertrude Stein in Fiesole, August 8, 1907]

My dear Gertrude,

Thank you for your two letters, which arrived safely. Please excuse me for not replying immediately. I haven't seen Raymonde yet, but I think I'll get to see her next month.* She has been placed in an orphanage run by nuns in Rue Caulaincourt, which is quite near us, and I can visit her on the first Sunday of each month. Apparently her mother has been traced, and before the nuns are allowed to keep her there needs to be a judgment against the mother, who has to have her rights over the child annulled.

I expect you know that the Salon d'Automne opens on October 1st this year. Will you be there for the private view? I don't think I'll go myself. My eyes are aching more and more: I can't keep them open in the sunlight and I'm getting very short-sighted.

I have so much to tell you. The summer has been particularly hard for me, both from a physical and a psychological point of view.

Pablo is working. Are you working where you are? I'm bored and often feel depressed.

I'll write more fully soon. Salmon's with us at the moment as well as another friend, so I can't write you as I'd like.

Please tell Madame Stein that I'm thinking of writing her a letter of 8 or 10 pages soon. Give her my regards. Remember me to everyone and wish Allan luck with the hunting.

Love, Fernande

P. S. Do write me. You don't know how much pleasure I get from receiving your letters.

* Raymonde was a child Fernande and Picasso adopted briefly in April 1907.

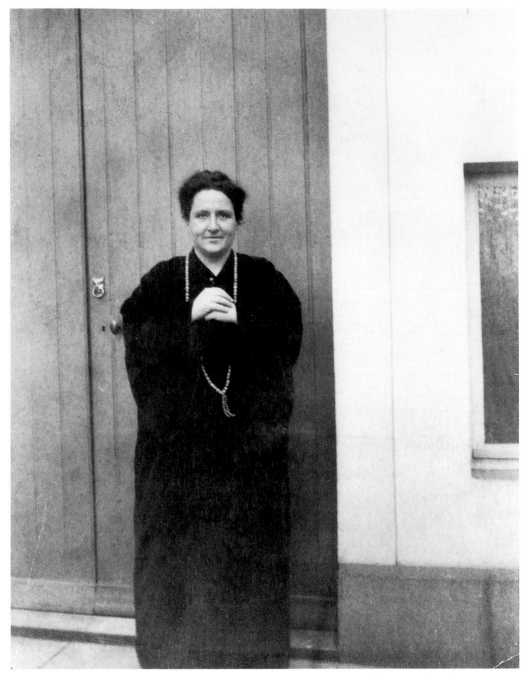

Gertrude Stein at 27 Rue de Fleurus, the Paris apartment she shared with her brother Leo, in 1907. Beinecke Rare Books and Manuscript Library, Yale University.

[Letter from Fernande to Gertrude Stein in Fiesole, August 24, 1907]

My dear Gertrude,

Do you want to hear some important news? Picasso and I are ending our life together. We are parting for good next month. He's waiting for the money Vollard owes him so as to be able to give me something with which to await—*events*.

What these events will be and how I will put my life together after this latest desertion I don't know. What a disappointment!

But don't imagine for a minute that matters will sort themselves out again. No, Pablo "has had *enough*." Those are his words, although he says that he has nothing to reproach me with; he just isn't cut out for this kind of life. Forgive me if I bore you writing like this, but I need to tell someone, and you are the only person who takes a little interest in me, and I'm so downhearted. Imagine what my life is like now, although outwardly nothing has changed. I'm doing all I possibly can not to show my despair and depression, but underneath it all I feel so disgusted and the future holds out no hopes. Oh, I'm devastated, believe me, truly devastated!

Do you think you could find me some French teaching this winter? What should I do? I believe it really is all over. Did you receive the letter I wrote two weeks or more ago when I said I'd write again? I could already see the end coming, but I was still hopeful. Over and over again this summer I've hoped, and all for nothing! I have dreadful bouts of despair.

Write to me, I'd like that. How will this end?

Please give my regards to all your family.

Sincerely, Fernande.

P. S. I'm looking for somewhere else to live. If you had been here you could have looked with me. It would have been a bit more fun! Tell Alice I'm not able to write to her as I'm really too miserable and ask her to forgive me. I don't believe I have any good fortune.

[Letter from Fernande to Gertrude Stein in Fiesole, September 2, 1907]

My dear Gertrude,

I received your letter, thank you. I'm in much better spirits than when I last wrote you, though I still feel very disoriented. I've spent the last few days looking for a place to live, which has taken a great deal of trouble as I need somewhere I can move into immediately. I finally found a place at no. 5 Rue Girardon, which is very close to the Rue Ravignan. There are certainly good reasons why it would have been better for me to go and live further away, but I think I'd be alone too much. In two

or three days from now, or perhaps a week, I'll be out of here for good. I'd have gone already if Vollard hadn't been out of Paris and left us in dire financial straits, when we're facing all the difficulties of a situation which is equally dire.

I expect to see you soon. Pablo is taking the idea of our separation very lightly. The few years we've lived together will leave no impression on him, and I think he'll greet my departure with no regrets and a huge sigh of contentment. And yet, as he says himself, I've never restricted his life or hindered his work. So don't you think it's a bit hard to accept that one has been toyed with, been the victim of a caprice? Maybe you think I'm making it all sound too dramatic, but I feel so disgusted with everything I've experienced in my whole life up to now. I lost my way and perhaps now I'll find it again, but I have so little faith in my destiny. Anyway, we'll see, everything has an end. It reassures me a little to know that, and to know that I can end it whenever I want. Meanwhile, I must buy some furniture....

I've nearly renewed contact with one of my aunts. I heard recently, quite by chance, of the tragic death of an uncle I loved very much when I was a child. He died two years ago and I wrote a letter to my aunt. She wrote back saying she'd like to see me. I don't yet know what I'll decide to do, as we didn't get on very well before. But perhaps I'll be so bored this winter that I'll be glad to go and see her from time to time. I'd dearly love to feel completely settled again.

And what about you? Is the weather good in Italy? Here we have nothing but storms and bad weather.

Give my greetings to everyone.

Sincerely, Fernande Belvalet*

[Letter from Fernande to Gertrude Stein in Paris, September 16, 1907]

Monday evening

My dear Gertrude,

I won't be able to come to lunch with you tomorrow (Tuesday). I had to do my shopping today, and tomorrow I've got to stay in and wait for the delivery. But it would be a great pleasure for me if you'd come to see me tomorrow afternoon. Alice will be with me and would be quite delighted to see you.†

* In 1907, when Fernande was living apart from Picasso, she briefly adopted the name Belvalet or Belvallé, possibly the name of her real father (see p. 12).

† Fernande had arranged through Gertrude Stein to give French lessons to Alice B. Toklas, who was visiting Paris with her friend Harriet Levy.

So until tomorrow, if possible. I'm dreadfully tired. I've been walking the streets since 9 o'clock this morning, hunting round the shops for wonderful bargains. I spent a ridiculous amount of money and my house will look like an old antique shop, believe me, and I still have quite a number of purchases to make.

I'll see you tomorrow, then. Here is my exact address: 2 Impasse Girardon. The Impasse Girardon is next to no. 5 in the street of the same name. You go the same way you would to get to the studio, except that when you get to the Place Ravignan you take Rue d'Orchampt,* the road to the left just past where I'm still living now. Rue Girardon is the continuation of Rue d'Orchampt on the other side of Rue Lepic.

I hope to see you soon.

Love, Fernande Belvallé

[Letter from Fernande to Gertrude Stein in Paris, September 19, 1907]

My dear Gertrude,

I can't come this week as I still have an awful lot to do, but if you want I could come to lunch with you on Monday and stay to chat during the day. Is that a convenient day for you? These troubles have set all my nerves on edge and I'm not really able to cope with it all. I don't know where to begin to get the house into some kind of order. I'm very pleased with my apartment; it was sunny when I woke up this morning. I have delightful concierges who do everything they possibly can for me. For two days now I've slept in my own home and I'm absolutely astonished not to feel disoriented. On the contrary, I feel very good and I sleep as I haven't slept for ages.

Have you got rid of all your tiresome Americans? I'll be so happy to see you, as we've seen so little of each other since you returned.

I'll see you on Monday then. Give my regards to Madame Stein and to everyone else.

I'm longing to be finished with sorting out the house.

I think Pablo is very fed up; he certainly looks it.

We'll see each other soon, then.

With much love, Fernande Belvallé

P. S. Alice would have loved to see you and hoped you'd come by when she was with me on Tuesday.

* Correctly, Rue d'Orchamps.

[Letter from Fernande to Gertrude Stein in Paris, October 8, 1907]

My dear Gertrude,

Thank you for talking to Miss Toklas about the omnibuses. She is giving me 2 francs a lesson and paid me yesterday for my first week, which was very timely as I was penniless. Times are hard! I have some other lessons in prospect for next week, so it looks as if it won't in fact be too bad. But all things considered, I'm quite unhappy and think of Pablo a lot more than I should if I had any sense. I see him very little and I'd rather not see him at all, as I'm always even more unhappy afterwards. I don't know when I'll be able to come and see you. I'm spending all my time looking for work, and going to your house would also make me unhappy. I'm too emotional, you see. I wish I could become really tough and not have my life interrupted by a mass of idiotic little things which sap all my spirits.

I'm writing about myself too much, perhaps, but I need to say these things so badly that I can't help myself and can only apologize.

I'm spending almost all my time with Alice. If you're going to come one day, do let me know. Otherwise it's very likely you won't find me at home, as I'm almost never here.

Hoping to see you soon,

My fond regards, Fernande

P. S. I think you've given outrageously high praise to my painting!!!

PICASSO AND HIS FRIENDS

Fernande's Memoir, Part 2: 1907–1909

After I returned to Picasso I no longer kept my journal, but I have vivid memories of many our friends and everything that happened.

We more or less gave up Vernin's and used to eat instead at Azon's in Rue Ravignan, opposite the house where Max Jacob lived. You could dine there for ninety centimes, including a small glass of something at the end of the meal, which was often poured by the *patron* himself. We went there, of course, not so much for the cooking as for the credit they allowed. This mounted up and up until they couldn't begin refusing us for fear of losing everything, and they would shyly ask for modest contributions towards the amount due. In their quiet, tactful way they were a real help to the artists, who, for their part, to reassure them of their solvency, behaved as if they hadn't a care in the world.

Picasso, Max Jacob, and Apollinaire used to go there regularly for a while, and they were generally joined by friends—Derain, Braque, Vlaminck, Van Dongen, Gaston Modot, Olin and Dullin all came quite often, and Paul Fort was an occasional visitor. I also saw Modigliani there. He was young and strong and you couldn't take your eyes off his beautiful Roman head with its absolutely perfect features. At that time he was living in Montmartre, in one of the studios on the bank of the gloomy old reservoir. This was before his *vie maudite* in Montparnasse, and, despite reports to the contrary, Picasso liked him a lot. How could any of us have failed to be captivated by an artist who was so charming and so kind and generous in all his dealings with his friends?

Another artist who was just starting out was Utter (I'm not even sure he was sixteen yet), who looked like a tiny workman in his blue overalls. He was given encouragement and guidance by Suzanne Valadon, and on their lovers' walks on the Butte, they would sometimes come across Utrillo lying in a drunken stupor against a milestone in a little side street near the Sacré-Cœur. Suzanne would take him home with her and mother him at the house near Place Pigalle, in Impasse Guelma, where she lived.

Several writers used to go to Azon's—Vanderpyl, with his round shape and

tedious joviality; René Dupuis (René Dalize), a former naval officer who was now a journalist (he was to die in the war); and also the celebrated Adolphe Basler, who didn't yet have much of a reputation. Basler was short and fat with plump, damp hands and the pious look of a parish clerk at his prayers. He was reticent, except that he was much too free with his compliments, always flattering and trying to please. But he was intelligent, and his purpose there seemed to be to watch, to listen, to remember and, above all, to profit from it all. Always trying to scrounge "a liddle gup of goffee," if he couldn't get anything better, he took from our world whatever he might possibly be able to make use of—and exploited it with undeniable skill. I wonder if he could have become such a distinguished "gentleman" without that group of artists and his own remarkable determination.

The circle of our friends was widening: Derain, Vlaminck, Braque, Herbin and other artists were coming more frequently to the studio. Derain, Vlaminck and Braque were an extraordinary and striking trio. Passers-by would turn their heads when they saw them, as all three were very tall and broad-shouldered and gave a remarkable impression of physical strength.

Derain was the tallest, slimmer and more elegant than the others, with a fresh complexion and smooth black hair. He affected English fashion in a rather ostentatious way, wearing fancy vests and ties in bright shades of green or red and holding his pipe in his mouth the whole time. He was calm, cool and sardonic and loved an argument.

Braque was shorter and heavier. His powerful head made him look like a white negro, and he had the neck and shoulders of a boxer, very dark skin, black curly hair and a clipped mustache. His features were strongly defined, and he deliberately adopted an aggressive manner and a coarse way of speaking. He was not elegant and his disheveled appearance also seemed to be intentional, but he looked comfortable in his baggy, readymade clothes, with neckties that were loosely knotted black strings, like the ones Norman peasants wear. He had a sharp intelligence and was quite adaptable; he was mistrustful, able and cunning—in a word, a typical Norman.

We had first met Vlaminck at Van Dongen's, where he often used to go. He was more natural than the other two. He was heavy and thickset with reddish fair hair, and his blue eyes often wore a naive, astonished expression. His rather brutal, obstinate look suggested he knew exactly where he wanted to go. He was very self-assured, and if he was proved wrong at the end of a discussion he appeared stunned. He had once been a racing cyclist and was so strong he thought himself more than a match for anybody. At that time he lived in Chatou with his wife and three daughters and was so poor that he often had to go home at night on foot. There was a bridge the road passed under, and he claimed he had been attacked there several times but had defended himself successfully on each occasion through sheer physical strength.

He had no use for the skills of boxing as against brute force—until the day, that is, when Derain and Braque, both of whom used to box quite regularly, defeated him soundly one after the other. We met him as he was leaving Derain's studio with a nose like a potato and in a pretty sorry state, but a convert to the art of pugilism.

Picasso was attracted to boxing. He enjoyed watching the fights and followed them avidly, and he would have liked to box himself, but he hated being hit or indeed hitting anyone else. I think he took just one lesson at Derain's, and that was enough. When the four of them went out together, Picasso was much the shortest, but because of his stocky build he gave a—quite unjustified—impression of physical strength, and he was always proud to be taken for a boxer, thanks to his three companions. In fact, although Picasso had always wanted to be famous, he would have preferred his reputation to have been founded on achievements other than his art. Max Jacob once said that Picasso would rather have been famous as a Don Juan than as a celebrated artist. He loved the attention of women and seemed very flattered by it, whoever they were and wherever they came from. In fact this attention was often all he needed, because his natural laziness and fear of entanglements generally brought his affairs abruptly to an end.

Derain was living at this time in Montmartre, at "Les Fusains," a strange artists' colony in Rue de Tourlaque, where he had his studio. His parents, who ran a dairy in Le Vésinet, didn't want their son to be an artist and refused to give him an allowance, but he was undeterred and worked so hard he was able to make great progress. With his wonderful feeling for color, applied with broad strokes of the brush, his harmonious compositions and the ease with which he could develop ideas, he was a very interesting artist. I always preferred Derain's art to that of his contemporaries. Picasso earned his pre-eminence because he was the most skilful and the most profound, ceaselessly trying to transcend what had already been done, but Derain was different, more French, more self-confident. His sound, robust craftsmanship was incomparable, and it was only his lack of that subtle quality of mystery, which is found in Picasso and sometimes in Matisse, that prevented him from reaching the first rank.

Vlaminck was then just a good impressionist painter, and he had not yet acquired the "knack" that characterized his later handling of paint. He had a great feeling for composition and for craftsmanship, but his lack of taste, of intellectual distinction and of originality with color made his work slightly vulgar. He was a talented painter, who made good use of his abilities, but never a painter of great quality.

Braque was a little younger and achieved prominence more quickly, thanks to cubism. He was more intelligent, but less naturally gifted than the other two, and his willingness to experiment may have been the result of his more limited abilities.

We did not see so much of Matisse, whom we had met at the Steins, as he was more retiring and lived with his family. He was already over forty-five, and with his

regular features and thick golden beard he had the look of a classic Great Master. Yet despite this appearance there was a serenity about him that must have been due to his having finally achieved a measure of success after years of poverty. He was very likeable, although he always seemed to be hiding behind his thick spectacles, which concealed the expression in his eyes. Once the subject turned to art, he would talk for ages, arguing, explaining, trying to convince his listeners and get them to agree with him. He possessed an astonishingly lucid mind and argued clearly and precisely, with economy and intelligence, although I believe he was a good deal less straightforward than he liked to appear. Matisse shone on occasions like this and was always in complete control, whereas Picasso was shy and diffident and appeared rather sullen. I think the credit for inventing "Fauvism" should probably go to Derain rather than Matisse, for it was one of Derain's paintings that Vauxcelles first described as "fauve." But Matisse undoubtedly became the leader of the school.

Everyone expected more from Matisse and Picasso than from any of their contemporaries, and they were quite friendly, although they differed widely in their outlook: "Poles apart," Matisse would say when talking about the two of them. He lost his usual composure when the first cubist works appeared and became angry. He talked of ruining Picasso and making him beg for mercy, although a few months later, when Picasso's new development was gaining acceptance, he was quite ready to claim that it was related to ideas of his own. Great artists need to build on each other's work.

We sometimes used to see other "fauves." Manguin, who was slightly younger than Matisse, was small and dark and looked very ordinary. He was the father of a large family, and his pictures seemed to reflect his personality—ordinary, correct, settled, rather limited, but honest and conscientious. As for Puy, Vallotton and Rouault, they managed to combine bogus realism with bogus distinction.

Dufy still looked very young, with fair, curly hair, and was just as elusive and delightful as the pictures he painted. He was not as bold as he later became, but his delicate paintings, if a little weak, were full of charm. He was not outstandingly talented, but highly intelligent. Friesz, his childhood friend, was more self-assured and had developed his natural gifts to produce more powerful and adventurous works.

Together with Braque, Dufy and Friesz made up a trio of shrewd, ambitious, intelligent and wily Normans, who made the most of their common heritage. They were friends, but they distrusted one another and were certainly jealous of each other too.

It was Vollard who bought all Picasso's paintings at that period. He had a strange face, but his impeccable taste in painting, natural refinement and highly original mind made him extremely well-liked. He used to turn up unexpectedly at the

studio and buy everything as a job lot. When he paid the two thousand francs that had enabled us to go to Gósol, he had taken away something like thirty canvases of various sizes. He also bought the plates of several etchings Picasso had done between 1904 and 1907 and reissued them in an album, which he sold for around one hundred francs in 1908. The best of these etchings are the ones of circus people, the scenes of poverty, and the one of Salome dancing before Herod.

Another time, when Picasso needed quite a large sum of money, he sold Vollard a few sculptures. Vollard may have had them cast in bronze, though I never saw them anywhere. There was an unfinished, roughly modeled bust of a woman; a fool's head with a cap and bells; and the head of a Spanish bullfighter with a broken nose, a work of powerful intensity that was full of life. Picasso's sculptures combine technical brilliance with great humanity, and it is a pity he did not do more. If they lack some of the power of his paintings, they have even more of that special grace that is so typical of him.

However, if you were to enter Vollard's gallery on the Rue Laffitte, you would never see a Picasso, or indeed many other works which the dealer owned. He kept them jealously hidden away in the cellars and would show them only to a privileged few. Vollard had not had an easy time as a young man, and more than once he started a gallery only for it to be taken over by his creditors. His eventual success came through determination and perseverance. He bought paintings by Gauguin, Van Gogh and, later, Cézanne, Renoir and Mary Cassatt, as well as works by other artists that did not increase so much in value. His flair only deserted him over his Van Goghs—he lost his nerve and sold them to Druet. As for the Picassos, he wasn't going to show them yet; he was waiting for the right moment.

Vollard was witty and amusing and excellent company. He used to entertain a lot in the cellar beneath the gallery, which he had converted into a dining room, holding receptions for artists, lunch parties and dinners there. He often served Creole dishes from his own country, but one day when we were going to dine there, he asked me to come and prepare a Spanish dish of Valencian rice that his cook didn't know how to make. Vollard loved telling stories that were a bit risqué, and his witty delivery was given a subtle charm by his Creole lisp, which seemed amusingly out of place in a man who was so powerfully built and looked so strong. Vollard's other guests often included Odilon Redon and Matisse, as well as a number of writers. I remember meeting Gabriele d'Annunzio's first wife there, who was charming and very pretty.*

With time Picasso's group seemed to grow more subdued, and as the intervals between the bouts of wild socializing grew longer, our existence became more and more reclusive. Work was the only thing that really mattered, and it dominated

* D'Annunzio married Maria Hardouin, duchessina di Gallese, in 1883.

everything. When everyone went out it was generally to the Médrano circus, while Picasso, Braque and Derain also used to enjoy the boxing, but otherwise we entertained ourselves with our own jokes, which were often quite tasteless. Once when Olin was performing at the Gaïté-Montparnasse (or perhaps at Bobino), Picasso sent him a crown of everlasting flowers made of yellow porcelain at the end of the performance, and there were always Max's songs, but otherwise our evenings together usually followed much the same pattern. In any case we would go to bed late and although Picasso had long since stopped working at night, he didn't get up very early.

He didn't much like the theater, he found it boring, and he didn't trust his judgment over classical music, although he might have liked it if he had ever agreed to go to a concert. He once told Déodat de Séverac that he would never listen to music for fear of misjudging the quality of what he heard. How arrogant he could be!

What he did like was the guitar, guitarists, Spanish dancing and gypsy dancers—everything that reminded him of his own country. The full, swirling dresses whirling around the dancers, the flowers in their hair, their mantillas fastened with tall Andalusian combs, their movements, their tiny feet, their hands expertly toying with their fans or playing the castanettes, all these things filled him with emotion. Every time he saw them he would marvel at the playing of the guitarists. He never became animated, but he was very intense, and his feelings would be translated into an expression of tenderness that would light up his face.

Picasso also liked everything to do with bullfights and toreros. Their costumes, heavy with gold gleaming in the sun, are not exactly in the best of taste, but for him they were in perfect harmony with the Spanish light. And he loved the swarming crowds at the bullrings, their shouting, their riotous behavior, their noisy excitement, which could change in a moment from adulation to abuse depending on the artistry or ineptness of their idols, the bullfighters.

He seemed to admire everything he was not cut out for himself, everything that was quite different. He enjoyed bawdy cabarets and cheap music halls, and he loved the little streets in the old port of Barcelona where girls in camisoles and white petticoats would attract passers-by with suggestive gestures. He loved everything that had strong local color or a characteristic odor, which he would inhale ecstatically. It was as if nothing abstract could stir his emotions.

If he had found similarly distinctive, colorful areas in Paris, I'm sure he would have been more willing to go out in the evenings, but here he was only interested in the popular festivals. He loved watching the Quatorze Juillet parades, although they still left him unmoved. He was able to make use of everything he saw. He made sketches, generally from memory, in brilliant color, seeming to record things objectively at first. But once his eye had registered something, he was able to reproduce what he had seen by translating it in his mind. This merging of intellect and imagination contributed to the originality of his work.

PICASSO AND HIS FRIENDS

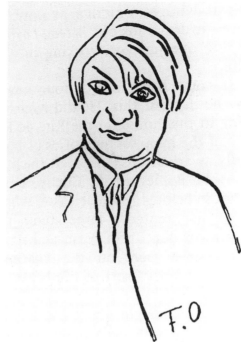

Fernande Olivier. *Self-Portrait*, reproduced in *Picasso et ses amis.*

Fernande Olivier. *Portrait of Picasso*, reproduced in *Picasso et ses amis.*

Nevertheless, he did adore Paris, and especially the clowns. When we all used to meet at the Médrano circus Picasso would go to the bar, which was filled with the hot, rather sickly smell rising from the stables, and he and Braque would spend the whole evening there, chatting with the clowns. He enjoyed their awkwardness, their accents and their jokes, although these were pretty feeble when they weren't actually in the ring. Picasso admired them and felt real sympathy for them. He knew Ilès and Antonio, Alex and Rico, and one day he invited a Dutch clown and his wife, who was a Polish bareback rider, to dinner. Both of them, but especially the man, were the coarsest people you could imagine.

This was the time when Grock was first appearing there with Antonet. He was a revelation, and there were storms of laughter and hysteria. No one ever left the Médrano before the performance was over, and some people would go three or even four times a week. I never saw Picasso laugh so happily as he did at the Médrano. He was like a child, unconcerned that what he found so funny was quite superficial.

He liked boxers just as much as clowns, but in a different way. He was in awe of physical strength and couldn't help admiring it, and the beauty of a prizefight appealed to him in the same way as a work of art. He would have been very proud to make friends with a boxer.

The population of the Bateau Lavoir was changing. André Salmon came to live in the building, moving from his little flat on Rue Saint-Vincent, which overlooked both the Saint-Vincent cemetery and the "Lapin à Gill."* The previous occupant of his basement studio had been Pierre MacOrlan, then still called Pierre Dumarchais, whom we used to see wandering in a melancholy way around the Butte, followed by a bassett hound. In winter he wore an enormous long overcoat, just like one Picasso used to wear because he suffered so much from the cold, but in summer MacOrlan always wore a cap, which made him look like a jockey because he was so tiny.

His great friend Cremnitz was also a friend of ours. Cremnitz had a little red goatee and was widely feared for his vicious wit and aggressive originality, although he also caused much amusement. Despite his chilling irony, he was unpretentious and cheerful and would sing charming old sea shanties in a flat, frequently tuneless, voice. But something must have embittered him, and you sensed he harbored a kind of jealousy he couldn't quite manage to hide. If he took against someone, he could become quite unjustifiably vicious.

He had been a friend of Jarry's, whom I met only a few months before his death, and they would often go out drinking together, collecting bottles throughout the course of the evening, which Jarry would take back to his house. All kinds of dreadful stories were always being told about Cremnitz.

He was often seen about with a young sculptor called André Denicker, who was the son of a professor at the Natural History Museum. Denicker lived with his parents in a house within the Jardin des Plantes itself, and he took us there at night on several occasions. Everything seemed mysterious and terrifying and I always felt there were traps all around us. At every step I expected to see a wild animal leap out, a ravening beast or a reptile that had been lying in wait in the bushes. But, however nerve-racking and alarming these walks were, they had a special charm and we went back again and again. After days of frantic activity they provided a kind of relaxation.

When the Van Dongens moved out, their studio was taken over by the painter Jacques Vaillant, and after he arrived things would get lively every night. He was cheerful and sociable, hard-working, hard-drinking and high-spirited, singing, shouting, smashing everything, and laughing with a strange grating sound when he had had too much to drink—which happened every evening. The building was chaotic enough as it was, but Vaillant's reckless behavior was the last straw for the concierge. All of us who lived there owed her a tremendous debt and she was always good to the artists she liked. We were always late with the rent, but she never uttered a cross word. From time to time she tried to bring a little more order into the place, but although she never succeeded she didn't really complain—except about Vaillant.

* Salmon moved to the Bateau Lavoir in 1908.

Quite often we used to go to Max's place, which was also on Rue Ravignan. As you entered his room, you would see him bent over his table, writing by the dim light of a smoky lamp. He lived on the ground floor overlooking a small courtyard where the tenants of the building threw out their household rubbish. A window opened onto this yard, but hardly any light came through it into the room, and the lamplight only accentuated the dismal gloom of the unlit corners of the room.

In general, Max led a very secluded and solitary life. He shut himself up in his dark, mysterious little room and survived on an illusion of happiness, though this never prevented him from working, in fact quite the reverse. Sometimes he would read us his essays or tell us fantastic tales, and we would be enchanted and amazed at his fertile and lively imagination. He also used to paint his lovely watercolors, which were so witty and clever and which he used to touch up with any material he could lay his hands on. Sometimes he would blacken a piece of glass over the smoking oil lamp and wipe the black onto the drawing with the end of his finger, or he would use the syrupy remains at the bottom of the cup of coffee he had just been drinking, or dust, which he gathered up from a book left out on the table, or whatever.

He did his own housework and seemed to be perversely conventional and meticulous about it. This meant that his room, despite its shabby look, was not at all depressing. It had a unique quality, and you felt that it was a refuge for intelligence. It had a wonderful, indescribable smell, made up of smoke, oil, incense, old furniture and ether distilled into a heavy perfume that none of us who had ever inhaled it could ever mistake, and which may itself have been an inspiration to Max. He himself combined many disparate qualities in a similar way—indefinable and unharmonious, held together by his brilliant wit.

On Mondays Max would entertain, and there were always a number of unfamiliar figures there, not saying or doing anything, sitting quietly, generally in one of the dimmest parts of the room. You could barely see because the glass chimney of the lamp was broken halfway up and the wick was badly trimmed, so that smelly black smuts would fall on all the guests. The strangers were usually heavily built workmen, and you could only tell they were there because of the pale reflections from their huge hands placed flat on their knees, as they seemed to be waiting with a slight air of shame. The odd mixture of people tended to make the atmosphere equivocal and rather oppressive, but also quite mysterious, giving it a markedly literary quality for people who like strange, sophisticated situations. It could have been a meeting of revolutionaries. And indeed, we were all part of the revolution against the whole established tradition in art.

Max was a most urbane host, attentive, friendly, courteous and flattering. He always had the right word for everyone, then, quite unexpectedly, he would come out with a sarcastic or spiteful remark, colored with his own peculiar brand of wit. People often thought Max was tactless, but his "gaffes" were always entirely deliberate.

His concierge used to keep an eye on him and did her best to keep him in order and take care of him. It was her opinion that he entertained too much and stayed out too late, and she used to scold him about the way he lived—which she didn't understand at all. He was the talk of the house and of the neighborhood, and she would have been happier if he had not been. She would have liked him to be more normal. He was an eccentric, fantastic character, slightly mad, but totally honest and helpful, and, as she always said, "nice to everyone and not at all stuck-up."

Max knew how to play on the self-esteem of his neighbors and the vanity of their wives when he read the cards and predicted happy futures for them. As a result, and perhaps in spite of themselves, they became quite attached to him. He particularly liked spending time in the company of local people—concierges, tradesmen, housewives in their blue overalls—saying that they made him feel as if he were living in some remote provincial town.

He was always on the lookout for any scandalous gossip, and the trivial, pointless stories women tell each other had a particular appeal for him: the tittle-tattle of malicious concierges, or of envious neighbors, who would read enormous significance into the most meaningless gestures. All this amused him, and he knew how to incorporate it into his creative work. He loved to wander down the Rue des Abbesses or the Rue Lepic in the mornings, when the housewives were out doing their shopping at the street-traders' barrows. He would watch their faces closely, listen, take notes, and remember every detail. Afterwards he would repeat it all to us with an air of innocent admiration. No one, not even Max himself, could ever tell whether he was sincere or just pretending. His best stories were about Quimper, his hometown, which he loved. He could go on about it forever, and each story was funnier than the last. His sense of the ridiculous would fasten on all kinds of different things, providing endless nourishment for his imagination.

He liked to amuse other people, and if he was in the mood he could be a quite dazzling entertainer. He could sing (and, if need be, give coaching in singing), play the piano or act the comedian, and he was always the life and soul of our parties. He would improvise scenes in which he always played the lead, and I must have seen his imitation of a barefoot dancing girl at least a hundred times, but it was a joy on each occasion. He rolled up his trousers to the knees to reveal his hairy legs, he opened his shirt wide to display his chest matted with curly black hair, he wore nothing on his head, which was practically bald, and, still wearing his glasses, he would perform his dance. His attempts to be graceful as he took tiny steps and pointed his toes were a perfect caricature that always made us laugh.

Then, when we were too exhausted to go on laughing, he would turn himself into a popular singer, putting a woman's hat on his head, enveloping himself in a net scarf and singing in a falsetto soprano voice, which was perfectly in tune but totally absurd. The songs were the kind you could hear in a music hall in the provinces:

　　　　　　　　　　　　　　　PICASSO AND HIS FRIENDS

Oh! we girls are all benighted
As our hopes are always blighted
We adore these soldiers bold
But our passion leaves them cold

And the chorus,

Oh! superb Pandor
Brigadier whom I adore,
Alas! if you are cold
To the love I feel for you
I'm telling you quite true
I shall do something so bold
You will have to have me taken by the law.

And the langorous sentimentality of:

Léna Calvé of Kerguidu
They say that your eyes have been
The death of a million soooooouls…

He used to sing Offenbach's "La Langouste Atmosphérique," "Sur les Rives de L'Adour," and many, many more songs which would enthrall us all night long. We never grew tired of them. He must have known every operetta, every opera, every tragedy, all of Racine and Corneille, and all the comedies. He used to perform the scene from *Horace* which begins "Qu'il mourut…" all by himself, playing each character in turn, constantly changing places and coming in on his own cues. He and Marcel Olin also used to perform a sketch of an elocution class with a stuttering pupil, at the end of which the teacher would be stuttering just as much as the pupil.

However, women scared Max, although he always put on a show of such audacity with them. He thought they made trouble. I think his first experience with a woman must have marked him for life: he used to tell everyone about his one and only Cécile, who later married a well-known comic writer and illustrator.*

Max Jacob always felt persecuted, above all by the wives of his friends, even those who loved him most. When he was talking to a woman, he could show such hostility that the conversation would end in a blazing fight. Afterwards he would go into hiding, but we all missed him and would try to find him in his lair on Rue Ravignan. He always made everyone grovel a bit before coming round, but we were used to him, and his return would be greeted with joyous celebrations.

What fun Max was! We could never manage for long without him. And he was always the one to arrive with flowers or candy on days when he had received a bit of money.

* Cécile Acker, also known as Germaine (or Geneviève) Pfeiffer. Her husband has not been identified.

Guillaume Apollinaire had been living with his mother at Vésinet in a very nice villa, but after he moved to Rue Henner, he also used to entertain once a week, on Wednesdays.*

What a difference from Max's place! Guillaume's apartment was light and clean, a bit finicky and conventional, with no particular taste, but simple and fresh. It was tidy, and everything was kept strictly in place, but the effect was slightly too calculated and pretentious. However, there was always plenty of light, during the day and at night. The drawing room, which was too small for all the guests, opened into a bedroom where you could escape to get some peace. People would settle down there, but they had to take great care not to disturb anything, or Guillaume would get terribly upset. The most important thing was that no one should ever touch the bed. If he noticed the tiniest wrinkle or the slightest hollow he would frown with irritation. His mistress told me they only ever made love in the armchair. His bed was sacrosanct! It had to be left untouched until the moment he went to sleep. Nothing could be placed on it, even though the hall was too small for all the coats, and if anyone was so reckless as to sit on the bed, it caused an uproar.

There were always lots of guests when he entertained, and Apollinaire would greet some of them with genuine friendliness, others with exaggerated informality. There was never much to eat. Guillaume was so childishly and unthinkingly stingy it made us all laugh, and some of his friends made fun of him for it. Cremnitz used to go through all the cupboards and cabinets and filch anything he could find there to eat. This made Apollinaire furious, and he would try and rescue whatever he could, asserting his sense of ownership in the strongest possible terms. In contrast to this egoism, Guillaume had a soft heart and was easily touched, though always emotionally rather than materially. He was frequently moved to tears, but I never heard him yield to an appeal for a loan. I can scarcely think of any friends he gave help to, whereas no one who ever appealed to Max Jacob was disappointed. Max would give anything he had. It was the same when they visited us: Apollinaire gradually got into the habit of eating at least one meal a day with Picasso now that we ate at home, while Max, though he was desperately poor, was much too modest to pay a visit at meal times unless he had been invited.

Apollinaire was becoming recognized in literary circles and was working as a journalist and art critic. He had contributed to *La Phalange*, which was edited by Royère, and to *Marges*, edited by Montford. I remember one evening, after a party given by *La Phalange*, how he and Picasso came home on the top deck of the omnibus and were throwing down copies of the review to the other passengers. They had drunk rather more than they should have done and were thoroughly enjoying this method of distribution.

* Apollinaire moved to 9 Rue Henner (formerly Rue Léonie) in April 1907.

Every day we would see Apollinaire bustling about with a parcel of reviews or books under his arm, always just between two meetings, two matinées, two articles, two banquets or two assignations. But he still found an opportunity to introduce us to his new acquaintances. He was very busy and enjoyed himself enormously, just like a child, and the fact that he had achieved such success and made so many brilliant connections while he was still so young made him rather vain.

Apollinaire had a right-hand man, Jean Mollet, whom we often used to see. He was a kind of second-rate Manolo, constantly searching for a job which he managed never to find. He enjoyed the confidence of Guillaume and that of Guillaume's mother, too, but many of the stories about the mysterious private life of Mme Kostrowitzky came to light through him. He was much too ready to betray people's most intimate secrets, and I suspect that he often embroidered the truth.

One day Guillaume and Picasso had run into a young woman who happened to be looking round Clovis Sagot's gallery in the Rue Laffitte.* She was an art student at the Académie Humbert on Boulevard de Clichy and looked like an innocent, slightly vicious little girl, or at least as if that was what she wanted people to think.

Marie Laurencin was twenty years old, with beautiful curly brown hair falling down her back in a thick braid. She looked short-sighted, and her face was goatlike with slit eyes set close to her sharply pointed, inquisitive nose, which was always slightly red at the tip. She went to a lot of trouble to cultivate an appearance of naivety—which in fact corresponded to her real character. Her complexion was the color of yellowed ivory, though her cheeks blushed fiercely whenever she was overcome by emotion or shyness. She was quite tall and her dresses always clung tightly to her slim but shapely figure. Her long red hands, like those very young girls often have, were dry and bony.

Picasso and Apollinaire took her with them to the Steins. As a joke, Leo Stein showed her a copy of Jarry's *Ubu Roi*, thinking she would be embarrassed by the crudeness of some of its language, but Marie was not shocked at all, and said with a candid smile:

"Heavens, I've never heard of this book; may I borrow it?"

Apollinaire was greatly taken with her, and was determined that we should accept her as one of our group, but this didn't happen right away. We found the fact that she never behaved naturally but always seemed to be posing rather silly and forced. She seemed to be chiefly interested in the effect she was creating and would listen to herself speaking, and watch her own, quite intentionally childish, gestures in the mirrors all the time. Guillaume found this very amusing, and they were always seen together. She still lived with her mother, a woman who had all the reserve and discretion that was lacking in her daughter. They had been renting an

* Marie Laurencin's meeting with Apollinaire and Picasso can be dated to May 1907.

apartment on Boulevard de la Chapelle, but moved after we had met Marie to Rue la Fontaine in Auteuil, where their cat, "Pussy Cat," ruled the roost. It was rather a cold house, but these two quiet provincial women gave people a friendly welcome there. Marie set up a delightful studio in one of the rooms, where she did most of her work, and whatever time of day we arrived, she would always come to the door herself, her palette and brushes in hand, which meant we had to steer clear of the paint. Her mother was always doing embroidery while she hummed old Norman songs remembered from her youth.

One day Apollinaire brought Marie to Picasso's studio. Immediately she started ferreting around, touching and disturbing everything. She didn't want to miss anything and poked about in every corner. She was extraordinarily unconcerned and cool about this, not showing the slightest embarrassment. When she wanted to look at something more closely, she held a lorgnette in front of her glasses, so that she could see better.

Eventually she seemed to have grown tired of her inspection and suddenly stood still. She sat down and appeared about to join in the conversation, but instead she interrupted it with a shrill, inarticulate cry. There was an astonished silence and everyone stared at her. "It is the cry of the Grand Lama," she informed us sweetly. Then she started fiddling with her hair and sat up abruptly with it flowing around her. Presumably she wanted us to admire what was undoubtedly her best feature.

All this was apparently completely artless—but—but—dear old Guillaume was quite enchanted. I'm not sure what the purpose of all this babyishness was; whether it was meant to be casual or flirtatious. Who knows?

Braque, who had been a fellow-pupil of hers at the Académie Humbert, used to tell us about the tricks the pupils liked to play on her. When we first met her, she wasn't pretty, but she was intriguing. Later she became rather more charming, but even then it was a rather strange and bizarre charm, perhaps because of her hesitant gestures, which were typical of people with poor eyesight. But it was impossible to get at the true personality or evaluate the real intelligence of such a pretentious little person. In the end we got used to her ways. When Apollinaire brought her with him, we took no notice of her.

As a painter, Marie would probably have had the same sort of career as Madeleine Lemaire or Louise Abbéma, not a very successful one, had it not been for Apollinaire. It was his influence and that of the environment he introduced her to that allowed her to discover herself and realize her ambitions. She quickly realized how she could profit from such an original and progressive entourage, and since her own temperament and instincts tended towards originality, she was soon successful. She had already been influenced by Persian art, but it was after she had unearthed the *Journal des Demoiselles* that she really found her own style. This was an old publication illustrated with charming engravings in pink, grey, blue and white, which were a real revelation to her. One day, when I was visiting her, I saw a little picture framed in a medallion that I thought was an original Marie Laurencin, but it was actually an illustration she had cut out of the magazine. After this, her art hardly developed at all, perhaps because there was no real depth to her talent. I find her pictures always suggest a combination of cunning and false naivety, and the fact that she managed to establish a reputation as a painter seems to me to have been due to her highly individual charm, which was a mixture of a childish awkwardness and an oddly unnatural quality.

Certainly when we first met her, nobody, dealers, collectors or her friends, took her painting seriously. It was just as a joke that Picasso persuaded the Steins to buy a picture from her—quite a large composition showing a few of the artists she went around with grouped together.

We were beginning to find life a little easier, as the Steins were buying as much as they could and visits from dealers were becoming more frequent. We hired a cleaner to come for an hour every morning (we paid her 20 centimes), and she swept with a feather duster which had not much more than its handle left. Since she wasted most of the time sitting reading the newspaper in the armchair we had just bought and drinking the coffee she was supposed to prepare for us, she had to rush around to finish in time and we would be awakened by dry, hostile little thumps as she banged the furniture and everything else in the studio.

It was at this time that Pablo bought me some large gold earrings. They were handmade and very light and simple, but they really suited me and complemented my looks. I never took them off, even in bed. I was wearing my hair very long and always let it down when I went to bed, so that despite my pale skin, the thick tresses of my chestnut hair with its golden lights and my narrow grey-green eyes slanting towards my temples made me look like a woman from the ancient Orient.

Picasso used to keep his banknotes in a wallet, and he could never quite bring himself to leave this at home. He kept it in an inside pocket of his jacket, and for safety's sake he would fasten it firmly with a large safety pin. Every time he had to take some money out, he would undo the pin as discreetly as possible, but this was not an easy task. It was, in any case, very funny, although his mistrustfulness could become irritating. I remember one day when he noticed that the pin wasn't fastened in quite the way he usually did it. He looked suspiciously around him and was convinced that someone had tampered with his "safe."

He was now preparing his own canvases. After ordering samples from several shops, he would make a careful choice and order a length of the sample he had decided on. He liked a fine, tightly woven canvas with a very smooth grain that was less absorbent than the others. This would mean that after the work was finished the paint would suffer fewer of the effects of aging. He rented a special place for preparing his canvases at the bottom of an old garden in Rue Cortot in Montmartre (it has since been demolished), where he could leave the prepared canvas stretched out to dry for as long as was necessary.

In spite of our easier circumstances, Picasso seemed to be increasingly preoccupied. He was frequently morose, perhaps because his constant working exhausted him, and he grew more and more anxious about his health. He was afraid of tuberculosis. He used to cough every morning, just because he smoked his pipe too much, and he would check every time to see whether he was coughing blood. One night he ruptured some small blood vessels in his throat while he was coughing and brought up some blood. He was absolutely panic-stricken and we alerted Salmon, who was living in the building. He summoned a doctor friend, who laughed and did his best to reassure Picasso but failed to convince him. He still believed he was sick and decided he ought to follow a strict diet. A few years earlier Picasso had always drunk well and eaten anything that was put in front of him, but now he could no longer bear to touch anything that was not prescribed on his diet. For several years I never saw him drink anything except mineral water or milk, or eat anything but vegetables, fish, rice pudding and grapes. Perhaps it was this diet that made him miserable and bad-tempered so much of the time.

More and more new faces were appearing now at Picasso's studio, people who were curious or enthusiastic about the new school of painting of which he and Matisse (in his own style) were the leaders. Picasso was surrounded by admirers, not all of

them with the best of motives, and was occasionally taken in by flattery, or by his own self-esteem, but although he enjoyed these devotees, he soon tired of them.

One day Matisse came to the studio to introduce an important collector from Moscow, a M. Tchoukine, a very rich Russian Jew, who was a lover of modern art. He was short, with a large head, a pale, sallow complexion and features like a pig. He had a dreadful stutter and could only manage to explain himself slowly and with great difficulty, which was not only embarrassing but seemed to diminish his physical presence even further. Picasso's painting was a revelation to the Russian. He paid very high prices for two canvases, one of which was the beautiful *Woman with a Fan*, and became a devoted collector. He apparently owned a magnificent house in Moscow that he had decorated with paintings by the greatest artists of every age.

On another occasion, a young man appeared, rich, elegant and distinguished, who excited amusement and irony among Picasso's entourage. They found him "enchanting." This was Frank Haviland, the son of a porcelain manufacturer from Limoges. He admired Picasso unreservedly and became his disciple and most devoted pupil. His only wish was to imitate his idol, which, unfortunately, he managed to do quite successfully. He was tall, fair-haired, much too stylish and much too young, and he continued for a long time to be Picasso's attentive and unobtrusive retainer. The "rich boy" was not particularly generous, but he did help his new friends as far as his rather stingy nature allowed. Now and again he would buy a small drawing or a little study, whatever was least expensive. However, he did take Manolo under his wing, and it was thanks to him that the sculptor was able to get down to work and retire to Céret, where he was relieved of all the day-to-day problems that had always plagued him.

One day the painter Thiesson, who was one of Picasso's friends, announced that he was bringing round his brother-in-law, Paul Poiret, a couturier just at the start of his career who was crazy about art and everything he thought was new. Poiret, who was very fashionable and a great innovator in dress design, took an interest in all the young artists. He arrived and made a sensational entrance, as he was dressed with a care that could not be accused of erring on the side of fastidiousness and moderation. He was friendly, pleasant and rather patronizing, prepared to admire everything without actually looking at it. He came in and fell back stunned before a small gouache—a portrait of a woman.

"Oh! Remarkable! Delightful! Admirable! A portrait of Madame?" he inquired, indicating the painter's companion.

"Yes," Picasso answered, grinning derisively. "It's a portrait of Madame—by Madame."

The atmosphere cooled—perhaps he felt humiliated. Then I was introduced to him.

I never forgot the dreadful mistake he made on this first visit. But Poiret immediately took to Picasso and his friends. He invited them to dinners and parties in his

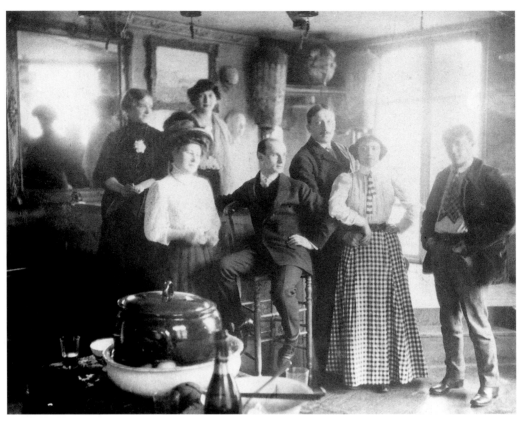

Guests at a party at Richard Goetz's apartment, 1907–08. Fernande stands behind two unidentified women, with (left to right) Wiegels, André and Alice Derain, and Picasso.

apartment on the top floor of a house in the Rue de Rome, where they met other artists: Paul Iribe, Lepape, Boussignault, Luc-Albert Moreau, Süe and Dunoyer de Segonzac. Dunoyer, who was closely associated with Poiret and a very pleasant fellow, did memorable imitations of the peasants from his part of the country. Poiret's fashion house was then in Rue de Pasquier, but soon afterwards he moved to Faubourg Saint-Honoré. His evenings were delightful—lively, amusing, unconstrained —and he managed to create a feeling of intimacy in that beautiful apartment.

Poiret earned his celebrity in the world of couture through his boldness, his generosity and his genuine love of art. He had great vision, and this was sustained by his extravagant tastes and the fact that he would never economize, whether it was a question of business, or a work of art, or anything else. Apollinaire, however, was unable to accept Poiret's view of himself as a "pure" artist. He wrote an article to this effect, stating that if couture was to be considered an art, it could only ever be classed as a minor art. Poiret never forgave him and used to have to watch his words whenever he spoke about Guillaume.

However, there was hardly anyone in our group who would rush to defend some-one who wasn't there. In fact, although they all seemed to be united by strong affec-tion, the minute someone left the others would start running him down. There can never have been an artistic circle where mockery, spite, and deliberately wounding words were more prevalent. There was often a common spirit about art and ideas, but rarely any common affection or generosity, and many of the protestations of admiration or friendship were almost wholly insincere. The worst offenders were Picasso and Max Jacob, who could never resist an opportunity for a witticism, which could often be malicious—even at the expense of their greatest friends. Max pretty much spared Picasso—there seemed to be no limits either to his admiration for him or to his deeply affectionate friendship—but he did not feel the same way about the others. Yet in spite of all this, it was an extremely tight-knit little clique that was hard for newcomers to penetrate.

Some of the most extravagant parties we all used to go to were given by the German painter Goetz, who had plenty of money and entertained in his apartment on Rue du Cardinal Lemoine. Germans seemed to be particularly interested in Picasso's art, which they believed they could understand better than anyone else. They sub-jected art to an almost scientific analysis, with the result that they perhaps rather underestimated its emotional content.

Goetz had had all the partition walls in his apartment pulled down to three-quarters of their full height, and he would set out huge cast-iron cooking pots and fill them up with dozens of bottles of champagne and slices of pineapple. You would dip into them with big silver ladles. Then he would serve huge geese, hot and streaming with fat, which were sliced on drawing boards with saws and choppers. Guests would be so merry and so noisy by the time they left that the neighbors always used to open their doors, and peer round them in disgust, to see what had been "going on" this time on the second floor.

We usually saw Uhde there, a former German officer, now a writer and art critic, who also used to visit Picasso's studio. He was the first person to "discover" Rousseau and bought many of his paintings at very modest prices, which enabled him to become an art dealer. He was a passionate admirer of cubism and helped the cubist painters by making them more widely known and promoting them abroad. Another of Goetz's guests was the young painter Wiegels, who came to live in the Bateau Lavoir. His moral standards were rather eccentric and he looked very equivocal—his head was shaven smooth, but his face, with its typically Prussian, coarse, pronounced features, looked young, and he had hard, piercing eyes. He didn't seem at all attractive, but gradually we grew accustomed to him, and as he began to lose his inhibitions his poetic qualities began to emerge. When we had got to know him well we discovered he was very gentle and extremely sensitive in a delightful, delicate way. He was a little wild, of course, but so were most of the

Germans we used to see. Once, after a party at Goetz's, Wiegels and Braque were sliding down the stairs and went feet first into the first-floor apartment of a resident in his night cap who had half opened his door at that very moment.

There were also more disconcerting people at these parties, like the Hoffmanns, a couple, both artists, who were much too friendly, or Froelich, enthusiastic and crazy—such a contrast to Uhde's cool correctness.* If you wanted to get a breath of air on the balcony or ventured into one of the few dark corners of the open-plan apartment, you would find embracing couples. Derain's wife and I weren't at all happy if we found our lovers enjoying the tender caresses of the German women, and fights would start. But her intense rage and my tears of misery would be dissipated in the chill air on the street and we would all climb onto the top deck of the Pigalle–Halle-aux-Vins omnibus to get back to Montmartre.

The parties given by Raynal in his apartment on Rue de Rennes were quite different—magnificent, but at the same time simple and very enjoyable. He lived there with his girlfriend, who was slim and very small, but extremely pretty, charming and gentle. She was also quite elegant, and intelligent, despite the fact that her lover could twist her round his little finger. Raynal was becoming a passionate critic of avant-garde art, and was merciless to anyone who did not follow what he considered to be the one true path.

Picasso continued to be driven by great ambition, despite the fact that he was reluctant to exhibit and never took part in group exhibitions at that time. He wanted to create a new kind of art, and although with his abilities he could have enjoyed great success as a traditional artist, he wanted to be an innovator.

I understood this more clearly one evening when we had taken some capsules of hashish at Azon's. We wanted to try out any new experience, and the different ways it affected the group of us who were there that night were fascinating. The hashish had no effect on Marie Laurencin, who went quietly home to her mother, but when we left the restaurant Paul Fort was running like a madman, while Salmon was limping along, more from nervousness than as a joke. The rest of us, Picasso, Max, Guillaume and I, went back with Princet to his apartment. All of us in turn felt the need to unburden ourselves, and this turned out to be very revealing.

Princet was crying because his wife had just left him for a painter,† but the affair seemed to provide some kind of consolatory joy and satisfaction for him. Apollinaire's fantasies were earthier, and he was madly shouting for joy because he thought he was in a brothel. Max Jacob, who was more accustomed than the others to sensations of this kind, was sitting quietly, blissfully happy, in a corner. But the

* The Hoffmanns and Froelich have not been identified; Froelich might be Otto Freundlich, who was part of the Goetz circle.

† André Derain

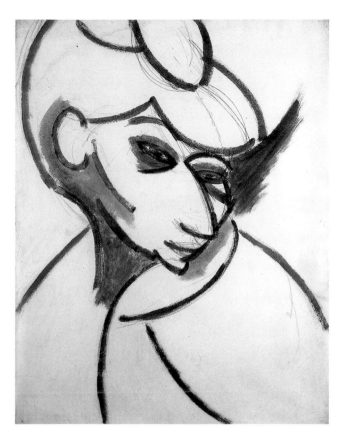

Picasso. *Portrait of Fernande.*
1907. Private collection.

effect of the drug on Picasso was more serious. He felt overwhelmed with despair
and screamed out that he had discovered photography and might as well kill him-
self, as he was left with nothing more to learn. He seemed to have had a revelation
that one day he would no longer be able to develop. He would reach the end, a wall.
He would be unable to go any farther. He would no longer be able to learn, or dis-
cover, or know, or gradually penetrate the secrets of the art he wanted to transform.

We would still take opium from time to time, sitting on straw mats with a group
of faithful friends and experiencing delightful hours of heightened intelligence and
sensitivity. There would be cold lemon tea, conversation and contentment. Every-
thing became beautiful and noble, and our love went out to all humanity as we
reclined in the carefully muted radiance of the big oil lamp, the only source of light
in the house. Sometimes this lamp would be extinguished, and only the glow from
the opium lamp would illuminate a few tired faces with its secret flickering…The
nights would slip by in warm, close intimacy, undisturbed by any animal desires.
Painting and literature were discussed with perfect clarity of mind.

I do not want to glorify taking opium, but I think it is an experience that can
benefit certain artistic personalities. I would even say that it may be necessary, with

the proviso—of course—that its dangerous side is understood, that it is used intelligently, so that you make it your slave and do not become a slave to the drug. Many great writers have composed while under the influence of opium—I could name several I know personally—and it gives them an extraordinary lucidity, allowing them to think and understand in an original way. It may encourage fantasy, but this is often profound and is always free of anything empty, mean, trite or vulgar.

Smoking opium without becoming poisoned by it—for that is the danger—is much easier than you would ever believe possible, although nature takes its revenge in the dreadful craving you feel for the drug when you are deprived of it, voluntarily or not, a craving that can only be overcome by the exercise of great will power.

When our group smoked opium, friendship became more trusting, more affectionate and more indulgent. But on waking the following morning this communion would be forgotten and everyone would resume their habitual bickering. We might all have become disastrously enslaved to opium had it not been for the suicide of our neighbor Wiegels. After an eventful evening, during which he took ether, hashish and opium in succession, he never regained his senses, and several days later, despite our efforts to care for him, he hanged himself. For some time the studio where he had died became a place of terror for us, and the poor man appeared to us everywhere, hanging as he had been the last time we ever saw him. We missed him and mourned him.

He was buried in the Saint-Ouen cemetery, and all his friends came to the funeral. On the way home we stopped at the Lapin à Gill, which cheered us up, and we began to forget the dead man. Nobody ever went to visit his grave, but after that no one ever smoked a single pipe of opium again.

[summer 1908]
The whole business drove Pablo into a state of nervous depression. He was unable to work and he couldn't bear to be alone, so I had to be at his side the whole time. I was in quite a bad way myself, but in view of Pablo's weakness I tried to overcome my own. In an attempt to cure him and to get away from the places that reminded us of the ghastly drama, we left Paris for a stay in La Rue-des-Bois, a small village on the edge of the forest of Halatte, seven kilometers from Creil. It was very remote and picturesque, and we rented a little outbuilding on a farm. It had no facilities, and we were surrounded by all sorts of animals and by villagers as ignorant as those we had met two years earlier near Bourg-Madame who asked us the name of the Queen of France! We had to live pretty much as if we were camping, but Pablo enjoyed the peace and tranquillity, although he didn't like the scenery. The surrounding forest was magnificent, but I realized that Picasso felt quite out of place in the French countryside. He found it too damp and too monotonous. "It smells of mushrooms," he used to say. He preferred the slightly acrid but warm odors of the rosemary, thyme and cypress of his native land.

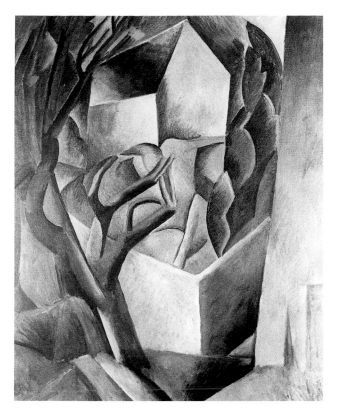

Picasso. *House at La Rue-des-Bois*, 1908. Pushkin Museum of Fine Arts, Moscow. The house in the painting, which stands at the end of the village, is thought to be the one Picasso considered renting.

Nevertheless, he was able to rest at La Rue-des-Bois. He had brought his dog, and his cat, which was about to have kittens, and a large and strange assortment of baggage. We ate our meals in a room that smelled like a stable and were lulled to sleep by the gentle murmur of sounds from the forest. We got up late, having slept through all the noises from the farmyard, which had been awake since four in the morning.

A succession of friends came to visit, staying for a few days before the next lot arrived. They occupied one of the two bedrooms, each of which contained one bed. Vanderpyl appeared, exhausted from having had to come the last seven kilometers on foot. He was accompanied by his girlfriend Amélie, a ravishing, uninhibited girl from the Midi—sometimes rather too uninhibited. She told us in her pure southern accent she needed a good bucketful of water to wash the "dust from the road" off her feet, when she saw how astonished we were at their dark color. They were a splendidly ill-matched couple: he was Dutch, heavily built, placid, intellectual and fond of good living—a taste Amélie knew how to satisfy—and he countered his companion's energy with an implacable sense of inertia. She was vibrant and passionate and complained to him the whole time about his lack of sexual activity. She used to wake us up in the middle of the night to complain about this. She would

make her way into our bedroom, half naked in her revealing blue nightgown, and sit on the end of the bed with her hands on her hips to pour out her troubles, while Vanderpyl called to her in a sleepy voice: "Amélie, you're bothering them. Come back to bed." She refused unless he promised to comply with her demands. Then she would go back to him, but next morning she would inform us in a voice full of disdain that the poor man's efforts had been unsuccessful. All this was enjoyable and amusing and helped us overcome the nervous stress, which could have become quite alarming.

Derain and his pretty wife also came. Her face was pale and touching, with a beautiful forehead, lovely eyes and a fine complexion, but she was unable to control her aggressive nature, and this was extremely difficult to put up with. Then Max Jacob came and spent several days with us, and Apollinaire and other friends too, which was a great help in getting us back in touch with the regular rhythm of life.

[Letter from Fernande in La Rue-des-Bois to Guillaume Apollinaire, August 21, 1908]

Dear Guillaume,

As Pablo wouldn't know how to explain everything to you, I'm standing in for him.

First of all, as Max [Jacob] is already here, you'll have to share his room for the 8 to 10 days that he's still supposed to stay. Then, if you want to economize, that is to say, spend no more than you do in Paris, you'll have to take your meals with us; otherwise there is only the local wineshop, where you'll be robbed because of the high prices. I do our cooking, buying everything we need from the farm. There is not much variety, but the food is very good, since I get eggs as soon as they are laid and vegetables gathered from the garden. As for milk, I watch the cows being milked.

All in all, I think that you won't spend more than 3 francs a day, including the bedroom, sometimes maybe less. I say bedroom as we only have one living room, and the woman who runs the farm rents out the other one.

We are surrounded by the woods, in a hamlet of 10 houses, so it's real countryside. The Oise is 10 minutes away from where we are, and as far as we are concerned, Pablo and I, we're very happy here, so much so that we are thinking of moving and settling here. We have even looked over a house that we'd like to rent. It's really very pretty; the house was an old hunting lodge, which, apparently Félix Faure visited. It's very large, very comfortable, with a big field at the back, meadows out front, and stables, barns and kennels for as many dogs as one could possibly want.

Anyway, do come; we shall be very happy. I think you'll be able to work; you won't be bothered by the least noise, I assure you. So much so that Max says the silence seems amplified.

The trains are very easy. At the Gare du Nord you take a ticket for Creil (2 francs 50 in 3rd class). Take the first express you can, but anyway they go all the time. The journey takes 50 minutes at most, and in the morning there's a train at 8:30 and another at 5 minutes to 9, but if you have one or two bags I think you'd do better to take the 1:15, as you'll find a coach at the station that will take you to la rue des Bois for 1 franc, but you must tell the driver that you want to go *to la rue des Bois*, as the carriage stops at Verneuil; the fare to Verneuil is 50 centimes and the driver will ask for another 50 from Verneuil to la rue des Bois. It's roughly 8 kilometres in all. If you take a train that doesn't connect with the coach, there are always cabs at the station that will take you to la rue des Bois for 3 francs, including luggage. That's what we did when we came. Look at a railway timetable as soon as possible—Northern Network trains for Chantilly, Creil, etc. My very muddled explanations may give you the impression that it's a very complicated journey, but that's because I write in a slightly confused way. I write so seldom that I can't remember how to do it.

Tell Marie Laurencin that I am going to write her a long letter and that we are hoping to see her one of these days. Send her my love. I was so pleased to get her letter.

My kindest regards to you and I hope to see you soon.

Fernande

If you come, would you mind bringing Pablo a bottle of Valerian (*Pachaut*), specifically this brand; you would be really kind to do this, as we can't get it here. The bottle should cost 5 or 6 francs and I'll reimburse you as soon as you arrive, as there's no way to send money from here.

Also, bring several towels for yourself. The farmers here can't believe that one might use several in a week.

It felt as if an ill wind had blown over us, but it had only taken us slightly off course, and our time in the country with our friends helped us forget more quickly the bad days we had gone through.

I wanted to rent a neglected property we found there, a large house with a huge park that we were offered for 400 francs a year, and I thought I was going to be able to talk Pablo into it. But at the end of our stay, once he felt free of the obsession that had been torturing him, he wasn't prepared to settle down in this remote corner. It was too damp and green, and too far from Paris—the only place in France he considered habitable.

So we returned to the city, leaving four or five of the kittens behind, as there was only room for one of them in the basket with the cat, who had had it all to herself on the journey down.

Back in Paris, Picasso and his friends returned to work. This was the time when Max Jacob threatened to achieve notoriety in rather an unusual way. He was no longer just reading the cards for his neighbors but became an astrologer, a fortune-teller and a clairvoyant. It was a new whim. I was never able to decide how seriously Max took himself or how sincere he was, but it was, at any rate, a new entertainment that appealed to our superstitions, and we often emerged from a session with him far more impressed than we were prepared to admit. He was consulted about everything and would always reply, telling us which stones or colors to choose and which metals we needed to carry about with us for luck. He cast our horoscopes and read our hands, which would be clammy with apprehension or hope. Poiret was one of his most devoted clients, and Max would give him guidance in the choice of colors for his ties or socks—telling him which ones would bring him good luck. He used to make us lucky charms, talismans whose weight would depend on whether they were made of parchment, silver, copper or iron, a decision based on date of birth and the stars that presided over our fate. They were always decorated with hieroglyphics, cabalistic signs, geometric shapes and weird figures, which Max engraved in his own absurd fantastic style using a hatpin I had given him. I am quite certain they were entirely drawn from his own imagination, despite his claim to know Hebrew. We jealously guarded our precious talismans, for fear of spoiling or missing out on our luck by losing them or displaying them. For a long time I carried around in my bag a heavy plaque of rough, red copper, two inches long, decorated with cabalistic figurations and my birth sign of Gemini. It wasn't that I believed in its talismanic powers, except that it was a gift from Max, but I knew that despite his waywardness he was like Candide and that any present from him could only bring happiness.

I remember that Poiret, who was the most superstitious of us all, could never look at a deck of cards without turning a card over. If it was a club or a heart he would be happy all day; but if he turned up a spade, it spelled disaster. Later on, the sales-girls at "Martine," his interior design shop, would lay out decks of cards on the tables with only clubs and hearts turned up, just to keep him in a good mood.

One day, when Pablo was visiting Père Soulier's bedding and junk shop in Rue des Martyrs, he bought a painting by Rousseau for five francs. It shows a life-sized woman in front of an open window, and Picasso was thrilled with it. It is quite charming, simple and sensitive, despite its naivety and rather stiff, stilted technique. The woman, who wears a blue dress, is set against a curtain in a shade of rich, deep garnet, with a tie decorated with an enormous tassel rendered in a strikingly life-like manner.*

* Rousseau's *Portrait de Femme*, c. 1895, was bought by Picasso in fall 1908. It is now in the Musée Picasso, Paris.

PICASSO AND HIS FRIENDS

Guillaume had already been to several soirées given by the painter, who lived near Rue Vercingétorix in a little street where he had a sort of studio, and he laughed with his great infectious bellow when he told us about these evenings. The next time he went to see him he took us with him.

Rousseau was a poor, charming man of unimaginable candor and naivety. He was not stylish and his face was suprisingly ordinary, with nothing to suggest any artistic qualities, although he was certainly an artist with a unique gift, a kind of genius. He had a slight stoop and tottered rather than walked, and his grey hair was still thick despite his sixty-five years. He had the look of a man living on a small pension. His expression was always gentle and kindly, though the color rose to his face if someone crossed or upset him. He usually agreed with everything that was said to him, but you could sense he was restraining himself and did not dare say what he really thought. He gave an impression of simple but obstinate common sense.

He wanted his pictures to be true to life and was so naive he seemed to have no idea that "Rousseau's truth" differed from actual truth to nature. He called his paintings "photographs," and the only difference he could see between his and those made by a photographer was the color. But he had such natural gifts you felt it would have been sheer madness to try and correct the strange and complicated truth that emerged from his simple, genuinely uncomplicated mind. Rousseau painted what he saw, but what he saw had the charming simplicity of vision of a gifted child coloring fairy tales or the adventures of Robinson Crusoe, or trying to represent his father, his mother, his sister or his dog, just as they appeared in his imagination. The "Douanier" must have lived in a world of perpetual enchantment.

When I showed him the painting Picasso had just bought and asked him if he had painted it in the mountains of Switzerland, he looked at me reproachfully, as though he thought I was trying to make fun of him. "Oh, come on," he replied, "surely you recognize the fortifications of Paris through the window where my wife is standing? I did that when I was a customs officer and was living near the…gate." I have forgotten which gate it was. I didn't dare tell him that I had thought it was Mont Blanc he had painted. In actual fact the fortifications do look like high mountains.

The poor old Douanier was so innocent and so childishly vain, he was easily taken in. He was not surprised by the sudden fame he enjoyed and thought it was splendid to sell a picture for thirty or forty francs. All the local tradesmen had had themselves "photographed" by Rousseau, but these images had been paid for with goods. However, he also allowed himself to get entangled in some very shady schemes, out of a simple desire to be helpful. One of these ventures almost got him sent to jail, but he was totally unaware of what was happening to him. He had been duped by dishonest people.

One evening he invited us to one of his soirées. When we arrived at about nine o'clock, two or three couples in their Sunday best were sitting stiffly on chairs that were arranged in tightly packed rows as if the studio were a lecture hall. There were

also benches against the wall, and a little platform at one end of the room served as a stage. Gradually the guests arrived, and to prevent congestion Rousseau insisted they should sit down in exactly the order in which they entered. He stayed on a chair by the door, like an usher at the theater.

There was a complete mixture of people there, the grocer, the butcher, the dairy-woman, the baker and their spouses, some other rather embarrassed people, possibly concierges from the neighborhood, and a whole crowd of intellectuals and artists—Georges Duhamel and his wife Blanche Albane, the actress, the painter Delaunay with his mother, Max, Guillaume, Uhde and his wife (who later married Delaunay), a few other Germans, Braque, in fact, the whole of our group. Once everyone had arrived, Rousseau climbed onto the stage and played a little tune on his violin to open the evening. It appeared to be "Oeillets du Poète" (Sweet Williams), chosen to pay homage to Apollinaire. This was followed by a recital by several local people—the women singing romantic ballads, the men singing bawdy songs complete with all the gestures, or reciting interminable monologues. Then Rousseau played the violin again, quite a long piece, and afterwards he sang "Ah! Ah! Ah! what a terrible toothache I've got!", miming the contortions of a patient at the dentist's. It was funny, but rather sad—I didn't enjoy the fact that Rousseau was making such a spectacle of himself. He seemed to me like a slightly retarded child with a family who were all pandering to him. But here the scene was set against a backdrop of large canvases, meticulously painted with a technique that was strangely grand and powerful. As I watched him moving about clumsily, looking at everything around him, confident of the admiration he aroused, I realized he didn't know how to think. He just imagined what he believed he saw. I found him irresistible and pathetic, but with his simple mind he rose above all the feelings he inspired, which, had he been aware of them, would have astonished him. He worked in an ivory tower created by his total failure to understand what other painters were doing. As we were leaving that evening, Rousseau was delighted: "That was certainly a successful evening!" he said.

Some time later Picasso decided to organize a banquet to be held in his studio in the Bateau Lavoir at his own expense in Rousseau's honor.* This bohemian project was greeted with enthusiasm by our friends, many of whom saw it as an opportunity to play a kind of elaborate practical joke on the painter. Some thirty people were to be invited, and anyone who wanted to come after dinner was welcome.

The studio was decorated with greenery, covering the pillars, the beams and the ceiling. At the end, facing the window, in the place set aside for Rousseau, a sort of throne was constructed from a chair raised on a crate and placed against a backdrop of flags and paper lanterns. Above this was a large banner with the words: "Honor

* The banquet was held in late November or early December 1908, a few weeks after the soirée Fernande and Picasso had attended.

PICASSO AND HIS FRIENDS

to Rousseau!" The table was a long board set on trestles. The seats, dishes and cut-
lery had been borrowed from Azon's. The glasses were thick, the plates small and
heavy and the knives and forks were made of tin, but nobody looked too closely at
things like that.

Everything was ready and the guests had crowded into the studio, which now
seemed much too small, but by eight o'clock the dinner, which had been ordered
from a local caterer, had still not arrived. (It did not arrive until noon the following
day!) We went off to scrounge what we could from the pâtisseries and restaurants in
the neighborhood while the guests went back to the bar and started drinking again,
encouraged by the tunes played on the pianola. At this point poor Marie Laurencin
(Coco to her friends), who was still quite new to this artistic world, became the
focus of attention for a small group who had made up their minds to get her drunk.
It proved an easy task. The first thing she did on coming back into the studio was
to fall onto some tarts which had been placed on a couch, and with her hands and
her dress covered in jam she started hugging everybody. As she couldn't be quieted
down, an argument broke out between her and Apollinaire, and Coco was sum-
marily sent home to her mother.

At last everyone sat down at the table. Rousseau, who thought that the food had
arrived, gravely took his seat, with tears in his eyes, beneath the canopy that had
been erected for him. He had drunk more than he was used to and soon fell into a
peaceful slumber. Speeches and songs had been composed for the occasion, and
Rousseau managed to say a few words, but he was so overcome with emotion and
pleasure that he was stammering. Throughout the evening wax had been dripping
onto his head from one of the Chinese lanterns hanging above him, but he was so
happy he bore this quite stoically. Eventually the drips formed a sort of small pro-
tuberance on his head, shaped like a clown's hat, and this remained there right up
to the moment when the lantern caught fire. Rousseau was convinced that this was
his final apotheosis. After that, as he had brought along his violin, he began to play
a little piece. He was no better as a musician than a painter, but his heart was in it.

Two or three American couples, who had turned up by chance, had to make great
efforts to keep straight faces. These men in dark suits with their women in light
evening dresses seemed a little like delegates from another world among all of us.
The women who accompanied the artists wore little dresses that were simple but
always original: Mme Agéro looked like a boarding-school girl in a black smock; her
husband was so casual you weren't sure if he knew where he was or not; the Pichots
and the Fornerods had come, as well as Jacques Vaillant, Max Jacob, Apollinaire,
Leo and Gertrude Stein, and many others. André Salmon and Cremnitz both pre-
tended to suffer attacks of delirium tremens at the end of the evening by chewing
up soap which frothed around their mouths—which horrified the Americans.

After dinner practically the whole of Montmartre filed into the studio, and the
ones who weren't able to stay made up for it by grabbing little sandwiches and any

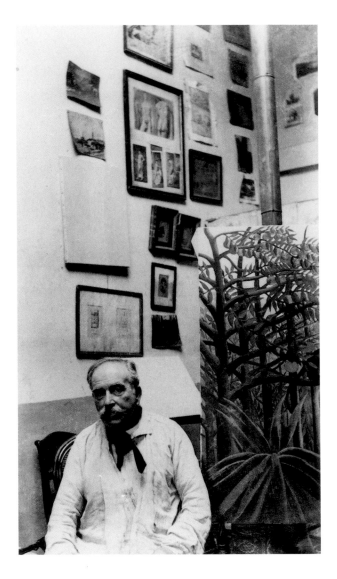

Douanier Rousseau photographed in his studio by Picasso, 1908.

other food they could get their hands on. I saw somebody stuffing his pockets full although I was staring straight at him. Rousseau sang his favorite song: "Ah, ah, ah, what a terrible toothache I've got!", but he wasn't able to finish it and ended up falling asleep again; he snored peacefully. Occasionally he would wake up with a jolt and pretend to be extremely interested in what was going on around him, but he couldn't keep it up for long, and his head soon flopped back onto his shoulder. There was something charming about his weakness, his naivety and his touching vanity. The memory of that banquet always affected him long afterwards. The dear man had taken it all in good faith as the homage due his genius, and he sent Picasso a wonderful letter of thanks.

It was at around this time that Rousseau did a double portrait of Guillaume Apollinaire and Marie Laurencin, in which Apollinaire appears slight and delicate —which he never was—and Marie Laurencin heavy and fat—which she never became.* One day I found him very upset because he couldn't finish the picture. He had decided to paint a row of flowers at the bottom of the canvas, but as they were to be a symbol of Apollinaire, he was adamant he needed Sweet Williams. These were not in season, so he had to wait six months before he could complete the work.

Another time he came to visit us as we were finishing lunch. He was miserable and began pouring out all his troubles, while at the same time he was eating fritters sprinkled with sugar, which he scattered all over himself. He was soon covered with it and my dog lovingly licked his trousers and jacket. He didn't move, but with tears in his eyes, watched her do this and continued to recount his sorrows.

He had already been widowed twice, but had now become engaged for a third time. He still retained affectionate memories of his late wives and had even paint-ed a picture in honor of one of them that was shown at the Indépendants around 1910—a man and a woman holding hands in a garden protected by dead couples adorned with little wings in the sky above their heads. Now, however, his prospec-tive father-in-law had inflicted a deep wound on Rousseau's self-esteem by telling him that he was too old for his daughter. In fact, she was fifty-nine and Rousseau must have been just over sixty-six, while the father-in-law was eighty-three. What really devastated Rousseau was that his fiancée was not prepared to go against her father's wishes. He was really sad about it:

"One can still be in love at my age without being ridiculous. It is not the same as it is for you young people, but does someone who's old have to resign himself to living alone? It's dreadful to have to go home to a lonely apartment. And besides, it's when you get to my age that you really need someone to warm your heart again. You know then that you won't die alone, but that a companion of your own age may be able to help you pass to the other side. Old people who remarry shouldn't be laughed at; we need to be close to another person we love while we are waiting for death, when we know it's approaching."

He said all this in a soft, tender, tearful little voice. In fact he never had time to carry out his plan: he died all alone in hospital a few months later.

Rousseau used to say to Pablo: "We are the two greatest painters of our time, you in the 'Egyptian' style, and I in the modern…" Why Egyptian? I'm sure he had no idea himself. This statement sums up Rousseau's intellectual abilities. He was con-vinced of this—I don't believe he was ever able to utter a word he didn't really mean.

* This painting, *The Muse Inspiring the Poet*, was begun in August 1908 and completed in spring 1909. It is now in the Pushkin Museum, Moscow; a second version, painted in 1909 is in the Kunst-museum, Basel.

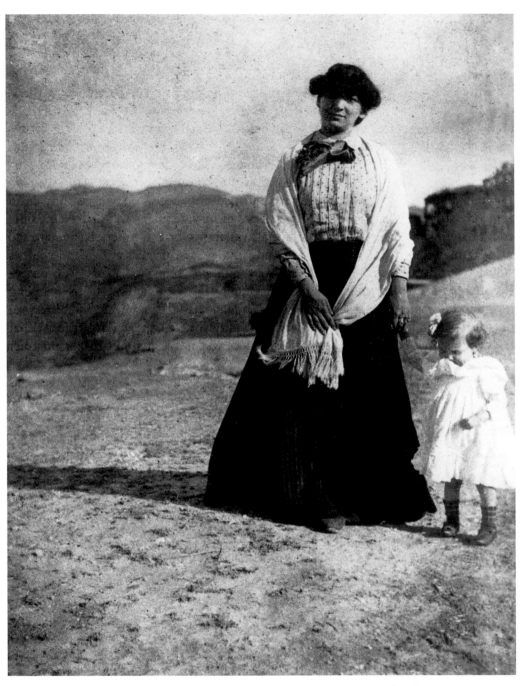

Fernande in Horta with one of the children of the village, photographed by Picasso.
Musée Picasso, Paris—Archives Picasso.

LETTERS FROM SPAIN

to Gertrude Stein and Alice Toklas, May 15–September 8, 1909

[Letter from Fernande to Alice Toklas in Paris, May 15, 1909, on paper from the Gran Continental Café-Restaurant]

Barcelona, May 15, 1909

Dear Alice,*

You'll be the first friend I've written to from Barcelona. I keep my promises, you see. Yesterday evening I sent off a huge number of postcards. I hope you and Mademoiselle Levy receive yours. I'm not enjoying myself much in Barcelona. After having been looking forward to coming here so much, I've reached the point where I can't wait to leave. However, I think we'll have to stay for at least two weeks. Is the weather still nice in Paris? Our train journey through the south of France was rainy and rather miserable and it rained here the day we arrived, but it's nice now. I'd dearly love to be in Paris, I can tell you. Please write back straight away; that would make me very happy. There were 14 or 15 of our friends at the station when we left, so it was quite an occasion. I looked for you, but didn't see you.

Here I'm causing a revolution in the town. If it goes on like this I don't think I'll be able to walk down certain streets without having cabbage stumps thrown at me. So far they've only jeered and burst out laughing as I go past. I find it a little upsetting and I'd really enjoy dowsing all those idiotic people with water. I'm disappointed by Barcelona, which now seems to me a ridiculous town, infernally provincial and very ugly at night, a town that is tolerable during the day only because of the brightness of the sun and the sky. The flowers are my only consolation. I'd love to send you some, but I don't know how I'd manage to get them to you while they're still fresh. I'll try and find out about this. Write me and tell me lots about yourself and about Paris and pray to God to give me the strength to stay five months in this country, which I was hoping to find as beautiful as I did before. How wrong one can be. I wonder how I managed to amuse myself and be so happy here the last time.

* Fernande writes "Dear Alice" in English.

Write to me. Write to me. It would be a really good deed. Please pass on every sort of good and kind greeting from me to Mademoiselle Levy. Tell her that as soon as I'm in the countryside I'll write her too, in English, and I expect she'll be quite delighted with that.

I leave you with assurances of all my love.

Affectionately,

Fernande

[Letter from Fernande to Gertrude Stein in Florence, May 16, 1909 on paper headed "Au 'Lion d'Or' Barcelona"; there is also a short greeting from Picasso]

My dear Gertrude,

We arrived in this horrible town of Barcelona on Thursday and since Thursday I'm sorry to say there is only one thing I've wanted to do—get away from here as quickly as possible.

No, truly, and although this might surprise you, I don't care for Spain at all this year, if Barcelona is anything to go by. Perhaps I'll like it better in the countryside— maybe or maybe not. In any case I'll write and tell you about it.

The weather here is dreadful. It was raining when we arrived and today the bull-fight was cancelled because of rain. I'm quite upset as I was counting on being entertained by something new.

What are you doing in Italy? Is the weather good and are you happy—happier than I am here? Please send me a letter here in Barcelona. I think we'll stay for per-haps another week.

I can't walk one step in the town without attracting a crowd. I'm creating a real sensation here, but I can assure you that it does me no good. I don't think Pablo likes it here at all and wishes we were already in the countryside. As for me, I'd love to be in Paris.

I had such good memories of this place, I just can't understand how I could have been happy here. It's horrible, horrible. A filthy provincial town, or even worse. In spite of all this, I'm really longing to see you here, and I have high hopes that your being here will reconcile me to Spain. If only they didn't make fun of me the whole time! Barcelona even without the sunshine might be tolerable, but can you imagine, they don't appreciate my hats, which I love so much, and call them "washtubs." To hell with these stupid natives who are so ignorant about *Parisian elegance*.

This is our address here: M. Ruiz Picasso
 Grand Hotel de l'Oriente
 La Rambla
 Barcelona

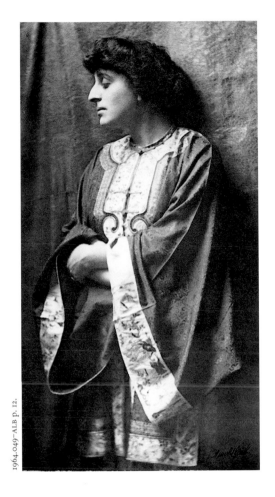

Alice B. Toklas, 1906.
Photograph by Arnold Genthe. The Bancroft
Library, University of California, Berkeley.

I'm counting on hearing from you, as I am from Miss Toklas, to whom I've also
written.

My regards to Leo.
Yours very sincerely,
Fernande

Barcelona, May 16, '09

[postcard from Fernande to Alice Toklas in Paris, postmarked Barcelona May 31, 1909]

Love to you both,
Fernande

I've been sick and was unable to write as I had to stay in bed. Do write me. We're
still in Barcelona because of this.

[Letter from Fernande to Alice Toklas in Paris, June 15, 1909]

Wednesday, June 15

This is our address: Picasso
 Posada Antonio Altés
 Orta por Gandesa
 Provincia de Tarragona
 Espagne

Dear Alice,

What has become of you? Where are you? Did you receive the cards I sent you from Tortosa?*

We're now in this little village, which is our final destination, but I'm still unwell and miserable.

I'd love to have news of you. I wanted to write sooner, but I just couldn't. You're the first person I've written to from here, and it's already ten days since we arrived. If you're in Paris, could I ask you to send me a few comic magazines? I get Le Journal and Le Matin from Barcelona, but that doesn't amount to much, and if I had other papers that were a bit more amusing I don't think I'd be quite so bored. Do write me as well, I would be so pleased. Don't pay too much attention to the laconic tone of my letter, but I'm in really pitiful shape. I think the state of my health must be very like Mademoiselle Levy's at the time I met her. Can you give me any advice about this?

The village we're in is very tiny, and the villagers are very nice. Unfortunately I have to see the local doctor, whose *Segnora Medecine* speaks French, and I can assure you that this doctor's wife is not much fun. She learned French in Bordeaux, where she spent part of her childhood, and speaks with a horrendous southern accent. We also spend a lot of time with the schoolmaster, who infuriates me because he studied French for a month in *Tortosa* at the Berlitz school and constantly repeats phrases like: "What is on the table? On the table there are some plates and glasses and knives, etc. etc." in his atrocious accent. And I have to put up with this all through every meal, as he's staying at our inn and we eat together. A *segnor apothicario* is also staying here—a pharmacist who has never studied pharmacy but apparently performs the functions of a pharmacist miraculously well. This *Arturo Ullrich* is a German, who left *Leipzich*, where he was born, because he didn't want to do military service, and came to Spain rather than anywhere else because he had read novels in which Spain appeared to him to be an enchanted land. He arrived in Barcelona with practically no money and without speaking a word of Spanish. Now he's here, he has a *job*, and he must earn about *90* or *100 francs* a month. He's very

* The card, with a view of Tortosa, was sent on June 5. Fernande described the town as "very pretty."

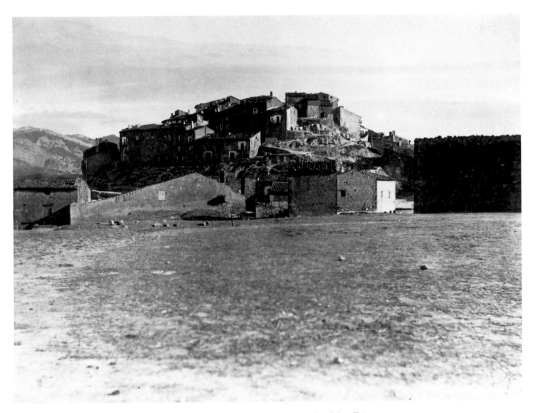

Distant view of the village of Horta de Ebro, photographed by Picasso, summer 1909.
Musée Picasso, Paris—Archives Picasso.

happy and is going to marry a local girl he's crazy about. Here, when they're *engaged*, a man is called a *novio* and a girl a *novia*.

The schoolteacher is very annoyed because she would have liked to make friends with me. She came to visit me the day after I arrived and immediately asked me to call on her, which I haven't done as I find her very tiresome. And what am I supposed to do with all these people who don't understand a word I say? Besides, I'm in exactly the same position with them as they are with me, I don't understand their dialect at all.

The *mayor* here is a real tyrant who ruins anyone who offends him.* The well for his water supply is in a place he keeps locked because he's afraid someone will poison it. He's an old miser who spends as little as he can of the government money he receives for local maintenance. He makes demands on all the peasants, and anyone who won't pay what he's asked for had better watch out, as he'll have nothing left

* In 1909 Don Pepito Terrats was mayor of Horta (with his son as his deputy). Some time after Fernande and Picasso left, the townspeople staged a revolt because of the mayor's practice of buying votes.

The house where Fernande and Picasso stayed in Horta, painted by the artist on his first visit to the village in 1898–99. Museu Picasso, Barcelona.

by the end of the year. People here who were once well off have lost everything for having defied the mayor—it's hardly credible, but it's a fact, and he has been mayor for the past nineteen years. But it would take me too long to explain this *particular* case. If you're interested, I can tell you more about it in Paris. It's really very strange.

There's something else here that I find very annoying, and that's the *sereno*. This is what they call the night watchman who walks around the whole town, or village, shouting out the time and the state of the weather. They have these *serenos* all over Spain. I always find them annoying, but here it's frightening. Just imagine a mournful voice waking you at night with the words

Praise be to God.

The clock has struck

ten o'clock (or more or less, depending on the time)

The sky is clear or *cloudy* (which also depends). In French this doesn't sound too bad, but in Spanish it's dreadful, and this is repeated roughly every quarter of an hour, since it hardly takes any longer than this to walk around the whole area. What's worse is that this official is an old gravedigger who has an infernally harsh voice.

Another disagreeable custom they have here, particularly if you've just eaten, is that when you pay a call or visit someone, whatever the time of day, it causes offense if you refuse anything you're offered to eat or drink—ham, sausage, wine, etc. etc....all those things that slip down easily, as La Fontaine says.

Something else here is a pianola, which the young people dance to on Sundays or sometimes on Saturday evenings.

There are processions, in which the children blow on wooden whistles as hard as they can, while (imagine this) the good folk who aren't walking in the procession throw—can you guess?—*confetti* from their balconies to glorify God. Real savages, aren't they? The cuisine isn't particularly varied either: every day there is mutton soup with saffron and lamb cutlets; the following day, lamb cutlets and soup, ditto. Only the *saffron* is rather overdone. This will give you some idea of my *country retreat*. I hope you never come across anything like it. The weather is not very nice either. It's quite cold, it rains quite often, and it's windy the whole time. On top of that, there have been earth tremors in the region recently, especially in Tortosa where we were before coming here, which is to say six hours from here on foot—quite delightful.

Has my letter bored you? It's in my nature that I have to bore my friends when I'm bored myself. It's really in spite of myself, I promise you.

The scenery is pretty, we're on a mountain, and *from a distance* the little village is very pretty. We're surrounded by mountains on every side, with a few olive groves here and there, some almond trees, a little rye, some wheat and I think that's all, also a little water—what I mean is a very few little holes which are filled by the rain from time to time.

Do write me! and if you could send me something to read you'd be the best of friends.

Please give my warmest good wishes to Mademoiselle Levy, and to you too.

Pablo is in the loft. He's working. Men are laughing, children are screaming, babies are crying, donkeys are braying, and I feel very sorry to take my leave of you.

Write me.

yours ever,

Fernande

P. S. If you could, and if it's not too much trouble, would you send me a book, really a very ordinary novel called *Amants de Venise* [Venetian Lovers] by that novelist who's so popular, Michel Levaco. It ought to be in all the book shops on June 15 at 65 francs. I'd like this book because I happened to buy the first part in Barcelona and brought it here, and I want to know what happens next—the first part, which I've got, is called *Le Pont des Soupirs* [The Bridge of Sighs].

I've forgotten to tell you that the people here thought we were photographers, and everyone in the region was thrilled to be able to have their *"portraits shot,"* which is a simple translation of their expression. This is all because of the camera Pablo owns, and it's quite unjustified, since he hardly knows how to use it. Well, that's how reputations are made. We were even told that Pablo could make a lot of money by photographing all the people in the village.

Goodbye again, Fernande

P. S. You'd do me a favor not to pay any attention to the composition of this letter or to my handwriting, but just remember that I only wanted to chat with you for a bit.

TO GERTRUDE STEIN AND ALICE TOKLAS: 1909

I've been so selfish, because I wanted so badly to complain and pour out all my troubles, that I've only spoken about myself without even asking for news of you or Mademoiselle Levy. Do forgive me, both of you.

[Letter from Fernande to Alice Toklas in Paris, June 26, 1909][*]

Saturday
When you're writing my address, underline *Orta*

Dear Alice,

I'm not yet able to write you in English because I'm afraid you won't understand what I'm trying to say. I received your letter and thank you very much. I like what you say about the last letter I sent you. The day I wrote you I was quite unwell, and I can't really think what I can have chatted about so as to entertain you. Anyway, for the past two days I haven't been feeling so bored and I don't just want to write about myself, but also, as you find this entertaining, about the people round here.

Did I tell you in my last letter that there's also a village idiot? He's a young man about 23 or 24 years old, and one of the theories is that his debility was caused by poverty and anemia. But other people—some of the local women—have told me that it happened in France (for he spent some time in France), where evil-minded people made him eat some herbs which made him insane. That's nice, isn't it. But it gets more complicated. This idiot suddenly fell in love as soon as he saw me, and he thinks about me the whole time, so that the people at the inn have had to tell him not to come back here. He was always coming to see me, and if I was in my room he'd want to come up, with the excuse that I must be bored on my own. The poor boy used to give me a terrible fright. As I'm French, he had the crazy idea that he had to speak French, and since he doesn't know this excellent language, he would articulate sounds like those that children make when they imitate foreign languages. Imagine how pleasant it is to find yourself in the company of someone who's strong and energetic and looks at you very seriously, and who speaks to you like that. As I couldn't understand him in spite of his loving me so much, he worked out that I must be a "tonta," and since he is a "tonto" we would make *two* "*tontos*," he said, which means, to translate the word "*tonto*" for you, idiots. This was not very flattering for "your humble correspondent," given that *I* am this humble correspondent. Yesterday the poor creature went off into the countryside, and no one is bothered, although they don't know what has become of him. In the morning he saw Pablo and me leaving to go to have lunch with some friends out in the country and complained to some of the villagers that I was always going off, not caring that I was leaving him all

[*] The date can de deduced from references to saints' days.

alone with his pain. Maybe he got it into his head to look for us, I don't know, but what I find most upsetting is to see the indifference of the people here, who let him become more and more crazy when he could be cured if he were put in a home or taken care of. I'm sure that if they did this he could be cured. Every evening they shut him up in the prison, where he shouts and sings all night long. As we're staying next to the prison, I've spent night after night unable to sleep. Last night was the first I was able to get some rest. You probably think I'm attaching too much importance to such a trivial subject, but you can't imagine how painful it is to see someone reduced to this condition, like a child. When he's here, he spends the day touching his toes and playing like a child. He lies on the ground, he jumps, he sings, he gets angry, etc. etc. When he's given something to drink, after he has finished he hurls away the jug or glass they've handed him, which means that people often refuse to give him a little water to prevent him breaking a jug that cost a few sous. I feel very sorry for him, and I wish they'd have him put in a home somewhere where he could be looked after and cared for. But I'm going on about him so much it's getting tedious, so I'll stop.

I haven't paid a visit to the *Segnora Medicin* for some time now, and I think she's rather put out about this. Our communications are confined to mutually over-effusive greetings when we meet in the evenings on our after-dinner walks. As for the Segnora *schoolteacher*, she takes no notice of me, as she's still waiting for me to call on her. On the other hand, I see a lot of the *Segnora* baker, who is a woman who was seduced before her marriage, though all was put to rights by her marrying her *seducer*. Her rehabilitation had its problems, as her husband's parents refused ever to see him again and wouldn't give him a centime. But it proves that good can come out of misfortune, since he became a baker and earns plenty of money and they have three children, all born in less than four years of marriage. There are a lot of children here, and most households are blessed with at least one each year. This does nothing to moderate their pride, and it certainly doesn't prevent them having one more the following year, unless it's twins, in which case they have *two*. But isn't it said that God grants blessings to large families?

Last Thursday we celebrated the feast of St. John in a very special way. Next Tuesday will be St. Peter and St. Paul, which is Pablo's name day, and that will be celebrated in an equally special way. I think that the only present I'll be able to give him here will be to dance to the strains of the pianola, but even this present will be more generous than those in other years as I've never celebrated his name day before. On the night of St. John's day there were games in every corner of the village and in the main square, too, to the sounds of a drum and a fife. The young country boys and girls danced the *hotta*,* which is a rather monotonous dance from Aragon, but still great fun as the young people were all fairly drunk. One of the local young men pressed me to dance with him. When I protested he said he'd teach me, and

* The *jota*.

when I absolutely refused he told Pablo he'd rather have just one dance with me than find 2 douro [duros], which is 10 francs. This is a real triumph, someone who values me at more than 10 francs. For the idiot I was worth as many eggs as he could give me, at least that's what he used to say. Am I really more successful here than in Paris?

I am also doing very well with the tyrant *Segnor Alcade* [sic] (the mayor). He invites me over in the evenings and seats me in his own armchair. As for the Segnor schoolmaster, he has been stricken with French mania and every evening as soon as dinner is finished he grabs his French book and reads and translates and makes me read and Pablo translate all the French he can, and the only good it does us is that we're learning by heart the Meditations of Napoleon I—for that's the title of the book he owns. A word of advice: if ever you see this book don't read it. It couldn't be more tedious, but I can't write any more about it today as it's quite impossible for me to string even a few thoughts together, as you'll have noticed, and what's more I can't spell any longer; I don't remember how.

Manolo and Monsieur Haviland may be coming to see us. If you could come yourself I'd be very happy and it would be fun. As you've been kind enough to offer to send me some books, I'd like to take the opportunity, with apologies for putting you to any trouble, to ask you to send one or two other things. I'd be very grateful if you could send me some washable silk thread, as I've started to embroider a blouse here and I don't have enough thread to finish it. I think you'll be able to get it at *Bon Marché*. Could you also get me *3 or 4 handkerchiefs to scallop*, ones with a simple scallop *where the pattern is marked in blue*. They will also be at Bon Marché. I'm attaching a few samples of the silk I need: could you send me two skeins or cards of each, plus:

2 skeins of black washable silk thread

2 - - - - of very bright green - - - - -

1 - - - - of white - - - - - -

(I don't have any samples of these; could you choose the green yourself)

a few skeins of embroidery cotton, brand DMC to scallop the handkerchiefs

As for books, could you go to Hachette, 79 Bd. Saint-Germain, and get me the translations of Dickens and Tackeray [sic] which are called Barnabi Rudge [sic], Martin Chuzzlewit and The Mystery of Edwin Drood by Dickens and Vanity Fair by Tackeray.

I'm really embarrassed to be asking you for so much but I thought it would cause less trouble if I asked for everything at once. If you could send the parcel by *registered* mail I think it would get to me more safely. I'll reimburse you for all this in Paris and I apologize for that, but there's no post office or messenger service here that will send money. It certainly is a very convenient place! I'm beginning to stammer a few words of Spanish, and I'm very proud of this achievement, but I speak it so badly that no one can understand me, which is not very encouraging. Gertrude and Leo have written to us saying that they have been to Rome. They are supposed to come here in September. If you came too we could all be together in Barcelona.

I've written Marie Laurencin, but she hasn't written me once since I left. I don't know why. You haven't told me if you and Mademoiselle Levy enjoyed yourselves in Barbizon.

In spite of everything I'm still bored.

As to your suggestion about writing some articles, I'd have no objection to your translating them, on the contrary, I'd be very happy, as this would lend some weight to them, but I'm sure I'd only be able to write them in letter form. If you like, I'll send you some letters in that vein and I'll try to write them a little better than this one. You could leave out any that aren't suitable and send the others to America. Tell me a little more about it, that would make me really happy.

Although you might think so, this writing paper isn't handmade. I bought it before I left at the *large* Magasins du Printemps. I think it costs only 2.90 or 3.90 francs a box and it comes in some very pretty shades of grey. You're wrong about the status of the woman you saw with Monsieur Vaillant; she's an ordinary demimondaine whom he has as his mistress. I know her. If you could send me Madame Jacolt's address, I'll send her some cards. In the meantime, give her my best regards.

May Monsieur Edstrom go in peace and get fatter and fatter until his fat hides his horrible eyes.

Tell Mademoiselle Levy that I'd be delighted to write to her in English, and although I haven't yet done this I won't put it off any longer. Give her my love.

Please excuse me once again for the inconvenience I'm causing you. With much love,

Fernande

The end.

P. S. My letter is very badly written but I can't face copying it out again, and anyway, I'd change it completely if I were to take this trouble.

[Letter from Fernande to Alice Toklas in Paris, June 27, 1909]

Picasso Posada Antonio Altes
Horta por *Gandesa*
Provincia de *Tarragone*
Espagne
Sunday

Dear Alice,

When I asked you to send me all those things yesterday, I forgot the most important of all: some waxed cloth for embroidery. I'm sure you know what I mean. It's cloth that's green on one side and black on the other which you place under the

material you're embroidering. If you'd be kind enough to add a piece of this cloth to the parcel I've asked you to send me I'd be most grateful.

I apologize once again for imposing on you, but I'm so bored here and there's no way of getting anything around here. Believe me, Paris is the only place in the world—or maybe San Francisco too. What do you think?

Yesterday evening after writing to you I felt very ill and had to go to bed. I think I have a kidney infection. I find it very tiresome, but I already suspected as much in Barcelona. What can I do about it here? At any rate, I feel a bit better today. I went to the café after lunch and played dominoes with some local friends, and I won 6 francs. If I were in Paris I would buy a bottle of perfume. Here there's not even anything to spend money on.

Did I tell you in an earlier letter that the landlady of the inn where we're living is very beautiful? She looks exactly like a sculpture by Monsieur Nadelman. You know the first one Monsieur Leo Stein bought, the one that isn't very big and depicts a large woman with a very thick neck and a fine head.

I am writing to the strains of the pianola as it's Sunday and there's dancing.

My poor idiot hasn't come back. Apparently he was arrested in a village not far from here and shut up in the prison. Perhaps he'll be brought back.

It seems that Madame the mayor's daughter is going to invite us to tea in response to a courtesy I paid her husband by offering him tea 2 or 3 days ago.

Listen to this: Madame the schoolteacher greeted me with a friendly nod yesterday evening.

The magazines you told me you'd sent me haven't arrived yet. It's quite cold, and since the windows are shutters with no glass in them if you want to see clearly you have to be cold and leave the window open, and if you want to be warm you have to put up with not being able to see clearly.

Did I tell you that we took some photographs the other day? If they come out I'll send you some.

With my best wishes.

Love,

Fernande

[Letter from Fernande to Alice Toklas in Paris, June 28, 1909]

Monday

Dear Alice,

Yet another letter, but this one is to reassure you as to the fate of the magazines and the books you sent me, which I received this morning. I don't know how to thank you for them.

It's going to rain and the weather is sultry which I find very unpleasant. Pablo is working and when this letter's finished I'm going to read. There's hardly anyone in the village. All the men are busy in the fields harvesting the wheat and as there's a church festival tomorrow they're having to work hard today to make up a little for the time that will be lost tomorrow.

Pablo may have to go to Barcelona and as my state of health prevents me traveling I'll be alone here for a few days and I'm sure I'll die. In fact he's going to do everything he can to avoid this. Can you imagine me here alone without anyone who understands me and being terrified at night because that damned sereno wakes me up every quarter of an hour while the candles burn down in just about the same time. That really wouldn't be amusing.

The schoolteacher is more and more charming, which I find a bore.

I cooked a dish of rice for lunch, which meant that I was able to eat a little better than usual. I'm going to teach the innkeeper to make a few dishes, since their cooking, although it's simple, gets very boring. When I write about the landlady of the inn I'll use her name, which is Francisca (Françoise in French). Don't you think it's a pretty name? It suits her very well. Pablo is planning to take a photograph of her and when I get it I'll send it to you. She's really very beautiful and very nice. Her granddaughters understand me very well when I try to speak Catalan and she does too. They're the only people in the village I can exchange one or two sentences with. I also get on very well with the children, who bring me flowers when they can find them. There are gorgeous carnations in the windows here.

There are some traveling tradesmen who turn up here, usually staying for a day. They are my bêtes noirs and what dreadfully unpleasant creatures they are. I can't stand anybody who wears town clothes and hats here, for they're generally completely worthless, common peasants who think they have the right to look down on all the others, who, I can promise you, are a great deal superior to them. I really like the peasants who remain truly *simple*. Have I told you that the men here wear handkerchiefs—a kind of scarf that's sometimes black or often dyed in very pretty colors —rolled and tied around their heads. It's a relic of the turban that used to be worn by the Moors when they invaded Spain. The men look very attractive and elegant, and very few of them—practically none—are fat. Even when they're older they're often still very slender and upright with handsome, expressive heads and distinguished, regular features. Some of them have very clear and hard steel-blue eyes, delicate lips and very white teeth, so that with their beautiful, long, elegant, strong hands, they are quite wonderful to look at, I assure you. Of course I mean those who are well off and don't work on the land themselves but have others working for them, so that they're not exhausted by a life of unending labor. The ones I'm talking about are the local rakes, the bad types who spend no more than 1 or 2 francs a day in the café—and that after playing and losing for several hours. They're not up to much good, of course, and given the strength of their muscles it wouldn't be very

advisable to pick a quarrel with them. But this doesn't stop me finding them very attractive.

I don't like the women so much, and I don't think they're very clean. At least they don't look it, and they're not very pretty. Many of the local women have been maids in Barcelona or Valencia and have acquired a veneer of civilization, but this appears incongruous if not ridiculous here. The local hairstyle is very attractive, with the hair pulled back from the forehead and braided, but these girls who have been *in service* prefer a rather more modern style which is gently, but oh so gently, puffed out over the forehead.

The small children are generally ugly and scream too much. I prefer the little girls of 8 to 12 years old, who are my friends here.

Naturally, to complete the picture, there's a little deaf-mute, to whom I'm also very attached. He is a boy of about 7 and seems very *intelligent*.

My idiot still hasn't come back, and despite everything I miss him. I had got used to seeing him behaving in his eccentric way on the square.

We're also very friendly with the chief of police. There are five policemen here, who are bored, and since our arrival this sergeant has obligingly put himself at our disposal and has offered to accompany us himself with his *police force* wherever we want to go. Can you picture us traveling about the place escorted by five handsome policemen dressed in black—this is the color of their uniforms, which are elegantly brocaded with *red, white and yellow* insignia. It makes a very pretty effect seen from a slight distance so that you can't quite make them out properly. One of the policemen looks like Apollinaire. Unfortunately none of them looks like Marie Laurencin, or I'd have felt quite at home, which would have been wonderful. The messenger— I mean the man who delivers the letters—looks like *Derain*, but I don't see any other resemblances to tell you about, apart from the resemblance of Max Jacob to the convict Renard—which is striking and revolting.

Alas, how sad the flesh,
And no books left to read
as the poet Stephane Mallarmé says, and how right he is.

I'm bored, I'm bored, and I won't hesitate to point out to you how generous I've been both with my letters and with the words contained in them, so as to set you an example.

You are the only person I'm writing to. Write me long letters, and if you find mine amusing I'll write you often, as it provides me with an excellent distraction.

I feel guilty about Gertrude. I haven't written her once since I arrived here. If I did, it would be at your expense, as I use up every topic in my letters to you and if I wrote Gertrude I couldn't write you, as I find it impossible to write the same letter over again.

Goodbye and thanks. Remember me to Mademoiselle Levy and much love to you,
 Fernande

Picasso's photograph of the Horta policemen. The one that reminded Fernande of Apollinaire stands third from right. Musée Picasso, Paris—Archives Picasso.

P. S. I beg you once more to pay no attention to the spelling in my letters and not to suppose I am totally ignorant. I have to write as the pen flows without worrying about anything. Soon you won't be able to enjoy the very pretty paper I've been writing on any longer. It has all been used up on the letters I've sent you, and you'll have to make do with the horrible paper I'm likely to get here, if I can still get any.

[Letter from Fernande to Alice Toklas in Paris, mid-July 1909]

Dear Alice,

I've been wanting to resume my letters to you, but I've been too ill again to write. Today I'm still not very well and can't write as long a letter as I'd like.

I don't know how to thank you, and I apologize once again for having put you to so much trouble with these errands for me. This very morning I received the box containing the handkerchiefs and other things you were kind enough to send me.

Unfortunately I can't even sew, as at the moment I'm compelled to lie flat on my bed for much of the day. It would certainly be far better for me to be in Paris, where I could be looked after. This is the real truth, but the doctor doesn't think I could stand the journey.

It's all very boring, I can tell you, and I'll stop now rather than bore you, too.

Everything goes on here in the same way.

Do write me—it would be a real kindness—thank you again and I'll write another letter soon.

Please give my very best wishes to Mademoiselle Levy.

Much love,

Fernande

*[Letter from Fernande to Gertrude Stein in Florence, mid-July 1909]**

Dear Gertrude,

Forgive me for not having written before, but it's because of my poor health. Everything exhausts me and there's nothing I can do. I think I have a kidney infection. The doctors in Barcelona already suggested this might be the case, but here it has been confirmed by the pain itself. I'd most certainly be better off in Paris, where I could receive treatment, but at the moment the journey would aggravate my condition too much. It's extremely irritating, especially as there's no kind of treatment here apart from diet and rest. I spend practically the whole day on my bed as I can't bear to be sitting up.

Pablo also finds it very irritating.

The greatest pity is that if it weren't for this we'd be so happy here. The countryside is very pretty and the people very good and kind. At the inn where we're living they can't do enough to oblige me. But I hope in any case to see you here, so that you can find out about all this for yourself.

I've written a few letters to Miss Toklas about the place. I wanted to write her more, but I had to stop as I was too ill. I haven't written to anyone else, although I ought to reply to Marie Laurencin, who sent me a very sweet letter, and to Madame Pichot, who is planning to come and see us.

Manolo may come too. He's in Spain with Monsieur Haviland and they've been to Gozol where we were 4 years ago. I think they would have preferred to come with us, but didn't dare, for fear of tiring Pablo. If that's the case, they were quite wrong.

* Fernande says they have been in Spain two months (they arrived in Barcelona on May 13), so the letter must have been written in mid-July. The previous letter, to Alice Toklas, was evidently written at around the same time.

I want with all my heart to see you here. We could meet you in Barcelona and if I'm still ill, Pablo could go on his own to pick you up. Khanweiler [sic] has written to say that he might come for one or two days, but I don't know when that might be.*

The countryside is truly marvelous, as you'll see. I'm worried by the fact that there have been earth tremors around here. Have you had them in Italy too?

I haven't known what to do during the day and now that it's impossible for me to do anything, I'd quite like to sew or do embroidery, but this is awkward when you're lying down.

What are you doing? I imagine you are happy. And how's Leo?

I'd have liked to tell you more about the life here, but I plan to do that as soon as I'm a little better, for in spite of everything I want to believe my condition will improve. If you know of anything I can do about it, please do tell me.

I sometimes have an unbearable pain in my kidneys and in my side, which makes me feel as if I'm about to drop dead, but this has only happened twice. But I'm very tired the whole time and very weak. There's a lot of blood in my urine and sometimes just blood, which is why I had to stay in bed for three days in Barcelona. What can I do?

Life is miserable. Pablo is morose and I can't look to him for any moral or physical support. When this pain strikes me he becomes very pale and that's all—he's as ill as I am. What's to be done if I don't get better? And here? You're the only person I can say this to, but I feel very depressed and on the verge of complete despair. The last thing in the world I want is for Pablo to know just how totally dispirited I feel. But do you realize that I've never really been sick before and that for the 2 months I've been in Spain I haven't had one complete day's respite. What can I do? I was sick even before we left Paris. I could feel it, but I was able to struggle on. Here I'm on my own too much. I can promise you that if this goes on for another month it will all be over and I'll be dead. Pablo is no help. He doesn't know what's going on and he's too selfish to want to understand that I'm the one now who needs him, that he's responsible for my condition and that it's largely because of him that I've been brought to this. He threw me into complete confusion this winter. I know all this is neurotic, but my nerve has utterly failed and I can't go on. What's to be done? If I'm unhappy it makes him angry. And then I'll tell you something else, which is not very certain—but I might be pregnant, though I don't suppose I really am. I've only suspected it for a week. But what should I do if I'm pregnant as well as being sick? And don't imagine that this might be what's making me feel like this this evening, because last month I was just as sick, although I wasn't so depressed.

Forgive me for writing you all this. When I started this letter I had no intention of doing so, but I let myself get carried away. I am so miserable, so lonely in spite of the fact that I do believe he really loves me. Pablo would let me die without noticing

* None of these friends did in fact come to visit Picasso and Fernande in Horta.

the condition I'm in, except that when I'm in pain he stops for a bit to take care of me. He doesn't understand or care at all about what might make my condition worse.

You'll think I'm much too preoccupied with myself, but you're the only person I can tell all this to. It's a bit theatrical and perhaps ridiculous, but it calms me down.

Do write me.

Give my regards to Pablo* and don't tell anyone about this.

I hope to see you soon.

With love,

Fernande

P. S. We received the American magazines you sent. Thank you.

[Letter from Fernande to Alice Toklas in Paris, mid/late July 1909]

Dear Alice,

Did you write me when you sent the sewing things or have you written since then? I haven't had a letter from you for so long that I'm afraid a letter might have got lost or that you're angry with me.

Please reply. It sounds as though the weather is very bad in Paris. Here it's not very warm and we've had a few days of dreadful wind. All the same, I think my health will improve. For the past two days I've been feeling better, although I became very sick again. If the improvement continues, the next letter I send you will be in English.

Pablo is working. He has been given the use of a room in the baker's house, as there was no room to spare here. Over there he has an empty room and peace and quiet.

People continue to be charming to me. I am constantly sent fruit and flowers, and the children at the inn here make me *delicate* things, but I don't know what to call the things they make, but you'll see them when I'm back in Paris. Madame Pichot has written me that she and her husband may possibly come to see us. I'll be very happy if they do, as life in spite of everything is a bit monotonous.

My idiot has reappeared. He was better for a while and resumed his work in the fields, but yesterday his singing annoyed everyone and he disappeared again.

The mayor is charming and I'm beginning to think that people exaggerate his role as a tyrant. With me he's extremely friendly, and he showers me with fruit and flowers. He adores children and always has candy for them in his pockets.

* Fernande surely meant to write "Leo."

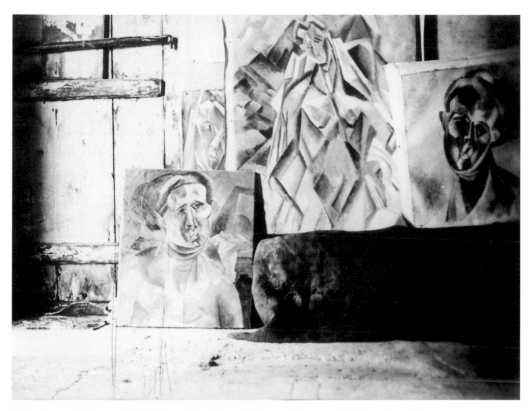

Paintings of Fernande in Picasso's studio at Horta, photographed by the artist.
Musée Picasso, Paris—Archives Picasso (Private collection).

I still haven't called on the schoolteacher, but we get on very well despite that.

We've started going in the evenings to play dominoes at the mayor's daughter's house and she makes us drink dreadful coffee. She has got this husband who's 23 years old and she has a child of 8 months. She must be 25 or 26 herself. Her husband is just a big child, and although I believe he's quite sick, he's very cheerful. All day long he repeats a French phrase I taught him—"j'ai fini j'ai gagné" [I've finished, I've won], but he says "j'ai fini de gagner" [I've finished winning], which is much nicer. He also knows how to say "qu'est-ce qu'il dit" [what's he saying?], which he pronounces "qu'est-ce que dit," and whenever his wife talks to him he pretends not to understand her and asks me "qu'est-ce que dit?" the way I always ask Pablo when someone speaks to me in Spanish. I believe he has tuberculosis but doesn't want to have any treatment.

I'll leave you now so that my letter can catch the mail and I beg you to write me. My regards to Mademoiselle Levy.

My love to you,
Fernande

*[Letter from Fernande to Alice Toklas in Paris, August 2 or 3 (?) 1909]**

Dear Alice,

Just a word to thank you for the letters and cards that you sent me. All the magazines arrived today. I've also had a letter from Apollinaire, in which he told me he had met you at Marie Laurencin's.

Have you returned from Vaux de Cernay? It's one of the prettiest places around Paris. Perhaps the man who followed you was a satyr. Well, everything must be all right, since he left both of you safe and sound.

My health is better now. I spend the day sitting in the square with the village aristocracy. I can speak a little, which is good as Pablo spends the day working in what he calls his studio. I'll send you some photographs of the countryside soon.

Will you thank Mademoiselle Levy for her card and give her my regards. I'll write a long letter soon.

Yours ever,
Fernande

P. S. I sent a card to Madame Jacolt. Thank you for the address you gave me.

[Letter from Fernande to Gertrude Stein in Florence, August 3 (?), 1909]†

Tuesday

Dear Gertrude,

It is inexcusable of me not to have replied to you sooner. Since my last letter my condition has improved considerably. Except for two or three occasions I haven't been seriously ill again. I spend most of the day outside, although, of course, I can't go for walks.

The two or three times I got sick again came after arguments, which goes to show that all this is a result of nerves rather than anything else. Yesterday, particularly, I felt unwell after lunch, but on Sunday I had been very upset. I think if my spirits were good I'd be well physically.

For about a week now it has been unbearably hot here and perhaps that too is bothering me.

* This must be the letter Fernande refers to in her next letter to Alice as having been written during the Barcelona *Setmana tràgica*. Riots broke out in the city following a general strike on July 26, and the army were called in on August 1. The letter to Gertrude Stein which follows is dated "Tuesday," i.e. almost certainly August 3. The common topics suggest this was written either the same day or the day before.

† This letter was evidently written at around the same time as the preceding one to Alice Toklas. August 3 was a Tuesday.

I'd so much like to make the journey you suggest in your letter. Maybe it's true. Better for me. But in any case I don't want to forego the pleasure of seeing you in Spain. I received both parcels of American magazines. I also received some books from Alice Toklas and some *letters*. They have just returned from a visit to one of the most beautiful areas just outside Paris. Mademoiselle Levy also sent me a card.

I am hurrying so as to be able to send this letter off. Apollinaire may possibly come here too.

I am doing a lot of embroidery, which will surely surprise you as much as it surprises me.

Is the weather still bad at Fiesole?

I'll write at greater length in two or three days.

I hope to see you soon, and my regards to you and Leo.

Fernande

[Letter from Fernande to Alice Toklas in Paris, mid/late August 1909]

Dear Alice,

It's a long time since I've heard from you. Perhaps the troubles in Barcelona are responsible for this. Your letters may have gone astray. We've been cut off from the whole world for some ten days without letters or newspapers, as nothing was allowed to come in from Barcelona. I wrote you a letter during that time.

How are you in Paris? Apparently it's dreadfully hot there. Here too it's very hot and I think the heat is the reason I'm once again not very well.

Did I tell you that the local doctor was treating me? He has almost cured my kidney problem, but I'm quite weak as there are very few things I'm allowed to eat, and these are always the same, so that since I'm neither hungry nor like what I am prescribed I end up not eating anything at all. I drink a lot of milk, which I hate. I think it's the one thing that keeps me going. It's rather tedious.

I was feeling much better—almost quite well—but for the past 2 or 3 days I'm worse again, though not nearly as sick as I was a month ago. I don't know what to do here. I've had my fill of sewing.

I wrote some time ago to Marie Laurencin and she still hasn't replied. Scold her for her laziness if you see her.

How is Mademoiselle Levy? In two weeks we'll probably join Manolo and your neighbor Monsieur Haviland at Bourg Madame, the French border village. Here nothing changes. The hunting season has opened and Pablo went hunting with a local friend (the owner of the café) and they brought me back a hare.* I'm still

* Joaquim Antoni Vives owned the local café, where he reportedly played the guitar all night long. It was here too that Fernande and Picasso often played dominoes with the Membrado brothers, Joaquim and Tobies.

playing dominoes and I shock the women with my colored scarves—including the one you gave me, which I wore the other night to go to a magic show. I don't really feel up to writing, or I'd have so many funny things to tell you about this place, but I expect I'll do it better in person in Paris. Remind me in Paris to tell you about the conjurors, the clockmaker, the horsedealer and the gypsies.

I hope to see you soon. Give lots of my good wishes to Mademoiselle Levy.

Yours ever,

Fernande

[Letter from Fernande to Gertrude Stein in Florence, late August 1909]

My dear Gertrude,

We received Leo's letter this morning. You'll be in Paris long before us. We probably won't get home before October. We're leaving Orta in about ten days from now and everyone is really unhappy. But we'll come back next year, and you'll come with us, which will be better. I like this place and if I hadn't been sick I think I'd have had a good summer. I'd really like to come here every year and I'd really like you to be with us. All the people here want to have us again next year. It's easy to rent a whole house for 10 francs a month with an wonderful view of the countryside and the mountains. A servant costs 1 franc a month, and for 6 or 7 francs a day 4 or 5 people can live like kings here. And what scenery. I'm sure you'll feel as I do when you see it. It can't be compared to Gozol. The people are very kind. The hunters bring me their game and the women and children give me fruit and vegetables. The women bake cakes to give me, and if when I leave I have to take away everything I've been promised I think I'll be forced to stay, so as not to have to hire an extra carriage. It's astonishing how much better I get on with the people here than with people in Paris.

After we leave we're going to spend two weeks in Barcelona. Pablo's sister was married a few days ago, and Pablo managed quite easily to avoid the chore of attending the ceremony. Maybe after Barcelona we'll spend the end of the month of September at Bourg Madame, the town across the frontier from Puycerda which we passed through on the way back from Gozol. Manolo is there with Haviland, but because of the war Manolo didn't want to cross the border and go into Spain.*

Pablo is working. Kanweiler [sic] wants to come here. He has written us letter after letter asking for directions, but it turns out that instead of coming on September 6, as he had told us, he won't be coming until the 14th. We would have

* Manolo was a draft dodger, and the troubles in Barcelona were presumably the "war" that prevented him crossing to Puigcerdà.

been willing to stay until the 6th, but it's impossible to stay until the 14th. He'll be very disappointed.

There are some wonderful things to write about here, but I just can't manage to do it. I think you'd find it all very interesting. There are these people who pass through the region and stay for a day or two and then leave. There are the clock-makers who do piano tuning. I wish you could hear the piano—it's a pianola—after it has been tuned. There are the horsetraders who come with a considerable number of animals. There are gypsies I find quite wonderful. There are beggars who sell prayers, there are actors, there are conjurors, tradesmen of every kind who have such strongly defined characters that it's a pleasure to listen to them. But I can't begin to tell you about them all properly, any more than I can about the local people. I'll tell you in person better than I can write about it.

Regards to Leo. Love to you,
Fernande

P. S. The doctor here has looked after me very well. I have no more pains and I continue to feel better although I eat almost nothing.

I now speak Catalan fairly well, but not completely. I can understand and make myself understood.

[Letter from Fernande to Gertrude Stein in Paris, September 7, 1909, on paper of Grand Hôtel d'Orient, Barcelona]

Tuesday, September 7, 1909

Dear Gertrude,

We reached Barcelona yesterday, but we'll only stay for a few days—5 or 6 at most. We're not going to wait for Khanweiler [sic], who's due to arrive on the 15th. I'd like to return to Paris this week. I think I'm definitely very sick, and a friend here who's a doctor* has advised Pablo to take me back there as soon as possible. I'm too tired to write a lot. I'd have liked to write to Mademoiselle Toklas too, but I don't feel up to it.

I'll be pleased to be back in Paris and especially to see you. Pablo too, now that he knows you're back there, isn't interested in anything except returning.

If I'm not too tired I'll come and see you the day I arrive. We're traveling on the express, which only takes 18 hours, but I think we have to. It will be more restful for me in first class and I won't get so tired, as it saves almost 6 hours. It's so tedious being ill like this, especially as it comes in bouts and whenever I'm better for a day

* Jacint Reventós.

or two I think I'm cured. For three months now I haven't eaten the equivalent of two eggs a day, and this has made me very weak, but I find it impossible to eat. I think you'll find I've lost weight, though not all that much considering how sick I've been and how little food I've had. I think I'm saying far too much about myself and my illness but I can't think of anything else, as it won't let up. Did I tell you in an earlier letter that the doctor has diagnosed *nephritis*? Two or three days ago I had another pain and a lot more blood came.

Well, I look forward to seeing you soon in Paris.

My regards to Leo.

Yours ever,

Fernande

P. S. Please give my best to Mad. Levy and Mad. Toklas.

We're in the same hotel in Barcelona as when we arrived, Hôtel Orient La Rambla.

[Letter from Fernande to Alice Toklas in Paris, September 8, 1909, on Grand Hôtel d'Orient paper]

September 8, 1909

Dear Alice,

I think we'll be in Paris on Saturday morning. I don't know what time we arrive, but we're taking the express from Barcelona on Friday at around 3 o'clock, which should bring us in to Paris around 9 o'clock on Saturday morning. We've been here since Monday and expected to stay for two weeks, but I'm sick and it makes more sense for us to return to Paris immediately. I've already delayed too long, and now it's going to be more difficult for me to be cured quickly.

If I can and am not too tired, I'll go to Gertrude's on Saturday afternoon. I'd love to see you. If we can't leave on Friday I think that we'll certainly leave on Saturday, but in any case I'll try to go to Gertrude's the day we get back. Would you be kind enough to let her know. I'm fed up here as I have to stay in my room almost the whole time. I don't even have the distraction of going out for lunch or dinner. I can't eat a thing.

Maybe the air in Paris will do me good.

I hope to see you soon. Give my regards to Mademoiselle Levy and love to you, Fernande.

P. S. Perhaps I'll have arrived before you get this letter.

RESPECTABILITY AND BETRAYAL

Fernande's Memoir, Part 3: Fall 1909–Fall 1911

It was on our return from Horta after spending four months in Spain that Picasso finally made up his mind to leave the Rue Ravignan, where he had occupied two studios, one just for working and the other to live in. It was a great wrench, and it affected him deeply, as he associated the Bateau Lavoir with the happiest times of his life. It is certainly true, as people often say, that once artists become successful they look back with regret on the days when they were poor. They leave behind the best of themselves in the places where their life was such a struggle, a struggle so essential to their artistic development. But above all they abandon their youth, by far the most precious thing in life. Artists hate growing old, and when they put their poverty behind them, they also lose something pure and passionate, which they will never be able to recapture: the brilliance, enthusiasm and creativity of their young days. Picasso was restless and needed constantly to experiment and make new discoveries, and this was really only possible in modest surroundings. Nevertheless he moved from his little place in the Bateau Lavoir to live at 11 Boulevard de Clichy, near the Place Pigalle.

He had rented a large north-facing studio and an apartment on the south side with two windows overlooking the beautiful trees and gardens of Avenue Frochot. Often, when we came home in the early hours, we would go to the window and listen to the birds singing before we went to bed, not getting up until eleven o'clock or midday. Picasso had taken on a servant, who quickly learned to understand his moods and took care not to bother him or make him angry, although she also imitated his habit of late rising, and then the housework suffered. But in spite of all the changes, Picasso wasn't as happy as he had been before.

It was the beginning of a completely different life, at least in its externals. We had to buy furniture. Even when he was already earning a great deal more money towards the end of our time in Rue Ravignan, it had never occurred to Picasso to furnish his studios, although for a while one of them had looked a little more comfortable when Van Dongen left a few pieces of furniture in Picasso's care during an extended trip to Holland. We had lived there for years rather as if we were camping,

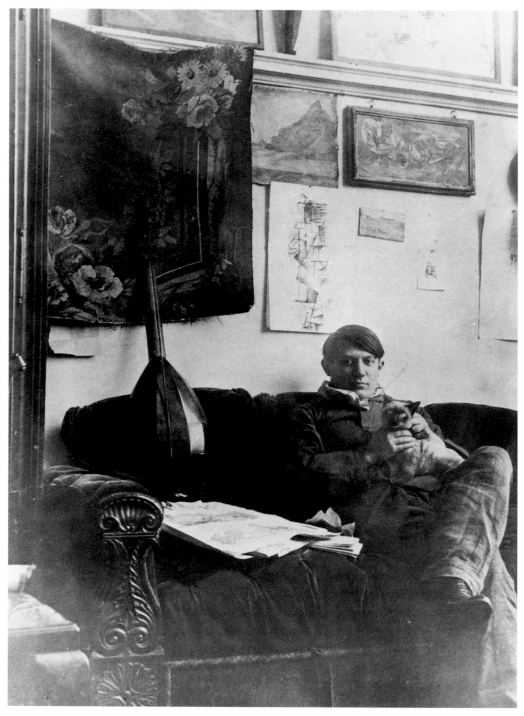

Self-portrait photograph of Picasso in his new studio on Boulevard de Clichy, 1909.
Musée Picasso, Paris—Archives Picasso.

RESPECTABILITY AND BETRAYAL

and our efforts to create a more pleasant atmosphere had done nothing to make the place more comfortable. We had slept on a bed frame which no one had ever thought of mounting on legs; we had eaten off a round table that was folded up and stowed in a corner after meals; a deal wardrobe stained to look like walnut had been quite adequate to store the linen. Whatever we could salvage was now used to furnish the maid's room in Boulevard de Clichy, and the only other things to be brought from the old studio were canvases, easels, books.... The movers were astonished at the difference between the two studios. "Surely," one of them said to Raynal, who was helping Picasso, "these people must have won the top prize in the lottery!"

Once Picasso was installed in the Boulevard de Clichy, he worked in a large, airy studio that no one was allowed to enter without his permission. In winter I could only go in to tend the fire. Every day he shut himself in there from two o'clock—earlier when he was able to—and worked until dusk. As always, no one was permitted to touch anything or do anything to disturb the disorder—a disorder that was never the kind of organized chaos that is meant to be fascinating or attractive. He would not allow the studio to be swept, as he always had a horror of dust, unless it was undisturbed. Dust flying around and getting stuck on wet canvases drove him crazy. Only every two or three months would he decide to stack his paintings and put away his collection of odds and ends in large closets, so that a more or less thorough cleaning of the studio could be carried out, and he only allowed this on condition that nothing was moved.

We slept in a bedroom on a low bed with heavy square copper bedposts. Behind the bedroom, at the back, there was a small sitting room with a couch, a piano and a pretty piece of Italian furniture inlaid with ivory, mother-of-pearl and tortoise-shell, which Picasso's father had sent him together with some other fine antique furniture. Our meals were served by the maid, wearing a white apron, in the dining room, which, although small, was very bright, as it was on the Avenue Frochot side. An antique cherrywood sideboard took up the whole length of one wall, and when it was sunny the warm tones reflected in the polished wood made it seem as though the sun itself was in the room. The sun also used to shine on the little mahogany organ that no one knew how to play, but which everyone would practice scales on so as to smell the incense that wafted out whenever the bellows were used. In each corner, mahogany side-tables were piled with bronzes, pewter vessels and pieces of china found in the Montmartre junk shops. The oval table was also made of mahogany and although it was quite large, it became quite cramped if, as often happened, we had more than four or five guests.

Picasso couldn't resist buying objects that he chanced to see on his walks, and these would end up cluttering the studio, which was full already. He found some good furniture that he liked, antique oak pieces with rather plain, heavy lines in Louis XIV style, which seemed to be his favorite. I remember one morning when he

came home in high spirits, followed by a man practically giving way under the weight of an immense, superb Louis-Philippe couch, covered in velvet of ecclesiastical purple and studded with pale golden buttons. Another time, he gave pride of place in the studio to a little armless chair with elaborate carving and a completely unsuitable cover of motheaten tapestry, which turned up one day on the back of a mover.

We would also go to the flea market, where everything was very cheap and you could get all kinds of artistic items. We found some beautiful pieces of tapestry there—verdures, Aubusson and Beauvais—but it was often difficult to be sure just what something was because of its condition. There were musical instruments, boxes, old picture frames that had lost their gilt, books, old stretchers for canvases for a few sous, and many extraordinary objects that gave Pablo enormous pleasure. He liked to surround himself with bric-a-brac, ludicrous pieces of furniture or trinkets ideally suited for decorating a concierge's lobby, such as dreadful, idiotically naive color prints with straw frames and little red bows at each corner. He was amused in an ironic way by everything that seemed to indicate a complete lack of taste, and he pretended to have no taste himself—a pose he shared with Max Jacob, who had quite a say in choosing the things that decorated the studio. There was dazzling blue glassware side by side with cups decorated with pastoral scenes. Flasks of all shapes and sizes were crowded together with simple, thick glass bottles, and the heavy pieces of pure cut crystal beside them appeared to have been left over from some princely function.

He would gleefully find charm in things that seemed merely ridiculous to other people. He dressed like a workman, but loved wearing the red flannel shirt with white dots on it that we had bought at the Saint-Pierre market with a beautiful crêpe-de-chine tie, in a crude, clashing color. He didn't care if the tie was dirty or ragged; all that he wanted was to amuse himself by creating a particular effect. For years he kept an old cardboard hatbox full of a great hoard of ties in every kind of fabric and color, and these constituted his only concession to elegance.

In the studio, along with the tapestries, the musical instruments and all the other bits and pieces, he had a little painting by Corot, a charming portrait of a young woman, and Negro masks. On the table there were African wood carvings, which he had started to collect a few years earlier. I believe that it was Matisse who first realized the artistic value of Negro pieces, followed by Derain, but both of them soon found they had to compete with Picasso, Braque and Vlaminck for the finest examples. Negro art did a great deal for their artistic development. Picasso became fanatical about it and acquired statues, masks and fetishes from all over Africa. The hunt for African works became a real pleasure for him, and he had some pieces that were really appealing in their clumsy way, with their finery, necklaces, bracelets or belts of glass beads. One felt like stripping them off to wear oneself. Picasso was particularly fond of one small mask of a woman where the white paint of the face stood out against the wood color of the hair, which gave it a strangely gentle expression.

One day Denicker brought an explorer to see Picasso in the studio, a naval officer who told us that on one occasion, when he happened to be with some natives who enjoyed making sculptures, he had been curious to see their reactions to a photograph, which was something they had never seen before. He had placed a photograph of himself in uniform in front of them, and one of them had taken it, peered at it, turned it over and over in every direction, and handed it back without having recognized or understood what it was. The explorer then tried to explain that it was his own image.

The African laughed incredulously, then took paper and pencil and began to do a portrait of the officer. In his own way he drew the head, the body, the legs and arms in the style of Negro idols and showed the image to the officer. But having looked at him again more carefully, he took back the drawing to add the shiny buttons of his uniform, which he had left out. The point of story was that he saw no reason to put the buttons in their proper place; they surrounded the whole figure! He did the same with the stripes, which he placed beside the arms and above the head. I don't need to spell out the comments this produced. Afterwards many strange things were seen in cubist paintings.

After the move Picasso started to go out more in the evenings. He was more willing to accept invitations and he regularly attended the Steins' Saturdays. One of the people we saw there was a very talented Polish sculptor, Nadelman, whose works the Steins were acquiring to add to their considerable collection of contemporary art. The other guests were a mixture of artists, bohemians and professional people, mostly foreigners. By nine o'clock the space in the studio became so crowded that people overflowed into the apartment. The spectacle of so many people in such assorted groups was strange, but everyone was discussing art or literature, although some hardly ever left the buffet.

Their hosts were busy being sociable with each group, but they were particularly attached to their two celebrities, Matisse and Picasso. Matisse always expressed himself clearly and intelligently, but Picasso was too sardonic to take the trouble. I believe he rather despised anyone who was not prepared to understand him without explanations. Although these soirées were not unpleasant, Picasso spent most of the time in a sullen, morose frame of mind. People pestered him, wanting him to talk about what he was doing, and it was difficult for him, especially in French, to try and give an explanation for something he didn't want to explain. He would be exhausted and angry by the time we left.

One day he noticed that two of his paintings had been varnished by the Steins without his permission, and it drove him into a cold fury. He wanted to leave immediately, taking his canvases with him, since he considered they had been falsified by the varnish. It took no end of trouble to prevent him creating a serious incident. Meanwhile, the Steins, who had no idea of the little drama that was developing,

were cheerfully going from one guest to another smiling across the room at Picasso, who was pale with repressed anger. Once they found out, they still smiled, not taking his anger seriously and telling him that the varnish would disappear, that they had only been trying it out. They were certainly wrong. How can people do things to artists' works without asking their advice?

For a time Picasso remained in a bad humor with them, but he was not able to resist their affectionate appeals for long—still less their flattering admiration for him, which they displayed at every opportunity. One day they came to pick him up and Picasso went back to his old habit of visiting their house.

When Apollinaire left the Rue Henner to go and live in Rue Gros in Auteuil, he continued to entertain on Wednesdays and sometimes we stayed to dinner.* One evening he and his girlfriend were preparing the meal, which was always the same: hors d'œuvres, a risotto, and stewed beef. When the table was set and the hors d'œuvres already laid out on it, Guillaume and his girlfriend began an argument, which became so heated they went to continue it in the bedroom. Cremnitz, who thought this had gone on too long and who was hungry, picked up a piece of sausage from the table and ate it. When Apollinaire returned, furious, red in the face and with disheveled hair, his first glance was at the table, and before he had recovered his breath he screamed: "Someone's eaten some sausage!"...You can imagine the gales of laughter that greeted this.

During the floods of 1910,† poor Apollinaire had a dreadful time. One day his street was transformed into a river and he found himself trapped in his house. He was only able to get out with the help of a friendly sewage worker, who carried him across the street on his shoulders. He came to see us afterwards, in high spirits, happily telling the story with a great laugh that seemed to come from the pipe he always held clenched between his teeth.

For a time the poet Louis de Gonzague Frick used to visit him every day, never failing to bring him an apple, which he knew Guillaume particularly liked. Gonzague Frick was hoping to join the artistic milieu around Apollinaire, which he found so fascinating. No doubt inspired by the memory of Oscar Wilde, he used to dress in a manner that was both impeccably correct and extremely affected and would make up his face with powder and lipstick. He was tall and elegant, always wearing a monocle and with a flower in his buttonhole. He completed the pose with the most exaggerated mannerisms, but we found this amusing and not disturbing at all. He always introduced his new friends to his mother, who would entertain them, although I'm sure she found it very difficult to become accustomed to this bohemian world, which seemed to her to be highly suspect. But she was Alsatian and had her

* Apollinaire moved to Rue Gros around the beginning of May 1909.

† The Seine flooded in January 1910 near the Pont de Grenelle and the Quai de Passy.

Frames from a short film of
Apollinaire and the artist and
writer André Rouveyre, made
in 1914.

own way of coping with her son's friends. She used to confide in Max Jacob, telling
him how indignant she felt as a mother when her son brought such undistinguished
friends home. "Who are all these little lumps of lard my son brings to the house?"
she would ask in her Alsatian accent, which only served to heighten the note of
contempt in her voice. Nevertheless, Gonzague Frick was always an enthusiastic,
honest and genuine admirer of the finest forms of art.

Guillaume had the use of his mother's automobile and sometimes took us to have
lunch with her at her villa in Le Vésinet. It was there that we met Mme de Kostro-
witzky's monkey. This monkey was unpleasant to everybody else, but made such
friendly faces at me that I was quite won over and wanted to have one myself. One
morning I decided to indulge this whim and went down to the *quais* with Mme Van
Dongen, where I bought an adorable little Chinese monkey. I was a bit worried
about Pablo's reaction, but what could he do once I had brought the monkey home
except grow to love her? Anyway, Pablo was getting to like animals more and more.
His fat dog, Frika, who was so faithful and gentle, had won him over, and he soon

became such a favorite of my little monkey Monina, that he allowed her to have meals with us and when she wouldn't stop pestering him, he accepted it with amusement. He would let her take his cigarette, or the fruit he was eating and she would nestle against his chest, where she felt comfortable. He loved to see her so trusting, and he delighted in the tricks she used to play on Max Jacob, whom she terrified, as I think all animals did. However, we had to keep anything fragile well away from her, as she would amuse herself by throwing whatever she could get hold of onto the floor out of pure devilry.

At that time we also had three cats, and later Pablo had a second dog and a tortoise as well, but he would have liked to have a house full of animals; he wanted a rooster, a goat, a tiger and rabbits—so that he could watch them multiply in the studio. There was a childish, tender side to his nature, which he seemed to fight against. But perhaps he also loved animals for the spectacle they made, for love of art —just as he loved clowns and boxers—rather than from kindness. He was someone who wouldn't allow himself to be deeply touched, and, as a result, he undoubtedly missed out on many pleasures without ever suspecting they were there to be enjoyed.

When Derain left "Les Fusains" for a studio at 13 Rue Bonaparte, a house where Dunoyer de Segonzac was already living,* he gave a famous housewarming party. You would always eat and drink well and plentifully with Derain. We were there with Apollinaire, Marie Laurencin, and perhaps Max Jacob (I'm not certain if he was there or not). Marie got drunk and was only able to repeat the one word "merde!", though from time to time she would sing old songs, in a delightful voice that was as good as her mother's, such as:

"In this sad old world you can only pine away [*twice*]
I'm in love with the dark girl and the fair one…"

and "The Hermit, Out for a Walk One Day," and "The Song of the Traitor Biron."† The Derains came out with us when we all left, causing a rude shock to the peace and quiet of Rue Bonaparte.

Once Derain wanted to give a demonstration of his strength, and managed to twist the railing on the little steps of the Pont des Arts. Later, at about three o'clock in the morning, we found ourselves near Les Halles and there Derain and Alice started to quarrel. We left them to it and they told us the next day that they had been arrested and taken to the local police station where they were charged with "insulting behavior." Later they had to pay a small fine.

Our stay in Horta proved to be decisive for Picasso's cubism. He brought back several pictures, the two best of which were bought by the Steins. These were land-

* Derain's move took place in 1910.

† Charles, duc de Biron (1562–1602), conspired against Henri IV.

Picasso. Cubist portrait of *Fernande, with Box and Apple*, 1909. Private collection.

scapes painted in a geometric way, in one of which the predominantly earthy colors were enlivened by the harsh green of palm trees.

Braque was immediately struck by this and left the group he was associated with, painters such as Friesz, Marquet, Dufy, Camoin, etc., who were still building on the achievements of the great Impressionists of the late nineteenth century. However, Braque did not adopt cubism without a display of typical Norman defiance and rebelliousness. The first time he discussed the subject at the studio, although Picasso was arguing his case very reasonably and clearly, Braque remained unconvinced. "In spite of the way you explain your painting, it's as though you want to make us eat tow or drink kerosene."

I don't know how, after this display of skepticism, Braque could have been convinced so soon, or what converted him to cubism, but not long after this he exhibited at the Indépendants a large canvas using cubist techniques, which he had apparently painted in secret. He had told no one about it, not even Picasso, who was his source of inspiration. It may be that he was hoping to take credit for the new style—which was worth a try, as Picasso never exhibited—but Picasso, who had only just disclosed his new method to his closest friends, was rather indignant about

it. However, Braque was never seen as the leader of the school. His qualities as an artist are charm, intelligence and a ready adaptability.

The new development owed its name to Vauxcelles, who irritably declared that these artists were no more than "Patagonian cubists." Vauxcelles seemed to think it was his task to destroy all new developments, until they were crowned with success, at which point he would rally to their support. But, quite apart from him, the birth of cubism was greeted with wild, angry and unjust criticism, an avalanche of abuse for something that was perhaps not worth quite such an uproar. The French are slow to accept what they can't instantly understand and are only mollified by success, but I don't understand why something they won't accept provokes such outrage. I know that the new schools of painting also produced a lot of laughter at the exhibitions in those days.

It was in this climate that Frédé's donkey, Lolo, became an exhibitor at the Indépendants under the name "Boronali," thanks to a bohemian joke thought up by Roland Dorgelès.* They got him to paint a picture with his tail after he had swished it over a palette full of color, and the canvas was exhibited. I think it was really a joke against Fauvism, which was then in high favor.

A young, ambitious German Jew had arrived in Paris some time before this and was trying, rather modestly, to set himself up as an art dealer in the Rue Vignon. Kahnweiler was very Germanic, intelligent, determined and cunning, though not as cunning as Vollard. Like a true Jewish merchant, he would take risks to make a profit and was adventurous and alert. He wanted Picassos, Matisses, Van Dongens, Derains and Vlamincks, and he managed to get them. He had a brilliant eye and sharp intelligence and actively courted young artists, attracting them to him by offering more than the other art dealers. In fact, it was quite easy to take advantage of him. If you pointed to a canvas and said, "Not that one, my friend, I have virtu-ally promised it to So-and-So," you could be sure he would "make a sacrifice" (as he used to say) in order to get it. But he would also bargain for hours on end, until the artist was beside himself with exhaustion and finally agreed to the reduction demanded.

He gradually accumulated all the most advanced works in his little gallery, which was decorated in grey velvet and natural burlap, and soon collectors began to find their way to the Rue Vignon. They had to go there if they wanted to keep up with the latest developments. Kahnweiler knew just how to set about things, and if the war hadn't come, I think he would have become the most important dealer in Paris and made a fortune.

There is no doubt that most of the avant-garde painters who won recognition when they were still so young owed this principally to the Germans. Russians,

* This incident took place in March 1910. Boronali is derived from *aliboron*, a jackass.

Hungarians and Italians followed close behind, enthusiastically following every new artistic development, involving themselves, copying and imitating, though often misunderstanding, because they approached things too excitedly and clumsily in their anxiety to join in the battle. Their singlemindedness did a great deal for cubism—and for Picasso, who became their spiritual leader.

But Picasso was always heartbroken at having to sell his paintings. Once a deal had been concluded and the pictures had been taken away, he would feel very unhappy and depressed and would not want to do any more work for several days. He found the whole process exhausting: the dealer's insistence, his bargaining, the time he took to think it over. By the end he was so tired that, left to himself, he would either have given everything away for nothing or else thrown the dealer out of the studio, just to have it all over with. He often used to say that there were certain pictures he would have liked to keep, so that he could go back and continue working on them. When he worked he paid no attention to the advice of the art dealers, who always became apprehensive when they saw his style changing.

It was at this time that Picasso began to make cubist portraits. He did one of Uhde, who gave him the little Corot I have already mentioned in exchange. Then the ones of Vollard and Kahnweiler. He worked for a long time on these portraits, especially the one of Vollard, which took months.

Some time earlier a very young Spanish cartoonist, an imitator of Galanis, Iribe and Gosé, came to live at the Bateau Lavoir. Juan Gris went to see Picasso, who liked young people and received him warmly, helping as much as he could. Gris had his own corner of the napkin at the meals we ate together in the studio. We didn't have much table linen and one day I said laughingly to Apollinaire: "I've only got one napkin left. Since there are four of you, you'll have to manage with one corner each." We adopted this practice—which inspired one of Guillaume's stories, "The Poets' Napkin."*

Juan Gris became Picasso's disciple, and although he had no great talent, he was shrewd and quickly attached himself to the cubist movement. He learned what might be called "the tricks of cubism," and made use of them with a kind of intelligence, but no artistry, and he never developed. Once he had established himself, he never departed from his style. In fact, cubism was useful to many artists who would never have been successful without it, by encouraging them to assume a character that was foreign to their inner nature. This was the case with Metzinger, Gleizes, Léger and others. Apart from Picasso, who created cubism, and Braque, who was able to refine it into something more decorative, sensitive and graceful, I don't believe any of the others contributed anything new or interesting to the style. Léger

* "La Serviette des Poètes," first published in *Messidor*, September 21, 1909, and later included in *L'Hérésiarque et Cie* (1910).

and Gleizes distorted the original meaning of cubism into a technical form, which may have insured its survival, but cubism seems to me to have attained its definitive character at the very outset.

The summer after our move [to Boulevard de Clichy] we spent our holidays in Cadaqués, a small Catalan fishing port, where Derain and Alice came to visit us. One day the four of us went to Barcelona, where we drank a lot of a local white wine, which was appreciated by Derain most of all. He particularly liked a tavern near the port which served free portions of ham that was so salty the customers had to keep on drinking. They caused quite an incident there one night.

We also made a similar excursion to Figueres one market day, but the only thing Derain could find there that was of any interest was an outrageous tie in gaudy colors, which he bought and enjoyed wearing for some time.

[Letter from Fernande in Paris to Gertrude Stein in Florence, June 17, 1910]

My Dear Gertrude,

17 June 1910

I've been wanting to write you but wasn't sure you would be in Fiesole as the cards I received were sent from Rome. So I waited, but now *here I am.* Thank you for sending the American magazines. I don't know if I've told you that we are definitely going to Spain. I think this plan was settled after you had left. There were too many painters going to Colioure [sic]—Marquet, Manguin, Puy, etc.—and Pablo begged off. We're going to Cadaqués, where the Pichots go every year.* It's on the other side of the frontier, roughly the same distance from France as Colioure is from Spain. We'll be there until September and during that time we'll be sure to go to Barcelona. Braque, Derain and Alice will probably come to Barcelona with us.

I've heard a lot from Alice [Toklas], as she wrote me and sent me flowers. She gave me a huge basket of roses to wish me good luck. Won't you join us here for a bit?

Our departure is fixed for the 26th of this month and with all the Pichot family there will be 18 or 20 of us.

How are you getting on in Fiesole? Is the weather good? Here it has rained a lot and it has been hot. Now the weather is miserable and practically freezing.

I received some cards from Mademoiselle Toklas. Has she arrived in Florence? I'd like to know where to write to her. Pablo received that journal from America for which a reporter came two years ago, who took his photograph and reproduced

* Picasso and Fernande departed for Cadaqués on July 1, accompanied by a maid and the dog Frika.

The main square in Cadaqués. The house where Picasso and Fernande stayed in 1910 is at the far right on the edge of the harbor.

several of his pictures. Do you remember us telling you about that little American who was visiting the studios of several painters (the Fauves) and was distributing little boxes (lighters) for lighting cigarettes.* There is a very long, very *American* article with portraits of Braque, Derain, Friesz, Herbin, Pablo and photographs of pictures. The rather large picture that you have of *three red women* is reproduced there. It's in an architectural journal. Perhaps if you haven't received it you could get hold of a copy.

Pablo is doing a portrait of Vollard at the moment. I'm not doing anything, as usual, and you ought to send me a letter. Do please admire my writing paper, but unfortunately you can't admire the hats I've made since your departure.

We're now very friendly with some clowns and acrobats, bareback riders, and tightrope walkers. We met them at the café and spend all our evenings with them. One is an American from San Francisco, who dances and sings Negro songs very well.

Do write me. Marie Laurencin has received offers for her work from Saincère [sic], who wants to buy some of her etchings. Give greetings to Leo and my best regards,

Fernande

* Gelett Burgess's article, "Wild Men of Paris," appeared in *Architectural Record*, May 1910.

Cadaqués, July 14, 1910

Thank you, my dear Gertrude, both for your letter and for the magazines. You wrote that you weren't having very good weather in Fiesole, and here it rained and was very windy for the first few days but for several days now it has been nice and quite hot. It's not very pretty here, not as pretty as many other places I've seen in Spain. If I wasn't afraid of offending Pichot I'd confess I find Cadaqués very ugly. First of all, there's nothing but sea, a few insignificant mountains, some houses that look as if they're made of cardboard and some characterless natives, who look as if they could just as easily be stonemasons as fishermen, although practically the whole population is made up of fishermen. The women, who are no different from anywhere else, except rather uglier, make no impression at all. A few fishing boats are beached in very small groups in various parts of the port, as there are only small narrow beaches here. There's nothing to buy except fish, as I had expected; fruit is quite scarce and of poor quality; and prices are almost as expensive as in Paris. We're living in a house that costs us 100 francs a month, and the only furniture is 2 beds, 2 tables and a few chairs. All things considered, although I'm not bored, I find it all fairly dreadful.

We have Frika and the maid with us. Frika is very happy and the maid is beginning to get used to it. She does all the shopping and although she doesn't understand a word of Catalan she manages to chat with everyone and to make herself understood—all with her speaking French and being answered in Spanish. I don't know if we're going to stay long. I'd love to have some news of Alice and to know where to write her. Give her my very best wishes and Mademoiselle Levy too. There are no neckties made of straw in Spain and Pablo would be very curious to see just what they are. For my part, I want to thank you for the coral. Coral is my favorite stone, except that it's not a stone, but I don't quite know what to call it. Anyway, it's what I like best and its magic properties mean I should always wear it to stay happy and healthy. There you are. Do write me again. We may be going to Barcelona for a few days.

My love to Leo and to you. Germaine and Pichot have asked me to send you their best wishes.

[Letter from Fernande to Gertrude Stein in Florence, August 10, 1910; with greetings from Picasso and Alice Derain]

Tuesday,
August 10, 1910

My dear Gertrude,

We have been in Barcelona since Saturday and should be leaving again on Thursday morning. Derain and his wife are here too.

The weather's not too good. The Pichots are also here and they're off tomorrow. I don't really know what to write you. We're a bit tired and we're looking for antique jewels, which are difficult to find anywhere else. There was a bullfight on Sunday, which wasn't very nice, and we attended a very fine display of Andalusian dancing and singing. I'll write you from Cadaqués.

My regards to Miss Toklas and also to Leo and you.

Love,

Fernande

[Paris, 1910–1912]

Picasso's financial situation was improving all the time, but despite this he became more and more moody. When he was asked what was wrong, if he was upset or sick, he would look at you with astonishment and answer: "No, not at all, I'm thinking about my work." He would shut himself up for whole days in his studio, not allowing anybody, whoever they might be, to disturb him, and he got furious if a tactless visitor forced his way through the forbidden door. He worked incessantly, only emerging at nightfall, and grumbled if something urgent forced him to waste a day. It seemed as if he was uncomfortable unless he was in the particular atmosphere he had created for himself. I am not saying he needed this to be happy, because I don't think he really was.

Meanwhile, there were always friends at his table, and it was rare for him to have dinner alone. Everyone worked pretty much as hard as he did, and he and his friends only saw each other in the evenings. People went home very late at night, but the time lost was made up for by their unremitting commitment to work. Outside working hours, the apartment was always open to all comers. He may not have enjoyed this as much as people believed, but he had become accustomed to it. As in the past, everyone was welcome at Picasso's table and we did our best with the money we had, which was often not very much, but we were no longer content with nothing, as we once had been. It is true that there was still an atmosphere of good cheer and intimacy, with shouting, laughter and conversation. Apollinaire would often recite his poetry or read out his articles, and we still enjoyed Max's flights of fancy. We would still admire the majestic bulk of Gertrude Stein, the beard of Van Dongen, now a rising star in the fashionable world, and the wisdom of Matisse, so impressive and attractive, and we were entertained by the slightly vulgar impudence of Braque, the charmless idiocy of Olin and the fantasies of Salmon. For brief moments Picasso's face, darkened by the cares of his painting, would light up with his biting wit, but although we were all still young I could sense an unspoken waning of friendship, as if we were aging prematurely. Sometimes there seemed to be a strange bitterness, though it was quickly curbed, a weariness with seeing the

same people every day, going over the same ideas with them, criticizing the same talent, envying the same success. Occasionally the old spirit would be recaptured on evenings when Max Jacob and Olin once again became the "close enemies" they had always been, and with cruel witticisms exchanged pointed insults with one another while we all laughed. Once or twice they became really angry and flew into a temper, hurling the contents of their glasses into each other's faces. But their anger soon subsided and the contest of wit would begin all over again.

If we were eating at home on our own, Picasso hardly spoke, and he would often remain silent throughout the whole meal. He appeared to be upset, although he was in fact only preoccupied. He was quite different from Apollinaire or Max, who became lively, gay and entertaining as soon as they were away from their work. Even Picasso would unwind quite quickly when he was in their company. He was lucky to have friends who were so different from him.

Picasso was receiving invitations for more and more parties. Poiret entertained a great deal, and Haviland gave large dinner parties in his studio in Avenue d'Orléans, and there were many others. Picasso always made a fuss about going. I never understood why, as it would have been so easy to refuse in the first place, but he was weak. He wouldn't have the courage to turn down an invitation, even though he gave offense later by staying at home. He was very fortunate that his friends were so tolerant, although there were a few he felt guilty about. But he harbored so much resentment against anyone who forced him to do something he didn't want to that people took care not to put pressure on him.

He began to entertain regularly and decided to do this on Sunday, which is a dreadful day for people who don't have to work during the week. He thought he could repay all the obligations of friendship he had incurred in a single afternoon. Picasso looked quite delighted to see his friends, even though he often felt like telling them to go to hell.

There were always people who wanted to see Picasso's studio. Austrians, Spaniards, Hungarians, Swedes, Germans, Japanese, and Chinese would appear at his house. There were not many Americans, apart from the Steins and a few of their friends whom they were trying to "convert" to avant-garde art. But they had a difficult task, as Picasso didn't appear to Americans to be succesful enough yet. The Austrians, Germans and Swedes, whose outlook often tended to be intellectual rather than artistic, would give profound philosophical interpretations of Picasso's new technique, which really had nothing at all to do with it. They would discuss these with the artist, sometimes until he was bored stiff—but then he always found it boring to have to explain himself in words. They considered him a "genius" and told him so in such extravagant terms that it was often embarrassing.

However, it was quite different with one of his Chinese visitors. Picasso had welcomed him very warmly as he was amused by the fact that someone from Asia was

so completely at his ease wandering around the studio, looking and studying at length and finally delivering his opinion. After several visits this man thought he had understood everything and he asked Picasso quite simply how long it would take for him to be able to paint like that. Picasso was quite disconcerted, and, as so often when he didn't know what to say, he began to laugh. I had come to realize that Picasso was only witty when he was attacking somebody. If he was taken by surprise, he'd be embarrassed and wouldn't know what to say. He had his own brand of humor, which was so sharp you could only take it if you knew him really well. Max Jacob and Apollinaire liked the cruelty of this kind of wit, so they encouraged him.

Apollinaire was also making money. He had been writing rather mysteriously for a bookseller on the left bank. I know he didn't like to say much about this undertaking, but he laughed about it innocently. Literature was not as easy to sell as painting, and it didn't pay as well.

It was Max who was the slowest to take off, but he stayed at home alone most of the time since he couldn't stomach all the intrigue that was necessary to get his work published. He seemed to lack the journalistic aptitude of Apollinaire and Salmon and spent too much of his energy on trivial little tasks. He always loved detail and minutiae and was a prisoner of his own imagination in the most insignificant as well as the most important aspects of his life. At this time he had just published his first book of Breton poems, *La Côte*, translated, he claimed, from old Breton, though we suspected they were entirely the product of his own poetic fantasy.* It was published by subscription and he had terrible trouble getting the funds together. If I remember rightly, the subscription forms he wanted people to sign committed them to six francs each. But this first book is one of the things Max ought to be remembered for.

Around this time, when we had heard nothing from Max for several days,† Picasso began to get worried, although he was quite used to his friend's unpredictable behavior. So he climbed up to the Rue Ravignan, where he found Max up, but in such bad shape that he made him go to bed. Since he couldn't stay with him, he asked the concierge to see that he had everything he needed, and to let us know if he got any worse. There was no point calling a doctor, who would only do what a previous one (who was a friend) had done: shrugged his shoulders and said that the first thing to discuss was detoxification. Max was half poisoned! I don't know how he managed to withstand the harmful effects of all the drugs he took, which he claimed sharpened his powers of prophesy as a "soothsayer." I was afraid the drugs would end up destroying Max's health, and they were harmful to his mental stability. Henbane, which he considered necessary for his "journeys," as its effects, according

* Published in 1911.

† This incident occurred in March 1911.

to him, unleashed his psychic powers, is quite a virulent poison, and in combination with the ether he also abused could have produced mania, if not insanity.

These "artificial paradises" removed Max from his dark, airless room, filled with the poisonous fumes from the overflowing trashcans in the tiny courtyard right under his window and with the odors of kerosene, ether and stale smoke, which caught in your throat the moment you entered—the room that accommodated the person, the madness, the desires, dreams, extravagance and material misery of Max Jacob.

But Max was not to be pitied, for he reveled in the idea of himself as a "poète maudit," and accepted his squalid existence almost without being aware of it. The squalor seemed to strengthen this fateful identity and allow him to extract a kind of enjoyment from it. Perhaps he also took pleasure in unhappiness. Yet he could be so gay and lively, and his poems, which he was always willing to read to us, communicated an intense feeling for life, for action, for fantasy, and intellectual activity. This seemed quite out of keeping with that neglect of himself and everything else which often meant that his friends would not see him for several days. His poetry is so original and subtle and employs such a personal form of expression to evoke the most everyday, ordinary things. But this acute poetic observation was even more evident in his sensitive drawings, with their extraordinarily delicate line. I don't know if Max was conscious when he was drawing, or if they were mostly done in spells of hallucination or under the influence of drugs. But that's not important anyway. What would have been the point of trying to decipher the unique diversity of his character. What we needed to do was try and look after him when he couldn't do it himself, when he became sick "like everyone else." We knew perfectly well what colossal—and pointless—efforts would have been necessary to restore him to a more objective sense of reality. It certainly might have cured him, but it could also have made him tragically disenchanted with life.

In any case, his friends, and Picasso more than any of them, used to laugh indulgently at his most outrageous behavior, and that encouraged him all the more. Perhaps I myself was doing him harm when I furtively slipped him the few francs he asked me for when he had no money. But he suffered terribly when he didn't take ether, in just the same way somebody might suffer from an abcess, or toothache, or a broken heart. It was very painful, and one couldn't help taking pity on such misery. Then, the next time he was dragged unconscious from the gutter of the Rue Ravignan, drunk on ether, I promised myself I would never give in to him again, but later I found it impossible to resist that agonized look.

Perhaps if he had not been so paralyzed with shyness by women when he was a young man and wanted to express his feelings, or if he had not been betrayed by his first and only mistress, Cécile, he might have found support from a woman which would have prevented him indulging in those practices for which he has been almost universally condemned. In our artistic world people understood and accepted Max's

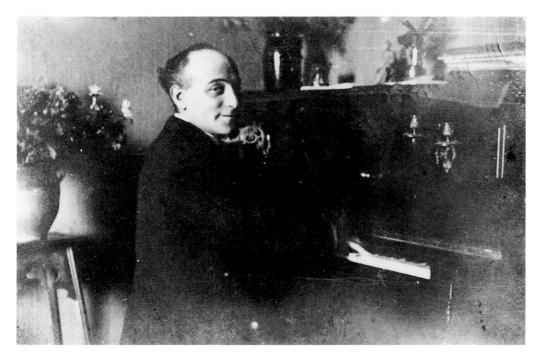

Max Jacob at the piano, 1910. Musée Picasso, Paris—Archives Picasso.

"transgressions," although they disapproved of them, but he seemed to become increasingly confirmed in his sexual and amatory deviance, and it became a problem. The world, society, was quick to condemn and showed no mercy, no understanding, no pity, no generosity. Nothing was in his favor.

When Pablo went back to see how Max was, he found him in bed in his dark room, very sick and being nursed after a fashion by his concierge, who was brewing herb teas for him. With great difficulty Picasso persuaded him to come and be looked after at our place. In the end he did come and a bed was made up for him in the studio. We had to take care of him, because he was really incapable of staying on his own, and with us he would at least have a comfortable bed and all the proper treatment. But what a difficult invalid he was to look after, in spite of his docility. He was both charming and maddening, refusing to take anything he didn't like, but being sweet and cheerful although he was so weak. He couldn't overcome his state of nerves, and I quite often lost my temper with him and ran after him, throwing everything at him I could lay my hands on. Then, the next day I would go and find him and smother him with affection, ready to start all over again. I was considered very badly behaved because of the way I spoke to him, but my anger gave me courage, as I can't stand deception. I find violence easier to understand than smallmindedness. Once Max had recovered, we realized just how anxious we had been and how much we loved him.

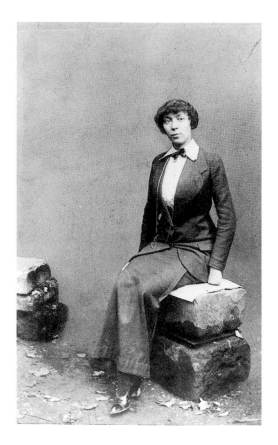

Marie Laurencin; photograph found among
Fernande's papers.

After our move to the Boulevard de Clichy we all went less frequently to the Lapin
à Gill, setting up a new headquarters at the Café de l'Ermitage on Boulevard
Rochechouart. The artists had their own corner in the right-hand aisle of the café,
at some distance from the orchestra, which they found rather tedious, although the
concertmaster, who was a fine violinist, provided some excellent music, which he
would play especially for them—though he was deceiving himself if he imagined
any of them ever listened to him. No doubt it would have been different if he
had played Negro music, but nobody knew about that yet. Braque only liked the
accordion, Picasso the guitar. MacOrlan, apart from the accordion, preferred the
hunting horn. Derain liked the harpsichord, the spinet, the flute and African
instruments, and he listened on the phonograph to records of Arab and Chinese
music. He liked any music that was strange and new, that hadn't been heard before.
I think that for a while he used to try to make primitive musical instruments
himself. He was always inventing things. When we visited his studio on Rue de
Tourlaque we would often find him trying to fly the little planes he had just con-
structed out of paper or cardboard! As for classical music, I don't think any of them
appreciated it at all.

RESPECTABILITY AND BETRAYAL

Marie Laurencin would sometimes come to meet us at L'Ermitage when she had got permission from her mother to stay out until ten o'clock; but she never stayed and would go home early like the good, conventional girl she always was. Otherwise, apart from Olin and Max Jacob, and sometimes "poor Basler," there were many new faces—Metzinger, Gris, Vaillant, Lombard, Mario Meunier, Serge Férat and his sister, the Baroness d'Oettingen, and many others—a few of whom had been part of our circle at the Lapin à Gill. Another of the young artists was Markous (who became known as Marcoussis); the complications of his love life, caused by Picasso, were later all over the humorous press, but Markous didn't lose his great sense of humor and drew a cartoon of the situation himself for *La Vie Parisienne*. I can still see this drawing, in which Markous is leaping around happily while Picasso is shackled with heavy chains.

Edouard Gazanion was another habitué of the Lapin à Gill who came with us to L'Ermitage. He was a kind of "poète maudit" and made us listen as he recounted his dreams, his sorrows, and his marital and literary difficulties. He always used to talk rather smugly about his "slim volume of poems," which we used to laugh about, because it never saw the light of day, but it eventually appeared as quite a substantial book. Gazanion had fair hair and a pink and white complexion and was hopelessly neurotic. He would get desperate about everything, from choosing a tie to suspicions about his wife's fidelity. His problems with Jean Pellerin were similar to Markous's with Picasso, though the two poets remained friends. Despite occasional, sudden bouts of malicious wit, Gazanion had the kindest heart I ever knew and was very affectionate towards his friends.

Serge Férat's real name was so complicated that Picasso never used to call him anything but Serge Apostrophe. His sister, "the Baroness" as we called her, was quite the most original and imaginative woman around (or at least that's what she thought). She would arrive dressed in ermine and gold, "showing off" quite a bit, but she was so good-natured and amusing when she displayed a little moderation that we were delighted with her. Besides, she was pretty, elegant, and distinguished.

Apollinaire disappeared for a week shortly after he first met the famous Baroness. He was discovered with her in Boulevard Berthier, where she used to live in a small hotel. He said laughingly that she had sequestered him in such a nice prison that he was sorry not to have been put away for life. He had been made to read his works, write poetry, and so on. She had simply been indulging a whim. She used to write and she painted; she was a cubist like her brother, and I believe that she was later converted to Futurism by Soffici, with whom she was always seen.

Besides all these, L'Ermitage had a clientele of boxers, one of whom, Sam Mac-Vea, attracted our attention because he looked like Braque. The two groups would jostle each other without speaking or greeting each other, and each had its allotted territory. Strange, disturbing men used to keep our group under observation, while the young ones, looking as if they came straight out of a novel, would be waiting for

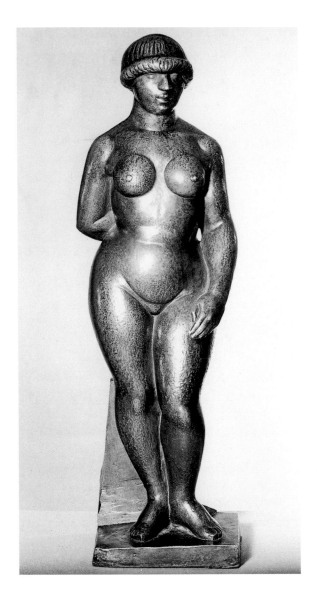

Manolo. *Standing Figure of Fernande*,
Céret, 1911. Kunstmuseum Bern—
Hermann und Margrit Rupf-Stiftung.

their girlfriends. From time to time these girls would let themselves be seduced by an artist, earning some fairly brutal chastisement from their men afterwards. We saw quite a few fights there, and once Braque and I saw Picasso lose his temper with a customer who had shoved him rather roughly, giving him one "straight to the jaw." We were absolutely astonished, and Braque quickly separated the combatants, unfortunately for Picasso's adversary. As an ardent boxing fan, Picasso was quite proud of the victory he won that day.

Later on (during the winter after we had been in Céret), the Italian Futurists erupted onto the Montmartre scene. Of course they went to see Picasso, and

RESPECTABILITY AND BETRAYAL

Apollinaire was crazy about Marinetti, their leader. They lived up to all their manifestos, with which they were extremely generous, and tried to make themselves look distinctive in an attempt to create a sensation. But their technique was not very good, and often they simply made themselves ridiculous. Boccioni (who was to die in the war) and Severini, who shared the fanatical dream that Futurism would oust cubism, started a Futurist fashion, which consisted of wearing socks of two different colors to match their ties. When they turned up at the Café de l'Ermitage, they would pull up their trousers very high to reveal one green leg and one red leg emerging from their shoes. The following day the red would be replaced with yellow, and the green with violet, for in general the colors had to be complementary. They evidently thought this was a brilliant new idea.

Soffici and Marinetti were at the forefront of the Futurist literary movement, and if anyone showed an interest in their ideas they would go on interminably. I once spent a whole night with Apollinaire and Picasso at Marinetti's, in the hotel room where he lived somewhere near the Place Pigalle. As dawn broke we were still there, having listened to him talk uninterruptedly since ten o'clock, without ever boring us.

I think it was thanks to Manolo and Frank Haviland that Picasso discovered Céret, in the eastern Pyrenees. In the summer of 1911 he went there a little ahead of me. He lived there just as he did in Spain, working throughout the day, spending the evening at the café, or with Manolo or Haviland, who had their own houses there. Later on, Braque also joined him there.

Manolo was making very attractive small sculptures, which owed their freshness to his slightly primitive style. They showed him to be an admirer of both Maillol and Paco Durio, but he absorbed these influences into his work in a way that did not compromise his own originality. I often used to see his little sculptures of peasants in the studio of Jean Van Dongen, the ceramist who was the painter's brother, as Kahnweiler, who became Manolo's dealer, used to get Van Dongen to fire them in his kiln.

Picasso had rented the first floor of a large building in the middle of a huge garden. There were three or four enormous rooms, one of which he used as his studio.

It was in August, while we were both in Céret, that the famous incident of the theft of the Mona Lisa from the Louvre occurred.* Picasso happened to meet Guillaume Apollinaire on the very day of his return to Paris and found him completely changed, terrified out of his mind. Apollinaire claimed he was being followed and pursued by the police, who had already searched his apartment, and he was frightened of being prosecuted in connection with the recent theft of some figures from

* The Mona Lisa was stolen from the Louvre on August 21, 1911, by Vincenzo Perugia. It was not recovered until December 1913.

the Louvre. He told Picasso that he was also implicated. In actual fact, a man called Géry, who, I believe, was the son of a well-known Belgian lawyer and had worked a few years earlier as Apollinaire's "secretary," had removed various statues and masks during the course of several visits to the Louvre.* He had done it out of a sense of adventure and for the fun of it, to prove that it was easy to steal from the museum. This had all happened some time before, and Géry, whom Apollinaire had brought to see us, gave Picasso two little stone masks, which were rather beautiful. He did not let on where he had acquired them, but simply suggested they should not be displayed too obviously. Picasso was delighted, and guarded these precious gifts by hiding them away at the back of a closet. Apart from this, there was just a small figure I had noticed on the mantelpiece at Guillaume's apartment.

From time to time we used to come across these small treasures when we were rummaging through the old Norman cupboard, but never gave them another thought—until, suddenly, Apollinaire was arrested. After the theft of the Mona Lisa, this Géry, who was witty and intelligent, but something of a crazy bohemian, decided, out of bravado, to confess to his thefts in a letter addressed to the *Paris Journal*, which published a sensational article on the "Thefts from the Louvre." The police were immediately alerted and started inquiries. They believed Guillaume was the leader of an organized gang, but I'm certain they wouldn't have found anything if this crazy Géry had not decided it would be amusing to write to the Public Prosecutor with precise details. He traveled all through the Midi, writing to the police from every town he passed through, and they kept on his track, although I don't believe he was ever caught.

I don't recall exactly what became of Géry, but I remember very clearly what a miserable life Apollinaire and Picasso led from the day Picasso had his unhappy encounter with Apollinaire. He immediately returned home to the Boulevard de Clichy to take "measures," and I can still see the two of them, like guilty children, terrified and seriously contemplating fleeing the country. I managed to prevent them giving way completely to their mad panic, and they decided to stay in Paris and get rid of the compromising pieces immediately. The question was how to do it.

Eventually, after a hasty dinner and a long evening of waiting, they decided to put the sculptures in a suitcase and throw it into the Seine in the darkness. They left on foot around midnight taking the case. At about two o'clock they returned, totally exhausted, bringing back the suitcase and its contents.

They had wandered around, but had never found the right moment, or else they hadn't dared get rid of their "parcel." They thought they were being followed and dreamed up a thousand possibilities, each one more fantastic than the last. In fact, although I shared their anxiety, I observed them closely that night. I'm quite sure that—perhaps unconsciously—they were both performing some kind of play for

* Géry Piéret had stolen the figures in 1907 and was working as Apollinaire's secretary in 1911.

RESPECTABILITY AND BETRAYAL

each other's benefit. It went so far that, although neither of them knew anything about cards, while they were waiting for the fatal hour when they had to leave for the Seine, "the hour of the crime," they pretended to play cards, as if they were gangsters, all evening.

In the end, Apollinaire spent the night with us and went the next morning to the offices of *Paris Journal*, where he handed over the "undesirable works" on condition that their provenance should be kept secret. This was a windfall for *Paris Journal*, who accepted eagerly. It was a scoop beyond their wildest dreams. But the following morning Apollinaire was awakened in Rue Gros by the police, who made a second search of his house.

We knew nothing about this, but when we had no news of our friend we became anxious, although we didn't dare go to his house. Then, one morning at about seven o'clock, Picasso's doorbell rang. The maid hadn't come down yet, so I opened the door and found myself face to face with a plainclothes detective, who showed me his identity card, introduced himself and requested Picasso to accompany him, so that he could appear before the examining magistrate at nine o'clock.

Picasso dressed quickly, but he was trembling so much I had to help him. He was practically out of his mind with terror. The policeman was good-natured and affable, he smiled in a cunning, insinuating way and tried to make us talk. But we didn't trust him and said nothing. Then Picasso, who really didn't understand what he was wanted for, was taken to police headquarters. The policeman wasn't allowed to take a taxi at his "client's" expense, so they went on the Pigalle–Halle-aux-Vins omnibus, which held dreadful associations for Picasso for months afterwards.

After he arrived at the police station there was a long wait, and then Picasso was brought into the chambers of the examining magistrate, where he saw Apollinaire, pale, disheveled and unshaven, his collar torn, his shirt open, wearing no tie, and looking pitifully gaunt, limp and broken down, a really sorry sight. He had been held for two days and submitted to a lengthy interrogation like a criminal, at which he had admitted everything they wanted him to. There was no room for truth in his confession, and he would have admitted to anything just to get some rest. Picasso was deeply shocked, and his apprehension turned to desperation. He had even less courage than he had had in the morning when he had been shaking too much to be able dress himself.

The events that followed, according to his account, are impossible to describe. He too could only say what the magistrate wanted him to say. In any case, Guillaume had sworn to so many things, true and false, that he had hopelessly compromised his friend—he was in such distress he would have compromised anyone. Apparently they were both in tears, and the rather fatherly judge had some difficulty maintaining his stern manner in the face of their childish sorrow.

It has been said that Picasso betrayed his friend and pretended he didn't know him. That is completely untrue. He certainly did not desert him, and, in fact, his

friendship for Apollinaire seemed to be even stronger afterwards. Picasso was not charged, but he was asked to make himself available to the examining magistrate as a witness.

Apollinaire was sent to the Santé prison, but was released after a few days thanks to his friend José Théry, a barrister who had taken on the quite straightforward matter of his defense. In the end, the case was dismissed, since the judge decided that the statute of limitations applied, although apparently the statute is not applicable in cases of this kind, which are considered to be crimes against the state.

However, many of Apollinaire's friends showed no sign of life for a while. They were afraid of being implicated. But Salmon, André Tudesque and René Dalize made numerous protests and collected many signatures on behalf of their friend, and André Billy (I think he was the one) arranged for Guillaume to work for *Les Soirées de Paris*, which helped him a lot. But apart from these few and Picasso, Max Jacob and José Théry, poor old Apollinaire saw hardly anybody during those anxious days. It was even impossible to persuade Marie Laurencin to write a few affectionate words of comfort to the man to whom she owed so much.

Long after the case was closed Picasso and Apollinaire still thought they were being followed. Picasso would only dare to go out at night in a taxi, and he would switch several times to put off his "tail." They had behaved like children, and as children do, they soon forgot their troubles once they felt sure the matter was closed. All that they remembered of the episode were the funny incidents, but I'm afraid Picasso never forgave me for having seen him so upset.

[End of Fernande's Memoir]

EPILOGUE

The End of the Story

John Richardson

Although Fernande never says as much, her relationship with Picasso had started to deteriorate long before the final debacle.* They had split up at least once: Fernande had walked out on him in 1907, when he was working on *Les Demoiselles d'Avignon* —hence the absence of this masterpiece from her pages. For his part, Picasso had been particularly exasperated when Fernande fell ill in Spain in 1909 (see her letter of complaint to Gertrude Stein on pp. 242–4). Also the move, on their return to Paris, from a scruffy studio in the Bateau Lavoir to a nice bourgeois apartment on the Boulevard de Clichy had made for more problems than it solved. Fernande foolishly luxuriated in being a lady of leisure with a maid at her disposal, and took to calling herself Madame Picasso. Picasso retaliated by renting an outside studio —in the Bateau Lavoir, which they had just left—going back to his bohemian ways, and, it would seem, entertaining girlfriends on the side. Fernande too had some brief affairs. The fact was, she was bored, she told Paul Léautaud, "You can't imagine what life with Picasso was like. Certainly he loved me. He did everything to give me all that I wanted, even if he himself would have starved. But his moods. Never a word. Whole days sitting, absorbed in himself. I wanted to talk to him, ask what was wrong. But you weren't allowed to say anything to him; he was thinking about his work."

And then in 1911 came the scandal of *l'affaire des statuettes*. As Fernande describes, Apollinaire and Picasso had come into possession of some primitive Iberian statuettes, which turned out to have been stolen from the Louvre by a former secretary of Apollinaire's. As a result of this rogue's indiscretions, the two of them would be suspected by the police of involvement in a far more important theft from the Louvre, that of the *Mona Lisa*. Apollinaire would be arrested and jailed (October, 1911); Picasso would not be charged, merely cross-questioned by the Sûreté, but this would leave him panic-stricken, his pride in shreds. Fernande believed that he

* Some of the material in the early part of this essay was incorporated in the second volume of my book, *A Life of Picasso*, pp. 221–233.

never forgave her for seeing him in this state. He became so paranoid that when he and Fernande went out at night, he would insist on changing cabs repeatedly to throw off non-existent "tails"; so truculent that he knocked out a local pimp for barging into him; and so disagreeable that Fernande took to going out on her own. More often than not she ended up at L'Ermitage, a noisy brasserie on the Boulevard Rochechouart that attracted a very mixed clientèle—painters, pimps, boxers, whores—and therefore a haunt to be avoided by a woman whose lover was as irritable as he was jealous. Fernande does not seem to have cared. She was out for adventure, and since she was, if anything, more seductive than she had been when she first met Picasso, she soon found it.

That fall, the Italian Futurists Boccioni and Carrà had arrived in Paris on a reconnoitering visit connected with their upcoming exhibition at the Bernheim-Jeune gallery. Besides checking out the competition at the Salon d'Automne, they insisted that Severini, the only member of the group who lived in Paris, take them to see Picasso, Braque, Léger and Apollinaire, who would write about their visit. In the evenings the Futurists would forgather at L'Ermitage. Among their hangers-on was a good-looking, twenty-two year old Bolognese painter called Ubaldo Oppi—"highly courteous and intelligent"—who was always badgering Severini to introduce him to Picasso. Severini finally took him to L'Ermitage to meet the Picassos and their friends Louis Marcoussis, a successful cartoonist who had recently switched to cubism, and his girlfriend Eva Gouel. In the course of the evening Fernande started flirting with Oppi, and they soon embarked on a passionate affair. Severini subsequently blamed himself, but "Picasso never reproached me for it," Severini wrote in his memoirs. "In the end Fernande was the hostile one. I never understood why." The explanation is simple. By setting her up with Oppi, Severini had enabled Picasso to unload her.

To carry on an affair under the ever watchful eye of Picasso, Fernande needed a go-between—and who better than her new confidante, Marcoussis's attractive and seemingly sympathetic mistress Eva? Picasso had taken a liking to Marcoussis and the two couples saw each other all the time, so clandestine meetings were easy to arrange. If anything went wrong, Eva was supposed to cover up for her girlfriend, but she had other ideas. Under the pretext of being a go-between, Eva was out to compromise Fernande and grab Picasso for herself.

To understand what happened in the course of the winter of 1911–12, we should remember that Picasso had turned thirty in October and, after the shock of *"l'affaire des statuettes,"* contemplated settling down, possibly marrying, as his family in Barcelona was always urging him to do. Even if his feelings for Fernande had not soured, he would never have made her his wife: she was too prone to miscarriages to be a mother, too indolent to be a good housewife, and too independent to submit to his tyranny. Moreover, Fernande was still not divorced. Eva, on the other hand, was longing to prove what a gifted *maîtresse de maison* she was, what a perfect

little wife she would make. To this extent she appealed to Picasso's residual bourgeois streak. She was also very pretty in a pert, Parisian way—a total contrast to the langorous Fernande—and although physically delicate and vulnerable, she was in most other respects remarkably tough. Eva was the right woman at the right time—the perfect mate for someone anxious to withdraw from the hurlyburly of bohemia and concentrate on work without having to worry about logistics; the perfect mate, too, for someone who was increasingly solicitous of his health and obliged to follow a rigorous diet.

During the spring Eva continued to manipulate this amorous triangle to her advantage, switching smoothly from being Fernande's go-between to Marcoussis's model mistress and Picasso's secret lover. Meanwhile she and her new admirer bided their time. On May 18, when all their pieces were in place, they detonated the bomb that enabled Picasso to send the guilty Fernande packing. Besides his dealer, Kahnweiler, the only person he confided in was Braque: "Fernande has gone off with a Futurist. I'm going to get out of Paris for a bit. I beg you to look after Frika [the dog] for a few days." And off the two lovers went to hide at Céret in French Catalonia, where Picasso had spent the previous summer and had a number of friends.

Fernande was left with nothing except her personal belongings and the lease for the Boulevard de Clichy apartment. The fact that this had been rented in her name made for problems. Now that Picasso had taken a house at Céret, he was forever asking Kahnweiler to collect the domestic articles he needed—sheets, bolsters, blankets, linen, clothes—as well as painting materials and have them shipped to him. Picasso remembered exactly where everything had been left: which shirt on which chair. The discovery that Louise, the maid, had stolen some things made the situation even more fraught. Distressed at Kahnweiler's incessant visits, Fernande finally threatened to have the dealer up for "violation of domicile." In the end he prevailed upon her to rent the place to him: that way he could no longer be charged with trespass. Whereupon she moved in temporarily with Picasso's old friend from Barcelona, Ramon Pichot, and his wife Germaine—likewise a former mistress of Picasso's.

No sooner had Picasso established himself at Céret than he was dismayed to hear that Fernande, having broken with Oppi, was on his track. He and Eva might have to move on. Thanks to information provided by Joaquim Sunyer—the Catalan painter whom Fernande had left for Picasso in 1904—the Barcelona newspapers announced Picasso's presence in Céret. Pichot had already written to check and, according to Braque, had announced that he, his wife and Fernande intended to spend the summer at Céret. "I am very annoyed by all this," Picasso wrote Kahnweiler: "first because I do not want my great love [for Eva] to be disturbed by the trouble they might cause nor do I want her bothered in any way; and finally I must have peace in order to work…If you see Fernande, tell her that she can expect nothing from me, and I should be quite happy never to see her again…" A week

later, Picasso told Kahnweiler that Fernande and the Pichots were definitely arriving and that he was off to Perpignan, "but don't tell ANYONE, ANYONE AT ALL where I shall be." Perpignan was too close to Céret for comfort; Picasso and Eva soon moved on in the greatest secrecy to Avignon. By the end of the year (1912), Picasso had proposed to Eva and been accepted by her. He took her to Barcelona to see his family. They would certainly have got married, if Picasso's father had not died in May 1913, followed almost immediately by the first symptoms of the cancer that would cause Eva's death in 1915.

Fernande had difficulty surviving. The affair with Oppi had lasted a few weeks at the most. He did not have the means to support her with the little luxuries to which she had become accustomed, so she broke with him. Whereupon Fernande may have had another transitory romance. This information comes from Serge Férat, a Russian toady of Picasso's, who was determined to present Fernande's actions in the worst possible light. She treated Oppi just like she treated Picasso, Férat says, "She took all his money and did not even reply to the letters he wrote in ink drawn from his own veins." Now that Fernande was on her uppers, "it appears that she is going to give herself up to *la basse prostitution*." Since Picasso had left her without a penny and, so far as we know, only one of his works (a small gouache) to sell; and since she

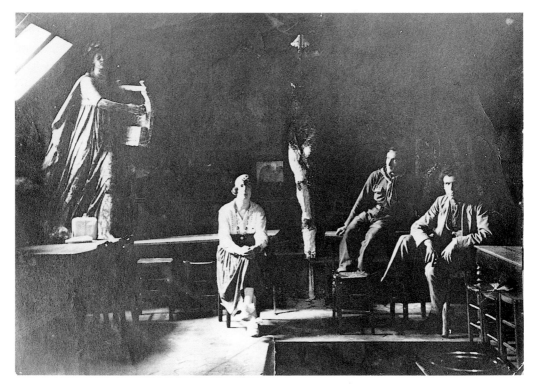

Fernande in the Lapin Agile, at the time she was giving poetry readings there, c. 1914.

was in despair at having made such a mess of her life, Fernande may have contemplated something of the sort. However, there is no evidence that she did. And when, shortly before Christmas, 1912, she threw herself on Gertrude Stein's mercy and asked her to help with the rent, she claimed to have found a job in the theater. Fernande also appealed to Apollinaire for a reference—could she say that she had worked for him?—so that she could get secretarial work. Paul Poiret came to the rescue and employed her as a *vendeuse*.

La belle Fernande did not have to wait long for another admirer. While living with Picasso she had had a brief affair on the side with Mario Meunier, a poet—"with the look and manner of a country curé," Léautaud said—who worked as Rodin's secretary. But she now embarked on a serious relationship with another young poet, Jean Pellerin. He wanted to marry her but went off to the war.

In her memoir of the early days in the Bateau Lavoir, Fernande often refers to the many friends she and Picasso had in the theater. Several of them—Marcel Olin, Charles Dullin, Harry Baur, Roger Karl—would become famous. Fernande describes them eating for next to nothing chez Vernin, then spending their evenings at the Lapin Agile. The best looking was Roger Karl, who had originally wanted to be a painter and then a writer. On March 16, 1917, Max Jacob wrote to Picasso (who was then in Rome) that Karl had been discharged and had written a fifty-page novella in the hope of becoming the French Dostoyevsky. "Tu parles, Carles," he added. Many years later Karl did in fact write a novel or two, but under another name. Thanks, however, to his looks, he soon made a great success as a movie star as well as a classical actor, and later still, as a golden voiced reciter of poetry on French radio. Karl could have been the greatest tragedian of his generation, Louis Jouvet said, if he had worked harder. Alas, he was also a drunk and a philanderer, notorious for having enticed the actress Georgette LeBlanc away from the Belgian playwright Maurice Maeterlinck. Some years after breaking with Picasso, Fernande embarked on an affair with Karl. He helped her get walk-on parts in plays and films; however, they did not start living together—in an attractive apartment on the Rue de la Grande Chaumière—until 1918. Fernande, whose morality worked in peculiar ways, refused to move in with him until Picasso got married. Karl, too, had a problem extricating himself from his affair with Georgette LeBlanc. As a major star, he must have been highly paid; however, he was extravagant and self-indulgent, and Fernande would always be obliged to pay her own way. Over the years she tried her hand at countless things: assisting an antique dealer, looking after children, working as a cashier in a butcher's shop, running a cabaret, reciting poetry at the Lapin Agile, reading horoscopes—a skill she had learned from Max Jacob. But she always fell back on giving lessons in drawing and French, and using her beautiful voice to teach diction.

In 1927 Fernande decided to embark on a challenging new project: a memoir of her life with Picasso. As well as journals to draw on, she had a good memory for the

telling incident and an acute sense of character and atmosphere. Given that she had a natural aptitude for writing, she did not need any help from her literary friends. Just as well, since most of them, with the notable exception of Max Jacob, had melted away. Gertrude Stein and Alice Toklas were the ones she most regretted. But in May, 1928, Fernande heard, through Marcoussis, that these women, who had once been her closest confidantes, wanted to see her again. She was thrilled; went to visit them; told them all about her book. An excellent idea, Gertrude said. She took the manuscript and promised to help her find a translator and American publisher. Meanwhile Fernande was not having much luck with French publishers. Her qualities—simplicity and liveliness of style and directness of observation—were not "literary" enough. In the end (summer, 1930), she arranged to have her story serialized in the evening newspaper, *Le Soir*.

Fernande's articles made Picasso understandably furious. Instead of using her original title, *Neuf ans chez Picasso*, *Le Soir* chose to call their series *Quand Picasso était pompier* (slang for academic kitsch), which is hardly the way to describe the Blue and Rose periods. Worse, this was the first time that intimate details of Picasso's hitherto very private life had appeared in a newspaper. However, his displeasure at the disclosures—drugs, mistresses, involvement in thefts from the Louvre —was nothing compared to that of Picasso's maniacally jealous, pathologically respectable wife, Olga. She was even more determined than he was to have lawyers stop publication in *Le Soir*. Six instalments would appear before their efforts prevailed. Meanwhile the eminent *littérateur*, Paul Léautaud, had been so impressed by the vividness of Fernande's story that he wrote asking whether the *Mercure de France*, the prestigious literary magazine he edited, could publish excerpts.

Madame Olivier "is really very pretty," the lecherous Léautaud reported in his diary, after one of Fernande's visits to his office, but "stayed too briefly for my liking. A crazy idea occurred to me. She is a painter, was Picasso's model. She presumably has no sense of shame about undressing. Each time she comes, she talks about her difficult life, obliged to give lessons…How about asking her to pose. How much an hour. Twenty-five francs, I imagine. Or even fifty. If she asks me for whom? For me. From time to time I'll treat myself to the sight of a pretty naked creature—a sight I don't get nearly enough of…I'll certainly be seeing her about the manuscript. I must have the audacity to proposition her."

Whether or not Fernande stripped for him, Léautaud agreed to publish three more excerpts of her memoir in three consecutive issues of the *Mercure*. To conceal from Picasso and his lawyers the extent of their excerpts, the *Mercure* took the precaution of omitting the words "*à suivre*" (more to follow) at the end of the first two instalments. Léautaud begged Fernande to write down, even if she did not actually publish, some of her more compromising stories about members of *la bande à Picasso*: for instance about a certain M., who, she said, "used to send himself five or six telegrams a day in order to avail himself of the young telegraph boys." By way of

tips, M. left small change lying around for the boys to pinch. Fernande promised Léautaud to write about these scandals, but to her credit she never did. It was not in her nature.

In the face of Picasso's litigious behavior, Fernande wrote the artist—their first contact since she had left twenty years before—a telling letter (May 13, 1932), in which she not only defends her memoir but plays on Picasso's superstitious fears by invoking threats of her own. "Until now I have never wished you anything but happiness, Now, every day, I shall make a wish for you to be hurt in the things you love most, affection, money, your health. And you will be punished for your utter heartlessness. I know it. I have only ever wished to see three people unhappy or hurt because they did harm to me. My husband (I married him when I was 17 and was still his wife when you met me) died *crazy*. An aunt who cast a shadow over my childhood saw her husband die tragically, and Eva Markous [Gouel], as you know, met a miserable end. I am in an impossible situation....Now I would like you to know unhappiness. At the first moment it arrives you will think of me....Now remember that you promised me several thousand francs the moment I put my affairs in order. You never gave them to me. Remember that unhappiness awaits you and I know there is a curse hanging over you. Fernande Olivier."

Undeterred by Fernande's threats, the artist once again tried to stop publication —in 1933, when Stock printed her memoirs in book form with a preface by Léautaud. Once again he failed. *Picasso et ses amis* came out to considerable success; and it has never ceased to provide art historians of the period with a major source of information. Thirty years later, Picasso told me that, much as he resented the invasion of his privacy, Fernande's book described things the way they were: "the only really authentic picture of the Bateau Lavoir years," he said.

Meanwhile Fernande had taken Gertrude Stein up on her offer of help. On April 13, 1931, she had written to say that, yes, she would be very grateful if Gertrude could help her arrange the book's publication in America. This would "rescue me from material difficulties that have left me at the end of my strength." Gertrude referred Fernande to her American agent, William Aspenwall Bradley, who agreed to represent her—find a translator and a publisher. It would be a great inducement, he said, if a celebrated writer, such as Gertrude, could be persuaded to write a preface introducing Fernande to the American public. Gertrude declined. She could not, she said, write anything that did not corresponde to her "*idéal*." Fernande was hurt. "Don't forget me, I beg of you," she implored Gertrude, "This book is the last card in my hand. If it doesn't succeed, I'll stop struggling for an existence, whose poetic meaning eludes me."

Fernande heard nothing from Bradley or Gertrude for two years. The reason became abundantly clear when friends in America informed Fernande that Gertrude was coming out with *her* memoirs. And instead of finding a publisher for *Nine Years with Picasso*, as Fernande wanted to call her book, Bradley had arranged

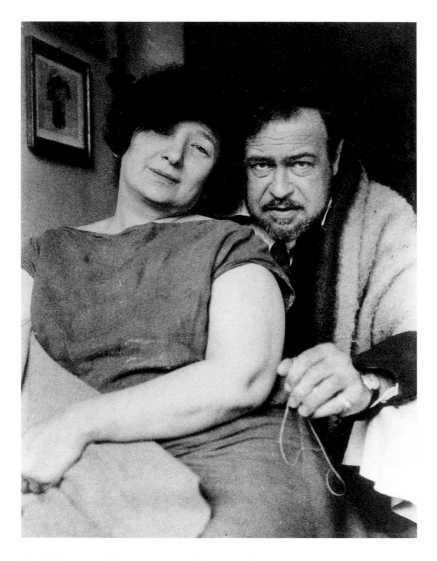

Fernande Olivier
and Roger Karl
during the 1930s.

for Harcourt Brace to take Gertrude's *Autobiography of Alice B. Toklas*. This turned out to cover much of the same ground as Fernande's book and to have once had a very similar title (*My Twenty-five Years with Gertrude Stein*). It also turned out to have been written, albeit with more art, in the same vivid, snapshot style—a totally new departure for this usually arcane writer. Bradley had arranged for extracts from Gertrude's entertaining book to appear in the *Atlantic Monthly*, and it was these extracts that friends brought to Fernande's attention.

Fernande had always regarded Gertrude as a mentor, someone to whom she could turn when things went wrong. Now, rightly or wrongly, she felt deceived as well as betrayed. On June 8, 1933, she sent Bradley a reproachful letter: "I am sure that my *Souvenirs* partly inspired [Gertrude's]. I have kept, punctiliously, to the

promise [of exclusivity] that I gave you. This has gone on for two and a half years. Enough time for me to redeem my manuscript…I refused to allow friends of mine in America to find a publisher for my *Souvenirs*. I was wrong." She was going to report the matter to the Author's Society, Fernande said; she was also going to write a letter to the *Atlantic Monthly*, pointing out Gertrude's numerous errors: something that several other angry victims of the writer's self-serving memory—including Matisse, Braque, André Salmon, and Tristan Tzara—would denounce in their *Testimony against Gertrude Stein* pamphlet (put out by *transition* magazine in February, 1934). Over thirty years would pass before Fernande's book would be published in America as *Picasso and His Friends* (in 1965, the year before she died). Meanwhile the *Autobiography of Alice B. Toklas* enjoyed a huge success in the U.S., and also in France, where it came out in 1934.

Since Fernande failed to make much money out of her book let alone her paintings, she was obliged to continue giving French lessons. A few women friends from the old Montmartre days (Marcelle Braque, Alice Derain, Guus Van Dongen) kept in touch and sometimes helped her out, but the ever increasing difference in their and her financial circumstances put an ever increasing strain on Fernande's pride. In 1936 Fernande made a new, much younger friend, a woman called Marthe Krill, who worked for the dairy in the building on the Rue de la Grande Chaumière, where she and Karl had an apartment. Madame Krill would bring Fernande fresh milk every morning. The two women bonded. They discovered they shared a similar Montmartre past and many of the same bitter experiences with men. Madame Krill, who had worked as a waitress at the Moulin de la Galette, had been obliged to run away from a battering husband and bring up a two year-old son on her own. To help her out, Fernande, who had always longed to have a baby, suggested adopting her new friend's son. Instead Gilbert became her godchild and, ultimately, heir.

By the late 1930s Fernande had become increasingly unhappy with Karl. He was not only unfaithful, he was lazy and drunken and, for all his gifts, no longer in much demand as an actor. Nevertheless, they stayed together. At the beginning of World War II, they left their Rue de la Grande Chaumière apartment and moved to Neuilly. Their life became a hell. Because they were both partly Jewish, they lived in fear of persecution, a fear that Karl's drunkenness and promiscuity did nothing to allay. Such affection as they still had for one another turned to hatred, and in mid-1943, they finally broke up. Fernande moved down the street to a one-room apartment—not much bigger than the *Demoiselles d'Avignon* canvas—on the ground floor of 42 Rue du Bois de Boulogne. Towards the end of the war she had so few pupils that she was more or less destitute. Beyond the occasional shopping spree, her rich adoptive sister did little or nothing to help her.

Fernande once again wrote Picasso (March 2, 1943) about her plight: "Pablo help me, for I am not like the others.…After the war I will know what to do. I'll give French lessons again. Help me." When, in the following year, Fernande read that

Picasso had become a communist, she decided to follow suit—not on ideological grounds but to get a secretarial job with the party. In another letter to Picasso (August 17, 1947), again asking for financial help, she described how her apartment had been sold for nothing and that she had never dreamed in her youth how miserable old age would be.

Fernande turned seventy-five in 1956. Increasing arthritis and deafness made it more and more difficult for her to work. Madame Krill was very solicitous, but what Fernande needed was money. Only one resource was left to her: a wicker valise containing the early diaries, letters and other documents on which she had based her original book. A great deal of this material—concerning Picasso as well as herself—had not been published: too "*intime*," to use the word she had strategically chosen for her title. But times had changed, so had her circumstances. Using Marcelle Braque as a broker, Fernande was promised a million old francs by the artist on the understanding that her *souvenirs intimes* would not be published—in his lifetime at least. And for the rest of her days, Fernande would receive a small pension from Picasso through the good graces of Marcelle Braque. Fernande's *Souvenirs intimes* would not be published until 1988—long after she and Picasso had both died.

In 1956 Fernande made a couple of appearances on French television. Picasso, who had not seen her for almost half a century, was appalled. A shameful performance, he said. She was too old and fat and toothless to make such a spectacle of herself. She had betrayed the image of beauty that she personified in his early work. In fact, for all that she was seventy-five and looked it, Fernande came across vividly on television; and to have heard her somewhat theatrical intonation is to understand why she was in demand as a teacher of diction. Eventually arthritis would keep her more or less bedridden. She found this exceedingly boring, she wrote her godson, Gilbert. Two days later, on January 29, 1966, this woman, who had been born Amélie Lang, who was briefly Madame Paul Percheron and occasionally assumed the names Bellevallé or Bellvalet and who had achieved immortality through Picasso as Fernande Olivier, or "*la belle Fernande*," died at the age of eighty-four. Fernande had always been terrified of dying alone, so kept her door unlocked. A fatal precaution; it did not save her from a solitary death, and it enabled a neighbor to make off with the bearer bonds she had purchased with Picasso's million francs.

BIOGRAPHICAL NOTES

Marilyn McCully

AUGUSTE AGÉRO (1880–after 1937), Spanish sculptor; he and his wife, who Fernande recalled was a seamstress, lived in the Bateau Lavoir. He was in touch with Picasso until at least 1937.

HERMEN ANGLADA CAMARASA (1871–1959), Catalan painter.

GUILLAUME APOLLINAIRE (WILHELM DE KOSTROWITZKY) (1880–1918), celebrated poet and great friend of Picasso's.

ALEXIS AXILETTE (c.1860–1931), figure painter and portraitist.

ADOLPHE BASLER (1875–1951), born in Poland, he became an influential art critic in Paris.

HARRY BAUR (1880–1943), stage and film actor.

JEAN BENNER (1836–1906), portraitist and close friend of fellow-Alsatian painter Jean-Jacques Henner. His twin brother Emmanuel was also a painter.

ANDRÉ BILLY (1882–1971), journalist, literary critic, writer; together with André Salmon, René Dalize and André Tudesq, founded *Les Soirées de Paris*.

HENRI BLOCH, violinist. Picasso painted a portrait of his sister Suzanne, a Wagnerian opera singer, in 1904.

UMBERTO BOCCIONI (1882–1916), Italian futurist.

GIOVANNI BOLDINI (1842–1931), Italian painter, who settled in Paris in 1871, becoming a leading society portraitist.

LÉON (JOSEPH FLORENTIN) BONNAT (1833–1922), history painter and professor at the Ecole des Beaux-Arts. His many pupils included Dufy, Friesz and, briefly, Braque.

ERNEST BORDES (1852–1914), history and portrait painter.

JEAN-LOUIS BOUSSIGNAULT (1883–1943), painter, engraver; he decorated Paul Poiret's showrooms.

GEORGES BRAQUE (1882–1963), painter. He and Picasso met in 1907.

BENEDETTA COLETTI (or BIANCO) CANALS, Italian model and wife of Ricard Canals. Her son, Octavi, was Picasso's godson.

RICARD (RICARDO) CANALS (1876–1931), Catalan painter. He left Barcelona in 1897 for Paris, where he lived for a number of years. The studio he used in 1899 at 130 Boulevard de Clichy was taken over two years later by Picasso.

EMILE-JOSEPH-NESTOR CARLIER (1849–1927), monumental sculptor.

ENRIC CASANOVAS (1882–1948), Catalan sculptor.

FABIÁN DE CASTRO (b. 1868), Spanish painter and gypsy guitarist, known as "El Gyptano."

EDGAR CHAHINE (1874–1947), etcher; born in Venice of Armenian parents, he moved to Paris in 1895.

FERNAND-ANNE CORMON (1845–1924), professor at the Ecole des Beaux-Arts, best known for his grandiose historical canvases and evocations of prehistory. He also decorated several important public buildings in Paris, including the Gare d'Orléans (now Musée d'Orsay).

MAURICE CREMNITZ (CHÉVRIER) (1875–1935), poet and publicist.

RENÉ DALIZE (DUPUY DES ISLETTES) (1880–1917), writer; a close friend of Apollinaire's.

LAURENT DEBIENNE, sculptor, whose real name was Gaston de Labaume (b. 1871).

GABRIELLE DEBILLEMONT-CHARDON (1860–1957), miniaturist, director of painting academy for miniaturists.

ROBERT DELAUNAY (1885–1941), "simultaneist" painter, promoted by Apollinaire.

SONIA DELAUNAY (1885–1979), Russian painter, born Sonia Terck. She married Wilhelm Uhde in 1908, but they divorced soon afterwards; she married Delaunay in 1910.

ANDRÉ DENIKER (b. c. 1885), son of Joseph Deniker, chief librarian of the Muséum d'histoire naturelle; the family lived in Buffon's house in the Jardin des Plantes.

ALICE DERAIN (ALICE MARIE GÉRY) (1884–1975). She married Maurice Princet in 1905, but they separated and divorced shortly afterwards; she married Derain in October 1907.

ANDRÉ DERAIN (1880–1954), painter. He and Picasso met in 1906.

MAXIME DETHOMAS (1867–1929), watercolorist and illustrator.

THÉOPHILE-LOUIS DEYROLLE (1844–1923), genre and portrait painter.

ROLAND DORGELÈS (ROLLAND MAURICE LÉCAVELÉ) (1886–1973), Montmartre chronicler.

EDOUARD-MARIE-GUILLAUME DUBUFFE (1853–1909), academic painter and decorator.

RAOUL DUFY (1877–1953), painter and designer, one of the fauve group.

GEORGES DUHAMEL (1884–1966), poet and critic; he married the actress Blanche Albane (1886–1975) in 1909.

CHARLES DULLIN (1885–1949), actor and, later, founder of the Théâtre de l'Atelier.

ANDRÉ (ALBERT ANDRÉ MARIE) DUNOYER DE SEGONZAC (1884–1974), painter.

CAROLUS DURAN (CHARLES DURAND) (1837–1917), celebrated portrait painter and teacher. He became director of the Académie de France in Rome in 1904.

PACO DURIO (FRANCISCO DURRIO) (1868–1940), Basque ceramic sculptor and jewelry maker, whose studio in the Bateau Lavoir Picasso had taken over in 1904.

Juan de Echevarría (1875–1931), Basque painter.

David Edstrom (1873–1938), Swedish sculptor and potter, whose estranged wife lived in Florence, where she became friendly with Gertrude Stein. Stein portrayed him in "Men".

Serge Férat (Jastrebzoff) (1881–1958), Russian-born painter (he sometimes used the name Alexander Rudniev). From 1913 he and Hélène d'Oettingen became joint proprietors of *Les Soirées de Paris*, the journal edited by Apollinaire.

Josep Fontdevila (1821–1910), former smuggler, and proprietor of the Cal Tampanada inn at Gósol.

Rodolphe Fornerod (1882–1953), Swiss artist, who married Germaine Pichot's sister Antoinette. Antoinette modeled for Picasso in 1905.

Paul Fort (1872–1960), poet and dramatist; he founded the journal *Vers et Prose* in 1905.

Othon Friesz (1879–1949), fauve painter.

Pau (Pablo) Gargallo (1881–1934), Catalan sculptor, who eventually settled in Paris.

Edouard Gazanion (1880–1956), poet.

Albert Gleizes (1881–1953), painter, who with Metzinger wrote *Du Cubisme* in 1912.

Richard Goetz (1874–1954), German painter, amateur boxer and collector.

Louis de Gonzague Frick (1883–1961), poet and essayist.

Juan Gris (José Victoriano González Pérez) (1887–1927), Spanish painter; he came to Paris in 1906 and moved into the Bateau Lavoir. He worked for several years as a cartoonist.

Grock (Adrien Wettach) (1880–1959), Swiss clown, who first appeared at the Cirque Médrano in December 1904. His partnership there during the following years with Marius Galante i Antonet became world famous.

Frank Burty Haviland (1879–1971), painter, who settled in Céret. He invited Picasso and Fernande there in 1911.

Jean-Jacques Henner (1829–1905), much venerated and honored Alsatian painter.

Auguste Herbin (1882–1960), painter. He lived for a time in the Bateau Lavoir.

Paul Iribe (1883–1935), illustrator and designer.

Max Jacob (1876–1944), poet and great friend of Picasso's.

Nellie (Eleanor Joseph) Jacott, a friend of Alice Toklas's who lived in New York.

Pierre-Georges Janniot (1848–1934), Swiss graphic artist born of French parents.

Alfred Jarry (1873–1907), writer and pataphysician.

Daniel-Henry Kahnweiler (1884–1979), German art dealer; he opened his gallery in Paris in 1907.

Roger Karl (Roger Trouvé) (1882–1984). He started as a painter, associating with Derain and the Chatou group, then became an actor. He was Fernande's longtime lover after Picasso.

Marie Laurencin (1885–1956), painter; girlfriend of Apollinaire, who promoted her work.

Fernand Léger (1881–1955), painter. He exhibited with the salon cubists in 1911.

Georges Lepape (1887–1971), painter, decorator and illustrator; from 1909 he collaborated with Paul Poiret.

Harriet Lane Levy (b. 1867), writer; a friend of Alice Toklas's from San Francisco.

Louis Libaude (Henri Delormel) (d. 1918), as Libaude a small-time art dealer; as Delormel, a writer and satirist.

Alfred Lombard (1884–1973), painter who worked principally in Provence.

Walter MacEwen (1860–1943), American painter from Chicago, who lived and worked in Paris.

Pierre MacOrlan (Pierre Dumarchey) (1882–1970), writer, chronicler of Montmartre.

Sam MacVea (b. 1885), American boxer who came to Paris in 1905 and established a boxing school in Montparnasse. He was known as the "Black Napoleon of the ring."

Christiane Mancini, actress; Jean Cocteau claimed she was his "companion" when she was a music student. Her sister was the singer Louise Mancini.

Henri-Charles Manguin (1874–1949), fauve painter.

Manolo (Manuel Martínez i Hugué) (1872–1945), Catalan sculptor and trickster.

Louis Marcoussis (Lodwicz Markus) (1883–1941), painter, who arrived in Paris from Poland in 1903. From 1906 his mistress was Marcelle Humbert (Eva Gouel, 1885–1915), who left him in 1912 for Picasso. See pp. 278–9.

Marinetti, Filippo Tommaso (1878–1944), Italian futurist writer.

Henri Matisse (1869–1954), painter; Picasso and Fernande met him in 1906.

Jean Metzinger (1883–1956), salon cubist associated with Gleizes.

Mario Meunier (1880–1960), Hellenist, who became Rodin's secretary. Fernande had had an affair with him while she was still living with Picasso.

Jean de Mitty (Demetrius Golfineano) (1868–1911), Romanian-born writer.

Amedeo Modigliani (1884–1920), Italian sculptor and painter; he arrived in Paris in 1906 and, following Picasso's advice, moved to a studio in Montmartre.

Gaston Modot (1887–1970), painter, who became a film stuntman and actor. In 1930 he played the lead in *L'Age d'or*, the film by Buñuel and Dalí.

Jean Mollet (1877–1964), secretary to Apollinaire, who dubbed him Baron Mollet.

Jean Moréas (Iannis Papadiamantopoulos) (1856–1910), Greek-born symbolist poet and leader of the "Ecole Romane" in Paris.

Luc-Albert Moreau (1882–1948), painter and illustrator.

Elie Nadelman (1882–1946), Polish sculptor living in Paris.

Hélène d'Oettingen (1887–1950), Russian-born hostess, writer and painter, who used the name Roch Grey and other aliases and claimed to be Serge Férat's sister.

Marcel Olin (d. 1916), actor and poet.

Jacques Patissou (1880–1925), painter, a pupil of Cormon. He won second prize in the Prix de Rome competition in 1905 and entered again in 1908.

JEAN PELLERIN (1885–1921), poet; Fernande's lover, probably at some time during 1912–14.

PAUL PERCHERON (1873–1917/18), Fernande's husband, from whom she was never divorced.

RAMON PICHOT (1872–1925), Catalan painter, married to Germaine Gargallo (1881–1948), who in 1901 was known as Laure Florentin. They ran the Maison Rose restaurant in Montmartre.

LOUIS GÉRY PIÉRET (1884–after 1938), Belgian huckster, who worked as Apollinaire's secretary and implicated him in the case of the theft of the *Mona Lisa* in 1911.

PAUL POIRET (1879–1944), painter and celebrated fashion designer.

MAURICE PRINCET (1875–1971), an actuary by profession. In 1905 he married Alice Géry, who left him for Derain.

JEAN PUY (1876–1960), fauve painter.

MAURICE RAYNAL (1884–1954), journalist and writer, author of the earliest monograph on Picasso (1921).

ODILON REDON (1840–1916), symbolist painter.

JACINT (JACINTO) REVENTÓS (1883–1968), Catalan doctor and friend of Picasso's in Barcelona.

GEORGES ANTOINE ROCHEGROSSE (1859–1938), history painter, orientalist, decorator.

ALFRED PHILIPPE ROLL (1846–1919), society portraitist and painter of civic decorations.

HENRI "LE DOUANIER" ROUSSEAU (1844–1910), painter.

CLOVIS SAGOT (1854–1913), former clown; picture dealer.

EDOUARD ALEXANDRE DE SAIN (1830–1910), history painter, director of art academy for girls.

OLIVIER SAINSÈRE, government official, painter and collector; he bought his first Picasso in 1901.

ANDRÉ SALMON (1881–1969), writer and close friend of Picasso's.

TOM SCHILPEROORT (1881–1930), Dutch journalist who arrived in Paris in 1905. He invited Picasso (but not Fernande) to Holland in June of that year.

DÉODAT DE SÉVERAC (1872–1921), composer; he met Picasso in Montmartre and later settled in Céret.

GINO SEVERINI (1883–1966), Italian painter, who arrived in Paris in 1906; affiliated with the futurists.

SERGEI IVANOVICH SHCHUKIN (1854–1936), Russian collector, who lived in Moscow.

FRANÇOIS SICARD (1862–1934), monumental sculptor from Tours.

ARDENGO SOFFICI (1879–1964), Italian painter and writer.

MATEU FERNÁNDEZ DE SOTO (1881–1939), Catalan sculptor.

EUGÈNE SOULIER (d. 1909), former wrestler; picture dealer known as "le père Soulier."

GERTRUDE STEIN (1874–1946), American writer and collector.

LEO STEIN (1872–1947), American collector and writer; he shared a house in Paris with his sister Gertrude. Their sister-in-law Sarah (1870–1953) attended Matisse's academy.

Louis (Marie Louis) Süe (1875–1968), painter and decorator.

Joaquim Sunyer (1875–1956), Catalan artist who worked in Paris until the outbreak of World War I. He later earned local celebrity, especially for his portraits. In a letter (January 1949) to his son he recalled that "Fernande was a beautiful and good woman with a sweet expression—I still remember that heartfelt look."

Gaston Thiesson (1882–1920), painter and art critic.

Alice B. Toklas (1877–1967), American writer; companion of Gertrude Stein.

André Jean Tudesq (1883–1925), journalist and writer; co-founder with Salmon, Dalize and Billy of *Les Soirées de Paris*.

Wilhelm Uhde (1874–1947), German collector, dealer and critic. He bought his first Picasso in 1905.

Miquel (Miguel) Utrillo (1862–1934), Catalan artist and writer. In 1901 he wrote the first serious appreciation of Picasso's work. He is thought to be the father of Maurice Utrillo (1883–1955).

André Utter (1886–1948), painter; friend of Maurice Utrillo, whose mother, Suzanne Valadon, he married in 1909.

Jacques (Gaston Emile) Vaillant (1879–1934), painter, who lived in the Bateau Lavoir.

Suzanne Valadon (1865–1938), artists' model and painter.

Félix Vallotton (1865–1925), Swiss artist who worked in Paris; member of the Nabis.

Fritz René Vanderpyl (b. 1876), writer, originally from Holland, who came to Paris in 1900; he wrote French poetry, novels and art criticism.

Jean (Johannes Leonardus Marie) Van Dongen (1883–1970), Dutch sculptor and potter. He arrived in Paris in 1904, living first with his brother Kees in Montmartre. He married a singer who performed at the Lapin à Gill.

Kees (Cornelis Theodorus Marie) Van Dongen (1877–1968), Dutch painter who began his career in Paris as an illustrator in 1899; he and his wife Guus (Augusta Preitinger), also a painter, lived in the Bateau Lavoir. Their daughter Gussie, later known as Dolly, was born on April 18, 1904.

Louis Vauxcelles (b. 1870), nom de plume of the critic Louis Mayer, who in 1905 coined the tern "fauve", and, three years later, "cubism." He also wrote as "Pinturricchio."

Maurice de Vlaminck (1876–1958), painter.

Ambroise Vollard (1865–1939), originally from Réunion, he became a celebrated art dealer and publisher of artists' books.

Otto von Wätjen (1881–1942), German painter, who married Marie Laurencin in 1914.

Karl Wilhelm Wiegels (1882–1908), German painter, who moved to the Bateau Lavoir around 1906 and committed suicide there two years later.

Ignacio Zuloaga (1870–1945), one of the leading Spanish artists in Paris in the early years of the century. His wife Valentine was the sister of Maxime Dethomas.

INDEX

Biographical notes can be found on pp. 287–292 for entries in **bold** type. Illustration references are in *italics*. Quotation marks indicate Fernande Olivier's spellings or disguised names.